FROM STILL TO MOTION

A photographer's guide to **creating video with your DSLR**

JAMES BALL > ROBBIE CARMAN > MATT GOTTSHALK > RICHARD HARRINGTON

New Riders

VOICES THAT MATTER™

From Still to Motion
A photographer's guide to creating video with your DSLR

James Ball, Robbie Carman, Matt Gottshalk, and Richard Harrington

New Riders
1249 Eighth Street
Berkeley, CA 94710
510/524-2178
Fax: 510/524-2221

Find us on the Web at www.newriders.com

To report errors, please send a note to errata@peachpit.com
New Riders is an imprint of Peachpit, a division of Pearson Education

Senior Editor: Karyn Johnson
Production Editor: Hilal Sala
Development and Copy Editor: Anne Marie Walker
Compositor: Kim Scott, Bumpy Design
Proofreader: Scout Festa
Indexer: Jack Lewis
Interior Design: Mimi Heft, with Kim Scott
Cover Design: Mimi Heft
Cover Production: Andreas DeDanaan
Cover Photo: Lisa Robinson

ISBN-13: 978-0-321-70211-1
ISBN-10: 0-321-70211-5
9 8 7 6 5 4 3 2

Printed and bound in the United States of America

Acknowledgments

Gary Adcock

Adobe

Adorama

Apple

Syl Arena

Philip Bloom

Scott Bourne

Luke Brindley

David Burns

Canon

John and Marcia Carman

Cool Lights

Scott Cowlin

Sam Crawford

Creative COW

DC Camera

Emmanuel Etim

Bill Frakes

Future Media Concepts

Chris Gorman

Rod Harlan

Mimi Heft

Ben Howard

Karyn Johnson

Staff of Jammin' Java

Ben Kozuch

Bob Krist

Brian Krist

Orlando Luna

Lynda.com

John Lytle

Stu Maschwitz

Adam Martray

Joe McNally

Nikon

National Association of
 Photoshop Professionals

Jason Osder

Barbara Parker

Moose Peterson

Jeff Revell

Staff of RHED Pixel

Ian Robinson

Lisa Robinson

Erich Roland

Hilal Sala

Jeff Schmale

Kathy Siler

Jeff Snyder

TIVA-DC

Sara Jane Todd

Alexis Van Hurkman

Women in Film and Video

Anne Marie Walker

Mark Weiser

John Woody

Zacuto

Foreword

From Still to Motion was written just for me. Okay, not really, but it might as well have been. About a year ago, long-standing clients of my photography business started asking for—no, actually demanding—video from me. My oldest client called me one day and said with sorrow in his voice that he may have to make a change because the print side of his company was giving way to web video.

Faced with being disintermediated, I decided to learn all I could about filmmaking. Fortunately, video-enhanced DSLRs became available at the same time. But just buying a Canon 5D MKII or similar camera wasn't going to be good enough. When you move to shooting video, it's a whole new ball game.

After delving deeper, I realized that it all made sense. As technology advancements have blurred many of the lines in media, it only makes sense that DSLR video is the next step in the evolution of still photography.

I spent more than three decades as a professional still photographer, and I admit that I thought the switch to video would be reasonably easy for me. But I soon found out that video presents challenges not found in still photography. There are new conventions to learn, new gear to get familiar with, and then there's sequencing, storyboarding, movement, frame rates, lighting, color, and so on. Let's just say that you'll be glad you have help with this once you make the move.

The help is right here. *From Still to Motion* provides solutions and detailed advice to help you solve these challenges. And what I really like about this book's approach is that it is practical. You won't be bothered with ethereal platitudes. The authors provide detailed tutorials, offer case studies, and even provide files for practicing postproduction tasks.

Whether you're a seasoned professional or a novice still photographer, if you are new to shooting video with a DSLR, this book has the answers you need, even if you don't know you need them yet.

Richard Harrington, Robbie Carman, Matt Gottshalk, and James Ball all have broad production and training experience. It's a dream team, and together they've produced an easy-to-read, detailed roadmap for anyone who wants to learn how to properly and professionally shoot video with a DSLR.

Thanks to some of the lessons I've learned from this team, I am still working for my oldest client. It turns out I'm not fungible after all. Make sure you aren't either. Enjoy *From Still to Motion*.

Scott Bourne
Publisher, Photofocus.com

Contents

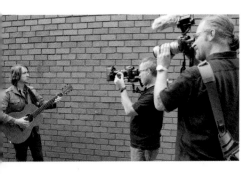

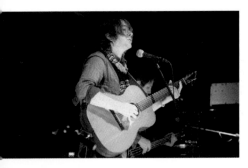

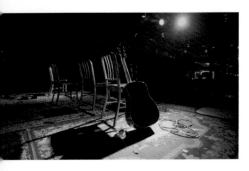

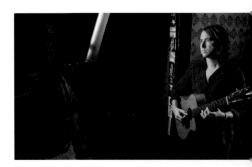

PART II CINEMATIC LIGHTING

PART III GEARING UP FOR MOTION AND SOUND

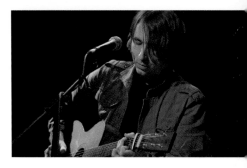

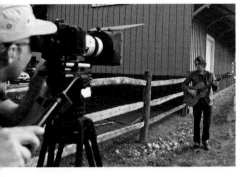

PART IV POSTPRODUCTION

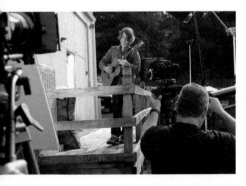

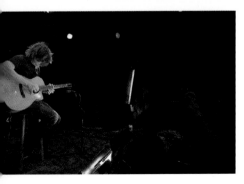

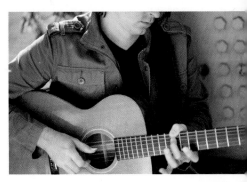

PART V CREATIVE EXPLORATIONS

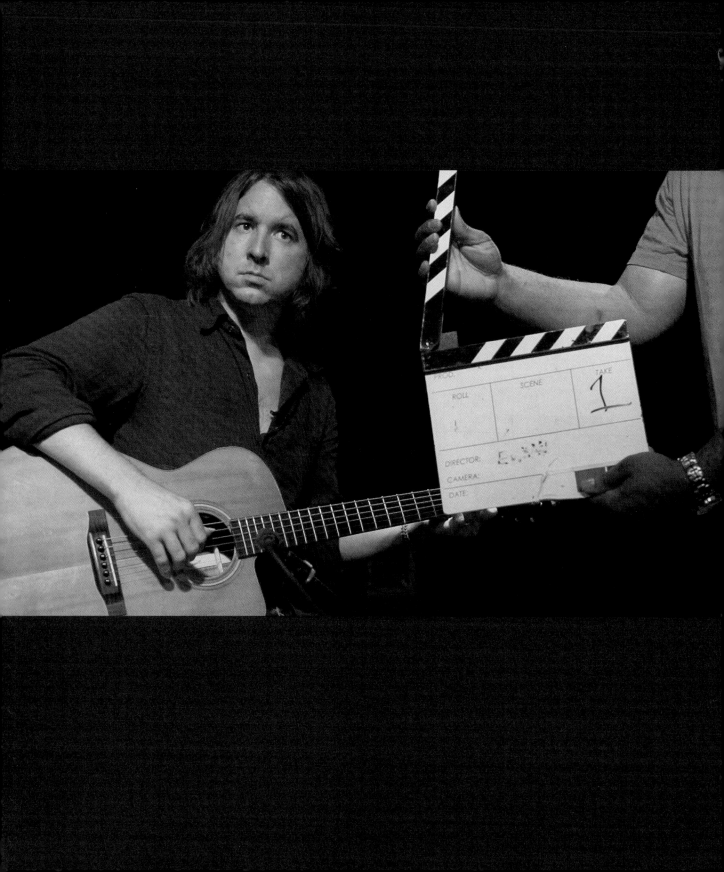

Part I

A New Way to Tell Stories

One of the reasons to add videographer to your title is the need to be challenged beyond what the static image can offer. Whether you are creating art, telling a story, or just exercising a new means of expression, you have a natural desire to try it with a motion-based medium. And what a nice coincidence that your existing equipment can assist you in your goal!

You will bring your existing photography skills with you to this new medium, and we're here to provide the knowledge base you need to shoot video as well as you shoot stills.

This section starts by explaining how to approach a video production. You'll learn to think and speak the language of motion pictures as we provide you with a solid overview of the technical aspects of video. This foundation will enable you to apply your already considerable creative skills to the right mind-set. You'll then need to devise a plan of attack as you consider how to go out into the real world with an efficient, flexible, practical strategy that gives you the highest probability of success.

From Still to Motion

An Evolution of an Art Form

It's an exciting time to be a photographer.

Only recently has a new crop of digital SLR (DSLR) cameras emerged with the ability to shoot high definition video. Professional photographers are evolving too, choosing to add video to their list of offerings to their clients. Around the world, photography enthusiasts have embraced video as a new means to tell stories. Even traditional video professionals are drawn to this new breed of cameras, not only for their portability, but also for their capability to record beautiful images.

TECHNOLOGY IS JUST A TOOL. IT'S WHAT YOU DO WITH IT THAT REALLY MATTERS. TO THIS END WE KNEW THERE WAS A NEED TO BALANCE THE ART, TECHNOLOGY, AND BUSINESS ASPECTS OF VIDEO TO TRULY SERVE THE PHOTOGRAPHY INDUSTRY.

What's all the fuss about? Well, to start, a DSLR is a great camera with an image sensor far bigger than even high-end video cameras. Toss in an incredible selection of lenses, great depth of field, and low-light sensitivity and you have a powerful tool.

At first glance the camera seems just like any other you may have used before—convenient and familiar. But once you start to shoot video, you'll quickly realize that it's a very different animal than when shooting still photography, with new challenges and related technologies to master.

We knew that a video revolution was coming. In fact, it was back in 2006 that we first played with a digital still camera that was capable of shooting HD video (the Leica D-LUX 3). Since then we've seen several other cameras that shoot both stills and video hit the consumer space. It was only a matter of time before video features migrated "up the food chain" into professional DSLR cameras.

However, we didn't expect the ferocious passion the addition of video would bring to the professional DSLR market. A seismic shift has begun, and photographers of all experience levels are looking at video-enabled cameras and trying to incorporate video into their skill sets. Some are fiercely in favor of photography evolving to embrace video, whereas others are equally against the change. The arguments actually share much in common with the digital versus film argument, which seems to have ended for the majority of photographers and landed on the side of digital.

We wrote this book for those on both sides of the argument. We believe that education is the key to an industry evolving. That those looking to embrace a new art (as well as those who fear it) would be able to make their best career decisions through an extensive look at this emerging art. We do not judge those standing on the sidelines; rather, we want to provide all groups with a broad case study and detailed exploration of years of practical cinematography and video experience.

When we looked at the market, we did not see any resources that truly served the needs of a still photographer staring into the world of video. Sure, some tutorials and websites were devoted to the topic, but they seemed to embrace only one part of the equation—technology. But technology is just a tool. It's what you do with it that really matters. To this end we knew there was a need to balance the art, technology, and business aspects of video to truly serve the photography industry.

Who This Book Is For

We wrote this book for you—just you. OK, you can tell your friends and colleagues about it. Whether you identify yourself as a professional photographer or an avid amateur, you'll find solid information in this book. Our goal is to teach the most professional techniques—the same techniques taught at top film schools and used by professionals around the globe.

What makes this book different is that it really is written with you in mind. As the cover states, this is "A photographer's guide to creating video with your DSLR." We take that promise seriously. We build on the knowledge you have (and even the gear you likely own) to create a thorough educational experience.

If you are not a photographer, we won't kick you out of the club. Just know that you're about to embark on a journey that closely examines a new art form. At times, the journey will be challenging. Take your time in this process so you can learn all that is offered. We spent a year creating this book (with seven very committed people crafting the words and photos you see on the page). Don't rush through it looking for the easy route; we've laid out a clear path (the details of which we'll get to in a minute), but just enjoy the ride.

What Gear Do You Need?

A common misperception is that the gear makes the photographer. Simply put, this just isn't true. Composition, storytelling, and artistic vision are all human skills that we can learn and get better at. A good portion of the book covers these important components of your visual craft, but as they relate to video.

Photographers like to invest in their tools, and working with video is an excuse to do this all over again. In this book we explore several options for DSLR video cameras and supporting equipment.

We do not favor any one camera or manufacturer. The equipment you see in this book is used for illustrative purposes. This is not a book about specific makes or models. Rather, it's about how to use the gear you have. As professionals, we may use gear that is more (or for that matter less) expensive than what you choose. We prefer to invest in the right tools (over time) so we can do our job with gear that we can depend on. Of course, we like to build a stockpile of gear too, and we're not opposed to a good deal either.

The point? Use what you already have. In this book you'll see a variety of approaches implemented, from using available light to completely constructing an environment with lights. Not only that but we'll teach you to build gear and reuse photography equipment along the way.

All we assume is that you have a DSLR camera that can shoot video. We don't care if you spend $900 or $9,000, just that you want to shoot. Sure, you'll quickly want to add a tripod and maybe a viewfinder, and there's a ton of cool gear you "could" add. But make sure you like working with video and want to continue down that path before investing in too much expensive gear.

We also assume that you have a computer to process your footage. It doesn't matter if you're a Mac or a Windows user. Several tools are on the market for editing your footage together, and we'll explore options for popular tools like Final Cut Studio and Adobe Creative Suite. If you're in the neighborhood for a new computer, we suggest checking the recommendations of the software companies that make editing tools. High definition video is often a RAM and processor guzzler that likes a fast machine with a good graphics card.

▲ When shooting DSLR video, you'll find an external viewfinder, like this one from Zacuto, to be a critical piece of equipment.

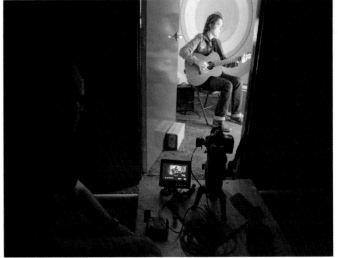

▲ The camera is put into motion with a dolly track. Focus is monitored on an external monitor throughout the camera move.

Our Approach

This is not a typical "how-to" book or tutorial on making great video, although there are a number of step-by-step sections and full-color photos demonstrating concepts. Below, we'll point out what makes this book and DVD unique, and what we hope you'll find is a rewarding and in-depth learning experience. We'll make strong recommendations on how to work your way through this book and use the supporting materials so you can get maximum return on your investment in time and equipment.

A Case Study

As mentioned earlier, we'll take you on a journey by rooting your education in a real-life project. We created a music video and a short documentary for a real, working musician, Luke Brindley (www.lukebrindley.com).

We chose this project for several reasons. First, it gave us an opportunity to showcase several shooting styles—indoor, outdoor, studio, portrait, event, and available light. Second, it allowed us to explore the technical challenges associated with DSLR video, including camera movement, multiple camera coverage, low-light photography, and synchronized sound. Third, we wanted to provide you with real-world project files to play with and give you inspiration for your own projects. Our final reason? Because what's more fun than some great rock-n-roll?

Branching Education

Even if you've never wanted to make a music video, stay with us as we share with you techniques that work for all photographers, whether you're shooting weddings, events, commercials, or any number of projects where video would enhance your work. As a bonus, in the final chapters of this book, we'll explore additional creative options, including stop animation and time-lapse photography.

We firmly believe that there's a lot of shared knowledge between photography and video. You'll meet top photographers from various photography genres including nature, wedding, commercial, and sports photography as they share their experiences throughout the book.

The Journey Ahead

Using the book and DVD in your hands should be a sequential experience. Under no circumstances do we recommend jumping from chapter to chapter during your first read. Why so rigid? We build on knowledge from chapter to chapter and section to section. We've included an index at the back of the book so you can quickly find information in the future, but we recommend you take a linear journey so you're fully prepared for the challenges ahead.

A Linear Experience

Let's take a moment to review how the book is organized. The book is divided into five parts that cover different aspects of the creative process.

PART I: A NEW WAY TO TELL STORIES

In this section you'll learn about telling stories with sequential images. This includes exploring the language of cinematography and planning for coverage when shots need to be intercut to tell a story.

You'll also learn how to complete essential planning steps, commonly referred to as preproduction. These skills ensure that you bring the right equipment to the shoot and that you and your collaborators are working in unity.

In addition, you'll receive a crash course on video technology in Chapter 4. This detailed chapter offers a clear understanding of the constraints in which you'll need to operate. Video is very different from photography, so it's important for you to understand some key terms you'll encounter throughout the book and your journey.

PART II: CINEMATIC LIGHTING

Perhaps the greatest difference between traditional photography and cinematography is the approach to lighting. You'll explore the options in depth, including how to plan for a scene, work with essential light controls, and use an emotional approach to lighting. We also explain several styles of lighting:

› Portrait lighting for great-looking interviews

› Shooting in low-light scenarios

> Shooting with bright outdoor light

> Using LED and compact lighting solutions

> Choosing low-cost or alternative lighting gear

> Adapting photo gear for video

> Building your own lighting and grip gear

PART III: GEARING UP FOR MOTION AND SOUND

In this section you'll explore the critical choices you need to make when shooting video. We'll cover some important aspects of your camera body and essential camera options like monitoring and power, as well as recording formats. We'll also cover options for lenses, including speed, manual controls, prime lenses, and the use of a follow focus.

A great camera and lens needs solid support. You'll discover the need for a video-style tripod, including options for a fluid head and base spreader. We'll look at advanced camera support options too, including stabilizers, body rigs, jibs, and dollies, which allow you to put the camera into smooth motion.

Great video would be nothing without sound to match. You'll learn recording strategies for microphones. Advanced options like mixers and synchronized sound are also discussed.

All your video and audio needs a place to live. You'll learn how to select the right camera memory to keep up with the high data rates of video. You'll also learn how to perform data backups in the field with the added safety of redundant storage.

PART IV: POSTPRODUCTION

The final stage of a video project requires putting all the pieces together. You'll learn how to transfer footage to high-speed editing drives. Important steps to preparing footage, including transcoding formats and conforming frame rates, are demystified.

Once the footage is ready, you'll learn the essentials of video editing. Interactive tutorials on the disc teach you the necessary steps of video editing. You can also explore the completed edit with all the footage used in the final music video. You'll learn how video pros

▼ Advanced camera controls like a follow focus allow you to make precise focus adjustments.

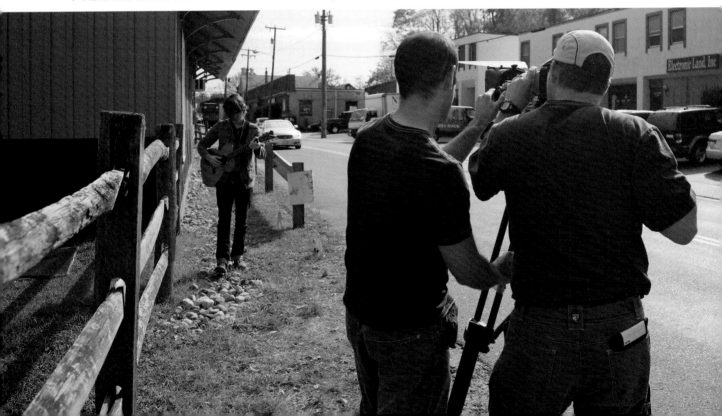

▲ A professional-quality tripod with a fluid head provides an important platform from which to shoot your video.

manipulate color and exposure for even more professional results.

When your project is complete, it's ready to share. You'll learn about creating DVD and Blu-ray discs as well as how to compress video for use on the web. Sharing options like Vimeo, YouTube, and Facebook are thoroughly discussed. You'll also learn to extract stills from your video file for web and print use.

PART V: CREATIVE EXPLORATIONS

The last section of the book provides information on two additional ways to create moving images with your DSLR camera. The first method, stop motion photography, showcases a classic animation technique that is used in television, film, and commercial spots. The second method, time-lapse photography, involves condensing time into short narratives. In both chapters you'll learn practical techniques to get you started in these new areas.

Iconography

Throughout the book you'll encounter several special symbols. These icons indicate a variety of ways that you can take the lessons deeper. Be sure to fully explore your options before moving to the next section of the book.

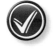 **Tip:** You'll find tips that offer practical and advanced advice to improve your shooting and editing experience.

 Document: We've included template files such as production forms and checklists to help jump-start your video productions.

 Web link: Online resources are provided for additional information and recommended equipment.

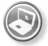 **Training video:** You'll find 37 training videos included on the accompanying DVD. All aspects of video production are covered, including planning, lighting, shooting, editing, and color processing, and web distribution.

 Hands-on files: We've included several hands-on exercise files so you can master the techniques covered in the book and in the training videos. We believe you should be able to use the same footage we did in creating the project.

 Raw footage: Throughout the book we'll identify opportunities to see through our lens. The raw footage will help you see the results that can be produced using the techniques discussed. We recommend downloading the folder named Through the Lens on the DVD and examining these clips as you read through the chapters.

Meet the Cast

This book is truly a team effort, much like the video production process. Because video is a multifaceted undertaking, we've come together to guide you through all aspects of video, from preproduction to post. You'll learn techniques we've used to create video projects seen around the world, but we'll speak the language of photography while teaching you.

The Authors

Meet the four authors behind this book. We've collaborated on each chapter to bring you the best of our collective knowledge.

JAMES BALL: DIRECTOR OF PHOTOGRAPHY

James Ball is a freelance Director of Photography and camera operator with 25 years of experience. Jim's expertise is applying the many tools of the trade to capture great moments as they unfold. He travels the globe for his craft, working on feature-length documentaries for various channels, such as National Geographic, Discovery, Smithsonian, and PBS. As a member of IATSE Local 600, he operates on dramatic features for HBO, VH-1, independent, and studio productions. You can contact Jim at:

> www.linkedin.com/in/jfball

> www.onlinejamesball.com

> www.twitter.com/dpjimball

TRAINING TO GO

You can load the included videos into your iTunes library for viewing in high definition. To convert for a portable media player (like an iPod or iPhone), just select the movies and choose Advanced > Create iPod or iPhone version. Transfer these files to your media library and sync them with your device for some on-the-go learning. Please respect the copyright of our book and don't share these with friends. This will help us continue to produce great training for you (and send our kids to college).

ROBBIE CARMAN: COLORIST

Robbie Carman is a professional colorist who works on broadcast television series and independent films. He's part of the first generation of certified Apple Final Cut Pro instructors and is certified in Final Cut Pro, DVD Studio Pro, and Color. Robbie co-wrote *Final Cut Pro Workflows* (Focal Press, 2007) with Jason Osder as well as *Final Cut Studio on the Spot* (Focal Press, 2007) and *Video Made on a Mac* (Peachpit, 2009) with Richard Harrington and Abba Shapiro. Robbie is a moderator in the Apple Color and DSLR Video forums on Creative COW and speaks nationally at conferences, such as the National Association of Broadcasters (NAB Conference). Robbie is the co-owner of Amigo Media (www.amigomediallc.com), a boutique postproduction company located in Washington, D.C. You can contact Robbie at:

> www.linkedin.com/in/robbiecarman

> www.amigomediallc.com

> www.robbiecarman.net

> www.twitter.com/robbiecarman

MATT GOTTSHALK: CAMERA AND LIGHTING

Matt Gottshalk is a DP/Editor and the principal of McGee Digital Media, which specializes in cinema-style HD production and post. He is well known for his film-style lighting in field production and studio shooting, and has shot a variety of productions for clients such as the USO, the Air Line Pilots Association, Fleishman-Hillard, Discovery Communications, the National Geographic Channel, and Pfizer, Inc. Matt also has 20 years of experience and expertise in motion graphic design and editing on both Avid and Final Cut Pro. You can contact Matt at:

> www.linkedin.com/in/mattgottshalk

> www.mcgeedigitalmedia.com

> www.twitter.com/mcgeedigital

RICHARD HARRINGTON: DIRECTOR AND EDITOR

 Richard Harrington is a director/ producer with national PSAs and CINE award-winning productions. He is also a certified instructor for Apple and Adobe, and an expert in motion graphic design and digital video. He is a regular contributor to Creative COW, *Photoshop User* magazine, and numerous industry blogs. He also owns the visual communications company, RHED Pixel (www.rhedpixel.com) in Washington, D.C. Rich is a member of the National Association of Photoshop Professionals Instructor Dream Team, designs conferences for the National Association of Broadcasters, and has written and co-written a number of books including *Understanding Adobe Photoshop* (Peachpit, 2010), *Photoshop for Video* (Peachpit, 2010), and *Video Made on a Mac* (Peachpit, 2009). You can contact Rich at:

› www.linkedin.com/in/richardharrington

› www.rhedpixel.com

› www.richardharringtonblog.com

› www.twitter.com/rhedpixel

Contributing Author and Gaffer

We had some extra help with the book from a great expert. Chris Gorman assisted us during several of the shoots and contributed the stop motion animation chapter.

CHRIS GORMAN

 Chris Gorman has been a technician in the film and television industry for 15 years. His early work as a grip on commercials and feature films honed his technical skills and allowed him to see that lighting plays a big role in conveying story. After more time spent on the electrical side of television and film, Chris started gaffing, a path he has pursued for several years.

Chris is also an expert on stop motion animation and creates films with his business partner, Jeff Schmale. Their production company, 1&9 Photography, produces stills and stop motion films for a number of ad agencies and national commercial clients. Both Chris and Jeff have very patient spouses and a passel of children each which makes it all worthwhile.

Technical Editors

Two other talented professionals provided their technical insight in helping to craft this book. Both men shared their knowledge and opinions to help us shape the book.

GARY ADCOCK

 Gary Adcock is the owner and principal of Studio 37 (www.studio37. com) in Chicago, where he spends his time consulting on production and post workflows for video and film. He also spends time working as a data wrangler and a Digital Imaging Technician - IATSE Local 600.

Gary is knowledgeable on all things HD. He serves as the Tech Chair for the National Association of Broadcasters' Director of Photography conference. He is also part of the International Cinematographers Guild's training committee.

Gary generously shares his knowledge of HD with the world. You can find him speaking at conferences and user groups about HD technologies. He writes for *Macworld* magazine and is a host at Creative COW (www.CreativeCOW.net). Few know that Gary spent over 20 years as a commercial still photographer specializing in tabletop and food photography.

Gary's client list includes Adobe, Apple, Sony, Panasonic, JVC, NASA, CNN, Discovery Networks, Leo Burnett, McDonalds, HBO, Major League Baseball, FOX, and National Geographic.

JEFF REVELL

Jeff Revell has been shooting professionally for more than 25 years and has a wide range of expertise in everything from landscape to travel to urban photography. Widely known as the photographer behind the popular Photowalk Pro blog (www.photowalkpro.com), Jeff shares inspirational images, hosts lively discussions, and creates tutorials on digital photography techniques. In addition, he leads training classes and hands-on workshops on digital imaging technology around the world.

Jeff is also the author of several books in the Peachpit *Snapshots to Great Shots* series on cameras and photography. Included are books on the Canon 50D, the Rebel T1i, the Nikon D5000, and the recently released D3000.

Documentary Photographer

Although there are many photos in the book, we had one principal photographer who helped us document the experience.

LISA ROBINSON

Lisa Robinson began her studies of photography in 1999 and immediately knew it would be a lifelong career. She began work as a print technician for Kodak and took any assistant jobs available while completing college. In 2005 she graduated Magna Cum Laude in Applied Media Arts & Photography from Edinboro University and started work with Apple, Inc. Her work with Apple put her in touch with the vast array

VIDEO #1: CHALLENGES IN DSLR CINEMA
Meet all four authors as they discuss an overview of the DSLR filmmaking process. Learn the challenges and opportunities you'll face in creating great videos. This is a great warm-up for the rest of the book.

of technology associated with digital photography and further cultivated her passion for beautiful images. Together with Ian Robinson, she founded SoftBox Media in 2006 and began photographing weddings in the Washington, D.C. area and beyond. In 2008 she became a member of Professional Photographers of America. Recently, Lisa's work has earned SoftBox Media the Bride's Choice Award 2010 from WeddingWire.com and TheKnot.com's Best of Weddings 2010 pick for photography in the D.C. metro area.

Musician

We're truly excited to introduce you to a great songwriter and performer. We feel privileged to base this book on a real-world project and hope you enjoy exploring the music and craft with us.

LUKE BRINDLEY

Luke Brindley is arguably the most promising singer/songwriter to emerge from the Washington, DC area in years. The New Jersey raised artist has released four critically acclaimed albums in the past five years, garnering praise from numerous national publications. His self-titled record is called "one of the best roots-rock records of the year" by *The Washington Post*; *Acoustic Guitar* recognizes "his own compelling musical voice"; and *Performing Songwriter* says simply, "Exquisite."

Luke received a 2009 Washington Area Music Association nomination for Songwriter of the Year, won the 2008 WAMA award for Best Contemporary Folk Album, and was a finalist in the 2009 and 2008 Mountain Stage NewSong Contest. He was a 2008 Falcon Ridge Folk Festival Emerging Artist, a 2007–2008 Artist in Residence at Strathmore, and more.

When asked about his influences, he names artists from Dylan, Neil Young, and Van Morrison to Springsteen, Paul Westerberg, Nick Drake, and early Bruce Cockburn, as well as authors and poets such as Thomas Merton, Rilke, James Wright, and Rumi. His lifelong pursuit of music has led him to West Africa,

Brazil, and Eastern Europe, and consistent touring nationwide. He studied guitar at Rutgers with Ken Wessel and built his own main guitar.

Luke and his brothers own Jammin' Java, a 200-seat music club in Vienna, Virginia. Luke is married to his high school sweetheart and has four children. He is currently in the studio recording new material.

About the Disc

In your hands is a book *and* a DVD. These two pieces are of equal value and should be used together for a complete experience. For best results, we recommend watching the videos and performing the exercises while reading or soon after reading the corresponding chapter.

What's Included

On the disc you'll find several useful items that are meant to bring the images in the book to life:

> View some of the actual footage shot in this project.

> Explore the edited video in the Timeline with Final Cut Pro or Premiere Pro.

> Watch comprehensive video training that explores several additional topics in great depth.

> Take advantage of the template files and PDFs to enhance your production and post workflows.

What You Need

Welcome to a high-tech world. You won't need the latest and greatest, but we do have some strong recommendations. To use the DVD, you'll need the following items:

> A Mac or Windows computer with DVD-ROM drive.

> The latest version of QuickTime installed to view the movie files.

> Video editing software like Adobe Premiere Pro or Apple Final Cut Pro. Other tools can be used, but project files for these applications are provided.

> Additional software such as Adobe Photoshop and Adobe After Effects for specific exercises. Trial versions are available from Adobe's website.

> A high-speed hard drive with a FireWire or SATA connection for editing video files. Internal laptop or computer drives can work, but a performance drive (RAID) is highly recommended.

Additional Resources

Technology and workflows in the world of DSLR video are constantly evolving. We find several resource websites useful to keep current. Here are some of the sites that will help you keep up with the book's authors and contributors, to stay current:

Book updates page: Visit www.peachpit.com/stilltomotion to check for updates and errata.

Creative COW forum: Get answers to your technology questions at forums.creativecow.net/dslr. You'll find us hanging out and answering questions.

Facebook group: Join us on Facebook at www.facebook.com/DSLRVideo.

Cinema 5D: Cinema 5D (www.Cinema5D.com) lets filmmakers converse and exchange ideas about the aesthetic and technical aspects of DSLRs.

PhotoFocus: Check out Scott Bourne's in-depth blog and podcast at www.photofocus.com. It is a great source of news and instruction.

This Week in Photography: Frederick Van Johnson and Alex Lindsay's weekly podcast and blog tackle the latest news about photography. Join them at www.twiplog.com.

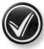 **COPY FILES FIRST**
We highly recommend that you copy the files from the book's DVD to a local hard drive. The DVD media can't spin fast enough to play back HD video smoothly.

Sequential Images

It's No Longer Just About the Shot

Whether you identify yourself as a photographer, videographer, or cinematographer, there is a lot of shared knowledge. All three think about composition and the related skills required when composing a frame to capture action in an artistic and compelling manner.

As you make the transition (or expansion) to video, the most difficult change you'll need to make is how you think about capturing multiple images and arranging those into a scene or a sequence. When taking a photograph, you are isolating a fleeting moment and capturing it as a still image. When you shoot video, you will need prolonged coverage of an event as it unfolds or you'll want to stage the event multiple times for capture by the camera.

WHEN YOU SHOOT VIDEO, YOU WILL NEED PROLONGED COVERAGE OF AN EVENT AS IT UNFOLDS OR YOU'LL WANT TO STAGE THE EVENT MULTIPLE TIMES FOR CAPTURE BY THE CAMERA.

Many photographers welcome this challenge, and there are many examples of world-class photographers transitioning to moving media to expand their skills in storytelling. The creative stretch is both rewarding and refreshing as it brings new challenges and opportunities. Similarly you'll find that most award-winning cinematographers profess still photography as their first love.

There is a lot of overlap between stills and motion. But there are also differences.

These days it's so much easier to experiment with both options when you have cameras that can change with the flip of a switch. But the mind's eye must switch as well.

Making the Transition

The challenge we see is that both photography and cinematography have developed relatively independent of each other for so long. While the best practices of still or sequential image gathering can be shared across the fence, each group has its own specific language, conventions, and thought processes that need to be adopted.

We know this transition is possible, just as bicyclists and cars can share the road. We're not asking you to choose one method over another, just to realize that you'll need to operate a little differently depending upon which style of shooting you're using.

What's common to still and sequential shooting?

As a photographer, you've already invested a great deal into honing your craft. Through training and practice you've learned that composition and framing matter. You use them to convey the message of your subject. Where you place your subject and what you surround them with conveys both information and an aesthetic sense.

You also know that lighting is a powerful tool. Much more than a technical need, lighting can convey emotional intentions. It can also serve as a character in the scene and truly express tone.

And of course… the subject is king. What you put in front of the lens has as much to do with a successful image as any of the photographic stuff. You need to choose subject and location wisely. Enhancing both with art direction and performance coaching helps as well. Other details like wardrobe, makeup, and color design matter—whether the image is moving or not!

Movement as transformation

The first point where a departure becomes clear is when you add movement. This can be a moving subject, background movement, a moving camera, or all of the above. While a photo can capture movement and have a clear sense of direction and action, it's not the same.

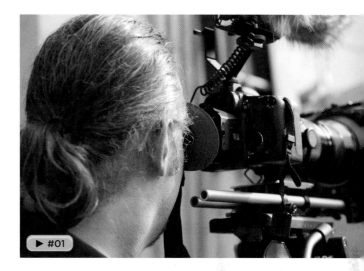

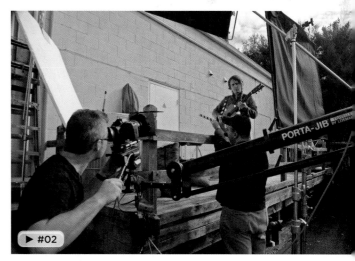

▲ The camera is attached to a jib arm to give it fluid movement. The Director of Photography can literally "float" the camera through the scene.

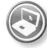 **WATCH OUR CAMERAWORK**

You'll find a folder of clips on the DVD-ROM named Through the Lens. Copy these clips to your local hard drive. When you see the clip icon placed over the images in the book, this means you can see the actual footage shot in a particular scene. Also check out the documentary and music video on the DVD-ROM to see more of the camerawork.

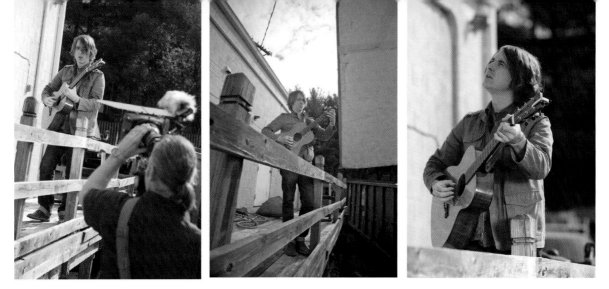

▲ Choosing video over still photography to record a live musical performance offers new challenges and rewards.

With movement comes new opportunities, but also new rules and best practices. While you may have considerable skills as a still photographer, sequential imaging requires you to expand your skills. You now have more than just a single moment in time and space to consider.

Sequential challenges

Very often the beauty of photography is that ability to tell a story, evoke an emotion in a concise, powerful, single image. The economy of that process is attractive. There is no baggage or excess. It often allows you to exert more control and expend more resources to get the framing just right, the lighting just perfect.

As you move to videography, you can break free of the limitations of a single image. Everything can change within a shot or across a series of shots. Subjects move through a space. With changes in lighting you can signify the passage of time. You can also see changes in the internal and external characteristics of your subject, which can show an emotional journey.

Of course less constraint also means more work. You are now bound to contend with even more variables.

Some will choose to approach a scene strategically, using multiple shots to convey a sequence. Others may need to capture events as they happen in real time (sometimes using multiple cameras).

Putting it all together

With video, you have a choice to make. Does the action for a scene happen in a single shot, or as a series of shots? The most common approach is to sequence multiple shots together to form a scene. Because a scene can run for several minutes at a time, you'll need to find pacing and rhythm that maintain the viewer's interest.

You'll likely work with a series of shots. These will typically vary in length and content. Shots are now extended to incorporate movement and depict a progression of change. A photo layout is a faint imitation of a motion picture sequence of images.

Your images must be in concert with one another to seamlessly edit together. This means that angles need to intercut well and that repeated action or coverage must be coherent. As you edit from shot to shot, the transitions must feel both natural and motivated.

The Language of Cinema

If you've ever stuck around to watch the credits of a movie, you've probably seen a myriad of bizarre titles (just what exactly does the Best Boy do?). The language of film and video is steeped in history and tradition, and you'll quickly discover that movies have their own terminology.

This special language is not meant to exclude newcomers. Rather it serves two major purposes. First, it helps to define the relationship shots have to one another. This is important, as you need to know how shots fit together within a scene or in the bigger story. Secondly, the language helps precisely communicate important decisions with regards to camera placement and camera movement. You need to be able to clearly identify and communicate options regarding lens choice, distance from subject, distance from the ground, and more.

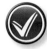

DON'T JUST ZOOM
It's important to remember to move the actual camera from time to time. If you merely zoom from a wide shot to a tight shot, the resulting edit will feel abrupt (which is often called a jump cut). For the smoothest editing, be sure to physically move the camera when changing composition.

▼ The fusion of still photography and video has led to an evolution in technology. To properly communicate with crew members, you must learn to speak the same language.

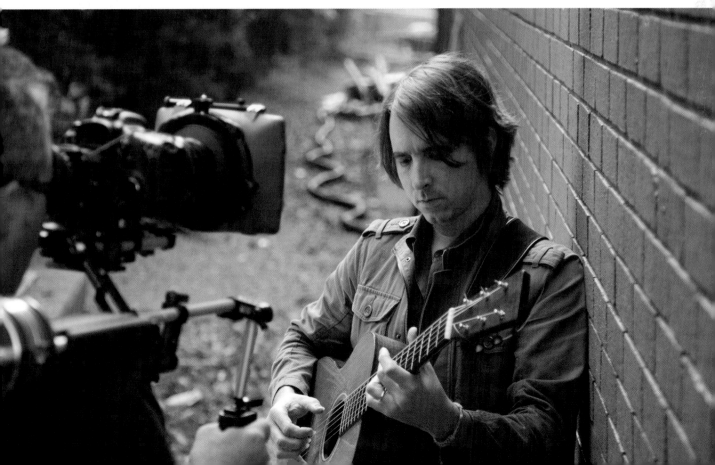

Shot Types

When shooting a scene, you'll typically favor getting multiple shots. This process is referred to as getting coverage. Just as a single photo can say so much, combining multiple angles together can tell the story better (letting you show interesting details or emotions). This process is important because it allows for more flexibility in editing. You can choose to condense action, cover mistakes, or even direct the viewer's attention with a variety of shot types. These shots have a language of their own. Knowing the most common shot types lets crew members talk to each other.

Wide Shot (WS): A wide shot (also called an establishing shot) is useful to show the entire subject. With a person, this usually means seeing from the top of their heads to the bottom of their feet.

Medium Wide Shot (MWS): This type of shot is usually used with a standing subject. The lower frame generally cuts the subject off at the hips or just above their knees.

Medium Shot (MS): A medium shot typically frames the subject from the waist up. With this type of shot, the subject and the location are given equal weight. There is typically enough room in the shot to see hand gestures and arm movement. If multiple subjects are in the frame, then it can be classified as a two-shot or three-shot.

Medium Close-Up (MCU): In this composition, the bottom of the frame passes through the midpoint of the chest. You can still see the setting, but the shot is more intimate. This shot is also called a bust shot, as it matches the composition of classic bust sculptures from the art world.

Close-Up (CU): You'll use close-up shots to capture things like facial expressions. A close-up can also be used for things like a subject's hands or interaction with an object in the scene. The goal is to isolate the subject and minimize (or even remove) the background.

Extreme Close-Up (XCU): An extreme close-up is generally reserved for dramatic action. It can be a tight shot of your subject's eyes or lips, for example, to add emphasis. You can of course use the same designation of CU or XCU for an inanimate object, such as a key going into a lock or a doorknob turning.

Point of View (POV): In this shot type, you are trying to let the audience see a scene through the character's eyes. The goal is to position the camera at eye level and match framing as to what the character would see. These shots are powerful, but should be used sparingly as they can be cliché.

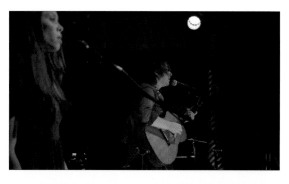

Over the Shoulder (OTS): If two or more characters are in a scene, a shot can be composed to show both. Typically one character is the focus while the other is used to frame the shot.

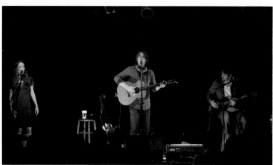

Master Shot: For many cinematographers, they'll capture an entire scene by first shooting a master shot. This shot is wide enough to see the location and all subjects and is shot for all dialogue and action (typically from a locked position). The entire scene is shot in one take from this position. Additional angles (especially close-ups) are then shot and intercut with the Master shot during editing.

Shot Angles

Besides composition, you may choose to adjust the angle of the shot for narrative purposes. The direction the camera is pointing as well as the camera's height can change how the viewer sees the scene.

Eye Level: For most documentary or "factual" coverage, eye-level recording is seen as standard. This is how most people see the world, and it is the most comfortable angle for viewers to watch from.

High Angle or Overhead: If you place the camera above the subject, it will have to look down on the action. This often creates a sense that the audience is more powerful than the subject and can lead to a sense of detachment.

Low Angle: A low angle shot places the camera below the subject. This can make the subject look more important or add more drama to a scene.

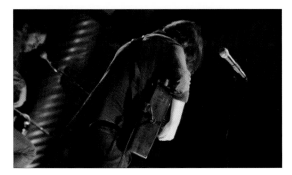

Dutch Angle: Sometimes the camera is canted at an angle. Typically this is between 25 and 45 degrees (enough that it seems intentional, but not so much that it's dizzying). This effect causes horizontal lines to be seen at an angle. Dutch angles are meant to convey tension or psychological uneasiness. Some styles of production (such as music videos) use them often, while documentary and instructional videos use them much less frequently.

Movement Types

Once you have the shots defined in relation to each other you need to think of movement within a shot. Both the camera and your subject can go virtually anywhere (just keep safety in mind).

You can choose to record camera motion with constant speed or vary the speed of movement to your liking. There are variations in the quality of the movement, and the length of the movement, as well as its motivation. Be sure to use these descriptive terms and their associated techniques in telling the story. We'll explore the hardware behind these moves in Chapters 11 and 12.

Pan: A pan is a horizontal camera movement in which the camera turns from left to right (or vice versa) along a central axis. Typically, pans are executed by attaching a camera to a fluid head tripod (more on this in Chapter 11), but they can also be executed by turning at the waist. The point of a pan is to show more of an area or to follow a subject without moving the camera from its current position.

Tilt: A tilt is similar to a pan in that the camera revolves around a stationary axis. The motion differs though, as it is a vertical movement. The camera moves from looking up to pointing down (or vice versa).

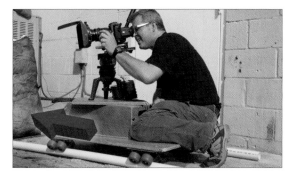

Truck: A truck shot generally refers to side-to-side camera movement caused by actually moving the physical camera. This type of movement is also called tracking or crabbing. To create smoother motion the camera is often mounted to special devices like a dolly or camera-stabilizing device.

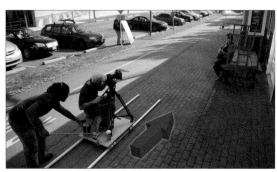

Dolly: A dolly is both a device and a movement type. The camera is mounted on a wheeled cart or platform. It then can move in and out (essentially closer or further) to the subject. The use of a dolly can create a very dramatic shot that engages the viewer. The use of a dolly generally requires an operator (called a dolly grip) to physically push the cart and control the speed of movement.

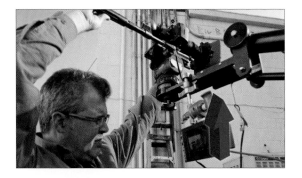

Pedestal (Boom): A pedestal move describes moving a camera up and down in physical space. It is different from a tilt in that the camera's physical axis is changing. Pedestal moves typically require advanced camera support like a boom or crane to lift the camera. Pedestal shots are often combined with other moves like pans and tilts to add drama to a shot.

Zoom: A zoom is typically executed by adjusting the lens attached to a camera. With most lenses, many feel that the zoom shouldn't be used while recording. Instead it's meant to offer flexibility in changing the focal length of the lens without having to swap lenses. Recording the zoom movement can be difficult to get right and usually comes off as a visual cliché. Be sure to rehearse zooms and get a smooth movement.

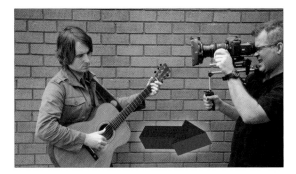

Follow: The goal when following is to keep a constant distance between camera and subject. These shots are useful as transitions to move the subject from one scene to the next. The most practical option is to use a Steadicam (or equivalent) rig to smoothly walk the camera next to the subject. These hardware devices help you balance a camera by attaching it to your body on a rig that is counterbalanced with weights. You can also hold the camera or use a shoulder rig.

 SMOOTH PANNING

To create the smoothest pan, be sure to rehearse the movement a few times. You will likely find a need to move or stretch your body to create the motion. For smoothest motion start with your body extended, then settle into a natural position at the completion of the move. You can also hide the start or end of a pan with editing, just be sure to extend your pan longer.

 VIDEO #2: MOVEMENT TYPES

In this video, you'll learn about common camera movement types and will view footage illustrating different styles of shooting,

Timing the Scene

Once you know the type of shot and shot movement, you'll need to determine the speed of the shot and overall timing for a scene. Identifying shot length is important so you can have both an efficient shooting experience but also adequate shot coverage for editing.

Here are a few guidelines to consider when timing your shots.

Coverage needs: Do you have any narration or dialogue that is already known? This is a strong indicator of how much footage you'll need for coverage.

Consider the angles: Are you using multiple angles, which you intend to edit together? If so, be sure to consider how the shots will combine. You'll also want to think about motivated points at which to switch angles. This could include natural changes in action like a hand reaching out or the turning of the keys in a car's ignition.

Be safe and repeat: If you're not sure about the timing (and even if you think you are), try running a scene a few times. By repeating the action and shooting it at different speeds you are better prepared for unforeseen challenges or requested changes during the edit.

Leave handles: When it comes to editing, you always want to leave 5 seconds of usable padding on each side of a shot. This extra footage is often needed for transitions or minor timing adjustments. It's also a good idea to let the camera roll for a second so you have a stable shot that is free from the vibration of the start and stop of the record button.

▼ Make sure there is ample shot variety when shooting with multiple cameras. Your editor will appreciate it.

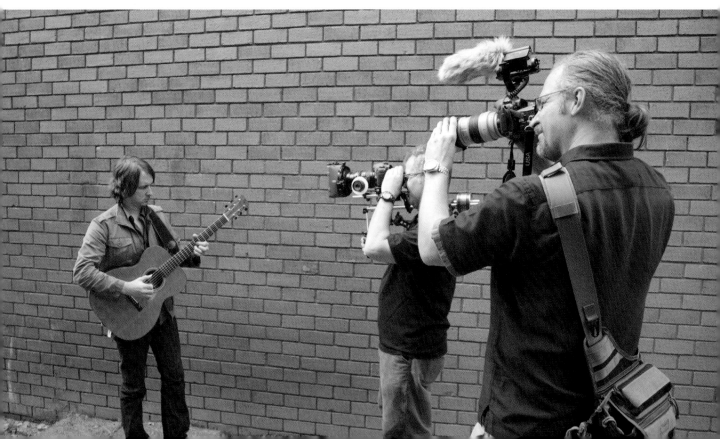

▲ A "center-punch" composition. There is no doubt where your attention should be.

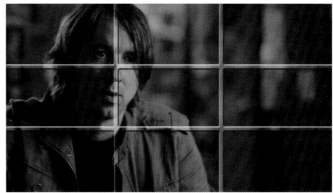

▲ The rule of thirds indicates major intersections where the subject should be placed. A traditional open frame directs your attention as much to the subject as it does to where *his* attention lies.

Composition Rules for Cinema

Composition is the basic foundation for creative image gathering. The choices you make before clicking the shutter to capture a still or hitting the record button to record video are very similar. Still photographers devote a great deal of time to get the framing just right. But in videography, movement itself influences composition. The framing will often vary throughout the shot. The moving subject must be framed in a satisfying way throughout the shot.

There are many new rules you'll want to follow as well as some classics that carry over from the photo world. We find these five rules essential for composing great video shots.

Eyeline

The eyeline is where your subject is looking in the frame. When multiple subjects are involved, eyelines establish an understanding of how each subject exists in space in relation to each other. For interviews your eyeline can vary. In documentary-style shooting the subject often looks into an interviewer who stands next to the camera. The closer the eyeline is to the camera lens, the more intimate the shot. Actually placing the eyeline into the camera can in fact engage the audience (just make sure the subject doesn't develop a deer-in-the-headlights look).

When sequencing shots that use an eyeline, particular attention must be paid to both "ends." The eyeline direction of the subject must complement the adjacent shot, whether that be of an object or a person. You want to line up the gaze with the object being gazed at. This is largely done by framing, which influences how we interpret eyelines. Usually you "lead" the frame, leaving a little more space on the side the subject is facing.

Rule of Thirds

You're likely familiar with the Rule of Thirds. Three vertical and three horizontal lines that are equidistant divide the screen. This creates nine sections on the screen. The intersections are reference points that can be used for guidance when framing a shot. The rationale is that points of interest naturally occur at 1/3 or 2/3 of the way up (or across) the video frame. These points often work well for positioning objects in the frame.

If you're creating a portrait-style shot, try framing so the eyes are placed at the left or right intersection. This is the most traditional framing for an interview, as it allows for a weighted area of the screen to be empty of subject and show background. The Rule of Thirds can be broken. Just be sure you are consciously deciding to ignore or break it.

180° Rule

If you have two or more characters (or even dominant objects) in a shot, you should follow the 180° Rule. This rule draws an imaginary line through the scene, one that should not be crossed. By keeping the camera on one side of the frame (essentially up to a 180° arc) eyelines remain constant. This helps the audience naturally be aware of the space as well as the relationship between the subjects interacting within that space.

When you start a scene, you need to draw a virtual line through the set. The original placement of the line is up to you, but you should not change it for the duration of the scene. If the camera physically crosses the line between shots, then the direction that your subjects are looking or moving seems to flip. This can be very disorienting to the audience and should generally be avoided. As with the Rule of Thirds, though, you are allowed to break this rule too once you fully understand it!

180° OF THOUGHT

In order to prevent reverse cuts, think the scene through. Try to pick a set of angles that can all be shot from one side of the line. If you're going to need multiple cameras, set those up on the same side of the line as well.

Matching Shots

One of the most important things to consider is how the composition of successive shots relates to one another. There is a language to composition that must be observed (or broken with clear intent).

Conventions in framing have evolved over the years along with all movie grammar. The shot types, shot angles, and move types we discussed at the start of the chapter need to become part of your design and vision. These are the shots that the audience has learned to expect, and while innovation is good, there are reasons for classic composition and standard conventions.

A beautifully composed frame will evoke an emotion without the viewer necessarily being aware of its cause. The elements that make up what works and what doesn't are sometimes hard to pin down. However, there are conventions that exist as a guide to your instincts.

The position of your subject in the frame matters, especially in relation to the shots intercut with it. Lines of interest arise from observing the rule of thirds creating a healthy tension between the unbalanced parts of the frame. The appropriate balance of elements placed in the frame is key to creating a harmony that, again, is hard to articulate, but we know how disconcerting a cluttered, disorderly frame can be.

▶ **This diagram shows the 180° rule. If the camera moves beyond a 180° arc, the characters will appear to switch places on the screen.**

From the Wikimedia Commons by grm_wnr with Inkscape. This file is licensed under the Creative Commons Attribution ShareAlike 3.0 License.

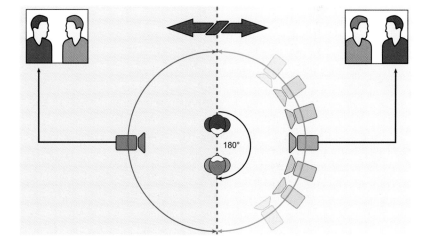

COMPOSITION IS THE BASIC FOUNDATION FOR CREATIVE IMAGE GATHERING. THE MOVING SUBJECT MUST BE FRAMED IN A SATISFYING WAY THROUGHOUT THE DURATION OF THE SHOT.

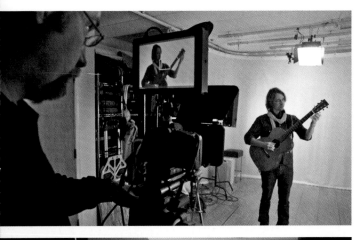

Ultimately these rules of composition serve a common purpose—to focus the viewer's attention with clarity. It must be obvious where the eye should go, or even the most beautiful composition has failed. Frame size determines the area of interest the viewer should be focused on. But frame size in relation to other shots creates its own impressions. Matching sizes between two subjects establishes a different relationship than say a close-up and a medium shot. Intercutting them together establishes dominance of one subject over another.

Moving Shots

A shot can have specific meaning in relation to another if you frame the space around a subject in a particular way. Leaving space between an actor and a frame-line suggests direction. For example, when moving an actor in and out of lighting elements, the foreground and background elements contribute to overall mood and direct the viewer's eye to the right place.

Moving the camera and maintaining a composition that contributes to the status of a subject in space is relevant in a way that doesn't apply to a still frame. A camera that establishes a distant and insignificant subject and slowly tracks into a close-up clearly changes the impression a viewer has on that subject in real, linear time.

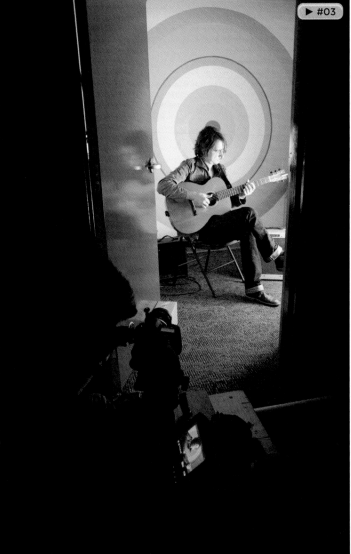

Movement within a shot requires a whole new style of management: Subjects have to hit marks, lighting has to cover an expansive environment, and choices need to be made as to how subjects and the camera will both move within the shot in relation to each other. The photographer must learn to sustain the control and quality of a still setup throughout an extended series of frames. Adding to the complexity, they must hold a shot through an extended and ever-changing environment. Can the quality of light and beauty of the composition be maintained as your subject moves across a room, down the stairs, and outside as he jumps into a waiting car?

◀ A slow tracking move from in and out of darkness adds depth to what is essentially a still portrait of Luke.

Sequencing Images

You'll quickly discover that video is much more than just capturing a scene with one long shot. Most scenes you'll shoot will be a collection of shots intercut together. There are several reasons for this approach.

Visual Interest: Viewers have grown used to faster editing paces. The speed at which you switch angles during an edit may be dictated by genre or personal tastes… but one wide shot just won't work.

Technical Necessity: You may need to hide something with an edit. It might be for safety (like the landing of a punch in a fight scene) or just to hide an exposure change (such as a transition from indoors to outdoors).

Emotional Impact: Changing angles and composition has a profound effect upon the viewer. Knowing when to go in tight or cut to a reaction shot is a learned skill, but one that is essential to creating a compelling narrative.

So, if you need all these angles to cut together… how can you pull it off?

Repeating Action

The most common approach to getting adequate coverage is to repeat the action of the scene. This means you'll want to get repeated takes of the action using different composition and camera position. These changes are important to ensure adequate coverage.

For narrative pieces this often means repeating the dialogue or action portions several times. You can ask actors or talent to simply run the scene again. Once a master shot is established, you can speed up the process by only doing coverage for individual actors

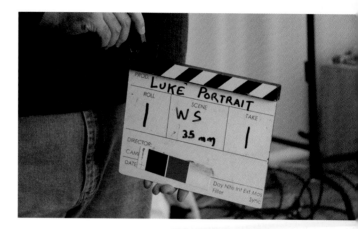

▲ This is a common slate. It marks each shot with a scene and take number. The clapper at the top is used to sync your picture with the soundtrack.

(skipping the parts of the scene that they don't read). Be certain that the talent (and you) are looking for visual continuity in performance.

If you're shooting an interview or a live action piece, you'll often keep a mental or written list of needed insert shots. Then after the principal angle is captured, you can record a series of insert shots. You may want to play the clip back and watch it to get the action elements just right.

If you are on a very complex shoot, a dedicated person may even be appointed to look for consistency between takes. This person is often called continuity supervisor or the script supervisor. Regardless if they have a title or not, someone needs to pay close attention between shots to make sure that elements stay consistent.

We've all been bothered by sloppy production. It makes us cringe when we see the clock on the wall jumping around or glasses on the table mysteriously fill and empty themselves. What about the actor's jacket that was zipped then unzipped between shots?

WATCH THE MUSIC VIDEO
If you'd like to see how several shots are sequenced, watch the complete music video on the DVD-ROM. Be sure to copy it to your local drive before watching.

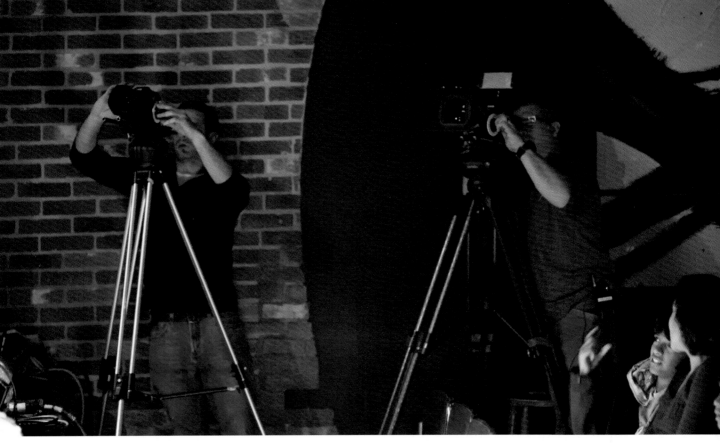

▲ Shooting multiple camera coverage with DSLRs greatly reduces costs, both in terms of production time saved and expensive camera rentals. Not to mention that some events just can't be repeated!

Covering a Scene with Multiple Cameras

Sometimes there's no way to get continuity without additional cameras. Whether it be a live event like a concert or speech, or maybe a onetime event like a rocket launch or a football game, there will be times you won't get another take.

When coverage is critical, but repeating action is impossible, the only option is to add another camera. For this project we shot two concert performances. The first performance we used four cameras and for the second we added one more for a fifth angle. Using extra cameras let us cover the action and ensured a successful edit.

There is, of course, the challenge of getting enough cameras and making sure that they match up with each other. Be sure to set the cameras up and match settings such as frame rate, frame size, and white balance. You'll also want to put into action a clearly thought out coverage plan (discussed next). Where will the cameras be placed in the scene and how will each compose a different, but complementary shot?

SHOT LIST TEMPLATE
You'll find a starter file that you can use to create your own shot list. You'll need either Apple Numbers or Microsoft Excel to use the template.

Making a Plan

In order to execute a successful shoot, it's a great idea to build a detailed plan. The goal here is to think about a scene and develop your shot sequences. You want to be able to determine the number of shots, style of shots, and of course order of shots that you intend to use.

Of course there are a few ways to go ahead and actually do this process. Some will create a storyboard, which closely resembles a comic book approach to describing the scene. Others prefer a detailed shot list that can be checked off as they go. And of course, some brave souls just wing it.

Storyboarding a Scene

If you work in bigger budget video or film, the storyboard is king when it comes to communicating your vision. Storyboards can be sketched by hand and scanned or they can be drawn right into a computer with a tablet (such as those from Wacom). Think of a storyboard as being much like a graphic novel or comic strip.

Storyboards play an essential role in the production of film and television. Storyboards were developed at the Walt Disney Studios during the early 1930s. The practice was soon widespread, and crossed over into live-action films in the 1940s.

While storyboards share much with the world of comics, they have a language of their own. They serve as a way for a filmmaker or video director to plan the story. The also help to pre-visualize a sequence to help the client or participants understand a scene. Storyboards are extremely popular in the advertising world as they help to convey important information before the expense of shooting is incurred.

Many photographers are quite comfortable sketching out their thoughts for a scene; others prefer to shoot test shots with a stand-in. When you go on a site survey or a location scout, shoot some sample shots with your assistant or a colleague. Whichever method you pick is up to you, the goal is to just think through critical sequences before you have a roomful of people standing around.

Creating a Shot List

An alternative approach to planning for a scene is to simply make a list of the shots you want. Be sure to identify elements like the location and participants, and then specify the angles that you need.

We recommend using a spreadsheet program like Apple Numbers or Microsoft Excel. You can also use database applications like FileMaker Pro or Directors NoteBook. This allows you to easily re-order shots and group them into a logical shooting order. You can then print the list out and bring it with you on the shoot. This way you can likely avoid the experience of missing coverage and sitting in the edit room trying to figure out if stick figures or shadow puppets will work to cover the missing scene.

▶ Luke takes a turn behind the camera. Great videos come from artists collaborating together.

Profile Bob Krist

Recognized three times as the "Travel Photographer of the Year" by the Society of American Travel Writers, Bob Krist is an award-winning freelance photographer who specializes in travel and editorial location photography. Bob's travels have taken him to all seven continents where he has produced work for dozens of publications, including *National Geographic Traveler* and *Outdoor Photographer* magazines. Bob is also a published author; his latest book, *Travel Photography: Documenting the World's People and Places* (Lark Books, Asheville, 2008), is available now.

As a pro photographer Krist sees tremendous possibility for photographers using video-enabled DSLRs to tell a story. "Photographers should try to be open to new ways of telling our visual stories, and video can help us do this."

Krist recognizes that starting to shoot video, for many still photographers, can be intimidating: "You add the dimensions of motion and sound, and you're in a completely different ballpark. The need for so many cutaways and detail shots is new to most still shooters, and the audio concerns are very foreign."

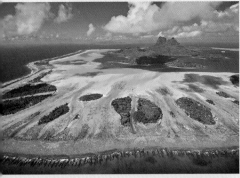

Even with these challenges, Krist has been able to make the transition into shooting video, partly through practice but also through learning about and studying shooting video. As Krist says, "The only way to overcome the intimidations is to try to educate yourself and meet them head on."

As a new way to tell a story, Krist has been using video to build multimedia pieces for his clients. The addition of video to his work has added new possibilities to what he can offer clients. "They like completed audio slide shows or videos for their websites." Krist admits that selling video content to clients who have come to depend on him for stills work has been an uphill battle, but he does see the industry changing. "Eventually, clients are going to be expecting every stills project to include some video, and even though there may be a bit of lag now, when they all wake up to that, it will pay to already be up to speed in shooting video, getting good audio, and learning how to edit it."

Speaking of editing, like many photographers, Krist sees one major challenge in producing video content—editing it. "I really think most still shooters can get the hang of shooting video with clean audio fairly easily, but

honestly, most of my video footage is still waiting to be edited." The challenges in editing content are not so much a lack of desire in telling a story but a technical challenge in using editing software. "I find the software to be hugely complicated, and I kind of long for the old days when all a photographer had to do was shoot and somebody else processed the images," says Krist.

For Krist, issues like editing as well as recording audio in the field are good reasons for video projects to be collaborative and have multiple people performing different roles. "I was covering a street fair in Buenos Aires that featured gauchos racing horses and putting a stick through a small ring. I shot mostly stills but also shot video. The big problem for stills guys doing both is when do I shoot video, when do I shoot stills, and when do I gather audio?" Answering his own questions, Krist points out, "I think we've always had *individual* photographers but video *crews*."

Filmmakers who shoot genres like documentary and indie film projects, and often rely on collaboration and use of crews, are leveraging the current crop of video-enabled DSLRs more than even traditional photographers. Krist says of the cameras, "They may be changing the indie film industry faster and more profoundly." He goes go on to say, "The Vince Laforet and Ami Vitale videos are stunning examples of the quality these machines can put out."

Krist has a word of advice for photographers who are faced with an increasingly mediated world and greater expectations to produce audio and video content: "If we want to stay relevant, it's a good idea to at least explore this new medium. If you try it and hate it, well then at least you know something more about you and your craft, and that's always helpful. But you may try it and love, and that's always a thrill. Personally, I'm enjoying the challenge and opportunities shooting video is presenting." On his own foray into shooting video, Krist says, "I've always been a field guy and not so much of a tech guy, so this going to be a long road for me, but one I'm looking forward to traveling."

For more information on Bob Krist and to view more of his work, be sure to check out www.bobkrist.com.

GEAR LIST
- › Nikon D300s and D90
- › Nikon 16-85mm f/3.5-5.6 VR and Nikon 70-300mm f/4.5-5.6 VR zooms
- › Nikon 35mm f/1.8 and Nikon 85mm f/1.8 primes
- › Hoodman HoodLoupe
- › Sennheiser MKE 400 small shotgun
- › Olympus LS-10 Digital Audio Recorder
- › Leica tabletop tripod as chest pod
- › Kodak Zi8 Pocket Video Camera (for situations where an even smaller camera is needed)

Before You Shoot

The Need for Preproduction

A video production has many elements: lighting, shot design, locations, audio, directing, and editing—to name a few. It sounds intimidating, but you'll find there are some similarities with still photography that will make the transition to video easier. Just as it's important to plan out the details in advance of a photo shoot, you must develop a plan for video that takes all these production pieces into account.

On the first day of the shoot, you should have executed the entire shoot in your head, on paper, in discussion, and in as many ways as possible in advance. You'd think that with enough planning the actual capture of the digital images would be a simple task. Oh, if only it were that easy! It always seems as though a detail gets left out—often an important one. Although these "learning lessons" become the grains of salt that season a true professional, you don't want them to disrupt what might be a long and productive career.

IT IS FAR BETTER TO PLAN AHEAD RATHER THAN WHILE YOUR EXPENSIVE CREW AND GEAR ARE WAITING FOR YOUR NEXT MOVE.

We know that most creative folks don't enjoy paperwork and planning, but advance preparation prevents potential problems the day of the shoot. Where will you place the camera? What kind of lighting is ideal? In what order will you shoot the sequence? How will you optimize the use of crew and locations? It is far better to plan ahead rather than while your expensive crew and gear are waiting for your next move. A little advance planning helps ensure that you can spend your production time getting beautiful footage, which is really the goal, isn't it?

Organizing the Planning Meeting

You've landed a project. The video you produce will tell a story that an audience will want to watch. Where do you begin? That's easy. Start with your client.

Who do we mean by the client? Well, every project has a reason for existing. Someone has decided there is a need to capture images and craft a video to communicate a message. The client is the person you need to satisfy. That person could be an individual who's hired you, an organization, or for that matter you. Take our advice and always keep the stakeholders in mind: This will guarantee your success.

Identifying Objectives and Constraints

By understanding the client's goals and project limitations, you can increase the likelihood that the intended message will be accurately and artistically brought to life during the other phases of production. By hashing through several issues up front, you'll be able to determine what the needs of the product are before significant time and expenses are incurred. Here are a few simple questions you need to answer at the outset of a project:

Who is the customer? Get to know your client. Determine how the client's expectations and experiences will shape the project.

Who is the target audience? The biggest sin in the world of video is forgetting the audience. Always keep in mind who you are trying to entertain.

How will success be measured? Know the criteria the piece will be judged by. The goal might be to drive an audience response (like visiting a website or a business) or to create an emotional response in the viewer.

What is the budget and deadline? Every video project is driven by cost and schedule. The approach you take (and the options you have) will be dictated by the universal forces of time and money.

Are there any technical requirements? Make sure you know how the finished video will be used. It might be for the web (the least technically demanding) or be shown on traditional broadcast television or at a film festival. You need to know the output formats to design a technical approach to the project.

Are there any resource limitations? Discuss any limitations that will affect your shoot, such as access to locations and talent. Find out if any special permissions need to be secured.

Developing the Creative Vision

You have likely been brought onto a project for your creative vision and skill at telling a story with pictures, but it's essential that you understand the client's needs and wants. The preproduction process ensures that the client's message and vision is understood. It is *the* most important phase in a project. You can make the most beautiful art in the world, but if it fails to connect with your target audience, you've failed.

Asking your client a few detailed questions up front can go a long way toward mutual understanding. Once the photographer, director, and client are on the same page, the creative process can really take off. Here are a few important questions to ask:

What main points do you want to make with the video? Make sure the client tells you the critical information the audience should receive. Keep this list to less than five items or the audience will lose focus. If no information will be communicated, identify the key story points that the audience should connect with.

Who is the primary audience? Have the client explain who is expected to watch the film. Describe the audience in demographic terms, because this will often shape your editing and shooting approaches.

Who else will view the project? Determine which other groups will likely see the program and should be considered.

What do you want audiences to think after viewing the project? Establish the logical response the client wants the video to generate. This ties into the information that is transferred from the filmmaker to the audience.

What do you want audiences to feel after viewing the project? Equally important is the feeling audiences are left with. Describe the emotional response or journey the audience should experience. This will drive lighting, composition, editing, and performance.

What do you want audiences to do after viewing the project? Every video has a purpose, whether it's to simply start a conversation or drive the viewer to action. Knowing the desired goal will help you create a video that contributes to the end result.

After capturing your client's answers to these questions and more, develop a written plan that describes your approach to the project. Also, consider adding a *treatment*, which is a narrative description about how the project's story progresses.

In addition, you can describe technically any artistic elements in the treatment to give your client a clear idea of the video you intend to make. Having a plan in your head is good, but documenting the details on paper so you can share it with your client and crew is far better.

Performing the Site Survey

Video professionals have always depended on site surveys to avoid any issues during a shoot. The site survey is very similar to a location scout, you just tend to dig deeper into the details. By visiting the locations you plan to use during your project (prior to the day of shooting), you can dodge potential problems.

The objective is to identify any location advantages and limitations. This puts a face on the story you'll be creating—a story that until now has just been a printed page or a conceptual discussion. Look for great shots and pinpoint any obstacles you should avoid that might impact your lighting or sound. When you show up on the day of the shoot, you'll have a game plan in place. You should also be prepared to answer questions from all your crew waiting for instruction. Every location is unique. You can't rely on second-hand reports and websites to truly tell you what you can expect.

After the site survey, schedule the shoot. Determine which locations you plan to use as well as what time you'll use them. Equally important is to try to identify backup locations and alternative shoot dates. During a shoot, unforeseen events can occur. Power outages, inclement weather, illness, traffic jams, construction noise, and the like can wreak havoc on a schedule, so have a backup plan! There are as many solutions as there are unanticipated problems.

As you visit project locations, try to view them with both a technical and a creative eye. Remember, a site survey is critical and should be executed as skillfully as the shoot. Have a schedule and a checklist, and stick to both. It's essential to the overall success of your video. When a site survey is done correctly, the shoot goes off easily and can be much more enjoyable.

 SITE SURVEY CHECKLIST
Looking for a detailed list for a site survey? We've got you covered with a checklist that will work for most shoot types. Be sure to review the list prior to your visit and add any further details you need.

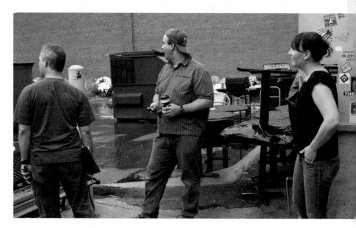

▲ Rich carries an audio recorder throughout the site survey. This lets him capture a sampling of the ambient noise levels in each location. He'll evaluate this when selecting shooting locations.

▲ Walking a location with a client lets you see their reactions to particular suggestions. Be sure to also take reference photos so you can review shots in future planning sessions.

Who Should Attend a Site Survey

Just who goes on the site survey largely depends on the size of your crew. If you're a one-man band, you'll likely be joined by your client (or perhaps you'll fly solo). But as the crew size grows, you'll want to include more attendees to ensure effective planning for the main shoot. Here's a list of important players:

Director of Photography: As the principal photographer, you should always scout the location. This allows you to identify shooting angles, lighting requirements, and any specialty gear that may be needed.

Director/producer: Your project may have a director or a producer, or the job may be one in the same. It is important that the project's leadership agree. The site survey will have the greatest impact on project planning, so it's important that the key decision makers are present.

Client: If you can get your client to attend your site survey, do so. This is an excellent opportunity to talk through the fine details of the project. It is also the point at which the project becomes very real, so it is an opportunity to resolve loose ends and finalize budget and technical details.

Technical department heads: Depending on the size of a shoot, you may be able to hire additional crew (such as lighting or sound professionals). If these people are able to come on the survey, bring them. If time or budget won't allow for their attendance, it's important that someone on the scout be assigned to collect (and convey) essential information. The goal is to prevent any surprises on the shoot day that can cause expensive delays. We'll explore the crewing process later in this chapter.

REMOTE LOCATION HELP
Don't let a little distance be the cause of bad planning. You can often hire a location scout who can examine potential shoot locations and take notes and photographs to help with project planning.

What Gear to Bring on a Survey

While there's no need to haul out all your gear to do the site survey, a few essential items are necessary. Being properly equipped allows you to make the most of your visit and ensures that you have accurate information for future review during preproduction planning. Here are some items you'll need:

Digital camera: Two types of images should be collected during a site survey. One image type is a visualization of the physical space. These are wide shots that provide those viewing them with a real sense of the place. The images should include the dimensions of the room, the available lighting, the height of the ceilings, the color of the walls, obstructions, and so on.

The other image type consists of previsualization shots. Experiment with camera angles and actually shoot some frames that might serve as a digital storyboard in the actual space. The goal is to capture representative shots that allow you to plan shot composition as well as the order in which the shots will be used.

The camera quality is up to you, but a high-end camera with interchangeable lenses will help you create digital storyboards. Although bringing your camera body and lens kit is desirable, it won't always be practical. You may find that a cell phone camera is enough. Some people prefer to bring their standard DSLR camera body and a single zoom lens onsite to shoot sample shots of the locations with a stand-in actor.

Digital audio recorder: A recorder lets you capture audio notes at the location, which is faster than writing notes. You can also record the ambient noise of the location to get an idea of the amount of audio interference you'll encounter. The recorder quality is up to you. We've used everything from an iPhone to a digital recorder depending on gear availability.

An Internet connected device: Make sure you have online access when needed. From checking the budget to reviewing the script, it's likely that you may need to confirm details. We find that a laptop is best, but we can often get by with a web-enabled phone.

Notepad and pencil: You'll often need to sketch site drawings to help identify camera placement and power sources. If you really want to work like a pro, you can

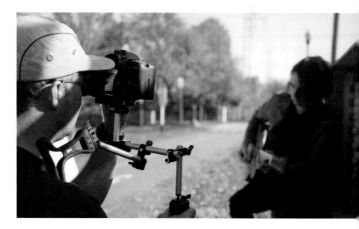

▲ Taking accurate notes about the sun position and location leads to accurate planning. Jim was able to utilize the sun as a key source on location with Luke as the shot was scheduled for the right time of day.

▲ Knowing the position of the sun can help you accurately plan for shots. Check out sunPATH from www.wide-screen.com.

▲ Don't assume that every outlet is in working order. A circuit tester is easy to carry on a survey.

hand out a "tech pack" to the crew. This typically includes location photos and set and location drawings. The items generate great questions from the newly informed crew that you might not have thought of.

Compass, SunPath Calculator, and GPS: Whether you're shooting interiors with windows or exteriors, you'll want to know where the sun is at any given time on shoot day. Several great software programs are available—such as SunPath and Helios—that can provide this data anywhere in the world, months in advance. This information is even more essential if you are relying on the sun as your principal lighting source.

Another tool to consider is an inclinometer, which is useful if you are trying to determine shadow angles. You might be able to calculate the perfect time to shoot your beautiful, backlit subject as the sun emerges between two buildings. Adding a GPS is useful if you want to get precise coordinates at your locations (especially for outdoor and remote locations).

Distance measuring devices: Tape measures, electronic or manual, are needed to measure anything that requires precision in placement. From the width of a

doorway to the height of the ceiling, these measurements can be useful for a range of setups, from rigging ceiling lights to laying dolly track.

If you need to measure long distances, take a cue from the fairways. A digital golf rangefinder can help gauge point-to-point measurements using a laser. This is an easy way to measure approximate distances of a few hundred yards with accuracy.

Circuit tester: A simple circuit tester from any hardware store let's you assess available electricity. Testing identifies which outlets are hot and whether or not they are grounded. You'll learn more about lighting in Part II of the book, but many lights (such as HMIs) are ballast-based lighting fixtures that draw a lot of power.

If you're working with multiple or large lighting fixtures, be sure to check out the main electrical distribution box to at least find out the size of the breakers in the box. It's a good idea to also get a sense of how the power in a space is laid out. Having four outlets in a room doesn't necessarily mean you have four full circuits at your disposal. You should know the electrical capacity of your location, or find someone who does.

VIDEO #3: WHAT TO LOOK FOR ON A SITE SURVEY
Join us on a site survey as we walk through a location and describe what to look for.

STORYBOARDING? THERE'S AN APP FOR THAT
If you have an iPhone, check out Hitchcock. It makes it easy to capture location photos and organize them into an animated storyboard.

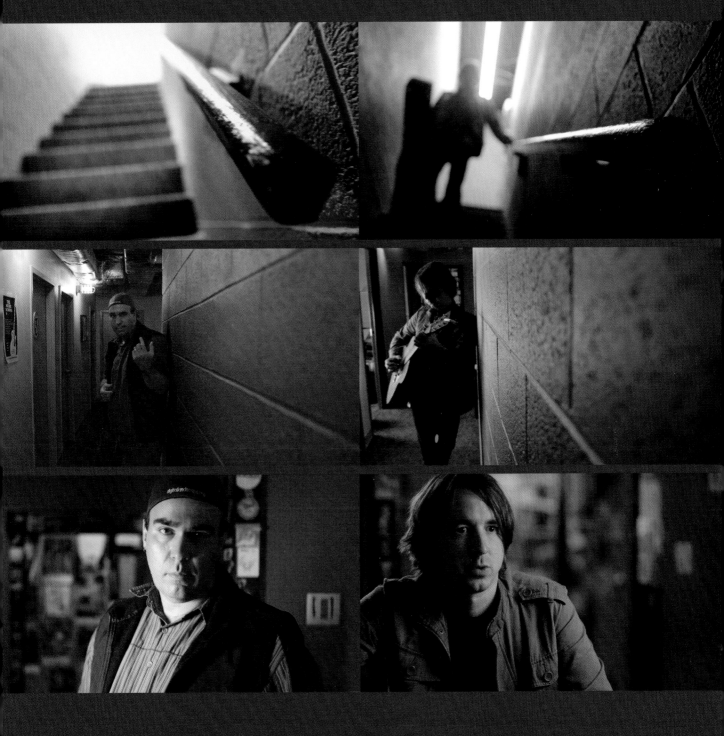

▲ Two prospective locations for portrait shots from the site survey. Both offer lighting challenges.

What to Look for on the Site Survey

Your goals for the site survey will vary depending on the type of video you're creating. Large events (such as weddings) require lots of thought as to where multiple cameras should be placed, whereas musical performances need special emphasis on audio acquisition. Always keep your end product in mind as you examine locations. Here are a few details to consider:

Location appearance: Does the location add to the story you are trying to tell? Remember you don't often need 360 degree coverage, but can you get cutaways and alternate angles that feel cohesive? Does the physical space need altering, for example, painting, cleaning, aging, or general propping? Can you handle these modifications, or do you need to call a carpenter?

Lighting sources: Are there any lighting challenges that need to be controlled? Windows can introduce variable light that needs to be managed or eliminated. Do you have fluorescent and incandescent lights in the same scene? Look at the available light sources with a critical eye so you can bring reinforcement lighting.

Power sources: How will you power your gear? Although battery power is possible for certain devices, it will eventually run out. You'll need a source to charge batteries and to power devices. Make sure you have enough outlets as well as extension cords for your equipment. You should also determine where the breaker box is located.

Audio interference: Are there any items in the shooting environment that will lower audio quality? Do the lights cause a hum? Is there heavy traffic from cars or airplanes? Can you access controls to turn the HVAC system off and on? We recommend recording room tone and analyzing it in the quiet space of your edit suite to determine how it will affect your production.

Parking and load in: Getting the crew and gear into the workspace can be challenging. Once you get everyone in, decide where you will park your vehicles.

Staging areas: Where will you load the equipment? Once gear is unloaded, where can you store it so it is safe and accessible? Do you have adequate room for the crew and the action? What compromises do you need to make due to space limitations? Are there any steps that you need to take to preserve the condition of the space, such as wall or floor coverings?

Permissions: Public and private locations may require permitting or permissions to shoot. Sometimes permissions can be informal; other times they can be strictly enforced. Although *you* may be used to "sneaking by," a video crew is usually large and more noticeable. Assess the situation in advance and get what you need to shoot legally. You may not need signed permits, especially with small crews and minimal shooting times. But if possible, it's best to get official permits. A shoot can be stopped dead in its tracks if you get booted out of your location.

ARE THERE ANY LIGHTING CHALLENGES THAT NEED TO BE CONTROLLED? WINDOWS CAN INTRODUCE VARIABLE LIGHT THAT NEEDS TO BE MANAGED OR ELIMINATED.

Crewing the Project

In the world of photography, you may add an assistant or support crew (like a stylist) as the project grows in complexity. With video productions, you'll find that the need for extra help with gear or lighting is often far greater than on photo shoots.

Throughout this book, we'll discuss several different approaches to crewing a production. Although a Hollywood crew can number in the dozens, we know you most likely won't enjoy this luxury. Crewing your project will be a careful balance of budget and skill.

Can You Do It All?

For some, photography is a solo activity. The ability to explore and document the world on your own is rewarding. If you take the solo approach, it is essential that you employ the KISS (Keep It Simple, Stupid) methodology.

Be sure to thoroughly test your gear and know its limitations. Also, pack only what you need and avoid making lighting or lens changeovers in the middle of the shoot. We're not big fans of this approach for complex shoots, but it can work well for acquiring supporting footage or simple documentaries.

Extra Hands Go a Long Way

Adding crew members often means that exponentially more footage can be captured. Even a two-person crew can generally shoot far more than twice as much professional footage as a single shooter. This is mainly because of the complexity of video, which requires those behind the camera to focus on composition, lighting, audio, and continuity. If you then add actors or human subjects to the mix, you need to focus on performance as well. When crewing a project, keep the following details in mind:

Minimize delays in shooting due to crew size and gear changeover: We often find that the cost of talent, locations, and gear rental are more expensive than adding another crew member. Being able to keep up the pace of shooting with the action lets you capture more footage.

Hire different crew talents depending on the project: If a project has challenging audio requirements, consider adding a dedicated audio technician. Sure, you can do this yourself, but don't attempt to learn audio with "on the job training" unless you're prepared for an angry client.

If you have lots of scenes or setups, an extra set of hands to assist with lighting will allow for quick switchovers. Use the same logic as having an assistant for a photography shoot.

Try to assign duties to specific people rather than having too much multitasking. If the guy assigned to setting lights is also in charge of getting lunch, it can cause some unwanted delays. Of course, budget will dictate what is doable. But if you delegate each crew member's duties efficiently, you'll have a top-notch team.

Don't forget the budget: You'll often need to creatively find a way to stretch your dollars. However, we often find that money spent on production crew saves a tremendous amount of effort during the postproduction stages. If you skimp on lighting or sound because you didn't have enough help or the right kind of help, you'll end up spending lots more time during your editing stages (with no guarantee that the end result will match your quality goals).

Teamwork Matters

As you know, there is no shortage of people with creative talent and technical expertise. But that doesn't mean we'd let them on our crew. The process of filmmaking is very much a collaborative team effort. Although the Director of Photography is often "in charge," the director needs to work with a myriad of other professionals on set. Your crew needs to be comfortable

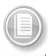

CALL SHEET
A call sheet is a useful way to communicate schedule and location information to your crew and client. We've included an Excel and Numbers template that you can customize.

▲ An extra pair of hands can go a long way on location. Here, a grip is responsible for some bounce lighting on our subject.

offering opinions and options but in a way that respects the chain of command and project requirements. Here are some crew members we find invaluable:

Gaffer: The gaffer is in charge of lighting on the set. A gaffer often designs the lighting approach and then executes it. On some shoots, the photographer can fill this role.

Grip: A grip is a technician who helps implement lighting on set. The grip also works with the photographer to help create and manage camera support systems like tripods and dollies for smooth camera movement.

Audio engineer: The audio engineer focuses solely on capturing clear audio with proper volumes. This is a very difficult position and is one of the best hires you can make for a project.

Production assistant: A production assistant is a jack-of-all-trades. An assistant can be counted on to perform a variety of tasks during production. Although this is generally a junior position, a production assistant can still be quite helpful.

Camera assistant: A camera assistant is responsible for setting up cameras and lenses. If you are using multiple cameras on a project, it is best to hire a

skilled person to fill this role. The camera assistant can also help with complex camera movements and manual focusing during a shoot.

Data technician: Video files are big, so you'll quickly fill up your memory cards. The data technician is responsible for archiving memory cards to multiple drives and returning cards to the photographer for reformatting and reuse. If you don't have a data tech, plan on having lots of memory cards and staying up late to clear them all off.

Keep in mind that different projects require a different number of crew as well as skills. You'll want to select your crew based on the potential crew members' technical expertise as well as their interpersonal skills. Both are essential to your project's success.

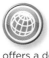
WHAT'S THAT POSITION CALLED?
Looking for a comprehensive overview of the various crew positions? Wikipedia offers a detailed overview of the many jobs on a film and video shoot. Visit http://en.wikipedia.org/wiki/Category:Film_crew.

▲ Matt adapts some existing gear to work with his Canon 7D camera. By stretching his available equipment, he creates a second camera rig.

Determining What Gear to Bring to the Shoot

We admit it, we like gear (and chances are you do too). We have specialty lenses as well as lighting and audio gear for specific scenarios. Having the right gear makes a big difference at the shoot and in your final product. When you're working out of your own studio, your gear is most likely close at hand. Unfortunately you can't bring it all with you on every field shoot. As we discussed earlier in the chapter, the site survey and client meeting will help you make informed decisions about what you'll need. Here are a few other areas to consider when deciding what gear to bring:

Story requirements: The type of story you want to tell will determine the gear you need to use. You've had your concept meetings, visited locations, and agreed on a strategy for telling that story. Now you'll gather the equipment you need to facilitate the goals you've

set. Don't forget to bring your notes as well. You'll need them on set for quick reference for each setup.

Basics: It's a given that you'll have a core kit of lenses, a camera body, and tripod support. Once a basic package is assembled, you can then decide when and where specialty items will be needed. We strongly recommend adding an HD monitor or viewfinder to your kit as well to check color, contrast, and focus. We'll explore all sorts of gear options throughout the book.

Specialty items: Specific shots may require advanced gear. You may need advanced camera support options like dollies or stabilization rigs (see Chapters 11 and 12). You may also need specific lenses for a long telephoto shot or a super wide fisheye view (see Chapter 10). Because you'll often need to rent or borrow

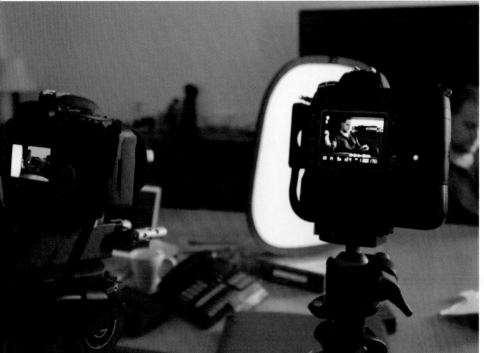

▲ A backup generator can ensure that you have constant power for lights.

◀ We put the Nikon D300s, Canon 5D Mark II, and Canon 7D through a battery of tests to make sure they'd work well for various lighting.

specialty items, be sure to determine when and if they are needed. If possible, try to group similar shots together (even if it means shooting out of order) to save money and time.

Power requirements: You may only need a generator for your outdoor locations or if you have unreliable electrical service. If the generator is not silent, be sure to consider how you'll isolate the noise. Can you move it far enough away from the shoot and use extension cords?

You get the idea here: Bring only what you need on the days you need it. Doing so saves you time when loading or moving locations, saves you rental costs, and lets you assign resources elsewhere. The key to success is keeping the costs in line with your client's expectations but knowing when you need to spend extra to ensure that all will go smoothly and safely. You need to cover yourself for unplanned opportunities or surprises.

CREWING WEBSITES

Do you need to add some extra depth to your crew? Local recommendations are always best, but here are a few websites worth looking at for freelance crew:

> www.cinematography.net
> www.craigslist.com
> services.creativecow.net
> www.mandy.com
> www.productionhub.com

Crash Course in Video Technology

The Technical Essentials of Video

If you hang around with video types, you'll swear they just make up words and phrases—progressive scanning, interlaced scanning, 1080p, 720p—the list goes on and on. Understanding these technical terms is an important step for learning how video works.

Video is an incredibly expressive medium to create with, and it can be hard to learn. Many rules as well as limitations can impact your video project, so it's important to know the technical terms of the underlying technology in video.

We often compare video to gravity. You don't have to understand how it works, but you're still bound by its limits. If you choose to ignore gravity and step off a ledge, it will not keep you from falling. Similarly, choosing to ignore the rules of video will not keep you from failing.

The more you explore video on your DSLR the more options you'll discover. But don't feel overwhelmed with video technology and terminology; once you know the basics you'll be armed with the knowledge to make the most technical decisions regarding video.

WE OFTEN COMPARE VIDEO TO GRAVITY. YOU DON'T HAVE TO UNDERSTAND HOW IT WORKS, BUT YOU'RE STILL BOUND BY ITS LIMITS.

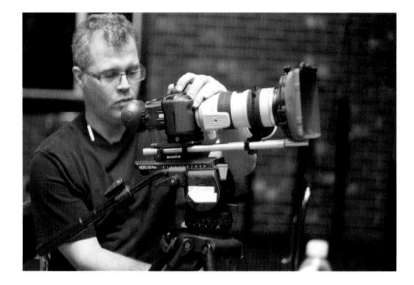

In this chapter, you'll quickly become more familiar with some of the specialized aspects of video. As a result, you'll be able to have intelligent technical conversations with crew or other professionals. You'll also be able to decode technical video nomenclature as you explore the rest of this book.

This overview is designed for you—smart photographers who want to truly understand their gear and get professional results. The information in the following sections is not the be-all and end-all of technical knowledge about video. Rather, it provides you with some of the key terms you'll encounter most often so you'll become comfortable with video terminology.

Frame Size

Frame size in video is similar to image or canvas size in photography. For example, the Canon 7D shoots an 18-megapixel image that is 5134 x 3456 pixels—the height and width of the image. These dimensions define the resolution and size of the image at 100 percent or full resolution. If you change models of DSLRs and the megapixel count of the sensor (10 MP, 21 MP, etc.), the frame size will vary.

With video, frame sizes are more consistent. High definition (HD) video has two standard frame sizes so video cameras, software, and displays can all work together:

> 1920 x 1080 (also known as 1080 or full HD)

> 1280 x 720 (known as 720p HD)

Most DSLRs are able to record HD video and standard definition (SD) video. Our advice is to go big and stick with HD. There is very little demand for SD video (and you can always downconvert or resize to SD or even for the web after editing).

Which resolution you choose depends on three factors:

> Hardware limitation (some cameras only offer one size to choose from)

> Any requirements from your client

> Other footage that needs to be integrated into your project

Frame Rate

Video works because the human brain can connect a rapidly shown series of still images to perceive smooth motion (due in part to a phenomenon called persistence of vision). In video, frame rate is the speed of these individual stills are displayed on screen. Frame rate is measured in seconds (and may contain a decimal value).

There are plenty of frame rates to choose from and your DSLR likely supports some (or all) of the following frame rates (measured in frames per second):

60 fps (59.94 fps): Standard frame rate for 720p HD used in the United States and other NTSC (National Television System Committee) based countries. NTSC is a set of video standards used in the United States and a few other countries.

WHAT PORTION OF MY SCREEN IS VIEWABLE?

Action and title safe areas are similar to the bleed area in print and are other important concepts regarding frame size. Be sure to check out this PDF on the disc to learn more about action and title safe areas, and how to protect for them in the field and during postproduction.

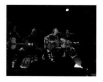

640 x 480

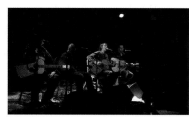

1280 x 720

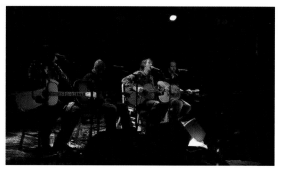

1920 x 1080

▲ **DSLR frame sizes compared. From left to right: standard definition, 720p HD, and full HD.**

▲ Video uses a succession of frames recorded at a certain speed (called frames per second). This can create smooth motion by tricking the eye so it doesn't see the individual frames.

50 fps: Standard frame rate for 720p HD used in Europe and other PAL (Phase Alternating Line) based countries. PAL is a set of standards for video used in Europe and other parts of the world.

30 fps (really 29.97 fps): The most common frame rate for broadcast in the United States and other NTSC based countries

25 fps: The common frame rate of video used in Europe and additional markets around the world that are based on the PAL standard.

24 fps (23.98 fps): A rate that closely matches that of motion picture film.

Fractional frame rates like 29.97 come into play in countries like the United States that follow standards set by the NTSC. Originally, the video frame rate in the United States was 30 fps (or a field rate of 1/60 of a second). This rate was used to match the 60 Hz AC power-line frequencies in North America. When color was introduced into the video signal in the 1950s, the rate had to be changed. To make color work properly with an existing transmission and hardware infrastructure, engineers had to slow down video frame rate signals by 0.1 percent, leading to a frame rate of 29.97 frames per second (or a field rate of 59.94 fields per second).

For compatibility with existing technology, the same logic has been applied to HD formats in countries that were based on NTSC standards.

Which frame rate you choose depends on a number of factors—two of which are the look you're trying to achieve and the frame rate of your final project, which is usually dictated by a broadcaster, a client, or the format you'll deliver the project on. Here are our recommendations:

> For footage that mimics motion picture film, a good choice is to record 24 (23.98) fps.

> For footage that will be used for broadcast, 30 (29.97) fps is a good choice for interlaced 1920 x 1080 material in NTSC based countries.

> If you're working with the PAL standard, you'll use 25 fps.

> For footage shot 1280 x 720, the best choices for broadcast are 60 (59.94) fps in NTSC based countries and 50 fps for PAL countries.

Line Scanning

As mentioned earlier, video works by the rapid display of several sequential images. But how those images load can vary. The two major methods of scanning or displaying a video signal are *interlaced* or *progressive*.

Interlaced scanning

Interlaced scanning was introduced to the television signal in the early days of transmission standards to offset the decay or loss of brightness in phosphors that cathode ray tubes (CRTs) of the day used. By using interlaced scanning, a near constant brightness of the image could be maintained. Scan lines or horizontal lines of pixels (when grouped together they are called fields) load in an alternating fashion in an interlaced signal.

Which lines load first depends on the format, but for most SD NTSC formats, the even lines (called the lower field) are scanned or displayed first. For HD or SD PAL formats, the odd lines (called the upper field) are scanned or displayed first.

Each line is scanned very quickly: For example, most broadcast television in the United States has a frame rate of 29.97 frames per second, so each field is scanned in at 1/59.94 of a second. Adding both fields together produces one complete frame. Most broadcast television with a frame size of 1920 x 1080 pixels uses interlaced scanning (or a special type of progressive scanning called PsF; see the sidebar in the next section for more on PsF).

Even though DSLRs shoot using progressive scanning (see the next section), at some point it's a good bet that your footage might be shown on an interlaced system.

Progressive scanning

Progressive scanning scans all the lines in order, starting at the top of the screen and moving toward the bottom. Progressive scan devices include some televisions, most computer monitors, film projection, and even the LCD on your DSLR. Broadcast television with a frame size of 1280 x 720 uses progressive scanning. Although both interlaced and progressive formats are available for 1920 x 1080 HD video, no interlacing exists for the 1280 x 720 HD format.

NTSC NO MORE?

Since the termination of analog broadcasts in the U.S., it's more accurate to refer to television as using ASTC (Advanced Television Systems Committee) standards. However, NTSC is still often used by many in reference to television standards.

▲ Interlaced scanning (left) can exhibit jaggedness as the image is split between two fields. Progressive scanning (right) does not exhibit this problem.

Technical Notation and Frame Rate Confusion

You might have seen technical notations such as 1080i60 or 720p60, which are shorthand notations used to describe a format's frame size (resolution), scanning method, and frame rate. In the notation 1080i60, 1080 means the format has a vertical resolution of 1080 pixels. The i indicates an interlaced (i) format (p is used for progressive), and the ending digits specify the frame rate or field rate of the format, which is where the confusion exists. But understanding this last number is really quite simple:

> If a format is progressive, the number represents *frames* per second. For example, 720p60 has a vertical resolution of 720 pixels, is progressively scanned, and has a frame rate of 60 frames per second.

> If a format is interlaced, the number represents *fields* per second. For example, 1080i60 has a vertical resolution of 1080 pixels, is scanned using interlacing, and has a field rate of 60 fields per second. But keep in mind there are two fields that make up each frame, so to get the frame rate, you simply divide this field rate by 2. The result of 60 divided by 2 is 30 frames per second, which in countries that use the NTSC standard (like the United States) the frame rate is actually 29.97.

Table 4.1 shows some common formats in shorthand that you'll encounter when shooting with your video-enabled DSLR or when working in postproduction.

Much of the confusion about formats and frame/field rates lies in the fact that people like to communicate details quickly and easily. Technically, it would be better to say a format is 1080i59.94, but that's a mouthful. Therefore, it's generally communicated as 1080i60 with the understanding that fractional frame/field rates are used. Adding to the confusion is that some DSLR cameras do not write video files properly, and frame rates need to be adjusted or reinterpreted.

Table 4.1 Shorthand Notations for Video Formats

SHORTHAND	FRAME SIZE	SCANNING METHOD	FRAME RATE
1080i60	1920 x 1080	Interlaced	30 fps (29.97 fps)
1080i50	1920 x 1080	Interlaced	25 fps
1080p60	1920 x 1080	Progressive	60 fps (59.94 fps)
1080p50	1920 x 1080	Progressive	50 fps
1080p24	1920 x 1080	Progressive	24 fps (23.98 fps)
720p60	1280 x 720	Progressive	60 fps (59.94 fps)
720p50	1280 x 720	Progressive	50 fps
720p24	1280 x 720	Progressive	24 fps (23.98 fps)

*When used for broadcast, 1080 progressive formats use a special type of progressive scanning called progressive segmented frame (PsF). This type of scanning allows progressively scanned footage to be used in existing interlaced transmission systems.

Aspect Ratio

Aspect ratio describes the ratio of width to height of an image or clip. You'll often see aspect ratio specified in one of two ways: using whole numbers like 16 x 9 or in a decimal ratio such as 1.78:1.

Most DSLR cameras shoot still images in a 3 x 2 (1.5:1) aspect ratio, which is slightly square. However, HD video is recorded in a 16 x 9 or 1.78:1 aspect ratio, which is slightly rectangular. It's important to note that the display on the back of your camera will become letterboxed or ghosted when shooting video. This cropped area is *not* part of your shot, so you may need to adjust shot composition.

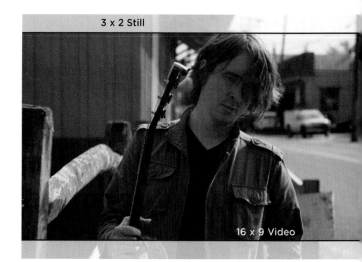

3 x 2 Still

16 x 9 Video

Compression

Compression really serves one purpose: to lower the data rate and therefore the size of a file. Compression is used on both still and video images. The goal is to make the file size small while maintaining acceptable visual or auditory quality (modern compression schemes can do an exceptional job at this balance act). Here are a few words and phrases to know when it comes to compression.

Codec: The compression scheme that a still, video, or audio clip uses is called a codec. Codec is short for *compressor/decompressor* or *compress/decompress*. We'll talk about video codecs throughout this book. Your camera as well as your editing systems use codecs (and no, they are not the same).

Compression ratio: The compression ratio is the amount in which a compression scheme is able to reduce the data rate/file size of an image, video, or audio clip compared to the original data rate/file size. For example, a 1 GB clip can be reduced to 100 MB by using a particular codec. In this case, the codec has a compression ratio of 10:1.

When you encounter compression, it usually takes two forms: lossless and lossy.

▲ Video-enabled DSLRs shoot video using a 16 x 9 aspect ratio and not the 3 x 2 aspect ratio often used for stills.

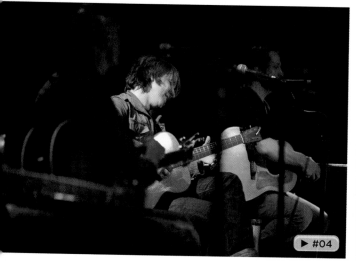

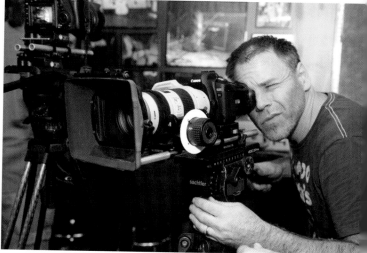

Lossless: Lossless compression works on the idea of what you put in is exactly what you get out, meaning the original source (in our case video) is unaltered after compression has taken place. The most common way lossless compression happens is by using a scheme known as run length encoding. Lossless video codecs, such as the Animation codec (which is typically used for archiving or transferring files), have a low compression ratio. Usually, it's no more than 2:1.

Lossy: As the word implies, lossy compression means you lose some image, video, or audio information. Lossy compression is a bit tricky because good lossy compression is a balancing act between quality, data rate/file size, color depth, and fluid motion. Almost every video compression scheme is lossy. Lossy compression schemes like H.264 (used on Canon video DSLRs) can have compression ratios of more than 100:1.

In practice you're probably already familiar with compression. You encounter lossy compression when you take photos using JPEG formats. JPEG compression, using a variety of techniques, can make a single image much smaller in size but results in a considerable loss of quality.

On the other hand, you use a lossless compression (or even uncompressed) scheme when you shoot in a raw format. These methods allow for much greater fidelity in color and tone with little to no compression. And before you ask, although raw video does exist, it's the size of an elephant, costs a fortune, and hasn't made it to the DSLR world (yet).

In video the word compression is used in two ways. First, it refers to which compression scheme (codec) is used to record the video and audio during acquisition. For example, the Canon 7D DSLR records video using the H.264 codec, whereas the Nikon 300s uses a Motion JPEG codec.

Second, compression in video refers to how video is handled during ingest and editing. It's possible to ingest video into your editing program using one codec and then work with it (edit the video) using a different codec. This is usually done to optimize the video for an editing application and playback on a computer—a process called *transcoding*. We'll talk more about transcoding video in Chapter 15.

VIDEO #4: VIDEO DEMYSTIFIED

Want to learn more about frame sizes, frame rates, compression, and the like? Be sure to check out this video as we break down these technical concepts further.

How Delivery Technology Impacts Production Technology

You have to know your destination before you can determine your route is a simple adage. But when it comes to video technology, what does this mean?

Simply put, you need to know how your video will be consumed or displayed (or at least which method is most important). By determining how your final delivered project will be viewed, you can make the right technical decisions.

Will the final product be viewed on the web or mobile devices? The web and mobile devices are the most forgiving mediums due to small screen size and acceptance of virtually any frame rate. As a general rule, you'll want to shoot a progressive format for the web. You should also use a low frame rate (like 24 fps) so your overall data rate is reduced to minimize download times. Also, shot composition should be tight to make your video easier to see on small screens.

Will the final product be shown on an SD TV or HDTV? If you are shooting for broadcast, you'll often have very

specific frame rate and technical requirements. You'll need to first determine the frame size (usually either 1080 or 720). The scanning methodology, frame rate, and codec are usually dictated by your client or the television network. Unfortunately, most TV networks have not yet put in place documentation that dictates technical standards of footage acquired with DSLR cameras and are scrambling to build those standards as more and more productions want to use video-enabled DSLRs.

Will the final product be distributed in theaters? Right now, films are being shot on DSLRs that you will be able to watch in a theater. To do this, you'll need to work closely with the film lab to ensure the specifications. Some details to think about would be shooting your film at 24 fps to match the frame rate of film, creating proper exposures so you can exploit the visual dynamic range of film, and shooting with a 180 degree shutter speed (a shutter speed that is double your frame rate) to avoid flicker.

Part II
Cinematic Lighting

Once you have your master plan in place, it's time for execution. Your lighting strategy makes up the lion's share of that plan. Lighting makes the image, and it's critical that you get it right.

Your lighting approach can be considerably different from a stills shoot. It starts with how you visualize it in your head while considering mood, story, and environment. You can then break open your toolbox, plug in the light, shape it, and alter it to your taste.

Lighting is one of the front lines where art meets the practical. You must transfer your vision into real-world results. Several tools are available to choose from, some naturally occurring (like the sun) and some that come from the bottom of your low-budget light kit.

Playing with the Light

Bringing Your Subject to Life

CHAPTER 5

You walk into a location with a scene

in mind. You've seen it on paper, talked about it in numerous discussions, and now you have the physical space in front of you. This is where your project comes alive.

The space will need some type of illumination. Whether it's for artistic or technical reasons (or even a little of both) you'll need to adjust the light in the space you're shooting. Through your efforts, you will shape, focus, and direct the light to get the desired results.

Light is the Primary Ingredient in Both Photography and Videography.

From the perspective of a videographer, lighting is the most effective tool for telling a story photographically. An incredibly varied and versatile tool, light is the principal filter through which you'll interpret your story.

Start your approach to a scene with the lighting in mind. Although it may seem intangible, we like to start from an emotive angle: Determine the mood and theme that needs to be created. Should it be sadness or joy? Fear or anger? Even though it may seem a little removed from the technical side of shaping light, you need to have an emotional response in mind.

Next, try to attach more tangible concepts to these emotions so you can bridge the gap between the story concepts and the physical world. You need to connect the emotions to your scene by deciding where they need to be staged in terms of light. Should the lighting be cool or warm? Soft or harsh? Industrial, gray, radiant, flat, directional, shadowed? Well, you get the idea. Make these decisions before you think about any practical lighting or technical approach. You can likely determine your lighting mood before you even see the location.

These days a lighting setup can be created from scratch. Lighting plans only need to follow one simple rule—make the subject look good. Consider this an opportunity to unleash your creative visions and draw on your knowledge of how light works.

In this chapter, you'll explore the power of light to evoke feelings. This begins your journey of playing with the light: Be prepared to change how you approach the subject.

Think Fast and Go with Your Gut

You walk onto your set; now what? Welcome to the first physical manifestation of all the ideas and concepts you've been kicking around in your head. Truth be told, it's very easy to become overwhelmed when trying to decide how to light a location. The natural tendency of most when presented with a blank canvas is to pause.

But it doesn't have to be that way. Let's take a look at a practical approach to breaking down a location and lighting a scene. You'll begin by making a few observations.

Analyze the Room

Before you start adding light, determine what you have to work with. What is the quality of the light in the room to begin with? Is it indirect? Harsh? Flat? Soft? What is the color temperature? Is it warm or cool?

Walk around the space and identify the current light sources in the room. Are there any practical light sources like lamps? Is the room plagued by mixed sources, such as fluorescent lighting with large windows?

The big decision you need to make is whether you want to completely create your lighting approach from scratch or if you want to augment the existing sources. Be sure to always analyze the light that already exists in your location. It is often a lot easier to work with what you have than to try to fight against it.

Consider the Action

You must consider the action that is being staged, or covered, when lighting. Where best can you play it out? Can you control the action of the scene, or is it unpredictable like a sporting event? Will it be static or moving? The events you are shooting will provide you with clues about a lighting plan. If subjects are moving, will they cast shadows? Does the action move from indoors to outdoors? The more you know about what's happening in front of the lens, the better you can make the scene look through lighting.

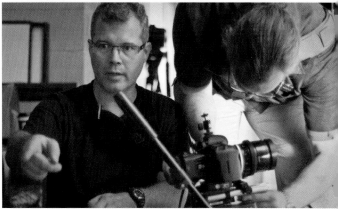

▲ Taking stock of the strengths and limitations of a location will guide you in your lighting strategy.

▲ A Kino Flo (through two layers of diffusion) creates a soft, wrapping key (left). The soft diffusion on the lights creates even lighting on the reflective surface of the guitar (right).

Determine the Mood

You must consider the appropriate mood for the scene. Will the existing environment or an alternative time of day motivate it? Can it be manufactured or manipulated by the production? How long does the mood need to last? For short periods of time, you can use natural lighting sources without having to worry about continuity. Longer shooting times mean controlled lighting (the sun tends to move on you). Condensing hours of shooting into a few minutes of screen time where the lighting matches throughout is a true skill. This is a real departure from still photography and is the essence of great camera operators. Keep in mind that lighting should enhance performances without being overly noticed.

Establish a Schedule

Evaluate time and resources compared to the amount of lighting coverage needed. It's all about relative equations: The more time and resources you have to expend, the more controllable the coverage. As allotted time and crew size decrease, compromises need to be made in either quality or quantity of lighting coverage.

There's a balance between the two (but it might take a "polite" argument to find it). You'll need to reach an agreement with your client or the director as to how much time can be spent lighting each angle within a scene. These decisions should be based on the evaluation of the space (it's always a matter of negotiation).

Work the Room

Now it's time to place your lighting sources to get the desired effect. Lights can be placed outside through the windows or get rigged in the ceiling. Lights can be set on stands or walked in and out on cue by crew members. They can be visible practicals (such as lamps) or even placed on the floor. They can be bounced, flickered, dimmed, colored, diffused, and so on. Your decisions are motivated simply by what works. Choices can be made for tangible reasons, like the camera needs to see 360 degrees, so you'll have to hang your lights. Or your choices can be based on your observations of the natural movements of light bouncing around in a room that indicate the light is more pleasing coming off the warm hardwood floor than gray linoleum ceilings.

Where your lights go will determine how much time and how many resources you'll need to light the scene. There are pros and cons to each scenario. Setting up

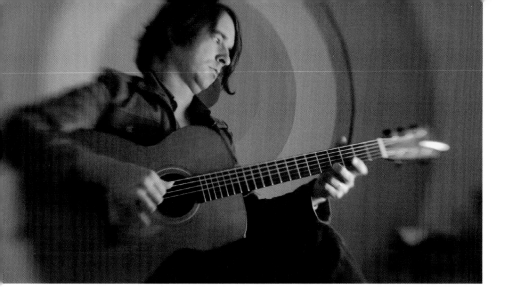

◀ Our soft source in action giving Luke a nice wrap. We allow the spill on the background to bring out the interesting art direction.

a difficult, time-consuming lighting rig may enable you to cover a scene in a single shot that sees in multiple directions. As a result, the time spent setting the rig ultimately becomes a time-saver in terms of allowing you to light the room only once.

Making 'em Look Good

One important consideration when lighting is getting the optimum quality of light on your subject's face. Decide how you want the light to wrap around your subject's face: Should the subject's face be broad or narrow? Hard and chiseled? Soft and shadowless?

The eyes are essential because they evoke all expression. So when you're lighting the face, the eyes should be your starting point. The face provides you with clues to the placement of the key light. Here are a few lighting suggestions:

> Broad sourcing (which leaves a large area of the frame open for motion) puts the key on the eye-line side of the camera. This works well for narrow, angular faces.

> For a fuller face, try a narrow side key (the opposite side of the eye-line).

> Look at the quality of the skin. Is it oily or reflective? What is the subject's skin tone? Is it smooth or pockmarked? All these surface features have an impact on your lighting choices.

▶ #05

▲ Even if you are going for a more side-lit look, it's always good to bring out the eyes.

VIDEO #5: GET STARTED LIGHTING
This lighting overview discusses our approach to key scenes in the finished video.

▲ Fluorescents like this Kino Flo Diva make a soft, pleasing key light.

▲ Soft lights create a lot of unwanted spill. Grip stands and flags help to control its direction.

The Essentials of Three-point Lighting

Three-point lighting is the basic starting point for film and video. This method utilizes three light sources focused on the subject from different angles. Mastering this technique is the foundation for more advanced lighting strategies. The goal of three-point lighting is to properly light the subject while also separating the subject from the background. This approach is the basis for portrait lighting, but it can be used in other situations as well.

Key Light

The key is generally your most intense light and is placed 15–45 degrees to the side of your subject. The main purpose of the key is to wrap the face in the appropriate quality of light based on the subject's features and the story you want to tell. Using a broad, soft source of light like that produced by a soft box or fluorescent fixture such as a Kino Flo is a popular choice when shooting interviews. If you have the room, a bounce key can be even more pleasing: The light is bounced off a flat surface or card and is reflected onto the subject's face to create soft light.

Ideally, you'll determine essential information about your subject before you light the shot. You'll want to identify important factors like skin tone and texture, hair color (or lack thereof), and wardrobe, so you can light accordingly. You'll also need to know the "color palette" of your subject so you can achieve the right lighting balance.

Fill Light

The fill is your secondary light and is generally placed on the opposite side of the key. Its purpose is to fill in the shadows cast by the key light. To what degree you utilize your fill light is a matter of taste. Ideally, you'll use a small lighting fixture or bounce the light off a card or flat surface. Often, you can use some reflected light off your key to produce some fill.

Selective use of fill light can have considerable impact on the mood you create. Try varying the amount of light used and look at your monitor or viewfinder after you make adjustments. The amount of falloff you use for the key (which creates shadows or transition) can really change a viewer's reaction to your subject's face. This light can significantly affect the mood of the portrait you are shooting.

You'll also need to experiment with the quality of fill light. When creating fill, you'll almost always choose

▲ When working in limited spaces, you can put the diffusion right on your light. It makes it easier to control the spill.

to reflect the lights off an indirect surface. Whichever surface you choose can make a big difference. Some are shiny and specular, whereas others just soften a source like butter. A shiny surface will not give you the same feel as a matte finish. Use the way different skin tones take the light as a reference point. You can also use a gold reflector to warm up your light. Just be sure to consider how reflections can affect the mood of the shot.

Backlight

Backlight is the third element in three-point lighting. Its purpose is to highlight the edges of your subject, separating it from the background, which creates more of a three-dimensional look. The backlight is identical to the hair light you might use in a portrait setup. Placement of the backlight is usually behind and above your subject, but it can depend on the shape and quality of the human (or other) head.

Sometimes the backlight works best close to the floor or off to the side (it is then called a *kicker*). The purpose is still the same, which is to create a multidimensional feel to draw the viewer's attention to a subject. The quality of this light can be as varied as the key and fill. A bald head often looks best with a bounced backlight, whereas a subject with a full head of hair can usually benefit from more of a direct treatment. Always look at your monitor to gauge what's best.

Luke Brindley Interview Setup

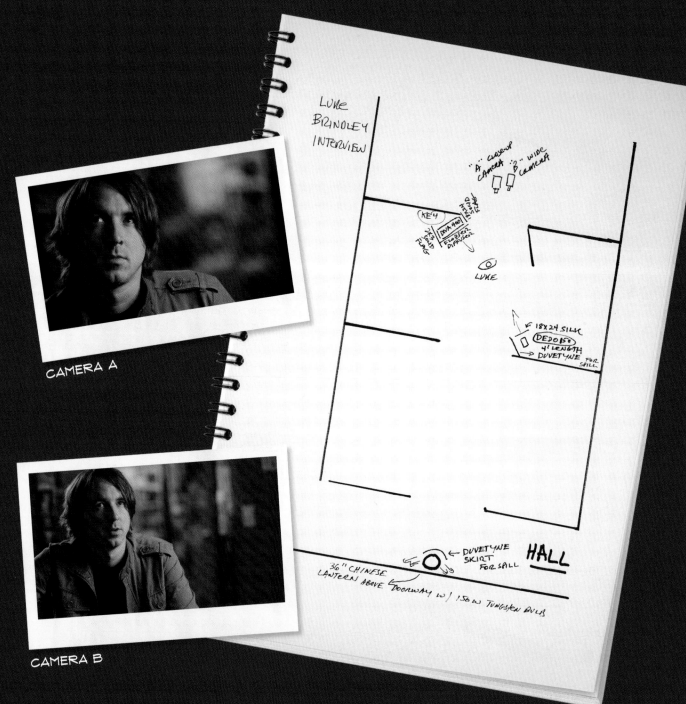

CAMERA A

CAMERA B

However, kickers and edge lights are not assumed for every shoot. Not every scenario requires a backlight. They just may not fit with the mood of your setup. People don't walk around in the world with little halos around them!

But you'll still want to separate the subject from the background to keep the viewer focused on the subject. You can accomplish this by lighting the background with the appropriate amount of contrasting shadow and highlight. In the right circumstances, this might be a more natural way to create separation. You can also do this through color variance, with warm colors making up your foreground and cooler tones receding into your background.

Putting It All Together

Once you understand three-point lighting you're well on your way to understanding the art of lighting. As photographers you probably know much of this. The new challenge you will have with videography is to maintain your three-point lighting sources throughout a moving shot, a moving subject, or multiple cameras, which can be really fun and open you up to some new challenges.

You can see the final result of combining the key, fill, and backlight on the adjacent page. When done correctly, the scene can be shot with multiple cameras.

◀ Small fresnel lights like the LTM Pepper are great for adding small highlights and edges to your setup.

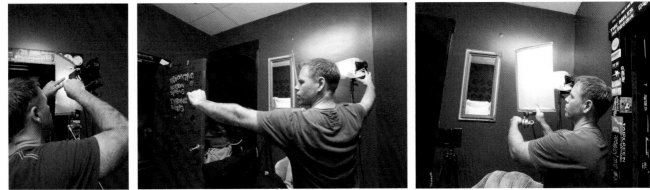

▲ A Dedolight 150 is employed for an edgelight. Without a stand-in, your fist can serve as a makeshift "head" to aim your beam. A small silk serves to soften and broaden your source.

▲ A background can be lit hard or soft. In this case, it's a 36" Chinese lantern creating a soft wash on the back wall of the set and lighting the space.

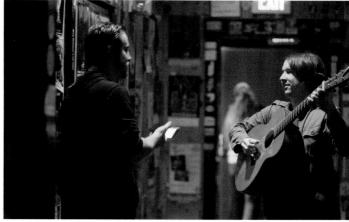

▲ The lighting here was placed to light the room in a dramatic way. The performers were later blocked in the best place to take the light.

Preparing the Scene

As the Director of Photography, you'll need to form a basic philosophy about location lighting. You'll want to develop ways of lighting that work in all situations. The following three approaches are essential and will affect most other creative decisions.

Light the Space

When lighting the space, the goal is to make the location look its best. Subjects then move through the lit space and land in predetermined areas that are flattering or scene appropriate. With this approach, the space is the subject you need to light. You might consider this method when the existing light sources in the room are your motivation for the overall look.

You'll want to *block the scene* by having the talent or stand-in act out the scene in a practice run. This will give you a picture of how big your set is—not only the performance space, but also the room you need for gear. You should put floor marks down for talent, camera, and sometimes lighting placement. You'll want to light only what's necessary to save time, and then develop a strategy for all camera angles and lighting adjustments to accommodate what you need to light.

Ideally, you performed a site survey during the preproduction stage. This should have given you some idea of what lights are needed for the space you are using.

Light the Subject

Lighting the subject is the right approach when you want to achieve the best look for a person. Although it's not as flexible as lighting the space, it works well for individual portraits or small group shots. You build the portrait and then work in your backgrounds. Subjects have their own optimum lighting treatment, which is dictated by their appearance and the mood or story you are capturing.

Lighting a subject generally requires more lights to work together to create your desired images, so using a stand-in is a great idea. Ideally, you might want to find a person who somewhat resembles your principal talent in height, hair color, skin tone, and so on. But in a pinch anyone will do, and it beats lighting the

▲ The angle of the incoming window light was too direct, so we blocked it off and added our own source.

air! Also, you can work the scene without testing the patience of your real talent. An added advantage is that everyone on the crew gets a rehearsal of the action to come.

A Balance of Both Approaches

Most shoots implement a combination of both philosophies: lighting the space and lighting the subject. Your experience and willingness to experiment will determine the balance. Lighting is all about creating an emotion.

Constantly ask questions that are relevant to your desired outcome. For example, how do I physically achieve certain emotions with all this electricity, metal, glass, and heat? Once you find the fundamental answers, it'll just become a matter of good-old fashioned problem solving.

▶ #06

▲ The incoming natural light from the background worked and matched our foreground key. So we used it!

Techniques for Controlling the Light

The environment surrounding a subject—the background and foreground—is the key element in creating a multidimensional space on the screen. If portraiture is the sculpture of the face with light, lighting the subject's space is sculpture on a grander scale. Remember that digital image technology works best when you give it enough of a contrast range to work with. You'll need to control your light to work with as broad a contrast range as possible without sacrificing details in the highlights and shadows. You can do this in several ways.

Create interest: It's not always about lighting, especially if you're short on time and resources. In your initial assessment of a space, try to find interesting features or apply a bit of art direction to create depth and contrast.

Identify physical elements: Color, shapes, and angles fill our world. Look for these elements so you can add lighting to augment, emphasize, or minimize them.

Strike a balance: Creating the right balance of highlights and shadows is the game. A well-placed hot window or shard of stray sunlight can start you off.

Use natural light sources: Look for natural light sources and attempt to use them. Just keep in mind the passage of time because those sources may change during the shoot and cause continuity errors.

Highlight shapes and textures: Try edging an interesting shape (like a plant, sculpture, or doorway) or up lighting a textured surface with dedicated lighting.

Remove lighting: Very often it's about taking away light; white walls need darkening; stray sunlight needs shaping or even elimination if it's not going to be consistent.

It is critical to keep the quality and shape of light consistent through your entire scene, which means you'll need to use the right tools and the right techniques. We'll continue to explore several lighting fixtures and options throughout this book. But here we explain some essential pieces of equipment and techniques you should use to place and control your lights in a scene. You don't need all of them to get started, but over time your collection will likely grow.

▼ Interesting art direction can make your lighting job easier. The lens you put in front of your fixture controls the spread of the beam it puts out.

▲ Flags offer more precise light control than barndoors, if you have the room. Bounce cards are more controllable with a clamp such as this Quacker clamp.

Flagging

A solid flag is one of several tools used to shape the light. Generally, a flag is a solid, black cloth in a metal frame that is used to literally cut the light to keep it from lighting anything you don't want illuminated. Flags come in many sizes, and it's not uncommon to see a virtual forest of them around a large fixture. A flag is the chisel that sculpts the lighting into the appropriate mood on your set.

You can also use barn door attachments on lights to shape them. These too can isolate the light into a narrower area.

Bouncing

You'll generally bounce light when you want a soft, less directional source. The hardware used for bouncing comes in several varieties. The gear is typically defined by its surface color, texture, finish, and positioning.

There are a few industry standard tools for bouncing, such as flexfill discs, bead boards, foam core, and reflectors. But the best thing about bounce illumination is that almost anything can be used as a legitimate tool for bouncing light—bed sheets, wooden floors, clothing, newspaper; it all works! Bouncing doesn't

need to be just for soft light. Mirrors of all shapes and sizes are used every day to steer that big beautiful sun onto film sets.

What's the easiest way to tell if light is bouncing? Just wave your hand in front of a reflector and see if a shadow appears on your background or subject. You should also know if the bouncing introduces any additional color cast on your subject. The color may be desirable, or you may need to adjust the white balance of your camera to compensate.

Diffusing

Softening a directional source is often done by putting some type of material in front of the light to disperse the beam. Broadening the source this way creates a more natural wrap on your subject. The larger diffuser you use, the less "lit" it's going to look. It also prevents shifting the color of the light (which often happens with dimming).

A good number of fabric and gel materials have been designed and are available for diffusion. Some have sexy names like Opal Tough Frost, Bleached Muslin, or China Silk. Others just use a manufacturer's number.

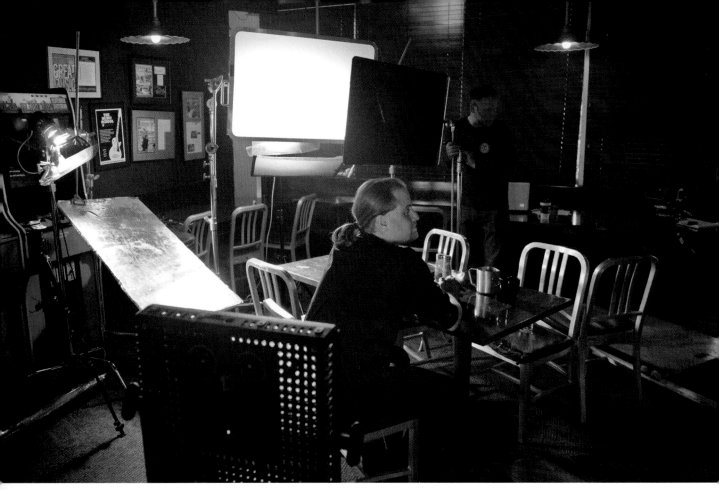

▲ In this scene, the lighting director is using a bounce card and a flag to control the lighting.

Whatever they are called, the name indicates the amount of light dispersal. You can experiment greatly with diffusion. Try combining multiple sources. You can also try diffusion in combination with other techniques, like a bounced source through diffusion. Just remember to keep the mood of the scene in mind.

Netting

Nets are another useful light subtraction tool. Although they are similar in appearance to flags, they are less powerful (allowing for greater flexibility). A net is not completely opaque, so it can let some light through. Think of a net as selective exposure control, only it's being done outside the camera. The light can get through a net, although a lot of those pesky little photons get caught like fish in a drift net.

You can use a single, double, or even triple strength net to lessen the intensity of light on a subject. Add nets to your forest of flags to get more precise control. Nets work well, say, if your actor is wearing a white shirt and you need to reduce its brightness, or if you need to reduce the brightness of an overexposed background.

Color Correcting

Although current camera system menus often have very selective color controls, there is still something organic about manually manipulating your color balance while lighting a set. Sometimes it's just easier to pin a color-correcting gel on a light and see the results immediately without any electronic middleman.

Color corrections can be done for purely technical reasons (the lamps available don't match the existing light) or for mood reasons (to create depth and contrast through color layering). Sometimes color correcting is not about gelling but actually replacing a bulb source. This is a very common practice if you are using existing sources (or practicals) in a room but the bulb color temperatures conflict with your desired color palette. Again, you can color correct with the trusty white balance in your camera, but when you want selective, varied color within your scene, it can be a lot easier to make adjustments to the lighting.

Matching

The matching process works together with color correction. Very often different fixtures in the same family of lamps do not match in color temperature. Such is the world; however, in an effort to control the mood of a scene, you must decide how much you want variances in color to slide.

Cameras are less forgiving of such differences than the human eye, so you need to make them see like you do. Whatever the discrepancy, there are correction gels in fractured increments (⅛, ¼, ½, full) that bring the renegade lamps into line with their siblings. If conflict is what you desire, then don't worry about matching the lights! Experience and preference will dictate the adjustments you need to make. But you still want to be technically aware of the impact of temperature. A color meter is a great investment for matching lighting.

You also need to be mindful of lighting changes as you move through a scene and move a camera. If the sources illuminating the scene shift in color, quality, or direction, they can jolt a viewer right out of a story, and that is not good!

The idea is to be invisible with your work, and consistent. You don't want lighting to look artificial, nor do you want it to shift throughout the day or scene. This

▶ The lighting director shown here has used two layers of diffusion to soften a light. You may need to stack diffusion to properly disperse light.

▲ A correction gel (1/2 CTO) is added to a day-
light-balanced HMI to warm up its output.

▲ Chris, the gaffer, replaces existing bulbs to get a better color
match. Matt walks the scene looking at the monitor to detect
unwanted changes in light quality and temperature.

can be tricky, especially if you shoot scenes out of se-
quence by hours or even days. It's possible that you
will need to shoot a scene over the course of several
days that lasts onscreen for a few minutes and have
it all match as if it happened in moments.

How do you do this? You can use a great tool that you
already have in your hand—a still camera! Shoot the
setup, the overall set, and whatever you need to doc-
ument to remember how you shot the earlier pieces.
Then you use all the lighting tools at your disposal
to shape, control, or duplicate the consistent, invis-
ible lighting.

Dimming

By controlling the electrical voltage to a light source,
you can vary its intensity. Dimmers vary in size and
scope, from little household boxes to multichannel
computer-controlled boards. You might want to carry
a few of the small dimmers (500W or less) to con-
trol any practical lamps you may encounter on a set.

For large lights, variable dimmers are available in all
ranges to manage the job. Be aware that dimming an
incandescent or quartz bulb will also change its color
temperature. If that is not desirable, it might be better
to control the light intensity by netting or *scrimming*

(little metal nets that go into the fixture to partially
block the light).

But be careful what you plug into a dimmer these
days! Anything with a ballast will either fry or short
out. Specialty dimmers are made for those family of
lights and are often built into a ballast, like a Kino Flo
or a Dedolight.

Dimmers are even made for neon lights, so you can
use that cool beer sign in your background without
using lots of messy color-correcting gel. Of course,
another treat in motion picture shooting is to use a
dimmer control for a variety of on-camera effects. For
example, try doing a gradual illumination effect while
rolling cameras as an interesting way to open a scene.

LIGHTING SUPPLIERS
Here are some of our favorite lighting
vendors:

› www.adorama.com www.arri.com
› www.fjwestcott.com www.kinoflo.com
› www.litepanels.com www.lowel.com
› www.zylight.com

▲ This 2K Magic Gadget box has both dimmer and flickering functions.

Standard Packing List for a Portrait Setup

- [] 1 650W Fresnel
- [] 1 Chimera soft box with speed ring
- [] 1 300W Fresnel with barn doors
- [] 1 100W Fresnel with barn doors
- [] 4 lighting stands
- [] 1 gel and diffusion jelly roll
- [] 4 300W dimmers
- [] 4 ground-wire killers
- [] 1 tungsten/daylight reflector
- [] 1 lightbulb box
- [] 1 Kino Flo 400 - 1 bank
- [] 2 bounce cards (white card stock)

- [] 6 C stands with arms
- [] 6 10-pound sand bags
- [] 2 6-port power strips
- [] 3 10-foot 3-port extension cords
- [] 2 25-foot extension cords
- [] 20 clothespins

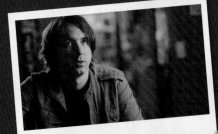

Profile Lisa and Ian Robinson

© Jeffrey Prehn www.jeffreyprehn.com

Lisa and Ian Robinson are a married duo specializing in wedding and event photography. Their company, SoftBox Media (www.softboxmediaphotography.com), is based in the Washington, D.C. area. This award-winning team has been recognized by TheKnot.com and WeddingWire.com for outstanding wedding and event photography. Not ones to be limited by traditional photography, both Lisa and Ian have taken advantage of video-enabled DSLRs to broaden their creative storytelling options when shooting weddings and events.

Traditionally, photographers *and* videographers have covered weddings. Although wedding photography is still the Robinsons' bread and butter, more and more they've been breaking with tradition and also shooting video for the weddings they cover. "We love the art of still photography. Sometimes though, video can add life to a typical photo slide show DVD," says Ian.

With so many photographers in the wedding industry, wedding photographers arguably have the largest field of peers from which to set themselves apart in hopes of catching the eye of a potential client. Lisa and Ian have found a way to incorporate video into their photography and offer something unique in the vast marketplace of wedding photography. "We see it [video] as value added; however, we do recognize the difference between a photographer and a videographer. And while we don't intend on ever becoming true videographers, we see the benefits of including video into what we do," says Lisa.

The transition into shooting video for Lisa and Ian, like other pro photographers, has been a bit bumpy at times, not only at the production stage of a project but also in post. For many photographers, learning new things about production and post can be intimidating. But Ian and Lisa have a pragmatic approach to shooting video with a DSLR.

"Let's be honest; shooting video and shooting video well are two completely different things," says Ian. "There's a fair amount of technical knowledge required, not only in the shooting phase, but also in editing and output. As you shoot, you need to have a firm grasp of what types of shots you'll need in order to achieve a successful edit. Likewise, you need to have a firm grasp of your editing software so you know exactly what you can or cannot achieve in post."

Lisa agrees and adds, "With video, you have to be able to consider sequential time and different camera options to add visual interest. For example, not just shooting video with your camera locked down on your tripod, but framing the action in and out of the frame, using rack focus techniques, utilizing depth of field, zooming, etcetera—all of these techniques help add visual interest and take your video from ho-hum to something special."

Shooting stills and video at weddings has presented three main challenges—"low light, audio, and stabilization," says Lisa. "Low light because you don't have the editing freedom stills have to 'clean up' the noise potentially generated in low light, audio because that's yet another area of technology many photographers have much to learn about, and stabilization because a lot of the good stabilization equipment can be very expensive."

For Lisa and Ian, the challenges of transitioning from still photography to video are worth it because they see video as being able to enhance the emotional aspects of wedding photography. "Video can help tap into another layer of emotion. It has motion, sound, and color, all things that happen in day-to-day life, and [that's] how people's minds work," says Lisa.

Ian shares a sentiment that is common among many photographers. "With still photography you only have the image—no motion and no sound— which leaves much open to the viewer's interpretation. It's exciting to think that video-enabled DSLRs allow us to use both mediums. We can become even better storytellers and weave the two together to come up with the most complete story."

The fusion of stills and video that SoftBox Media has been able to bring to its work has only been made possible by the gigantic leap forward in DSLR technology. "The coolest thing about them [video-enabled DSLRs] is that you can shoot both high-quality stills and high-quality video at the same time. Previously, you could never do that on one piece of equipment," says Lisa.

Ian sees a bright future for video-enabled DSLRs. Already a proponent of a raw still workflow, he sees this ability coming to mainstream video DSLRs soon. "Raw video, much like raw still photography, would be awesome; the video shot on these cameras is of high quality but it's still highly compressed. Hopefully, the future will bring less compression, and even more."

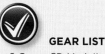

GEAR LIST
› 2 Canon 5D Mark II,
› Canon 5D
› Canon 30D
› Canon 20-105mm L f/4
› Canon 17-40 L f/4
› Canon 50mm f/1.4
› Canon 85mm f/1.8

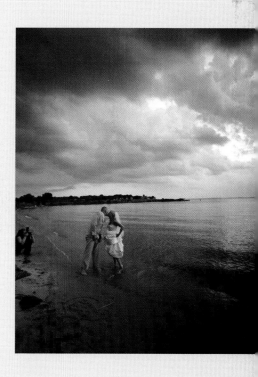

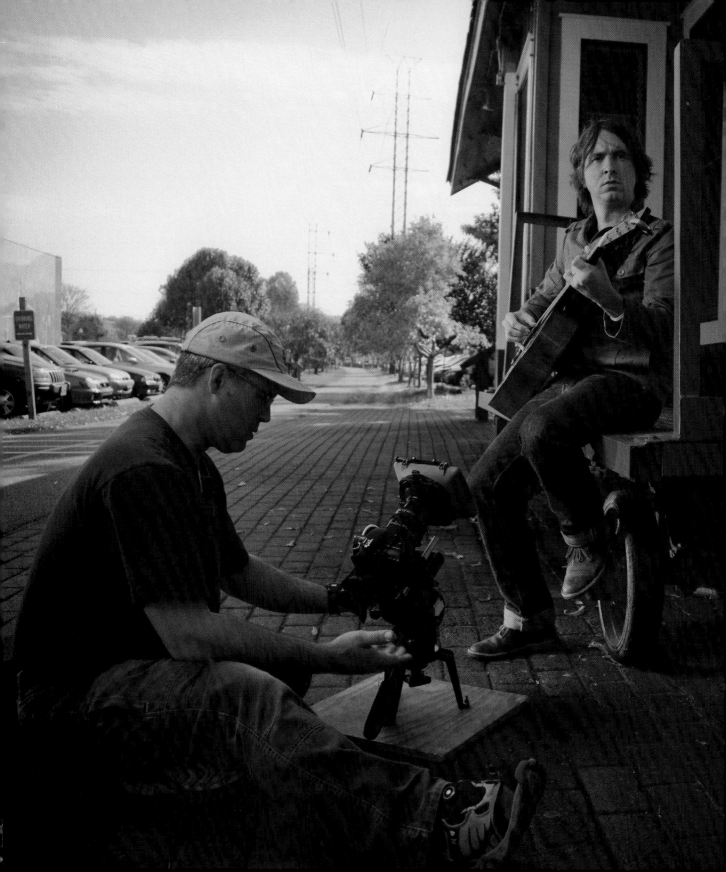

Using What You've Got

Making the Most of Available Light

Some photographers rely solely on the light at hand. These purists capture images with what nature (or the shooting environment) gives them. Landscape photographers wait for the perfect time of day to shoot, getting up before the sun to get to their locations early. They search to find the perfect spot to shoot as the sun rises (or sets). Truly beautiful shots can be captured during those magical hours of lighting.

Other photographers know they have to work with only what they have. It's not likely that a bride will reschedule her wedding time for a time when lighting is best. And the photojournalist can't dictate when the news happens. So, learning to identify (and shape) available lighting is an essential skill for all photographers.

NO MATTER HOW GOOD A PHOTOGRAPHER YOU ARE, YOU CAN'T COMPLETELY CONTROL THE SUN. IT WILL MOVE IN YOUR SCENE AND DESTROY CONTINUITY.

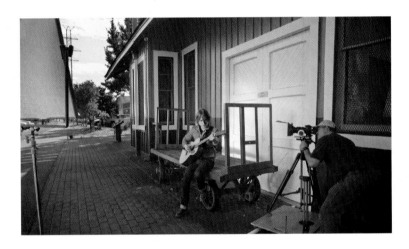

The same holds true when shooting video with a DSLR. Using just the available light is a tempting option: It requires no packing, doesn't cost much to harness, and can be very flattering. Most often you'll want to utilize the great depth of field options that video-enabled DSLR cameras support. The problem is that too much light can cause you to stop down and ruin the filmic effect. The workaround is to change the available light and adjust your shooting style to get the best image.

But available light doesn't just include the sun. Shooting video brings you to a myriad of locations and decision points. You may also find that more often than you'd like, you'll need to work with only the existing light sources to maintain your budget or production schedule. Let's explore some practical ways that you can control light to produce the best video.

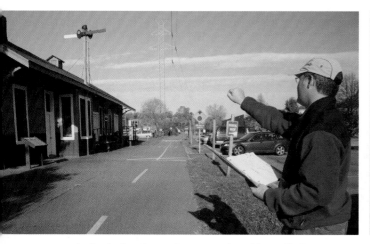

▲ Analyzing the sun's expected position will dictate where to place reflectors to bounce needed light onto Luke.

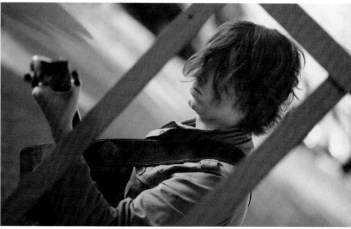

▲ As the sun moves, so do shadows. If you are shooting a scene from multiple angles, you'll need to carefully avoid continuity errors due to shadow creep.

The Goal of Lighting

A picture is successful if it clearly captures and expresses the desired feelings or message. Because of this singularity, you can afford to apply considerable resources toward your end goal. You need a clear focus to achieve great composition and perfect lighting.

With DSLR cinema, a similar outcome is challenging to say the least. The difference between the two mediums is clear when you add movement and the need to record that progression in sequence.

As you begin experimenting with videography, you'll need to take all the skills you apply in still work and adapt them to moving through time and space. You now have more than just a single moment in time to consider. With a moving image, you are free of the restrictions of capturing a single frame but instead are forced to deal with even more variables.

Invisible Light Continuity

No matter how good a photographer you are, you can't completely control the sun. It will move in your scene and destroy continuity. The amount of variation in the quality and quantity of light that takes place over the course of a shooting day must be minimized for a scene to be believable.

Changes in sun direction, cloud cover, and color temperature need to be invisible. You must keep each shot in the scene consistent to persuade your audience to believe the look you are creating is real. This means you'll either need to shoot a scene quickly before you can spot changes or choose to overpower the available light. If not, you can easily knock the viewer out of the story. Nothing interrupts the viewing experience like a change in continuity.

Sequential Image Continuity

As a photographer, you may choose to shoot in short bursts, where you capture 3–10 frames. However, when you capture video, you capture several more frames than that. Unfortunately, a single shot rarely makes a full scene, let alone tells a story.

Sequential images need to flow together with each other to be seamlessly edited. Shots are extended to incorporate movement and show a progression.

▲ Picking the right location and time of day for your available light to fall is part of the game.

Scenes exist as a continuum of these shots and must be synchronized with each other

This sounds easy enough, right? Except the time span of the story you are shooting is much shorter than the actual time it will take you to shoot it. When shooting video, you'll often choose to intercut multiple shots together to convey a scene. These shots will likely be shot out of order, which leads to intercutting. It is very likely that the lighting you had for the wide shot is different from the close-up. The goal is often to create the illusion that the action is all happening in a similar time and space.

Your lighting must stay consistent, even when you change angles or your subject moves. All the activity to set up your camera and move to the next angle (and the next) until you complete your shot list takes time. And all the while, the sun continues to move.

So how do you make it appear as though the quality of light on your subjects doesn't jump around in a matter of seconds on the screen? It's your job as a Director of Photography to create the illusion of these short time periods that occur onscreen using all the resources you have. You may choose to use reflectors to bounce the light into position or shape the light you have using diffusion. You may also need to control its temperature through grip gear or in the camera. When all that fails, be prepared to supplement the light with additional sources when necessary.

Back to the Big Picture

When striving for lighting continuity, you want to look at the big picture as much as the minutiae of the work. The trick to a successful illusion is to maintain continuity in the quality of light throughout the scene. You

No matter how good your grip is when shooting stills, video is different. If you want tack-sharp footage, you must stabilize the camera.

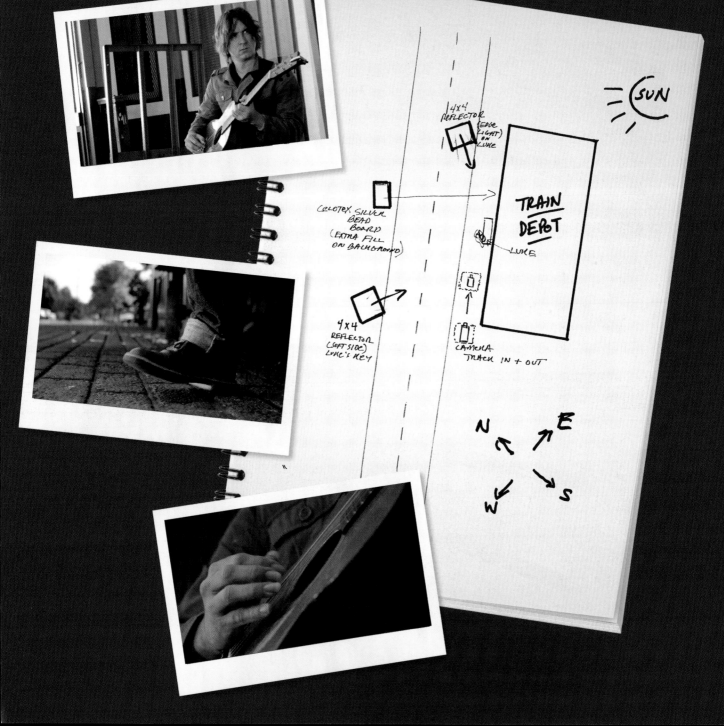

must strive for this consistency whether or not it is in harmony or conflict with the actual conditions. We find that asking a few questions can go a long way.

WHAT IS THE EMOTION OF THE SCENE?

Are you trying to convey a mood with color and tone but the available light is not cooperating? Just because the sun is setting doesn't mean you want a warm glow in your shot. Keep in mind, there's the current reality, and then there's the reality you make.

Two ways to change the color of a scene are to try forcing a white balance or to try adding glass filters to a matte box.

WHAT IS THE TIME OF DAY FOR THE SCENE?

You need to sustain the duration of a scene, sometimes over several hours. A scene that requires warm, golden tones to set the mood might be shot at the end of the day when the sun is low in the sky or just after it sets during the famed "golden hour."

But you may have to create that mood at different times of day to accommodate a limited shooting schedule. You'll need to shape or direct the light so it appears to remain consistent. Often this means using reflectors so you can angle the light into place. Even as the sun moves, you can still "point" the light in the right direction, which will allow you to harness the available light (even as it tries to run away from you).

WHAT CAN YOU ADD TO PRESERVE THE MOOD?

Working with available light doesn't always mean that you have to use it as your only lighting source. It just means that you are maintaining or augmenting the existing light because of its critical nature in the scene.

You can be more mechanical about your lighting and consider the practical motivations for consistent lighting. Determine the available lighting sources at your location and then match or augment them with additional lighting.

For example, you might be shooting a night scene lit by mercury vapor street lamps. If so, then any video lights you add would need to be gelled and color corrected to match your practical lighting to maintain the same look and mood.

Or perhaps you've been using sunlight pouring in from a window. But what happens when halfway through your scene the clouds move in? You definitely want the wide shots to cut well with the close-ups. So, you might need to supplement the available light by adding some daylight-balanced lamps (like HMIs) and set them up to shoot through the window in place of the sun.

▶ #07

▲ You place your light reflectors just like lighting fixtures; in this case, as a side key.

▶ #08

▲ Additional bounce cards are used for edges and fill. They have to be adjusted as the sun moves.

WHAT CAN YOU KILL?

Although it's convenient and seems to work, don't become too attached to your existing light as is. From the very first look at a location, start assessing the available light. Are there any overhead lights that need to be flagged or shut off due to unflattering color cast? Are the available lights too harsh for your subject? Sometimes flatly lit spaces can be appropriate for a scene but not necessarily for interview or portrait style lighting.

A fluorescent–lit room doesn't need to look like a moody dungeon. You don't have to shut off all the existing lights if the look they provide is right for the space or your scene. Your subject can still look flattering. How so? You can subtract light from the side of your subject's face or from above to create a dramatic "wrap" without changing the mood of the room.

Capturing Accurate Color in the Field

Be honest, how often do you depend on software to fix your images after the fact? The ability to change color temperature, saturation, and vibrance in a digital darkroom is a wonderful option. Unfortunately, when a DSLR camera is set to video mode, these post adjustments are severely limited (don't worry; we'll teach you all our tricks in Part IV of the book).

The compressed formats used to record video on a DSLR camera will flatten the dynamic range of your images and generate only minimal data to work with. Although video tools have some capability to fix color, you'll want to capture your footage as close to right at the outset as you can. Relying on software to fix

Are There *Any* Lighting Rules?

There is real life, and then there is "real life" in the movies. What we portray in a video is really just a simulation of a reality.

There are all kinds of ways to depict the real world with lighting. Your approach should be based on careful observation of the natural (and artificial) world of lighting around you. But keep in mind that there are conventions of lighting that are considered acceptable interpretations of reality.

We have all seen blue moonlight or perhaps characters lit by "electric" candlelight. And what about that endless supply of eye-level sunlight (attractively portraying characters at all times of the day)? We often accept these conventions as real. They provide a way to manipulate the available light outside the consistency of reality without taking the audience out of the story.

Sometimes lighting is based solely on what the character needs photographically. Portraying your aging female lead in the reality of overhead sunlight may be authentic but may also get you fired. You'll learn to find the softest, best portraiture light for her and stick with it no matter what the environment.

The skill is to integrate existing and additional light seamlessly into the natural, appropriate look you have set overall for the scene. You want to make the most of available light but add to it or shape it as necessary. Simply put, do whatever it takes. So, you make the rules and break them at the same time!

color means more effort and more dollars spent during postproduction. It's essential that you capture as accurate an image in camera as possible.

When using available light, you'll often be mixing color temperatures. As such, your colors will likely be affected. Getting the color you want requires thought and action but not a lot of effort.

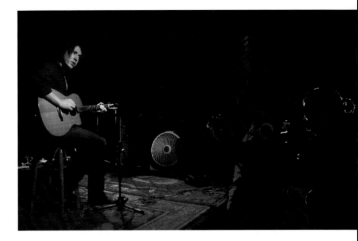

▲ Colored lighting in this location will cause issues with skin tones. You'll want to supplement the scene for a more accurate color balance.

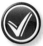 **FLATTER IMAGES CORRECT BETTER**
Your camera often tries to "help" you get a better image. When shooting video, it's a great idea to capture a flat image that can be color graded during postproduction. Check out this great entry at ProLost (http://tinyurl.com/dslrflat).

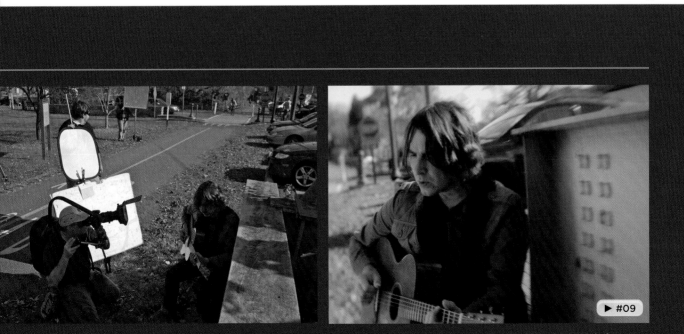

▲ While this entire scene is lit with reflectors, we still utilize the same principles. A reflector from the back helps frame Luke as a fill lights up the face.

► #09

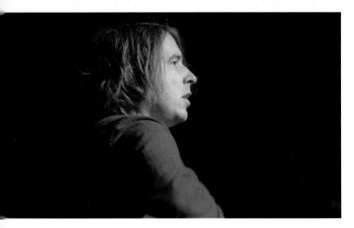

▲ In locations with a lot of mixed lighting it can be hard to find a reference. As a general rule, let a flesh tone be your guide.

Choosing the Appropriate Color

Start by determining what color scheme is appropriate for your scene. Do you want it to feel cool or warm? Or maybe you're striving for a complex palette—one that is mixed throughout.

Always consider the flesh tones as a reference. That's where the viewer's eye goes first. What are you saying about the characters? Are they warm and vibrant? Is the world they inhabit healthy or toxic? It's not always about white light and "normal" flesh tones. For example, you might be shooting a scene in a hospital and want a cool, sad tone. Or maybe you're shooting a romantic dinner with warm candlelight and intimate tones.

Look closely at the natural light that already exists in a space. It should offer you several clues for a starting point. Does the natural light complement or conflict with your intended color scheme? You may have to manipulate and control it to achieve your narrative goals.

Decide which tools you need to execute your choices in color control. Consider using certain options in your camera. You can change the white balance to give the entire image a very different temperature and feel. Other options like picture style adjustments and lens filtration can give you specialized looks. Or perhaps you'll need to change the existing light in your scene. Sources can be moved, blocked, gelled, or flagged. Try closing the blinds or turning off the overhead lights.

However, we must warn you against shooting too much stylized color. We've often had clients completely change their minds during the editing stages. It's best to adjust your camera and lighting so you're close to the intended color palette without making a change of direction impossible.

Much of the footage we shot for this project will eventually be converted to black and white for a music video. Other times the footage will be shown in color but needs to maintain an "everyman" and "aged" feel.

As such, we favored warmer and browner shots, but also looked at the scenes in grayscale when judging exposure. Although we could have shot in grayscale by tweaking camera settings, we decided that we'd have greater control and more flexibility modifying the color during postproduction.

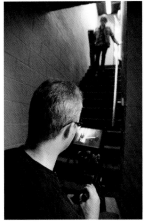

► A single, practical fluorescent at the top of the stairs works perfectly for the mood we wanted for this shot. We white-balanced accordingly.

► #10

Resolving Lighting Conflicts

Just because you want a certain look doesn't mean the available light will always cooperate. Often, the natural light in the space will conflict with your goals. To change the color of outdoor light, there are several approaches.

If you're shooting outside and need to change the color of outdoor light, you can try manually white balancing your camera. Although you can use a pure white, we often find that a warm balance works well. Using off-white cards can force your camera to balance to a different point.

Table 6.1 shows you the typical color temperature for different kinds of light. These temperatures can be used to adjust white balance in the camera.

Table 6.1 Temperatures of Lighting Sources

TEMPERATURE	SOURCE
1,700 K	Match flame
1,850 K	Candle flame
2,700–3,300 K	Incandescent lightbulb
3,400 K	Studio lamps
4,100 K	Moonlight
5,000 K	Horizon daylight
5,500–6,000 K	Typical daylight, electronic flash
6,500 K	Daylight, overcast

If you're shooting indoors with mixed lighting (such as fluorescent bulbs, tungsten lights, and sunlight colliding), you'll have to get a little creative. The goal is to have most (if not all) of the light falling on your subject the same kind and color temperature. This way your subject will maintain a cohesive look when you color correct the footage.

This can be solved in two ways. You can gel windows with either color correction or neutral density film. There is also neutral density film that balances daylight to tungsten. Gelling windows will modify the outside light coming into the scene so it better matches the interior lighting.

The other option is to change the temperature of the lights you are using to add to the available light. You can adjust many lights for different color temperatures so they match the dominant light source. With some lights, like Kino Flos, you can swap out bulbs. For other LED-style lights, you can often dial in their color temperature to compensate for or even influence color.

AN EASY WARM BALANCE

A convenient way to get a custom white balance is to use the WarmCards set. You can pick up a set for less than $100 at www.vortexmedia.com/WC_VIDEO.html.

Staying on Color Target

If accurate color is your goal, we recommend you take the time to set up the camera correctly. On multicamera shoots, this is even more important. Point all the cameras at the same calibration target and make sure the camera settings match.

Whenever we move cameras, change lighting, or switch scenes, we use a reference card or target. The target should have pure black, pure white, and middle gray on it to make it easier to color correct your footage during postproduction. Most nonlinear editing systems offer a three-way color corrector filter, which perfectly calibrates off these three reference tones.

One product we use is a QPcard (www.qpcard.se), which is priced at about $5 per card. These disposable cards can be attached directly to your clapboard. Chances are you'll need a clapboard on set to synchronize audio recording or multiple camera angles (more about this in Chapter 13). Because the cards fade over time, you should remember to put a fresh color balance card on your clapboard for each shoot. They are small and lightweight, and easily fit in your gear bag. Using QPcards is a small investment in money and effort for accurate color.

Another option we keep on hand is the PhotoVision calibration target (www.photovisionvideo.com). This target comes in several sizes, some small enough to literally fold and fit in your pocket and others that top out at 34 inches in width. This target functions the same as a QPcard with three strips of black, middle gray, and white. The benefit with these targets is that they can be flipped and used as a standard reflector to bounce light on set.

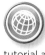

FIXING WHITE BALANCE IN POST
Want to learn about using the 3-way color corrector with skin tones? Check out this free tutorial at http://tinyurl.com/3waycc.

▲ Using a reference target on set allows you to move at a faster pace without fear of improper color balance.

▲ During editing you can adjust color based on the black, gray, and white points in the calibration target.

Shooting with Outdoor Light

It is much easier to control light when you're shooting indoors than when you're shooting outdoors. With just a ceiling and a few walls, you can better control all the variables. It's best to darken your environment first and then rebuild the quality of light you need.

When shooting outdoors, especially in bright light, you'll quickly realize the weaknesses of video. Natural light can degrade image quality. So you'll need to understand the challenges you'll face and explore the technical workarounds needed to solve your imaging problems.

Dealing with Weather Conditions

There are many variations to the look of a "sunlit exterior." The key is to separate your personal feelings about the weather and instead think like a camera; repeat after us, "be the camera."

A cloudless day with bright sun certainly makes for more pleasant working conditions but is a real pain for continuity as the sun moves across the sky. Without a cloud in the sky, direct sun will produce hard shadows. Not that there's anything wrong with this look, but it may not be what you want.

Although very few people like to work in the rain (it wreaks havoc with the gear, and the work slows down), there are benefits. Shooting on overcast days means that the light will pretty much be even throughout the day, which makes it far easier to maintain lighting consistency.

Video pros love to hear the words "partly cloudy" because it practically guarantees uniform lighting. Adequate cloud coverage provides a pleasant softening and diffuses the light. Some videographers call it "God's soft box." But if it gets too cloudy, it can turn your beautiful, directionally sourced landscape into a flat, shadowless scene.

We often check the web to get hourly forecasts to maximize the best light. All weather conditions can be desirable (or not) depending on your creative intentions.

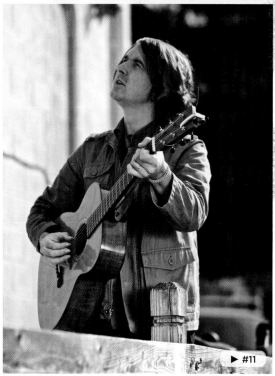

▶ #11

▲ The sky was mostly cloudy during this shot. Shooting with coverage was a big help and required only a single bounce card to reflect the available light.

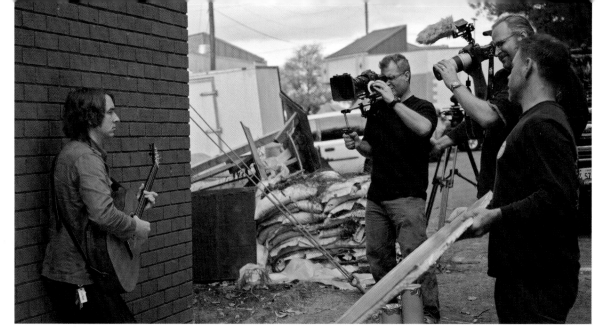

▲ Sometimes a well-placed bounce card can go a long way. Having an assistant to hold one gives you greater flexibility in focusing the light.

So the look of your outdoor scene usually depends on elements beyond your control. But you still have to make a solid decision on how you want the scene to look.

If you're lucky and your schedule allows for it, you might have the luxury of waiting for the right weather that matches your story. If you must shoot on a given day, you'd better hope your lighting budget is big enough to overpower whatever is in the sky (you'd be amazed at how big these lamps get).

But most likely you'll need to make your shot decisions based on the weather the day of the shoot and more or less roll with it. Fortunately, many tools are available to help you compensate for outdoor conditions. From location choice to overhead diffusion (such as a silk), even a bad day can be overcome.

Choose Interview Locations Wisely

If you're shooting interviews outdoors, consider finding a place that is slightly out of direct sunlight, for example under an overhang or under the shade of a tree or tall building. It is often better to bounce the light toward your subject than to have it directly beat down on your subject, creating unflattering shadows.

Keep in mind that the shade will change the color temperature, so you may need to check the camera's white balance.

Shooting under an overhang can provide an exposure approximately four stops down from the direct sun. It can also help keep your talent comfortable, which generally has a positive effect on the quality of the interview or performance.

You should also carry a compass and SunPath Calculator with you. Knowing where the sun is in relation to your scene can help you choose the best shots. Nothing can mess up an interview more than having your subject squinting in pain as the sun beats right into his or her eyes.

BE CONSERVATIVE

It's often best to shoot a little dark and fix your images in the editing or color-grading stages. The main objective is to not clip your highlights when shooting a movie.

Protect Those Highlights

Although you'll have some flexibility during postproduction, it will feel more like you're working with JPEG images rather than raw files. Push an adjustment too far and you'll see posterization. Shoot too dark or too bright and you'll have no information to work with and possibly quite a bit of noise. Therefore, it's very important to protect your highlights.

Don't let the brightest part of the image get clipped. If the histogram is pushed against the right edge, it means you have no information to work with. Although you can recover this data with a raw file, it will be totally lost in a video clip.

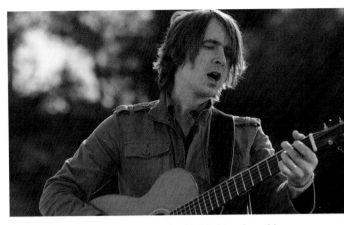

▲ Careful attention was paid to the highlights when this image was shot. Even the brightest areas do not exceed a value of 252 on an RGB scale. The image can be further enhanced with tools like Adobe Photoshop or Apple Color.

Kiss Raw Goodbye

Most professional photographers have grown accustomed to the flexibility that shooting in a raw format provides—great control over highlights and shadows as well as the ability to recover exposure problems.

Unfortunately, your DSLR won't shoot raw when it's set to video mode (not yet anyway!). So, you'll need to dig back into your past experience (be it film or JPEG) and retrieve the knowledge needed to help you make important decisions during the shoot.

When shooting outdoors, we recommend using a viewfinder (such as those from Hoodman or Zacuto). These devices make it much easier to see an LCD display as well as judge the quality of exposure. By removing all light pollution, you can make accurate decisions.

Just because you're working with a movie file doesn't mean your future options are totally limited. During postproduction, you'll edit your footage together to tell a story. After the shots are selected and ordered, you can further enhance your footage. The first pass is color correction, which addresses issues with color and tone. Optionally, a color-grading pass can also be done to further improve the images with stylized adjustments that affect the mood and tone of the footage and thus develop the story.

▲ Shielding the camera's LCD using a loupe or viewfinder makes it much easier to judge exposure.

▲ When shooting video, your shutter, ISO, and iris may be fixed. Bright exteriors may require the use of glass ND filters to keep your exposure in line.

Using Your Camera Controls

As a photographer, you're used to shooting in different program modes for unique situations. Perhaps you enjoy the ease of aperture priority? Or are you more of a manual mode shooter who likes to tackle all the decisions?

When shooting video with a DSLR camera, your basic tools for exposure control are ISO and aperture. Unfortunately, with video you'll lose the shutter option as a choice because you'll want to keep it at 1/50th or 1/60th for natural motion.

The recent introduction of digital cameras that can emulate cinema frame rates is a great leap forward. But the "film look" is not based just on the frame rate. To get a true filmic image, you need to use the optimum shutter angle to accompany that frame rate.

The industry standard for film cameras is a 180-degree shutter. This is literally a measure of the chunk of disc taken out of the spinning shutter to expose the film. To calculate how to set your light meter to expose for that shutter, use this simple formula: one second ÷ (frame rate x 2).

For example, when shooting 24 fps, you would set your light meter to a 1/48th second exposure time. At 30 fps, you would use 1/60th of a second. Following this rule ensures that the motion blur created by the camera looks natural. You can manipulate shutter angle for a stylized approach, but we recommend starting with this basic formula.

Of course, one of the best aesthetic reasons to shoot video with a DSLR is shallow depth of field. If you like this look, you'll want to leave the aperture wide open.

So that leaves you with only the ISO feature to adjust. But even if you set the ISO to a low rating (around

VARIABLE NEUTRAL DENSITY (ND) FILTER

A great option for dealing with harsh sun is to use a variable ND filter, which can be easily attached to the end of your lens with screws. It offers 2–8 stops of ND.

▲ Your light meter is still handy for calculating filter factors and light ratios.

▲ A reflector board mounted to a stand is best for adjusting and locking your bounce onto a subject. The bigger the size, the bigger the source.

100), you may have issues toward controlling depth of field. On a bright day you'll still need to lose some additional stops.

So what's your alternative? Filters! A good two-stage matte box offers great exposure control. With it you can layer filtration over the lens to get the exposure down to where you need it. Try using neutral density or polarizers to pull down the overall exposure. You can also use graduated filters to help you control exposure in select areas of the frame like the sky or a sandy beach, for example.

Working with Lighting Controls

We've learned one important fact when it comes to large balls of solar energy. You can't overpower the sun with a DSLR camera. Even though your eye may be able to adjust, the camera just can't make that adjustment.

MATTE BOX ROTATION
A matte box with a rotation stage allows you to dial out polarized light and easily select the areas of your frame that you want to darken with your graduated filters.

Now, we're not saying you should give up. Rather, you just need to alter your approach and gear up. To get to the real work of managing exposure latitude as well as the quality and direction of your sun source, you'll need to use the tools in the lighting and grip department.

REFLECTING LIGHT

The sun needs to be bounced and wrapped around your subject. Instead of letting the sun dictate your lighting, angle it so you get the key and fill light that you need. No matter where the sun is located in the sky, you can steer it toward the place you most desire, which should be the most pleasing angle.

A variety of reflectors and bounce cards can bring in the sun as your key, edge, or fill light. They can be hard sources such as mirror boards or softer surfaces with texture to diffuse the light. You can also control which color they reflect. Bounce materials often come in silver, white, and gold.

DIFFUSING LIGHT

You will also want to manage the quality and amount of light shining on your subject from the sun. In still photography, you can often overpower the sun with strobes or a flash. No such luck with video. In video you must use good old-fashioned nuts and bolts "gripology."

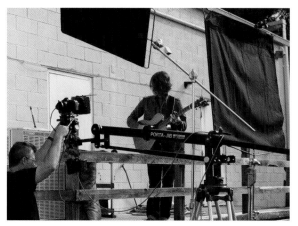

▲ Large open frames skinned with a variety of diffusions can be placed in the sun's path to soften things up. You can have a number of thicknesses prepared in advance to adjust quickly.

▲ These same frames can be covered with solids to subtract light as needed. We call it negative fill.

One method you can use to deal with harsh light is to gently diffuse it by flying a large silk (also known as a diffusion panel). These panels come in a variety of sizes and can be placed over your scene in a large frame. The frame stretches the silk to create a soft surface to diffuse the light. Overhead silks come in full, half, and quarter strength to regulate how much

toplight you want to allow on your subject. If your subject is moving, you may have to use a very large overhead silk (the maximum standard size is 20 x 20 feet) or perhaps use a smaller size and walk it next to your subject. These traveling elements apply to reflectors and bounce cards as well.

SUBTRACTING LIGHT

Sometimes your best bet is to try subtracting light. This is especially true on overcast days. If the cloud cover has made the sun source flat and shadowless, it's hard to portray a directional source on a subject because there is nothing to reflect.

Try bringing in a large black solid on one side of a subject. You can create the feel of a directional source by subtracting the ambient light from one side of your subject's face. Negative lighting is your friend on overcast days. The black solid can vary in size just like your silks and bounces. You may be able to get by with a small 2 x 3-foot flag. If you need a lot of motion in the scene, you can explore options like a 12 x 12-foot butterfly frame. In a pinch, you can ask your audio guy for a sound blanket (usually one side is black).

ON A BUDGET?

Don't worry about rushing out and buying all the grip gear we mention. In most cities you can find companies that rent grip gear affordably for big shoots. You can then start to build (or even make) your own gear over time.

MAINTAIN BALANCE

Remember, if you knock down your lighting too much with a silk, it can affect your background. If you're shooting in full sun, the background may wash out.

Shooting in Low-light Conditions

The differences between reality and its screen version have always been based on the limitations of the camera's ability to interpret what the human eye can see. Although video cameras are making technological advances at a frenetic rate, the goal they have yet to achieve is to see as the human eye sees. This is most apparent in low-lighting conditions.

Our eyes can adapt to fairly dim situations. But camera sensors can't do the same. We have the usual tools in today's video cameras to accommodate low light: They include controls in iris, gain, gamma, black levels, and shutter, just to name a few of the in-camera tools you can adjust to get a usable exposure.

But shooting in low light is about so much more than just getting a proper exposure. That is just the base point from where you start to work. As the subject and lighting change with movement, you may need to make dynamic adjustments to maintain focus, exposure, and quality.

Maintaining Critical Focus

While most DSLR cameras allow you to shoot at a wide aperture in low light, this won't solve all your problems. Sure, you'll find that your image retains that nice short depth of field we all seek. But getting and maintaining critical focus can be difficult if not impossible. This is

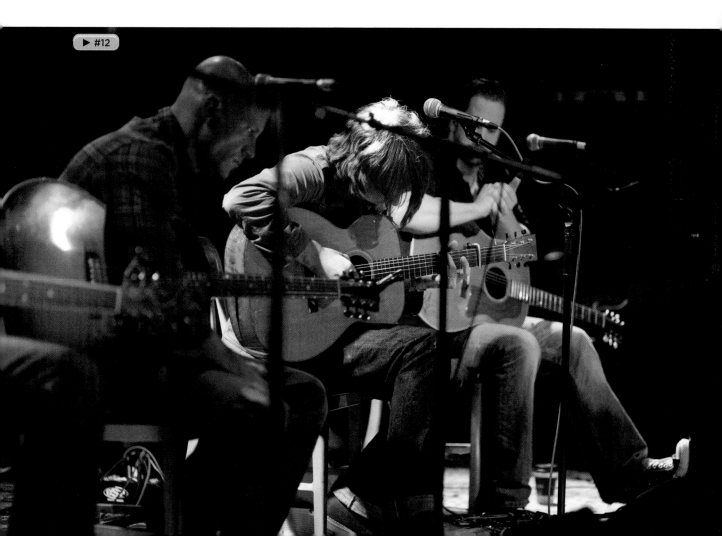

▶ #12

one of the greatest challenges to overcome and can really hurt the quality of your images.

Toss in moving subjects, and focus issues get worse. If you're shooting a video with lots of motion, you need to pay close attention to the amount of light as well as the quality of light. Each will greatly affect the way you move the camera as well as the way you focus the camera.

The following sections describe a few measures you can take to still attain a film-like depth of field and not pull your hair out during a low-light shoot.

RAISE YOUR ISO

Try changing the sensitivity of your camera to get the best results. Instead of shooting at ISO 100, try bumping it up to 400 or even 800. You can then close down your aperture to a reasonable level. Be sure to test your camera beforehand to see how raising the ISO increases the appearance of noise in your footage.

We have found that ISOs often stair step each other. That is to say the noisiness of the image can vary greatly between settings. If a particular ISO looks too noisy, try dialing down one (or even up one). Certain ISOs perform better than others when shooting video. Again, you'll need to experiment with your camera and take a close look at the recorded footage on a large monitor or with a magnified viewfinder to see if there are any quality issues.

LOWER YOUR SHUTTER SPEED

A low shutter speed allows more light to reach your sensor. You can then close your aperture to maintain a film-like short depth of field and still have a decently longer space to keep your subject in focus.

Also, be aware that shooting at 30p looks much more natural with a shutter speed of 1/60th of a second. If you're using a camera that shoots 24p, a shutter speed of 1/48th of a second will also result in a more "classic" film look.

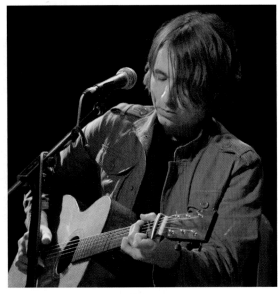

▲ We are shooting this performance in an ISO range of 1250–1600, but focus is still critical using the telephoto lens above.

ADJUST YOUR APERTURE

The less light that's available, the larger an aperture you'll have to use to record a properly exposed image. This means that your depth of field will decrease, making it much harder to keep your subject in focus.

If you or your subject are moving, keeping your focus gets even more tricky (and may a higher power help you if you are both moving!). No matter how good your grip is when shooting stills, video is different. If you want tack-sharp footage, you must stabilize the camera.

GIVE IN AND ADD MORE LIGHT

Yes, the whole point of shooting in low light is to capture a "moody image." But you can always crush the image in postproduction to get that look. When color grading, you can adjust the black and white points as well as midtones to get a richer image. Stop driving yourself insane when your focus is thinner than a supermodel on rice cakes. Break out some wattage and light up your subject.

Using the Shadows

Don't be afraid of the dark. Allow your subject to wander in and out of varying ranges of exposure to set the mood you want. You see him when the story dictates, and you don't when he's not needed. Shadows can greatly impact the mood of a scene and are an evocative narrative tool.

The quality of lighting matters as well when it comes to shadows. If it's harsh and directional, your shadows will be sharp and deep. Consequently, if the light is dispersed or bounces off surfaces before it reaches your lens, it may pick up a color cast on its journey to you. Although this can be fixed in post, it means more of your time. Take a close look in the shadowy areas for color spill.

Be sure to block your shots with shadows in mind. Have a moving subject land in a stopping position near an available lighting source to deliver a line. Move the subject out of the shadows and into the light when he needs to show an expression or reveal himself to the audience. When you need to transition, you can have the subject quickly disappear into the shadows.

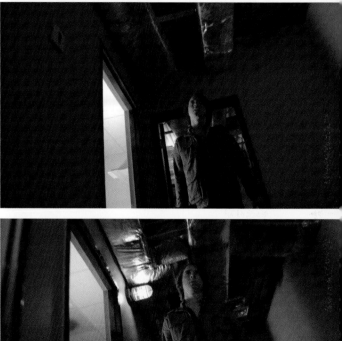

▲ Moving through shadows and light creates a distinct mood. We've lit this hallway with pools of warm light from open doorways for Luke to travel through. Note the cool background wash to add even more depth to the shot.

Little Lights

Compact and Lightweight Solutions

Many photographers are passionate about their off-camera flash. The use of a small flash can have a dramatic impact on the overall quality of captured images. These small units are affordable and portable, making them the first step into professional lighting for most.

In the world of video, compact lighting is a premium technology. Unlike a small flash that only strobes, video lights must be continuous in their output and consistent in their quality. These features must then be crammed into a small package with low power demands. Because of these requirements, the lights tend to cost more than traditional lighting instruments.

Compact lights can be hard to beat when you're flying to a shoot. They work great for small crews who need to be nimble for on-location shooting. Using modern, compact lighting instruments allows for pleasant lighting without the drawbacks of heat or bulk.

USING MODERN, COMPACT LIGHTING INSTRUMENTS ALLOWS FOR PLEASANT LIGHTING WITHOUT THE DRAWBACKS OF HEAT OR BULK.

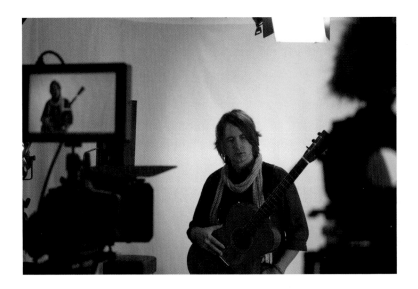

A number of technologies are available to choose from. Small HMIs, fluorescents, and LEDs are the most popular. They all offer native daylight color balance to easily mix with a predominantly daylit world. But they can easily convert to other color temperatures to adapt to different environments. Compact lights generally draw less power, yet put out disproportionately high amounts of illumination. They can offer versatility in how they are powered, usually accepting a large range of AC voltages, and even better, can use a range of batteries either designed specifically for the unit or batteries you might already have in your kit.

With several manufacturers on the market, you'll find products at various price points. We'll explore the options and point out some of the essentials to look for when building a compact kit.

LED Lighting Essentials

Photographers and videographers are drawn to LED lights like moths to a flame. The technology used in LEDs is a light emitting diode, which is based on semiconductor diodes. When turned on, electrons combine to create electroluminescence and thus colored light. It is the relatively modern development of white light from LEDs that allows them to be used as lighting instruments.

Construction of LED Lights

An individual LED is not very bright. So to be useful as a source of video lighting, an array of LEDs must be placed together. The combination of multiple LEDs increases the output of the light. When placed into a grid of 256 or 600 (like the Cool Lights panels or spots), an instrument that rivals the output of traditional "hot" lights is created.

Although it's possible to purchase raw LED lights, the challenge comes in matching them into sets. Ideally, all the LEDs should be matched in brightness and color. The matching step is crucial to produce properly balanced light at the right color temperature

LED Configurations

Common configurations of LEDs are available as both 9 x 9-inch and 1 x 1-foot dimensions. You can of course find smaller and larger sizes as well as rectangular light panels. These lights provide a broad source of light that can be used for all tasks.

Three of our favorites include:

LitePad: Made by Rosco, the LitePad is wafer-thin plastic that embeds LED diodes in a variety of rectangles, squares, and circles, enabling you to cram a light source into just about any space.

Litepanels: One of the best-known manufacturers of LEDs is Litepanels. The Litepanels product has a high-output, 1 x 1-foot fixture that is modular in design so it can be coupled with others to make 2 x 2-foot or 4 x 4-foot configurations.

▲ Top: Rosco LitePad with dimmer control.
Bottom: Litepanel Mini with onboard battery.

▲ A 1 x 1 Litepanel and a Cool Lite 600 LED fixtures in action. These lights put out attractive, even light.

Cool Lights LED 600: A 9 x 9-inch affordable daylight-balanced fixture that has the equivalent output to an Arri 650 Fresnel.

LED lights can also provide a pleasing "catch light" for interviews or spontaneous shooting. If you're looking for a small panel to mount directly on a camera, check out these products:

MiniPlus and MicroPro: Both units are made by Litepanels. The MiniPlus runs off proprietary batteries, whereas the MicroPro uses standard AA batteries.

Zylight Z50 and Z90: These small, flexible lights are very bright and versatile with multiple color temperatures, useful presets, and wireless controls.

The Benefits of LED Panels

So if LED lights are more expensive, why are they so popular? From personal experience we have to say that the lights really "grow" on you. Although we haven't discarded our existing lights (nor should you), we have invested more dollars into LEDs than any other lighting technology.

Here are the key advantages that keep us coming back.

Less heat: Unless you're lighting on a cool outdoor location, heat is usually undesirable. Hot lights make

your subject uncomfortable and can cause burns if bumped or touched. Hot lights must cool before you move them, and the bulbs are fragile and expensive to replace when broken.

Because LEDs are solid state, they emit a lot less heat than incandescent lights. Therefore, not only can you work in tighter spaces, but you can also move the lights closer to your subject if the situation requires it (without turning your subject into a pool of gelatinous liquid). Plus you can easily use gels and diffusion material on your lights without melting them.

Less power: One of the biggest drags on a shoot is blowing a fuse. It can cause your production to come crashing to a halt while you mount a search party to find the building manager to access the breaker box. Fortunately, LED lights are very efficient and draw relatively little current. They offer more output than their quartz counterparts at a fraction of the power draw.

You can safely plug several LED lights into the same circuit and know that you won't blow it. However, this is a real hazard when using multiple 650W and 1K tungsten lights. Nothing is more unnerving than having your set almost perfectly lit, turning on your last light, and then hearing the "bang" of a breaker signaling that you overloaded the circuit. With LEDs you are pretty safe in that regard.

Portability: Just as many photographers have discovered the flexibility of off-camera or handheld flash work, so have videographers. One of the great features of battery powered portable lighting is that it can be moved easily. You can readily reposition the light as you move the camera, even during a shot! If you're walking with a subject, the subject's eye light can move with them.

This is a major reason to keep the light off the camera. You don't want to be restricted by a fixed distance because of a camera-mounted light. Be sure to keep the quality of the light soft by adding diffusion, and have an assistant walk with the light.

The idea is to hide the light's presence as much as you can. You don't want to look like a cameraman on the evening news with a "sun gun" strapped to your camera. Rather, let the light and subject find equilibrium so they move together, allowing the light to act more like a natural fill source. This is particularly useful for nighttime or low-light shooting. A moving source can really save you time by preventing you from having to rig a bunch of fixed lighting throughout the shot.

Battery power: Time is usually of the essence, so you can really save time by abandoning power cords and the use of AC power. You may be at a location where power simply is not reliable or doesn't exist. That's when you need to go battery powered. Many LEDs can run off common camcorder batteries or removable power packs. This is a great way to shoot in quick run-and-gun situations where power is not readily available. Because the LEDs draw such little current, they can run on batteries for hours before the lights dim. Modern lithium-ion and nickel-metal hydride batteries are very lightweight, so they don't add a lot of weight to your kit.

▲ Because the LED lights can be both lightweight and battery-powered, the crew can literally walk and hold a key light.

SMALL LIGHTS AND SECURITY CHECKPOINTS

Although some of the small lighting units can fit in your laptop bag, be sure to bring a battery. Security often wants to see lights powered so they know what the strange-looking electronic device actually does. Bring your smallest battery and make sure it's charged.

Less weight: Their lightweight quality is really the key ingredient in making LEDs so desirable. Aesthetically, we would all probably prefer sun-sized movie lights pumped through muslin to render painterly images. But we just can't lug around all that equipment and function in today's fast-paced, low-budget environments.

As a stills shooter, how many times have you traveled with big, monoblock strobes? It's a pain (in the back or neck), right? They are heavy and unwieldy, which just doesn't make for a good combination. A Litepanels 1 x 1 gives you 500 watts of output and weighs just 3 pounds. The MiniPlus is only 9.6 ounces. This style of light means less weight to carry around, but it also opens up the possibilities of where you can actually place the light, which is anywhere really.

If you travel by air much, lightweight gear is practically a necessity. Airlines are charging more and more to fly with gear (especially heavy gear), so you'll feel the pain in your wallet. LED lights are compact and light, and you can fit several of the large panels in a normal suitcase.

▲ These LED fixtures from Litepanels and Cool Lights offer adjustable output. The light on the left offers dimmer controls while the one on the right features bank controls.

Tough gear: Breaking a bulb on set (or en route) is annoying. Pack a traditional light while it's still hot or bump it on set and you'll be in the market for a new bulb. Of course, it's not just any replacement bulb. Be prepared to shell out $40–$100 for a bulb for pro lights.

On the other hand, LEDs are tough. The bulbs are made of high-impact plastic, which has been formed into a small lens. Unlike glass bulbs, they're less susceptible to impact that would shatter a normal bulb.

Advanced Controls

A wide range of LEDs are available for every budget. Cool Lights LED fixtures range from $250–$450, but you can invest in larger, more sophisticated panels like the 1 x 1 Litepanels or the Zylight IS3 for $2500 or more. Several features make LED lights attractive, but not all features are included for each price point

or size. When shopping, be sure to explore the available options to get the most versatile lighting kit. You should consider features like dimmer and bank controls as well as the ability to modify color and temperature.

DIMMER CONTROLS

Most LED lights include dimmers that allow you to dim the output from 100 percent down to 0 percent intensity. This is a useful feature for adjusting the intensity of the source to exactly where you need it. With normal incandescent lights, you have to use a separate dimmer, and if the dimmer doesn't match the bulb, you'll get buzzing. With traditional lights, the color temperature changes as you change the voltage. With LEDs, the dimmer precisely matches the light's output so you get a smooth, quiet, and consistent amount of light (with no color temperature changes).

BANK CONTROLS

Some lights will incrementally change color temperature when they are dimmed. So it is essential to have the ability to change the amount of light falling on your subject. Several manufacturers include "bank" switches, which allow you to shut off entire rows of LEDs. This lowers your light level without changing the color temperature.

HOW TOUGH ARE LEDS?
For a great demo of just how tough LED lights can be, watch the clip at
http://tinyurl.com/vidled.

COLOR TEMPERATURE

Many LED lights have a fixed color temperature, typically 3200K for indoor light and 5600K for outdoor light. But as discussed in Chapter 6, you'll often find that you'll need to mix indoor and outdoor light to get the scene right.

Wouldn't it be nice if you could vary your lights to match the existing color temperature of your environment? Well, some LEDs can! Be sure to check out models like the Zylight Z90 and IS3, the Litepanels Bi-Color, and the Gekko Kelvin Tile. Presets are offered for 3200K and 5600K color temperatures. In addition, these lights offer a rotary knob to precisely dial in other color temperatures between full daylight and indoor incandescent light. This allows you to adjust for mixed lighting situations.

The Zylight line has an additional feature that allows you to add or subtract green to the various color temperatures. Why would you want this? Well, most fluorescent lights found in offices and industrial environments exhibit a "spike" in the green part of the spectrum. With the ability to either add or subtract green to the color temperature of your light, you can match the existing lighting, thereby neutralizing the green in your subject's skin.

COLOR CONTROLS

Although a pure white light is often desired, there are uses for color controls. You might need to balance against colored lights at a location. Or, you might be trying for emotional impact. One of our favorite uses is to change the color of the LEDs to add accent lights to the background of a scene.

Some LED models let you change the color of the light without knocking down the intensity (which is the major drawback of using colored gels on traditional lights). The ability of some fixtures to actually go into "gel mode" is a great option.

FLICKERING LIGHTS

Some cheap LED and fluorescent lights cause a visible on-camera flicker. This can often be solved by adjusting the intensity of the light but is most prevalent in cheap LED solutions.

Before LEDs, many Directors of Photography would carry around a "gelly roll," which contained gels from the entire spectrum so they would have the ability to color the lights a certain color. Not only is this a slow process, but it is harder to achieve a pure color cast because the actual light is not pure white and has its own color temperature. When an LED shifts into "gel mode," it starts with a pure white light, and then, through the solid-state circuitry, it rotates through the entire color wheel and delivers a pure, unadulterated color with a simple twist of a knob.

REMOTE CONTROLS

One last feature, currently found only on the Zylight model of LEDs, is the ability to wirelessly control a series of LEDs from just one light. Lights are essentially slaved together (much like how flashes can be grouped). This allows one light to control all others or for a remote control to be used on all lights.

This works great for event-style or theatrical lighting when you may want to make a lighting change due to performance (such as a musical number). Change the color or intensity on one light, and the rest follow. This can allow for a lighting change during a scene that is smooth and precise. Just link all the lights together beforehand through the wireless option, and then, when you control one, you control them all!

▲ Zylight offers powerful, versatile fixtures with the IS3. Precise color controls are truly useful on set. Image courtesy of Zylight.

▲ Kino Flo Diva lights offer color temperature-accurate choices in high output tubes and a dimmable ballast built into the fixture.

Other Lighting Technology

You might think that with all the talk about LED lights that they're the only game in town. This just isn't the case. Two traditional lighting technologies—fluorescent and HMI—can also fit into compact places. These lights work well with your LED lights and can address weaknesses that LEDs suffer from.

Fluorescents

Compact, flicker-free fluorescent units predate the LEDs in the video business. These lights are workhorses in the production industry and are used for all sorts of scenarios like green screen, compact studios, and location work.

Fluorescent lights offer many of the same features as the newer LED lights:

> Cool burn

> Soft, broad source

> Low power consumption

> Built-in, flicker-free dimming

> Accurate color temperature

> Relatively lightweight

Although LEDs have surpassed fluorescents with additional features like infinite color control, portable battery power, and durability, fluorescents often win out on price and are still great options for a compact light kit.

Kino Flo is the leader in the fluorescent lighting market, and we've all used its products extensively. The company makes small, reliable units like the Diva-Lite 400 and 200, the Desk-Lite 121, and the BarFly series. These units all feature a roughly 4 to 1 output advantage over their tungsten brothers.

However, there are a few drawbacks to these fluorescents. They are larger-framed than many LED fixtures, and the glass bulbs are more fragile. Still, many photographers love the soft quality they provide. We recommend carrying at least one fluorescent in your kit for a larger, softer key light for portraiture. Most take 55W, high-output bulbs color-balanced for daylight and tungsten.

OTHER FLUORESCENTS
Mole-Richardson's BIAX series is comparable in price to the Kinos, with 2-bank and 4-bank kits in the $700–$1000 range. Cool Lights offers similar versions at a much lower cost (below $600). Be sure to check out the Westcott Spiderlite as well (around $400).

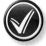

BE CAREFUL WITH FLUORESCENTS
If you break a fluorescent bulb, it will emit a small amount of mercury. Be sure to clear the set for 15 minutes and ventilate the area.

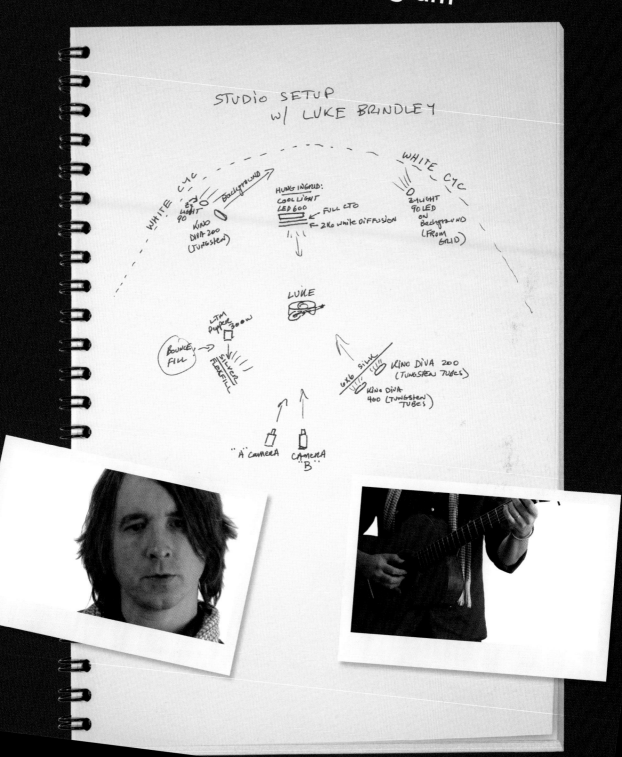

▲ The K5600 Joker 200 HMI Par Light. Note that its ballast also works with lithium ion camcorder batteries.

HMI

If you've ever used an HMI light, you might be wondering why we're bringing them up when discussing compact lights. Larger units, like HMIs, metal halides, and Pars often require their own sizable case. There are a few very specific HMI lights that are compact and meet our needs for easy portability. Notable features include:

> Low power consumption

> High output for lighting

> Battery power capability

> Daylight color balance

> Flicker-free output

The greatest reason to add an HMI light to your kit is that it offers hard-light capabilities. Good videography often needs contrasty, dramatic images. Hard light creates highlights needed to achieve that look in your frame. You'll have a hard time achieving that look with your LEDs and soft Kino Flos.

So what can you do? A few lights are both compact and powerful. Be sure to consider the following lights:

> K5600 Joker 200 HMI Par

> Arri 125W Pocket Par

> Bron Kobold 200W Par

Each of these lights can deliver the same intensity and quality of light as a much larger 750–1000W quartz light. They do this while only drawing 3 amps or less of power. All three will work with DC power sources like wearable battery belts or external batteries.

These are the most expensive lights you can buy for a compact light kit. They range from $3,500–$5,000 depending on the options you choose. We know this seems high, but we also know that there are lenses with a similar price tag that you own (or at least want). If you need that hard-light punch, an HMI Par can be a great addition to your shoot (just remember that they get much hotter than an LED light).

Recommended Kits

As you're shopping for compact lights, always keep your end goals in mind. Are you trying to light solely with LEDs, will you use fluorescents too, or are you just trying to supplement your existing lighting? Are you transitioning gradually, or do you need to switch to an entire LED-based system in one pass?

LEDs are very versatile, so buying a few different types will provide you with a great deal of flexibility. You'll find that LED lights work well in many different shooting scenarios, so they'll quickly become a strong addition to your toolbox. Although we explore kits here, you can always add to your lighting toolbox one light at a time.

Small Kits

We all need to start somewhere with a lighting kit. If you want to achieve true professional lighting, you'll want at least a three-light kit. You can put together a useful, barebones Cool Lights budget starter kit for about $950, which includes:

Cool Lights 5600K Softbox Kit: This low-cost light kit can be used to create a soft key source.

Cool Lights LED 600 Panel: This powerful light has a 9 x 9-inch panel that offers four banks that can be switched on or off. The panel also comes in spot or flood configurations.

Cool Lights LED 256 Spot: This small light is perfect as a backlight or hair light to separate the subject from the background.

We've already examined the flexibility of the light-weight Zylight system, which offers LEDs with color controls. You can create a kit with the following items for about $5,000:

Zylight Z90 LED Double Kit: This kit includes two powerful lights that can work at both 3200K and 5600K temperatures. The kit also contains power and mounting accessories.

Zylight IS3: This versatile panel can be adjusted between 2500K and 15000K for an incredible brightness range, making it four times brighter than other large panels. It offers the same color correction and color gel features of the smaller Zylight models.

Specialty Kit

If you'd like to step up and get a larger kit with some specialty lights, take a look at Litepanels, which offers several light options. We've already discussed the MiniPlus and MicroPro, but there are several more options to choose from. This robust Litepanels starter kit costs about $8000:

Litepanels Mini One Flood and One Spot Fixture Lite Package: This two-light kit offers a spot and a flood for greater flexibility.

Ringlite Mini: This circular light measures 10.5 inches in diameter and is 2 inches thick. It can provide soft light to a subject directly in front of the camera. This light works great for music videos, fashion, and portrait-style lighting.

Litepanels 1 x 1-foot Bi-Color Light: This flood provides both 3200K and 5600K light that can be controlled with a dimmer.

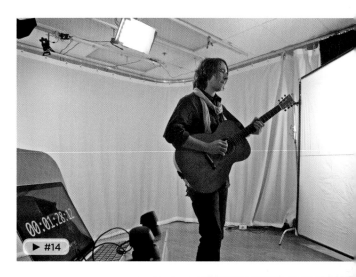

▲ A Cool Lights 600 LED fixture on set with Luke Brindley (top). The Cool Lights unit is lightweight enough to use as a handheld light (bottom).

 QUICK BALANCE

To get a quick match, white balance your camera to the location first. Then hold out a color reference chart in front of the camera (or in a pinch just frame up someone with a neutral flesh tone). While watching your monitor or live preview, switch through the various gels in your kit until you get a good match.

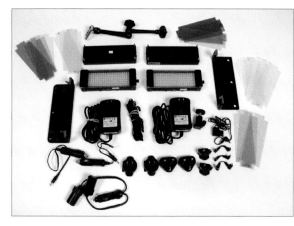

▲ A 2-light panel mini kit. It includes numerous options for mounting and powering the fixtures.

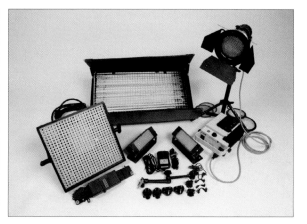

▲ A portable travel kit that combines a variety of lighting fixtures that can get you through many shooting situations you may encounter.

Global Traveler Kit

If money is no object, here's a great kit to build out for about $12,000. You'll recognize some of these lights from the kits mentioned earlier in the chapter. Great lighting kits can be built over time, so you can create this juggernaut gradually. This kit contains just about everything you need when traveling and is small enough to transport easily. Bigger lights could be rented from a local grip house to supplement your "ready-to-fly" kit:

Kino Flo Diva 400 Universal: This light provides a soft, dimmable key source with a lot of punch. The ballast is built into the head so there are no cables to mess with. Be sure to get the universal model so it works with all global voltages.

K5600 Joker Par HMI: This light offers AC/DC ballast with Anton Bauer battery mounts. It's a great hard-light source for background highlights.

Litepanels 1 x 1-foot Bi-Color Light: This versatile light can be powered off the same batteries as your Joker. It can also be a great follow light for a walking subject. You can use it as a great soft-edge light as well.

Two Litepanels Mini One Flood and One Spot Fixture Lite Package: This combo offers two spots and two floods. You can put these lights anywhere. Hide them in front of a computer screen, place them on the dashboard of a car, or mount them to your camera. The kit has all the jumper cables, adapters, and mounting bases that you need.

Lighting Accessories

On their own, lights are very useful. But when combined with accessories to further shape or control the light, they become indispensable. A host of accessories are available to augment and implement all the compact lights we discussed earlier. Many of the kits discussed include these items, but if the needed accessory isn't included, be sure to not skimp when purchasing. Add-ons from specialty companies can also make lighting effortless. These accessories fall into three general categories: light modifiers, mounting accessories, and power sourcing.

LIGHT MODIFIERS

With light modifiers, the goal is to further diffuse or direct the light for advanced control. This can be done by using soft boxes, gel kits, barn doors, and egg crates. Here are a few notable options to consider:

› Zylight offers a very cool little Chimera for its Z90 and Z50 lights, which can really spread the light over a 5 x 7-inch surface.

> The Litepanels MiniPlus offers snap-on louvers to control the amount of spill coming from the unit, as well as hard acrylic color-correction gels.

> The Cool Lights LED 600 has an option for a flexible soft box that acts much like a Chimera Softbank and folds compactly for travel.

Remember that LEDs are a bunch of small spotlights. If you put them close to a subject, you'll see a visible pattern. To get around this, most manufacturers have soft boxes that specifically fit their LEDs.

Unlike "hot" lights, once you soften the light through the soft box, you can bring it much closer to your talent because the LEDs generate far less heat. Only put a large soft box on an LED that is designated as a "spot" LED. The models labeled "floods" may not have enough "punch" to be usable after the light exits the front diffuser.

MOUNTING ACCESSORIES

Lights are most useful when you can get the fixture exactly where you want it. Hotshoe mounts put the light right on top of your DSLR, and articulating arms let you further move it around on the camera. Suction mounts are popular for putting a light on a smooth surface. A variety of clamps, base plates, and stand adapters are available to further your creativity in light placement. That is the benefit of small LEDs; their versatility is limited only by your imagination. And some of these accessories may already be in your kit.

Other essential accessories for compact lights include various small grip gear, like a foldable tripod to place the lights on or near the ground. You can also

VIDEO #7: WHAT TO LOOK FOR IN AN LED LIGHT
In this video we explore our favorite LED lighting features.

PORTABLE POWER
Looking for some LED juice to go? Be sure to check out the Visatec Powerbox at www.bron.ch/vt_home_us.

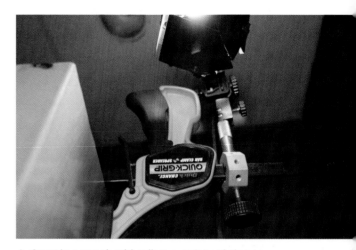

▲ Over time you should collect a variety of clamps and mounts in your kit to put that light in just the right place!

get super clamps to place the light on a doorway or stairway railing. Be sure to get a wide variety of adapters and mounts. Most compact lights offer a ¼-inch threaded mount or can be easily adapted to mount on a standard ⅝-inch grip stud.

POWER SOURCING

The great thing about LEDs is that they offer several options to power them up. Batteries are the most popular because they let you light your shots with few limitations. Almost all manufacturers make their own battery pack, but you may already have other options in your kit.

Most manufacturers offer adapters for camcorder batteries made by Anton Bauer, Sony, Canon, and Panasonic. Batteries are expensive, so if you can double their duties, it will save you big money. Remember, LEDs draw very little power, so batteries can last for a very long time.

When batteries won't do the job, you still have a few other options. Lights often come with AC adapters, but you might want cables for running off a car's cigarette lighter. If you travel overseas, you will need a selection of plug adapters or power supplies for various countries. For the greatest flexibility, look for lights that can operate at both 110 and 220 volts.

Make It Good, Fast, and Cheap

Lighting on a Budget

While reading the previous three chapters on lighting you probably thought at least once: But I don't own that gear. Don't worry; we fully understand that dollars can be tight. We're firm believers in thinking creatively.

There's always another way to accomplish a lighting setup. Sure, having the pro gear is nice, but there will be times when the gear is not available—for example, when your budget is tight or the airline lost your gear. No matter what the reason, knowing how to get by with less is an important skill.

Many choices are available to solve your lighting problems when you're on a budget. The first approach is to look for low-cost gear alternatives. It's ideal to have the top-of-the-line options. But electricity is electricity, so you can often get by with a more economical option.

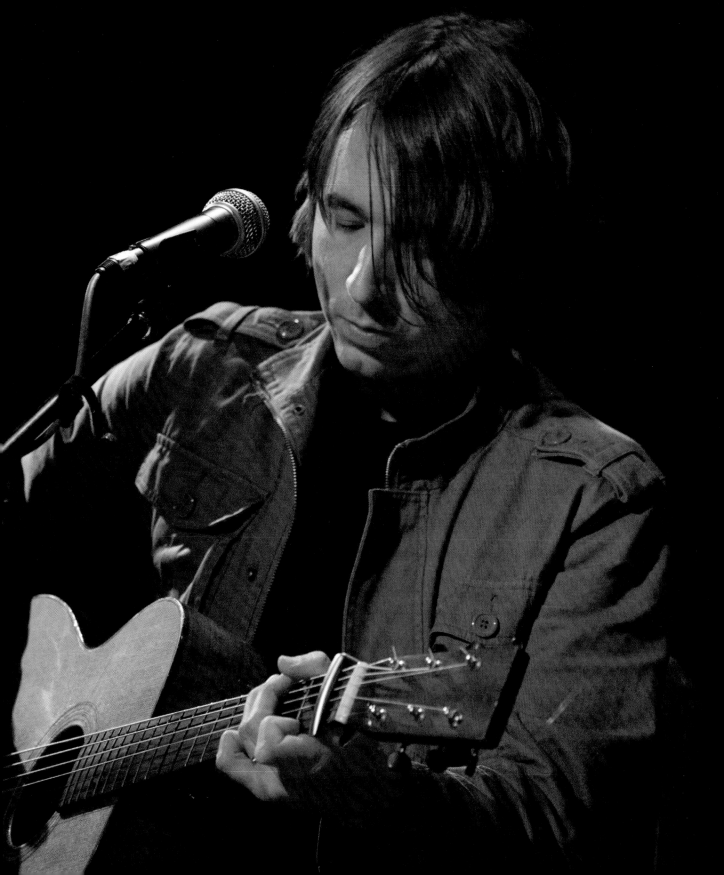

HAVING THE PRO GEAR IS NICE, BUT THERE WILL BE TIMES WHEN THE GEAR IS NOT AVAILABLE— WHEN YOUR BUDGET IS TIGHT OR THE AIRLINE LOST YOUR GEAR.

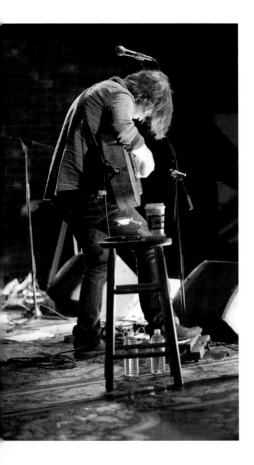

You should also make the most of your current gear. You've already made an investment in lighting equipment, so it's best to get some returns on it. By reusing photo gear, you may already have what you need to get the job done.

Of course, if you're adventuresome, you can build some of your own equipment by just taking a trip to a couple of stores. Swing by the hardware store for some basic electrical supplies, and then stop in an art supply store for some Coroplast or foam core. With some glue, fasteners, and a few hours of your time, you will be pleasantly surprised at how easy it is to build quality lighting instruments at a relatively low cost.

Let's explore ways to expand your video lighting options without draining your bank account.

Low-cost Alternatives

These days, a little creative thinking can go a long way to help you stretch your budget. Nothing says that you have to use video or photography lighting equipment to light your production. You also might be able to find great used gear for a reasonable price. Here are a few options that might work for your productions.

China Balls and Lanterns

Using a China Ball is a great way to gently illuminate a room. Cinematographers love this kind of light because it provides an even 360-degree soft light that looks natural. They are typically made of heavy-duty paper, silk, or polyester that is wrapped around a wire frame and can be expanded into a ball or other shape. When combined with a bright bulb, they can really illuminate a space.

You can find many types of these decorative lanterns that are meant for party use or home decor. These lanterns are fairly disposable (and can be flammable, so don't leave them unattended). The good news is that you can get a 30-inch China Ball for about $10. The more robust pro lanterns sell for $40 or so, tend to last longer, and are less likely to heat up.

Although you can get by with a cheap light fixture, the more robust Lanternlock fixture will hold a China Ball fully expanded and does a good job of keeping the bulb from touching the fixture. You can add one to your kit for about $60 at www.lanternlock.com.

The best part about a China Ball is that it evenly diffuses the light. These lanterns make a great soft light for portraits and close-ups. You can also use multiple China Balls on set to illuminate a large area.

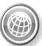 **CHINA BALL VENDORS**
Although you can find China Ball lanterns at nearly any party or home decor store, we can recommend a few retailers for great selection and prices.

› **Filmtools** (www.filmtools.com/chinlan.html)
› **Asian Ideas** (www.asianideas.com/lanterns2.html)
› **Paper Lantern Store** (www.paperlanternstore.com)

▲ The Lanternlock fixture works well to expand the China Ball lantern and to keep the bulb from touching the sides of the paper lantern.

Work Lights

Although they're not lightweight and can get very hot, you can't deny that work lights are easy to acquire. These are the type of lights you see in a workshop or on a construction site and are generally found in every hardware store.

We've used these lights more than once. Lost bags and little time can lead to desperate measures. But with care and a few minor changes, you can easily use work lights for your production.

Grates: The most common type of fixtures have metal grates over the cages, which can cause irregular shadows. You'll want to remove the grates if possible or shine the light through a diffuser.

Stands and handles: Work lights often include stands or metal handles, so you can usually position them or hang them as needed.

Heat and safety: Work lights are typically very powerful (and hot). Be careful to avoid burn injuries by using proper safety equipment like gloves and securing the lamps with sandbags.

Positioning: Try bouncing the light off a wall or ceiling to get a softer light. You can also use reflectors or diffusers to reduce the power. One other method is to move the lights outside and blast them through a window (like a poor man's HMI).

Reflector Clamp Light

One of the easiest lights to find is a reflector clamp light (also called a scoop). For less than $10, you can find these at just about any hardware store. The light consists of a socket, a mounting clamp, and a metal reflector to focus the light.

These fixtures use a standard, medium-base lightbulb. You can add a standard 200W bulb or go the extra step and use a color-balanced ECA Tungsten Photoflood Lamp, which is better suited for photography tasks. You'll need a few of these to get the job done, but they are cheap and easy to locate.

You'll also want to take greater control of the lights by using colored lighting gel. You can easily attach gels for special effects or color correction using clothespins and the attached metal bowl.

Adapting Photo Gear

The fusion of photography and video may seem new to you, but the truth is the two technologies have been on a path toward convergence for some time. There are many similarities between modern video cameras and digital photography cameras. In fact, the way in which these cameras' sensors process light is very similar.

This is a good thing, especially as you, a photographer, venture into the video world. Most likely, you already

▲ Work and reflector clamp lights can be used in a pinch for video lighting. Images © Fotolia.

DEALS ON PROFESSIONAL LIGHTING GEAR

You can often find used lighting equipment that sells for a good price on a few websites. Professional video lights have a long, useful life, so don't avoid looking at older gear. Check out the companies in the following list for used gear. Most sites contain a used gear link.

> **Adorama** (www.adorama.com)
> **B&H** (www.bhphotovideo.com)
> **Visual Products** (www.visualproducts.com)
> **Wooden Nickel Lighting**
(www. woodennickellighting.com)

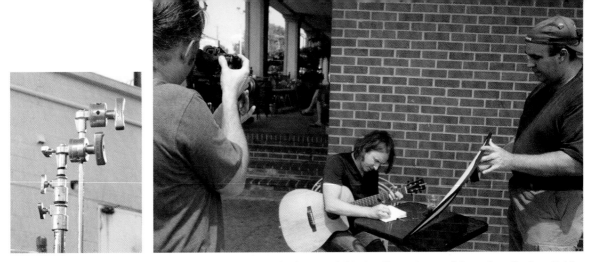

▲ A 2.5-inch grip head works well to attach lighting and grip gear (left). A reflector is a useful way to reflect sunlight onto a subject as fill light (right).

have a good deal of the support (or grip) gear you need for shooting video. Let's be honest: The more photo gear that you can repurpose for your video project the more money you can save for special equipment that you can't make yourself (like a great tripod or a follow focus).

Light Stands

If you're a wildlife photographer, you probably don't own many strobes. But if you've built up studio lighting over the years, it can often be adapted to video. Most of the same stands you use for your studio strobes are well suited for continuous lighting too. Just be sure not to overload your stands with a heavy video light.

If you already use studio strobes, like the White Lightning Monolights, your stands are definitely heavy enough to support some of the bigger continuous lighting fixtures, like an Arri 650 or a Kino Flo Diva fluorescent fixture. Just keep in mind that some of the continuous lighting instruments you want to use may be even heavier than you're used to. Try adding some additional weight on the legs by using sandbags to maintain a safe set.

Don't just put away your lighter-weight light stands. Chances are they can be put to good use holding lightweight grip gear like flags or a piece of foam core. Try adding a pony or spring clamp and attaching a FlexFill, a silk, or even a bed sheet to diffuse a light source.

If your light stands have ⅝-inch spud heads, you can treat them as a lightweight C-stand. To open up your options for mounting grip gear and vastly expand your light control options, try attaching a 2.5-inch grip head. By adding this simple accessory to your light stands, you can attach flags, arms, and nets to adjust on-set lighting.

Reflectors

When you shoot video with a DSLR camera, you don't have as much latitude as you would with a still image. Unlike a raw photo, the video files will be pretty much "baked in." So, you must try to "get it right" in the camera as much as possible, which is why your lighting is critical.

Fortunately, the reflectors you may already have can help tremendously. With a reflector, you can control your contrast ratios and fill in shadows. This is especially important because it is in the shadow detail where you will see the most noise if it is to occur at all. Whether you are shooting outside and need to bounce some sunlight back onto your subject or simply want to reflect some of your key light onto the fill side of your interviewee, a gold, silver, or white reflector is a key piece of essential gear in the filmmaking world.

Gold: A gold reflector works best for outdoor lighting. It picks up the color of sunlight and can reflect it to match color temperature.

▲ A butterfly diffusion frame can also be used as a large scale diffuser (top). Continuous lights like a Westcott Spiderlite can also be adapted for video use (bottom). Spiderlite photo by Brad Moore.

GET A MAFER CLAMP
One of the best pieces of gear you can add to your kit is a Mafer clamp (about $35). This versatile clamp can attach to doors, tables, railings, or a light stand. It also offers a 5/8-inch stud to attach a video light.

Silver: A silver reflector reflects the most amount of light. It also doesn't change the color of the light.

White: A white reflector works indoors and outdoors. Because it's not metallic, it doesn't reflect as much light as the other two colors.

The best part of using a reflector is that it is easy to adjust. By tilting the angle or moving its position, you can get immediate results. It usually takes only a few inches of movement or degrees of tilt to get the needed results. Be sure to keep your FlexFill reflectors handy; you'll find them just as useful when shooting video.

Diffusion

As a photographer, you know that one of the many ways of "painting with light" is to spread out and soften harsh directional light. Diffusion can be used in many ways to help shape your continuous lighting as well as that big HMI in the sky (also called the sun).

Most photographers are used to diffusing their strobes with soft boxes such as the Chimera series (www.chimeralighting.com). You may be able to use these same soft boxes with your hot lights, but first make sure they are able to take the heat of continuous lighting. Strobes get hot, but they rarely stay hot for the long period of time that continuous lights do. Even if you can't use the actual Chimera, you may still be able to use the speed ring as well as the diffusion from the front of the soft box in any new video-capable Chimera you may buy.

Another tool you might have are handheld diffusers like the Lastolite TriGrip (www.lastolite.com). Although an assistant normally holds these, you can easily attach them to a light stand. Be sure to pick up a mini clamp or a reflector holder so you can put those diffusers to good use.

If you're fortunate to have large sheets of diffusion material or even a butterfly/overhead diffusion cloth, you are already ahead of the game. These overhead tools can knock down and soften harsh overhead light into a pleasing big soft box of diffused light. Experiment with different weaves and thicknesses of cloth until you find one that is manageable in a stiff breeze but also doesn't cut down the light too much.

Continuous Lights

Many photographers have switched from using strobe lights to continuous lights. One of the most popular options is a Westcott Spiderlite. Although these lights aren't quite as bright as video lights, they do offer useful diffusion and daylight-balanced fluorescent lighting. If your light can output continuous illumination, you should definitely give it a shot. Be sure to use any diffusion options (such as umbrellas) that came with your kit.

Other Grip Gear

It is rare that you can get away with putting lights and reflectors where you want them by just using light stands. Sometimes you'll need to clamp a light to a railing on a staircase to get it where you need it. Other times the light might need to be close to but not on the floor. These are just a couple of examples of when your typical light stand just won't cut it.

The same goes for any flags, scrims, or other light modifiers you need to rig to help shape the light in your scene. You may already have other photo tools in your gear bag that can hold gear. You can also use lighting modifiers like C-stands, clamps, and rigging gear when lighting for video as well.

▲ Keeping clothespins and clamps around on set can make lighting and grip gear easier to mount.

Photo Gear You Want to Reuse But Shouldn't

Unfortunately, not all gear can be turned into video gear. It's a matter of function not cost.

Strobes: Many photographers have come to rely on strobes for their powerful ability to fill in a scene. Unfortunately, a strobe only provides lighting for a brief instant. This works well for still photos, but it just won't work well when shooting sequential images for video. A strobe would create constant changes in light, so unless you want a "strobe light" effect, avoid using those studio strobes.

The equivalent of a strobe for video lighting would be either an Arri or Mole-Richardson 650/1000W Tungsten Fresnel with a 3200K color temperature. You can also use a K5600 Joker Bug 400/800W HMI (5600K daylight balanced) fixture. These lights are high-powered, reliable workhorses found on many film sets.

Modeling lights: When shooting stills, you need a modeling light to give your camera enough light to grab an autofocus point. Unfortunately, when it comes to video, a modeling light is just too low in power, and you have very little means of controlling the spill from it. But you have plenty of other options when choosing a useful continuous lighting instrument without breaking the bank.

Radio triggers: Radio triggers (like the always popular Pocket Wizards) have revolutionized small-flash photography as well as on-location photography with studio strobes. Since your video lights need to be on constantly, your radio triggers will probably be better off in your bag unless you are going to trigger your strobes for special effects.

DIY Lighting and Grip Gear

It never hurts to save a little money by building your own grip gear. You'd be surprised at how a quick trip to the hardware store can result in some great grip gear—whether it's a swing through the heating department to build a guerrilla 4 x 4 shiny board or a jaunt to the electrical department to build your own dimmers. You'll be able to save some of your hard-earned cash and feel good that you know the equipment you're using inside and out.

For filmmakers there's an even greater benefit. These bulbs can be bought with daylight-balanced (D65) color temperatures, making them an easy addition to most scenes. Their output is also very bright, making them an efficient instrument as well. CFL bulbs provide lots of light without much of a draw on the circuits; plus they're cheap. Now you know why we love them.

CFL Bulbs

You've likely heard about compact fluorescent light (CFL) bulbs because they're a more "green" alternative to the traditional incandescent lighting used in most homes. These bulbs are typically sold as energy-saving lights because they draw less power than conventional bulbs.

Homemade CFL Soft Box

As a photographer, you probably already use a soft box for your strobes. Spending about an hour or two of your time and using some basic electrical parts, you can build a quick and easy CFL soft box that will cast a nice soft light around your talent. Combine five CFLs together with flush-mounted sockets, some Coroplast, and some semitransparent cloth, and you can easily build your own soft box that is daylight balanced and requires very little power.

Shopping List (Get the following equipment, and then watch the video)

> 2 Carol 14-gauge, 17-foot primary wires (1 black, 1 red)

> 5 Ecosmart 75W daylight compact fluorescent lights

> 5 flush-mount lightbulb sockets

> ⅝-inch "baby plate"

> 1 15-foot extension cord

> 16 x 16-inch plywood

> 18 x 18-inch opal diffusion

> white paint

NOT ALL CFL CAN BE DIMMED

Because they are essentially fluorescent lights, not all CFL bulbs can be dimmed. If you need to dim them, be sure to shop carefully for those that can be dimmed. You can also keep different wattages on set and use diffusion to soften the light as needed. If you're using multiple bulbs, you can also remove a few from your light.

VIDEO #8: HOW TO BUILD A SOFT BOX

Learn how to build your own soft box using about $60 in parts and an hour of labor.

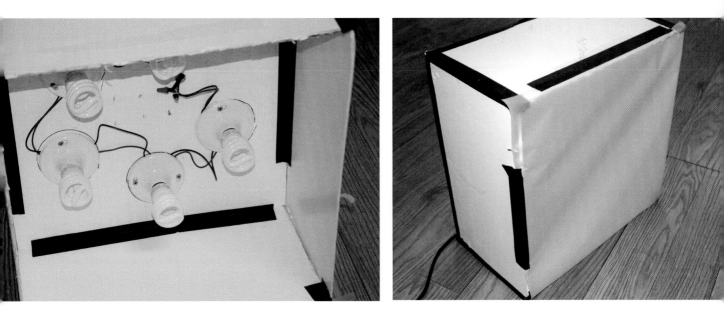

DIY Reflectors

You may have a set of FlexFill reflectors from your photography kit, so you should definitely put those to use. However, you'll quickly find that you'll need more for video due to the increased number of angles you'll be shooting. Video and film guys are fond of using a variety of cheap and easy-to-find materials for bouncing light, for example:

> **Foam core** from an arts or crafts store can be used as is or wrapped in Mylar or aluminum foil.

> **Tyvek insulation** with a shiny surface works well.

> **Foldable aluminum auto shade covers** can be easily repurposed.

All you need to do is clamp one of these materials onto a sandbagged C-stand, and you can reflect fill light onto the shadowy side of your subject. These reflectors can also be used to reflect available light to serve as the key light. The reflector will scatter the light in a pleasant, soft manner and increase the apparent size of the light source. You'll be able to then "wrap" the light around the subject's face.

Another cheap source of reflective material is Reflectix foil. This double-insulated foil comes in 25-foot rolls and is used by contractors to insulate ducts and other building spaces. Its surface is highly reflective, but it also has a stamped pattern on it that reflects the light in a more irregular way. You can get a roll of this at your local building supply store, staple or glue it to some foam core or even some 1-inch Styrofoam insulation, and you have a cheap, homemade shiny board.

SPACE BLANKET
Be sure to pick up a space blanket from your local sporting goods store to reflect light. These compact foil blankets have a gold side and a silver side, and cost about $5.

VIDEO #9: HOW TO BUILD A REFLECTOR
Learn how to build your own reflectors or shiny boards. These are a big help when bouncing available light.

Homemade Dimmers

You can make your own dimmers from common electrical components found in any home improvement store. These dimmers can then be used for everything from dimming a practical lamp in your shot to dimming a 1K Chimera. Buy your components in lots of five (or more) to make several at once. You'll save money and have dimmers for every one of your lights at the same time.

Shopping List (Get the following equipment, and then watch the video)

> 1 15-foot extension cord

> 1 1K light dimmer

> 1 outlet switch wall box

> 1 light switch cover plate

> wire nut connectors

> electrical tape

 CHANGING TEMPERATURES
As you dim lights, the color temperature may change. Be sure to always check your white balance after making lighting adjustments. You may also find a light meter handy to adjust your camera manually.

 VIDEO #10: HOW TO BUILD A DIMMER
One of the most important pieces of lighting equipment is a dimmer. You'll want several on set so you can control the intensity of your lights.

 SHOPPING LISTS
For a handy list to take with you, we supplied shopping lists for the CFL soft box, reflectors, and dimmers on the DVD-ROM.

Profile Syl Arena

Follow Syl on Twitter @Syl_Arena.

Photo by Victory Tischler-Blue

Photo by Victory Tischler-Blue

Syl Arena is a commercial photographer who specializes in portrait, life-style, food and beverage, and architectural interiors. He's a noted expert on Canon Speedlites and an avid blogger who maintains the site www.PixSylated.com. A recognized expert in small-flash photography and an early adopter of digital workflow, Arena has always embraced technology that helps him capture great images. As such, video was a natural extension of his growth.

"In the past, the boundary between stills and motion was very distinct," says Arena. "Now the line is getting very narrow. I expect that many of us will walk between the worlds of still and motion frequently and without hesitation."

That walk is being driven by market demand. "Clients and prospects are increasingly interested in multimedia and motion pieces for their websites. For me, my conversion is motivated by my desire to stay technically competent and economically viable," says Arena. "Motion is becoming a 50/50 partner with my stills work. I am convinced that to remain economically viable as a commercial photographer in the future means that you'll have to shoot motion."

Because he was an early adopter, Arena has had plenty of time to explore the benefits and limitations of shooting motion. "There are a lot of reasons for a stills shooter to be intimidated by motion, none of which are good reasons to not blunder forward.

"The explosive acceptance of the HDSLR has caught Canon completely off guard," says Arena. "That these cameras are now being used for so many diverse purposes—from Hollywood to home movies and everything in between—was never anticipated. So, essentially everything we are doing now with HDSLRs is jury-rigged."

Arena offers some practical advice for the experienced still photographer:

> "White balance and exposure are critical when shooting motion on an HDSLR. Unlike shooting stills in raw or even JPEG, the H.264 co-dec is ultracompressed. So there's just not much room in postproduction to fix exposure mistakes."

> "In motion, it's critical that the camera move. Yet, it's very hard to move the camera by hand. HDSLRs don't have the ergonomics for shooting like a video camera does. All the weight is out front; thus, camera support becomes critical."

> "In motion, having multiple points of view is very helpful. If you're shooting a scene that can't be reshot, such as an event, then you'll likely need multiple cameras."

> "The smaller the format the deeper the depth of field. With the 5D Mark II at a very wide aperture, the DOF can be as thin as a sheet of paper. It's impossible to get accurate focus off the LCD alone. You need a loupe, or better yet, an external monitor."

Although he's on his way to mastering the production aspects, Arena has decided to not focus on postproduction. "I'm perfectly comfortable lighting for motion. I'm even moderately competent at audio. It's editing that is my greatest challenge. So I've decided to position myself as a DP and let others edit. There's just too much to know between shooting and editing. In the stills world, it used to be that there were photographers and there were retouchers. Over the years, Photoshop has gone a long way to blur the distinction between the two. I'm sure it will be the same for the world of HDSLR cinematography. But for now I'm spending my time behind the camera rather than in front of the computer."

GEAR LIST

> Canon 5D Mark II and Canon 7D
> Canon EF 24-70mm f/2.8 L (for run and gun work)
> Canon 24mm f/1.4 L II
> Canon 35mm f/1.4 L
> Canon 50mm f/1.2 L
> Zeiss Ikon 85mm Planar f/1.4 T* ZE
> Zoom H4N recorder
> Gitzo G-2380 Video Fluid Head
> GT2540LLVL Leveling 6X Carbon Fiber Tripod Legs
> Zacuto Z-Finder
> Marshall Electronics' V-LCD70P-HDMI External Monitor
> Redrock Micro Rails & Follow-focus

Good Audio Is Essential

Arena has quickly learned the essential nature of quality audio. "Sound quality is more important than the video quality," says Arena. "Viewers will put up with bad focus far longer than with bad sound."

To improve his captured sound, Arena has invested in quality audio gear. "About the only use for the built-in audio is to create a "scratch-track" to help with the syncing of externally recorded audio. Even for this, a shotgun mic in the hotshoe is really helpful."

Arena suggests looking at gear like the BeachTek audio adapter products, which can overcome the auto-gain circuits in many cameras. He's also a fan of the Zoom H4N recorder: "For the price, the audio quality is great!'

Of course, mastering audio may be an extra thing that a photographer might not want to learn. "The next step up would be to hire a dedicated sound guy with a mixer and boom" says Arena. "This is the first place I'd spend money if I have to hire crew. Hire a sound guy before you hire anyone else."

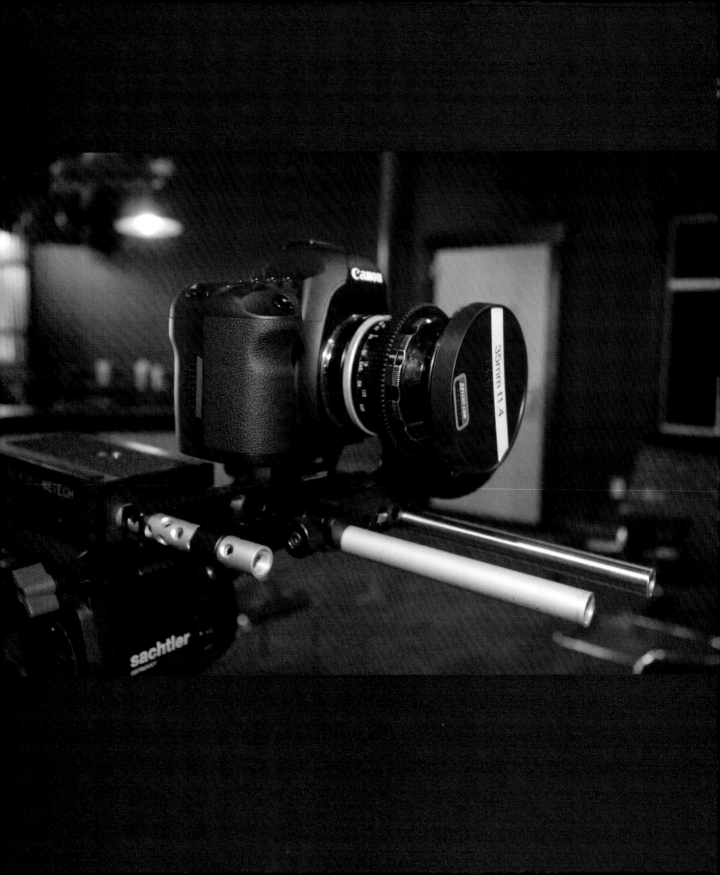

Part III

Gearing up for Motion and Sound

There's no getting around it, the camera is at the center of the action. All that meticulous planning and staging exists to be recorded. You'll need to choose from a pile of gear to enable the camera to capture what you want. The purpose of camera bodies, lenses, and accessories is not only to execute the shots you desire, but also to play a creative role in the look of what you record.

Because you are recording moving images, you also want the option to move the camera. All the verbs apply here: gliding, chasing, supporting, tracking, flying, and so on. Fortunately, there is a tool for each.

And because movies are about picture and sound, we'll get you up to speed on the technology of audio recording.

The work doesn't stop after recording is finished. Video and audio files need a place to live so they can be delivered to your editor at a later time. Data management in the field is the least glamorous aspect of the work but is important enough to require a disciplined routine.

Body Parts

Selecting a Camera Body for Video

Lights, lenses, tripods, and audio gear are all important components of shooting footage, but no other piece of equipment is as important as the camera body you choose. This single piece of equipment is responsible for capturing the results of all the other equipment, as well as technical and aesthetic choices you make on a project.

When it comes to choosing a camera body, you'll need to consider features, ergonomics, and of course price. Manufacturers like Canon, Nikon, Panasonic, Sony, and now RED are making some very compelling options for camera bodies. Although you may have a brand that you've used for years, you might want to take a fresh look at your options when shooting video.

Video-enabled DSLRs have split personalities. Currently, most manufacturers focus on having their cameras perform as traditional still cameras first and video cameras second.

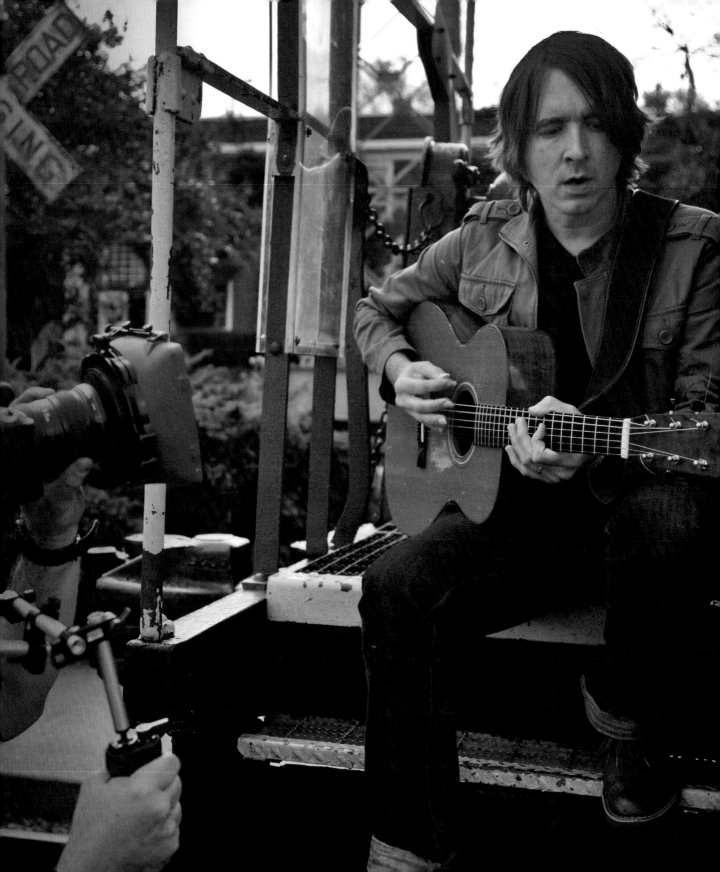

WHEN IT COMES TO CHOOSING A CAMERA BODY, YOU'LL NEED TO CONSIDER FEATURES, ERGONOMICS, AND OF COURSE PRICE.

Although you may feel compelled to buy the top-of-the-line, $5,000 camera body, it may be overkill. If you'll be shooting video primarily, you can often get identical video features of an expensive camera on a less-expensive body. Video features are pretty standard across a product line, and the more expensive body likely has additional features that only benefit still photography.

One thing is for certain: The video-enabled DSLR camera body market is extremely fast moving. The technology and features in modern camera bodies will continue to evolve. For that reason, this chapter explains more about core functionality when choosing a body and some associated accessories rather than specific camera models. Armed with this universal knowledge, you'll be able to make smart decisions when choosing a camera body as the equipment continues to advance.

Selecting a Camera

Which video-enabled DSLR you choose is largely a matter of personal preference, but there are several factors to consider. Since the world of video-enabled DSLRs seems to change every day, we highly recommend you actually try out or test a camera before deciding to purchase it.

The camera you choose won't be of much use if it doesn't feel right in your hands or the sensor crop factor frames your subject in a way that's objectionable to you. You can't do much with the footage if the camera doesn't shoot the frame rate or resolution that your project requires.

Ergonomics

How the camera handles and its physical feeling is an important part of choosing a video-enabled DSLR. If the camera doesn't feel right, you'll probably be thinking about how hard the camera is to hold rather than focusing on the important tasks like capturing great video. As when evaluating a camera body for use as a still camera, you want the camera to meet specific criteria.

Size: The body you choose should fit your hands well. If the body is too small, your hands will get in the way of the controls. Conversely, if the body is too big, you'll find the body hard to hold. With that said, you won't always be holding your camera. A small body can easily

mount in tight places like a car or underwater housing. A bigger camera body can be attached to accessories that make it feel more like a traditional video camera.

Weight: The weight of the camera body you choose is also important. Entry-level video DSLRs tend to be rather light, which is great for travel. However, this can make them hard to handle, especially when a large lens is mounted (making the camera very front heavy). Pro bodies (or bodies that have battery grips installed) tend to be heaviest and provide a nice counterbalance to long lenses. Be careful not to choose a body that is too heavy for what you can handle, especially if you intend to do lots of handheld work. If the camera is too heavy, you'll end up with shaky footage.

Sensor Resolution

It seems like the megapixel wars will never end. As a still photographer, you know that every successive generation of cameras seems to have a higher sensor resolution. A few years ago, an 8-megapixel camera was considered high end. Now you can find that resolution in several consumer point-and-shoot models.

When it comes to sensor resolution and video, don't let the megapixel count influence your choice of camera body. We know that you'll likely use the body you choose for both stills and video. Choose a camera body that meets the megapixel requirements of your still images and don't worry about sensor resolution for video. Why you ask?

Anytime you're shooting video on a DSLR, you'll be using only a fraction of the available pixels on the sensor. Take for example the 21.1-megapixel Canon 5D MKII, which has a max resolution of 5616 x 3744 when taking still photos. When shooting video at 1920 x 1080, your effective megapixel count is only 2.1 megapixels!

The important detail to understand about sensor resolution and video is that the more pixels on the sensor the smaller and more tightly packed those pixels will be. Higher density sensors (a lot of pixels packed into a small space) can possibly increase noise that is visible in the stills and video of that camera.

Full Frame vs. Cropped Sensors

Perhaps the fiercest debate when it comes to DSLRs is full frame versus cropped sensors. This argument rages not only in still photography but also in video.

Allow us to first give you a little background. A full frame sensor matches the size of a 35mm film frame, and the sensor is approximately 36mm x 24mm. Manufacturers like Canon, Nikon, and Panasonic have different sizes for their cropped sensors or smaller sensors but generally adhere to standardized sizes based on the APS (advanced photo system). APS-C and APS-H are the most common.

So why does it matter what size the sensor is? As a general rule of thumb, the larger the sensor the greater influence on depth of field (DOF). Put simply, a large sensor allows you to blur the background easier than a small sensor with the same lens.

▲ As sensor size is reduced, crop factors come into play. Crop factors multiply the focal length of any given lens. Also, smaller sensors make achieving a very shallow depth of field more difficult.

Crop Factors

If you choose a body that has a cropped sensor, you'll need to examine the sensor crop factor. Cropped (or smaller) sensors multiply the focal range of any given lens.

All lenses have focal ranges based on a 35mm frame. For example, let's say you're using a 70mm–200mm lens. On a full frame body, the focal range of that lens is as marked. But if you put that same lens on a body with a cropped sensor, the effective focal range is multiplied due to the smaller sensor size.

Here are some common crop factors used in cameras today:

> 1.3: This crop factor is used by Canon on some of its 1-series bodies that use an APS-H sensor like the 1D Mark IV.

> 1.5: This crop factor is used by Nikon for all of its non-full frame cameras.

> 1.6: This crop factor is used by Canon for its APS-C bodies like the 7D and the Digital Rebel series.

> 2.0: This is a large crop factor ratio that's used by Micro Four Thirds image sensors like the one featured on the Panasonic Lumix GH1 DSLR.

If you have a camera body with a 1.6 crop factor, that 70mm–200mm lens now becomes 112mm–320mm. Cropped factors can be useful for video. You can get much longer reach on your lenses without having to purchase extremely expensive telephoto and supertelephoto lenses. Unfortunately, the opposite is true when trying to shoot wide. To get a nice wide-angle view (which you'll likely want for many video shots), you'll need to purchase wider lenses, which are often more expensive than "standard" lenses.

◄ Most DSLR cameras allow you to change the frame size and frame rate that's used for recording using their menu system.

Most likely you're already familiar with this debate in photography, so what's the big deal? Well, a driving force in the popularity of video DSLRs is that their sensors are gigantic compared to traditional video cameras. Those large sensors allow for greater control in the depth of field (which many equate to a cinematic look).

Choosing a full frame sensor lets you get the best possible depth of field. Full frame bodies are the most expensive, so you'll need to decide if the added depth of field of a full frame sensor is worth it to you.

Supported Frame Sizes and Frame Rates

Two major differences with different models of video-enabled DSLRs are the frame size and frame rates that they support. When evaluating a camera body, be sure to check out the maximum frame size the camera supports.

1920 x 1080: Choose a camera with a maximum frame size of 1920 x 1080 if you want the best resolution that HD video supports. You may also need this size if you're doing lots of video projects for broadcast television.

1280 x 720: Cameras with a resolution of 1280 x 720 (like those made by Nikon) are capable of producing beautiful images. Although not the highest resolution, they are still considered high definition.

Another feature to consider with a video-enabled DSLR is what frame rates it supports. Models like the Canon 7D and 1D Mark IV offer multiple frame rates. It's now possible to shoot at a variety of frame rates including fractional frame rates, which are used in the United States and other countries that use the NTSC television standard. For the most flexibility, choose a camera that is able to support the most frame rates.

On-camera LCDs

You're probably used to looking through your camera's viewfinder to frame a shot and then focus on a subject. In fact, you may have become a bit lazy due to how reliable the autofocus systems on modern cameras have become.

CAMERA SYSTEMS AND LENSES
If you already have a significant investment in lenses for one camera system like Canon or Nikon or you have lots of lenses that only work on cropped image sensors like Canon's EF-S or Nikon's DX, these factors should influence your body choice. It can be very expensive to replace lenses for different systems or replace lenses that only work on cropped image sensors if you get a full frame body.

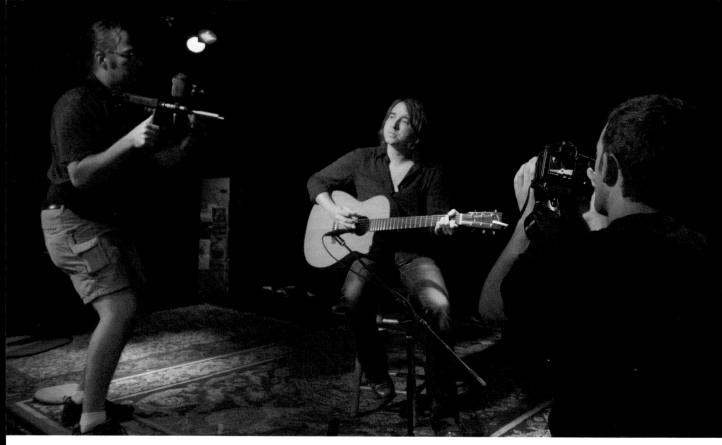

▲ When shooting video with your DSLR you'll use the on camera LCD, which can make judging focus and exposure challenging.

Unfortunately, autofocus isn't really an option with video. In the world of video-enabled DSLRs, you don't use the camera viewfinder but rather the camera LCD when shooting video because the mirror that is used for the viewfinder is always flipped up to constantly expose the sensor for video.

Since you'll be using the camera LCD for framing and evaluating video focus, you need to be very discerning. Here are a few simple criteria to use when choosing a camera body in terms of its LCD.

Size: The larger the LCD the better. Large LCDs make it easier to see your footage. The current crop of video-enabled DSLRs have screen sizes of up to 3 inches.

Resolution: A large LCD is no good unless it's also high resolution. Camera LCDs are measured in dots or pixels. A high number indicates a higher resolution and therefore more clarity on the LCD screen.

Brightness: You'll be viewing the camera LCD under different lighting conditions; therefore, we recommend getting the brightest camera LCD possible. You'll prob-ably also need to supplement it with a viewfinder or an external monitor (check out the section "External Monitoring" later in this chapter).

Flexibility: Some DSLRs offer viewfinders that can be angled for easier viewing. This improves your options for holding the camera above or below eye level when shooting. Exercise caution with this type of LCD, they can actually break off the camera body with to much force.

RATE IT
For more specific information on various frame rates that your camera may support, check out Chapter 4 for detailed explanations.

Powering the Camera

When you're shooting video, it is essential that you realize your camera will need much more power than you usually use when just shooting stills. The extra power requirement is due to two factors: First, you'll be using the Live View function of the camera, which means powering the LCD continuously, which will drain batteries more quickly. Second, to record video, your camera's processors and memory card will be working all the time.

So, to ensure that your DSLR has enough juice to power you through your documentary, interview, or feature film, you'll need to enhance it. In this section we explore several different issues related to powering your video-enabled DSLR.

Live View Power Considerations

Up until DSLRs started to record video, Live View was considered a consumer-oriented feature that most pro photographers shunned (in fact the feature wasn't even found on most DSLRs). After all, who in their right mind would use a small (often not complete) field of view *viewfinder* to compose and take photos?

But this has changed. Now, most DSLRs provide a Live View mode to preview a video shot and also view the shot when actively recording. One downside to Live View is that it uses up valuable battery power. For this reason, your camera's Live View mode default settings include shutting it off after a couple of minutes.

You might be used to shooting hundreds or even thousands of shots on a single battery when shooting stills, but when shooting video, a single battery might last only a couple of hours. Therefore, it's essential to have additional batteries with you when shooting video. We recommend packing five batteries per shooting day for each camera body. If you have the option of charging batteries easily, you can get by with less (but why chance it?).

▶ Using a battery grip allows you to extend your shooting time by using multiple batteries, since when shooting video you'll drain batteries faster than with stills.

Using a Battery Grip

If you don't want to swap out batteries all the time, another option is to use a battery grip (although battery grips are not available for every camera). You're likely familiar with battery grips. But basically, a battery grip doubles your power capacity because two batteries are in use. Sometimes one is contained in the grip and one in the camera body. Other times, two are in the grip. This added power is great for shooting video, because you'll be able to shoot for longer time periods than with a single battery, which is important. When shooting video, you'll be using the camera's Live View mode, which can quickly consume battery power.

A battery grip often allows you to change batteries quickly since the battery door is located on the rear or side of the grip. This may not seem like a big deal, but if the camera is mounted on a tripod, having to remove the camera from your tripod (and stop recording) just to change batteries can be a pain. Some battery grips allow you to keep recording video even in

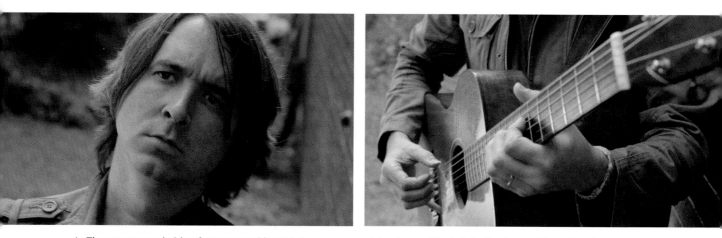

▲ The compressed video formats used by DSLR cameras can introduce artifacts into the image. These two frames are extracted from footage shot on a Canon 7D. You may notice light compression artifacts in the shadowy areas.

the middle of a battery change. As a result, you can avoid missing a shot due to power drain.

If you start using a rail system with your camera (we discuss rail systems in Chapter 12), you won't have to remove the camera from the rails to change batteries. However, be aware that using a battery grip with your rail system may change your ability to use follow focus systems as well as rail-mounted matte boxes on your DSLR, because the battery grip "raises" the camera vertically, which might prevent those accessories from reaching the camera.

Overall, we think of the battery grip as a "nice to have" component when recording video. You get additional power without having to switch batteries all the time. Another benefit is that those extra shutter and menu dials are always useful when you need to take photographs too!

Tethered Power

If you are working in a studio or other location where AC power is available, an AC power adapter is a good alternative to changing your batteries frequently. The only downside is that it limits camera movement, especially if you are on a jib or dolly. We'll often power a camera with AC power for stationary shots (like interviews), and then switch to a battery when on the go.

Recording Compression

One of the most important factors when evaluating a DSLR for use in a video environment is the format or codec the camera records in (just keep in mind the compression scheme a camera uses is determined by the manufacture; you can't change it). To understand why this is so important, let's compare how video compression relates to still compression.

When shooting stills, you shoot raw, TIFF, or JPEG. Raw files allow for superior latitude during processing since raw images are not processed by the camera. At the other end of the spectrum, JPEG files "bake" a lot of information into the file, making it necessary to get the shot right at the time of capture.

In the world of DSLR video (as of this writing) there is no such thing as raw video recording (we wish there were!). Instead, video-enabled DSLRs record in a variety of compression schemas. Some of these formats are more heavily compressed than others or use older compression schemes that do not produce as high quality video as newer ones. So you need to think about the effect of each on overall image quality.

H.264 and AVCHD

H.264 is a video compression standard that's based on the MPEG-4 standard. OK, if you're technical geeks like us, it's based on MPEG-4 Part 10 (if you win on Jeopardy, you owe us!). H.264 is a modern codec that offers remarkable footage with little loss of quality and minimal compression artifacts.

H.264 has become a standard for high-quality web compression, but recently it's also being utilized for high-quality acquisition. Currently, Canon cameras like the 5D MKII, 7D, and the Rebel T1i all record H.264 formatted video.

AVCHD is a very close cousin of the H.264 codec. Essentially, AVCHD is a brand name for H.264 encoding. Offering the same benefits as H.264, AVCHD is marketed by Panasonic and Sony, and video DSLRs like the Panasonic Lumix GH1 can use AVCHD to record HD video.

In Part IV of this book, we'll talk more about editing with and transcoding H.264 and AVCHD footage.

Motion JPEG

For years Motion JPEG has been a stalwart compression scheme. Motion JPEG is the oldest compression scheme that modern video-enabled DSLRs use. It has the lowest overall image quality but also allows for the most recording time since it is so heavily compressed.

Besides small file size, another benefit of shooting Motion JPEG is that it is natively supported by several video-editing applications. Unlike H.264 and AVCHD, it is not very processor intensive, making it less demanding on your computer during postproduction. Currently, Nikon video-enabled DSLRs record using the Motion JPEG codec.

 WRAP THIS!
The idea of file wrappers tends to confuse many people. QuickTime, AVI, and MXF are all examples of file wrappers. This means you can have, for example, a file that uses H.264 or Motion JPEG compression but is wrapped in a QuickTime wrapper.

Recording Length Limitations

One major aspect of capturing video you need to be aware of is the recording length limitation of your DSLR. Your camera can only record video for a finite amount of time before you need to stop it. Know your camera's limit, or trust us, it will bite you at exactly the wrong moment.

This limitation usually varies from 5–12 minutes per clip. As a still photographer, you're used to limitations like burst rate and the number of raw files that can be written in continuous shooting mode. These limits might not seem like severe restrictions. But if you've used a traditional video camera, you'll be rudely awakened by the fact that most video-enabled DSLRs have such short recording length limitations.

Why do DSLRs have a time limit? Most video-enabled DSLRs format their memory cards using the Windows FAT32 file system. This system limits files to 4 GB or about 12 minutes of continuous recording. Other manufacturers impose even lower limits due to hardware performance. Although this time limit might sound crippling, in most cases you can work around it.

If you're recording an interview, a concert, or video that consists of long segments, make sure you know your camera's recording limitations. Here are some helpful workarounds.

Plan breaks: If you're recording an interview, estimate how many questions you can record in 12 minutes. In our experience, the number is between 3–6 questions (depending on the question and the complexity of the answer). If you're recording a concert, stop for a few seconds after each song.

Minimize downtime: If you reach a recording limit for either an individual recording or overall on a card, try to minimize downtime. Have a second card ready to go (correctly preformatted and erased). Try to do your best NASCAR pit stop impression and swap the card quickly. We often keep a second card right on the camera strap to speed things up.

Stagger coverage: If you're using multiple cameras, don't start or stop them at the same time. You can get overlapping coverage between two or more cameras. Just make sure that at least one camera is rolling at all times. That way you'll minimize the chances that you'll miss any action.

NOTHING IS CERTAIN BUT DEATH AND TAXES
In addition to FAT32 limitations, DSLRs also have recording length limitations due to taxes. European tariffs are higher on video cameras than they are on still cameras. A video camera is defined as one that records over 30 minutes of video in one take. Not wanting to make multiple cameras for different markets, DSLR manufacturers have conformed to the European rules.

On-camera Monitoring

Still photographers are used to squinting through a small square (aka the viewfinder) on the top of their camera for hours on end. A good viewfinder allows you to properly frame the shot, judge exposure, and see important technical information about the shot you're about to take.

With video-enabled DSLRs, you can't use the camera viewfinder when shooting video because the sensor always needs to be exposed, unlike when taking a still, which simply flips up the mirror for the viewfinder during the actual shot (called mirror blackout). So, you must rely on the camera's LCD, which presents two major problems.

First is critical focus. When shooting video, it is a lot harder to focus when you must rely on using the LCD. At wide-open apertures, it is virtually impossible. This is due to the reduced contrast ratios that the LCD offers compared to the viewfinder, and the autofocus in Live View is simply not as good as when using the camera viewfinder.

Second, because the LCD is exposed to on-location or on-set lighting, it can become very difficult to see. This is why many photographers shield the LCD and convert it into a viewfinder of sorts.

Using Attached Viewfinders

One of the accessories we like most is the attached viewfinder, or loupe. This add-on enhances the camera's LCD and works much like a professional camcorder's viewfinder. A good loupe can increase the magnification of the LCD, thereby helping you see just how much of your shot is (or is *not*) in focus.

Some viewfinders attach via rubber bands, whereas some attach by means of a "frame" that adheres to your LCD cover. Others require the use of a rail system to attach them to your camera.

We prefer those like the Zacuto Z-Finder, which is not only robust and built to a high standard, but also offers an adjustable diopter that can be finely adjusted. When you have one of these viewfinders attached, your LCD almost looks like a big-screen TV, and it becomes *very* apparent when you are or *aren't* in focus. If you factor in that many cameras let you zoom into the image 5x or even 10x, getting sharp focus becomes easy. Additionally, because the loupe covers the entire LCD, it makes it a perfect accessory to see in adverse lighting conditions like bright sunshine.

Here are some additional attached viewfinder models to check out:

> **Hoodman** (http://bit.ly/uaMvf)

> **LCDVF** (http://bit.ly/8E7S0q)

> **Cavision** (http://bit.ly/5nk0rk)

Cameras with Swivel LCDs

Sometimes you'll want to shoot from an angle other than eye level. Whether you're trying to get a low-angle point of view shot or holding the camera above the crowd at a concert, a swivel LCD can help you achieve shots that would otherwise be impossible.

So one feature to check when you're evaluating DSLRs with swivel LCDs is that the contrast and image maintains color fidelity when they are viewed off-axis. You also may want to invest in or make your own sunshade for the LCD when shooting outdoors or in a concert environment where external lighting can wash out the screen.

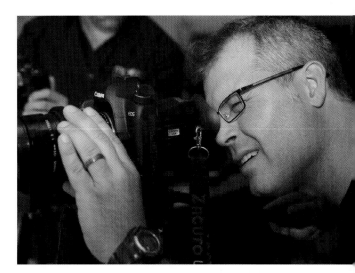

▲ An attached viewfinder, such as the Zacuto Z-Finder, makes it easier to see the on-camera LCD to judge focus, framing, and exposure.

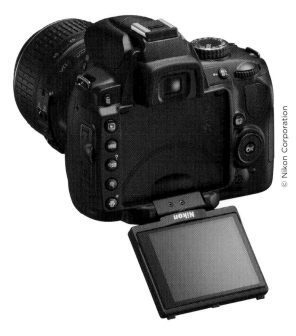

© Nikon Corporation

▲ Many new DSLRs feature swivel LCDs that make getting low angle or overhead shots easier.

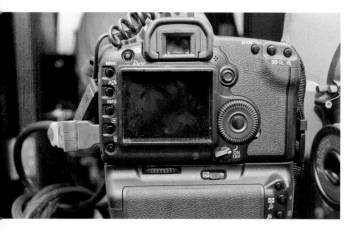

External Monitoring

You don't usually watch TV on a 3-inch LCD do you? We hope not! So when shooting video, don't monitor your footage on a small camera LCD screen. Instead, use a large, external monitor. Using an external monitor when shooting video provides a ton of benefits. Having the ability to see what you are shooting on a large screen is helpful for checking your framing and focus. A large monitor is also ideal for showing your client, the director, the makeup artist, and others what's happening on set.

Additionally, external monitors are the best devices for making critical decisions about exposure and color because they can be calibrated to strict contrast and color standards. Some monitors even have evaluative tools like waveform monitors and vectorscopes (which we talk about later in this section).

Using HDMI with an External Monitor

The best thing about using the HDMI port on your camera is its digital signal. This means it provides a higher resolution than the analog video out, and the picture quality is also much higher.

Using the HDMI output on your camera also means that you can connect a high-quality external monitor to evaluate exposure and framing. So what type of monitor should you use? Well, here are a few choices.

Computer monitor: Many modern computer monitors have HDMI inputs. So you can go to your local computer store and purchase an off-the-shelf computer display for a relatively low cost, and by using the HDMI connection, you can see your image on a screen that is much larger than the camera's own LCD. Just make sure you calibrate the display using calibration software/hardware like the products made by X-Rite, Datacolor, and Pantone attached to your computer before

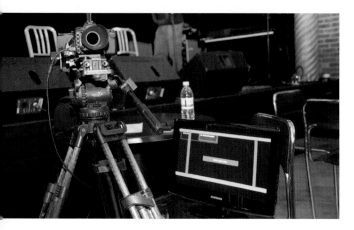

◀ Marking out your active area makes it easier to check composition on an external monitor. Here we use a consumer-quality HD television for monitoring the concert performance. You might consider doing the same on your camera's LCD.

going out into the field, so you can get accurate contrast and color. Although these calibration probes are often used for print workflows, choose the D65 or daylight balanced color settings and a gamma setting of 2.2 to monitor video.

LCD or plasma TV: It's a sure bet that you won't want to lug around a 50-inch plasma TV in the field, but if you do a lot of studio recording, having a very large LCD or plasma TV on set that has an HDMI connection can be a great way to monitor footage. It will give you a good indication of how your audience will most likely view your content. Of course, several smaller, portable (and cheaper) displays are available. Just keep a close eye on the contrast ratio when choosing a display.

As with any display, make sure it's calibrated. Several "over-the-counter" calibration tools are on the market to choose from, like those from Avia and Digital Video Essentials.

Dedicated field monitor: With HDMI becoming a standard digital connection type, many companies make high-quality field monitors (usually between 6–10 inches) that have HDMI connections on them. These monitors are capable of producing great contrast and are very color accurate.

Although these monitors differ in features and cost, we like LCD field monitors—like the V-LCD70P-HDMI from Marshall Electronics and the Small HD DP1—for their small size, accuracy, and ability to run off standard camcorder batteries.

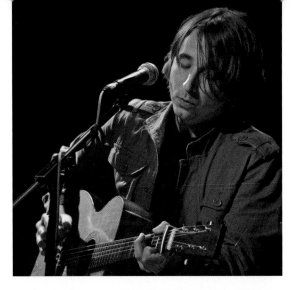

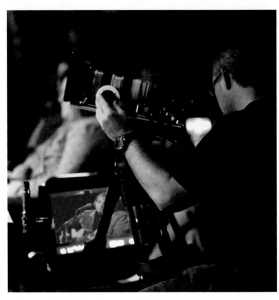

▲ A large monitor can be a key tool in judging focus, especially if the camera's LCD screen is in an awkward place for viewing.

USING AN HDMI CONVERTER WITH AN HD-SDI MONITOR

Some high-end broadcast video monitors or older broadcast displays don't have HDMI. If you want to use one of these monitors on set, you'll probably need an HDMI to HD-SDI (High Definition Serial Digital Interface) converter. HD-SDI is a digital video standard that sends HD video and audio over a standard BNC cable. These converters convert the HDMI signal to a standard HD-SDI signal that can be used by many broadcast monitors.

VIDEO #11: CALIBRATING AN EXTERNAL MONITOR

Having an external monitor doesn't do you much good unless it's calibrated. Check out this video to learn more about how to calibrate your external monitor to get the most out of your video-enabled DSLR.

YOU DON'T USUALLY WATCH TV ON A 3-INCH
LCD DO YOU? WE HOPE NOT! SO WHEN
SHOOTING VIDEO, DON'T MONITOR YOUR FOOTAGE
ON A SMALL CAMERA LCD SCREEN.

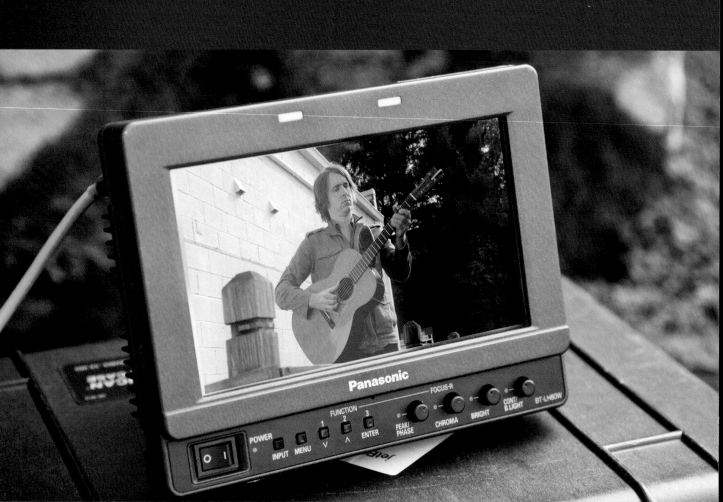

Using Additional Monitor Features

One of the best benefits of using a professional monitor is that the monitor often has test instruments that are more common to edit suites. These test instruments are called a waveform monitor and a vectorscope and they allow you to evaluate footage for contrast and color without ever lying to you like your eyes can.

Other benefits of some monitors are that they have additional features like false color and peaking displays to check exposure problems, and framing tools like 4x3 marks if you need to protect for 4x3 display when shooting for 4x3 television or DVD.

WAVEFORM MONITOR

No doubt you're used to viewing a histogram, which offers a graphical representation of each pixel in your photo, from dark to light. Well, a waveform monitor can show you the same information that a histogram does but with some added benefits.

What distinguishes a waveform monitor from a histogram is that the footage onscreen is actually mimicked from left to right on the waveform monitor, which helps in placing "where" a particular lightness or color value occurs onscreen. This is a useful way to spot problems with lighting and exposure.

When looking at a waveform monitor, you might be confused as to what is actually going on. However, a waveform monitor is pretty simple to read once you know how to read it.

A waveform monitor uses a scale of 0 IRE (Institute of Radio Engineers) or 0% (which is absolute black) to 100 IRE or 100% (which represents white). Most waveforms have a bit of extra room at the bottom to about –10 IRE or –10% and at the top to about 110 IRE or 110%.

The graphical representation of the video signal on a waveform (known as the trace) mimics each pixel

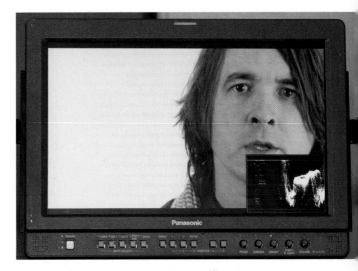

▲ Onboard tools like a waveform monitor and vectorscope on many professional monitors allow you to accurately evaluate contrast and color in a clip.

onscreen. The waveform monitor shows you where a feature is onscreen when looking at it left to right. So, if you have a light object onscreen on the left side of the frame, you'll see that object as a spike on the left side of the waveform monitor.

One of the primary uses of a waveform monitor on set is to measure overall exposure. Some Directors of Photography (DP) use the waveform monitor to expose skin tones at about 65 IRE on the waveform monitor scale. Once you know how to read a waveform monitor, you'll see it as a valuable tool in your arsenal to achieve the best video images.

VECTORSCOPE

Another useful tool that many external monitors have is a vectorscope. A vectorscope is the main tool you should use to measure color and saturation in a clip.

A vectorscope is set up like a color wheel where hue is represented as the angle around the vectorscope and saturation is represented as distance from the center.

So, if you have lots of trace pointed to the blue target on the vectorscope, you know something blue is in the frame. How far that trace extends toward the blue target indicates how saturated the blue is.

VIDEO #12: READING A WAVEFORM MONITOR AND VECTORSCOPE

If you're new to reading a waveform monitor and vectorscope, check out this video to learn the basics of these powerful tools

Through the Lens

The Unique Demands of Video

Nothing seems quite as desired, nor generates as much discussion, as the glass that you put in front of your DSLR. After all, what good is a sensor without something to focus light onto it? Good glass is practically a religion to some folks, and we'll admit we lust over quality lenses all the time.

You are probably familiar with this fanatic lust of lenses. In fact, you've probably built an extensive collection of lenses for your kit. It's not that shooting video is dramatically different than photos, but the requirements for good glass are amplified. When you switch from freezing time to capturing it, you need precision hardware. In some ways the fanaticism in video is greater due to unique shooting situations.

NOTHING SEEMS QUITE AS DESIRED, NOR GENERATES AS MUCH DISCUSSION, AS THE GLASS THAT YOU PUT IN FRONT OF YOUR DSLR. AFTER ALL, WHAT GOOD IS A SENSOR WITHOUT SOMETHING TO FOCUS LIGHT ONTO IT?

Lenses are more than functional pieces of plastic, metal, and glass. A good lens is the tool that "sees" what you are shooting. Your lens choice directly impacts the aesthetics and the quality of your project. Therefore, you'll want to be as discerning as your budget allows.

There's more to how a lens performs than just its aperture and focal range. You need to consider its weight and length, and how it will influence the form factor of your camera in relation to your shooting style. Is it a prime or a zoom lens? What about factors like image stabilization, sharpness, and build quality? And then there's the greatest factor to consider for most professionals—price.

All of these attributes contribute to a lens that you can have confidence in and use to get great shots. When these factors don't combine well, the result is a lens that frustrates you every time you mount it to your camera. Considering that you'll be shooting 24–60 still images per second when capturing video, you want to get the balance right.

In this chapter we explore selecting a lens for your video-enabled DSLR. Although we can't tell you what will work in every situation, you can use this chapter as a guide for selecting glass for your camera. We'll point out features that we find invaluable (as well as those we can live without).

Selecting Lenses

You may have found your niche shooting style—be it landscape, portrait, macro, and so on. You've probably invested in a set of specific lenses that work well for your style of photography. We recommend that you immediately move these lenses into your video workflow and try them out.

When selecting additional lenses for video work, you'll need to be more varied in your choices. You'll likely want a range—an ultrawide lens, a superfast lens for low-light shooting, and an ultralong lens to capture faraway action. With video projects, you'll have a plethora of shooting situations, each requiring a different lens.

When you're trying to choose a lens, you'll have an amazing amount of choices: wide, telephoto, fast, slow, specialty, cheap, and expensive. So, how do you decide which lenses are the best choice for your kit? Well, besides the actual application or use of the lens, you'll need to consider several characteristics when it comes to getting the right lens for your camera. Let's look at some of these qualities.

Lens Brands

One of the first decisions you'll have to make when choosing a lens is either selecting a lens made by your camera manufacturer, which is called an original equipment manufacturer (OEM) lens, or purchasing a third-party lens.

OEM lenses tend to be more expensive than their third-party counterparts, but they often work "better" than third-party lenses. The reason we say better is that OEM lenses are usually offered in a wide variety of focal lengths and apertures. In our experience a good OEM lens like a Canon L series lens is sharper than a third-party lens.

Sigma, Tokina, and Zeiss are just a few of the dozens of non-OEM lens manufacturers. The main advantage of third-party lenses is that you can get tricked out lenses that are generally cheaper (although some can be way more expensive) than their OEM equivalents. So why would anyone pay more for an OEM lens?

First, a third-party lens reverse engineers a lot of technical aspects of an OEM lens, such as how it mounts to the camera, autofocus, lens stabilization, and so forth. When a lens is reverse engineered, chances are a feature won't match the OEM lens 100 percent.

But one of the cool things about third-party lenses is that they're usually offered in multiple mounts (typically Canon or Nikon but also for brands like Sony or Panasonic).

Does it matter if you choose an OEM or third-party lens for video? Not really; a good performing lens is a good performing lens. We've found awesome OEM lenses for video and some bad ones. Likewise, we've found some great third-party lenses for video, like the Tamron 17-50 f/2.8 CR DI II and the Sigma 30mm f/1.4 EX DC HSM. But make sure that when comparing OEM and third-party lenses of the same focal length and aperture you also compare them for build quality and sharpness.

MATCHING LENSES
When you're shooting a scene using multiple lenses, it's very important that the visual quality of your lenses match. Once shots are cut together they can be distracting if they differ in quality. Many companies sell sets of lenses, but if that's not an option, test all the lenses you want to use in a scene to see if they visually match each other well.

Using Lenses on a Full Frame vs. Cropped Image Sensor

As we discussed in Chapter 9, DSLR cameras have full frame image sensors and cropped image sensors. The difference between the two types of sensors has a significant impact on two areas of lens selection. The biggest difference is that manufacturers like Canon, Nikon, Tamron, Sigma, and Zeiss produce full frame lenses that work with both full frame image sensors as well as cropped image sensors, *and* they produce lenses that will only work with cropped image sensors.

So how do you tell the difference between the different types of lenses? Fortunately, lens manufacturers denote lenses that will only work on cropped image sensors using unique monikers like Canon's EF-S or Nikon's DX.

Besides the basic difference of the lens accommodating different sensors, the other main difference when using full frame lenses on cropped image sensors is the multiplication value of the focal range, which is called the crop factor. It's important to keep this multiplication effect in mind when planning your video shots, as it may have an impact on how you frame a shot.

When you're using a cropped image sensor, the focal range that the lens claims to use is multiplied by the crop factor. For Canon cameras the crop factor is 1.3 or 1.6, for Nikon cameras it's 1.5, and for the Panasonic GH 1 it's 2.0.

Crop factor can impact your lens choice dramatically since you'll effectively get a longer lens at any given focal length. If you're using a cropped sensor body, we've found that to get that classic portrait style lens (50mm) we need to select lenses in the 24–35mm range. But in the long end of the focal range we can save quite a bit of money by choosing telephotos in the 200–300mm range that allow an amazing amount of reach compared to true supertelephoto lenses.

Adapting a Lens to Your Camera Mount

Collecting good lenses can be a life-long pursuit. We're willing to bet that you probably have some favorite lenses that you've had for years. Unfortunately, those lenses might not fit the system you're currently using. For example, you might be using a Canon body but have a ton of Nikon lenses. What can you do?

Lots of companies make adapters that allow you to mount a lens from one manufacturer on a body from another. Although adapting a lens like this sounds like the perfect solution, there is one major drawback to be aware of: You won't get any autofocusing capabilities. Fortunately, this is not the biggest deal for video since you'll focus manually in most cases.

Adapters from companies like Fotodiox and Novoflex are good quality, well built, and fairly inexpensive. One restriction to be aware of is that although you can get an adapter to use your favorite Nikon lens on your Canon camera body, the reverse is *not* true. Why? The reason is the difference in the flange distance to the front element on Canon lenses. For many other lens brands, adapting them to a Canon mount is also an option.

▲ Mount adapters like this one from Fotodiox allow you to adapt lenses from one camera system to another.

▲ The crop factor of a camera can dramatically influence the framing of a shot. The image on the left was taken with a full-frame (no crop) body while the image on the right simulates a shot with a 1.6-crop factor body. Both shots used the same lens.

Image Stabilization Lenses for Video

One lens feature that you've probably used on lenses when taking stills is image stabilization (IS for Canon lenses and VR for Nikon lenses). This technical miracle makes getting sharp shots in low-light, slow shutter speed situations much easier than without a stabilized lens. So what about using image stabilization for video?

We think that IS lenses are a great choice for shooting video, especially in handheld situations and interviews. If you can get around a few potential issues IS lenses can really shine. The first issue is battery power. When shooting with an IS lens your battery will be drained faster so you'll want to carry more batteries in your kit or be prepared to charge more often.

Another issue is audible noise. Most IS lenses use a complex system of tiny motors and gyroscopes inside the lens to correct for movement. If you're trying to record audio with the built-in microphone or with an on-camera microphone mounted in the hot shoe of the camera, those mics might pick up the tiny motor noises of a working IS system.

While IS systems do work very well, they can't work miracles. You can't depend on an IS system to compensate for every bump and jump in a piece of video. Instead of going high tech, sometimes the best solution is a low-tech one: physically stabilizing the camera on a tripod. We're not saying that image stabilization is evil, but it should not be your first or only choice of stabilization.

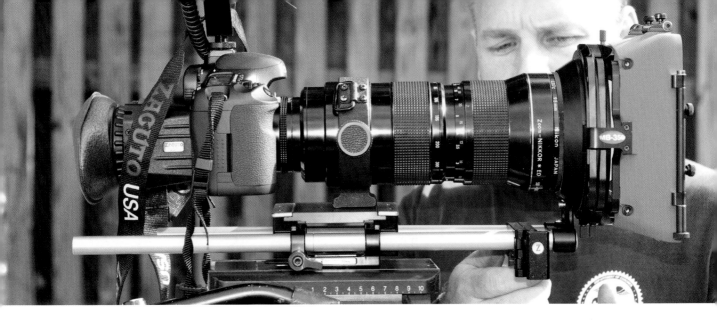

Focal Length

A major choice you'll have to make when selecting lenses for video is focal length. As a photographer, you're probably accustomed to having a wide variety of focal lengths for different purposes. In general, the video world is no different. Having a range of focal lengths can help you in many situations. However, when shooting video, you first need to consider that often you can't or don't want to get very close to people when shooting a scene. So even though we like to have a variety of lenses with us on a shoot, we tend to choose lenses for our kit that are very wide and very long.

Focal length is also a key ingredient to telling a story. An image framed exactly the same with a 14mm, a 50mm, and a 135mm lens have different interpretations entirely. Wider lenses require you to be close to the action, yet provide deep focus and broaden facial features and architecture. Longer lenses compress the action, thus isolating subjects due to shallow depth of field as well as narrowing facial features. Middle focal lengths closely mimic normal human vision. The choices you make influence your shooting style significantly.

Here are some essential focal ranges we have in our kits (in your own projects you may find it necessary to have lenses that fill in the gaps).

10–35mm: Depending on the body you're using (cropped or noncropped image sensor), lenses in this range are best for wide-angle shots. In video work these lenses are great for taking in lots of action in a scene or for establishing shots for a scene. They let you see the big picture without having to position yourself far from the action.

50–100mm: Lenses in this focal range work great for portraits and interviews. Be sure to think about the effect of the close-up on your subject. Does your subject need makeup? Is the lighting flattering? Lenses of this length can start to show tiny details you may want to avoid.

200mm or greater: Long telephoto lenses are ideal for compressing the background of a scene but are also perfect when you want to let the action unfold in front of you without having to actually be in the action. Additionally, we love long telephoto lenses to get close-up shots of hands, facial reactions, and small details that really help tell a story.

Lenses can come as primes, which have only one focal length on the lens, or as zooms, which provide a variety of focal lengths. Later in this chapter we talk more in detail about when to use primes, zooms, wide-angle, and telephoto lenses in video work.

Converting a Photo Lens to a Cinema Style Lens

Lenses for DSLRs were intended to shoot photographs, not video. Of course video has a whole bunch of different requirements, and as such, many people choose to convert their lenses to cinema style lenses. Before we tell you about the advantages and disadvantages of converting a photo style lens to a cinema style lens, keep two facts in mind: When converting your lens to a cinema style lens, the lens will often need to be completely taken apart. This *will* void any warranty that you might have on the lens. Also, many of the lens conversion companies do not guarantee or warranty their work. Even so, we've used several converted lenses and the change is welcome.

Zoom and focus dampening: One problem that you'll quickly find frustrating when using a photo style lens to shoot video is that the zoom and focus rings on a photo lens are too sensitive. The slightest movement can change your focus or zoom. When converting a photo style lens to a cinema style lens, dampening is one of the main objectives. This makes the controls a bit more resistant (and therefore offers smoother transitions in movement).

De-clicking aperture: If you're using a lens that has a manual aperture control on the lens, converting a photo style lens to a cinema style lens will "de-click" the lens so that you can do "splits" between apertures like videographers do with their traditional video cameras. This makes it easier to change a shot as the subject moves through different lighting conditions in a scene.

Gearing: Although you might be using a follow focus system that comes with gearing, that type of gearing is usually just a strip of hard plastic that attaches to and goes around the built-in focus ring. When converting a photo lens to a cinema style lens, it's possible to have gearing for a follow focus system built into the lens. Sometimes this is accomplished by press fitting a Delrin focus gear that is specially matched to the diameter of the lens.

Focus, zoom, aperture ring direction: Some lenses (most notably Nikkor lenses) focus, zoom, and adjust aperture in the opposite direction of most cinema style lenses. So, when converting a photo style lens to a cinema style lens, focus, zoom, and aperture direction can be reversed. Just be aware that this is a very time-consuming procedure, which means it's expensive to have the conversion done. Depending on your background, this change can make your gear feel more familiar. But it may also mean spending lots of money only to confuse your motor memory. Think long and hard about "flipping" the controls.

▶ This Nikkor lens was converted to a cinema style lens. Note the press fit Delrin focus gear.

▶ #15

Aperture and Lens Choice

When choosing a lens for photography, you typically want the fastest lens: In general, the same holds true for video work. One of the main advantages of a fast lens is that at wider apertures (f/1.8, f/1.2, and so on) the ability to leverage the amazing depth of field characteristics of a DSLR sensor becomes much easier.

Of course, a fast lens has one major drawback—price. But even though fast lenses are expensive, having a few in your bag is essential for photo and video work. We recommend using lenses that have an aperture of f/2.8 or larger. If your scenes will have quite a bit of light available (like when working outdoors), an aperture of f/4 should work just fine, and those lenses have the benefit of being cheaper.

One other detail to consider about aperture and a lens is where the aperture control is for the lens. Some lenses (like many from Nikon) have an aperture ring alongside the focus and zoom rings. This allows you to precisely control aperture during a shot and is very useful when you need to stop down in a situation like walking from indoors to outside.

Other lenses like those from Canon and newer ones from Nikon have electronic aperture control, meaning that aperture is controlled on the actual camera body. Electronic aperture control can be less expensive but has a major disadvantage in video. Unlike an actual aperture ring, which can be smoothly controlled, electronic aperture control jumps or pops as each stop is reached, which is not a desired effect to have in a video shot.

Match the Lens to the Shot

So you have an entire arsenal of quality glass: fast zooms, primes, wides, and telephotos. How do you decide which lens to grab when shooting a scene?

Like everything else, it all depends on *what* you are shooting and the environment you're in. We urge you to experiment in your projects. In this section we give you some broad guidelines for what lens or what type of lens to use when, but these are just guidelines. Your own aesthetic or the technical demands of the shot you're trying to get may require you to use a lens that's not normally used in a specific situation.

When To Use Prime Lenses

Most Directors of Photography (DPs) choose primes, both on feature films as well as independent projects, for two main reasons: speed and sharpness. A quality prime lens with a wide aperture of f/1.2 to f/2 allows you to shoot in existing light or low-light environments more easily. Primes are universally faster than zooms due to the way they are manufactured.

Prime lenses have less moving parts and fewer elements than zoom lenses. The result is a sharper image. Sharpness combined with the weight savings of having less glass in the actual lens means primes are go-to lenses for many pros.

Primes are great for videos in which you are able to control the environment. You are stuck with the focal length, so if you can block out any movement in the scene in advance, control the lighting, and want that nice shallow depth of field that these lenses deliver, prime lenses are a good choice.

The good news is that video uses many "classic" composition rules (which you learned about in Chapter 2). When you combine these rules with good camera support (which you'll learn more about in Chapters 11 and 12), you won't find primes to be very limiting in most situations.

When To Use Zoom Lenses

Zoom lenses are often used when you need to change focal length quickly or you need the versatility of different focal lengths because of the situation. However, you'll find that making smooth zooms while recording is difficult to do with most DSLR lenses because the zoom ring doesn't have a lot of dampening and zooms will tend to have a jerky feel to them. We tend to zoom and then shoot, only utilizing the zoom to frame the next shot.

With that said, many documentary shooters use zooms because there isn't a way to stop the event or subject just to change lenses, and it certainly is useful for example to be able to go from a 50mm standard shot of the interviewee to a nice 200mm close-up to emphasize a key moment with just a twirl of the wrist. If you are in a situation where you can't buy/rent/carry as many lenses as you want, a zoom lens is a good compromise.

There is a trade-off between zooms and primes. Zooms are generally slower than a fast prime, so you'll need to raise your ISO to match the exposure of an equivalent prime. But this isn't a bad trade-off for the versatility a zoom affords you.

Using Wide Lenses

Wide-angle lenses are probably the most coveted pieces of glass (even more so when they're wide-angle prime lenses) among photographers as well as videographers. Nothing can quite convey a vast landscape, provide a child's low-angle point of view, or establish a key opening scene like a nice wide view.

Beware, a visible barrel distortion is inherent to wide-angle lenses when a subject appears close to the lens. In some cases, such as in music videos, this may be a look the director is specifically going for.

If that isn't the look you want, you must carefully pick the correct focal length to give you the frame you desire without unnecessarily distorting straight lines within your shot.

▲ We find that zoom lenses offer greater flexibility in focal length but a prime lens has better performance in low-light situations.

► #16

Using Telephoto Lenses

Telephoto lenses, aka the "big guns," are very useful for compressing space, allowing you to make your subject and the background seem "flatter," and imparting a nice soft focus to the background.

"Teles" are great for portraits, but you already know that. What you may not know is that they are very useful in interview situations for getting a more natural reaction from your interviewees. Why? You are not right on top of them with a shorter lens, so most likely they feel a bit more comfortable and less intimidated with the camera farther away.

You'd be surprised at how differently someone reacts when the video camera is positioned an extra three feet away. Try it and see.

Using Specialty Lenses

Many other out-of-the-ordinary lenses are available that, although they may seem to be "one-trick ponies," you may find very useful for certain situations where no other lens will do.

Macro lens: One specialty lens we love to have with us on a shoot is a macro lens. A macro lens lets you focus extremely close to your subject. Many macro lenses have the ability to focus 1:1, meaning that your camera can actually see the object you're focusing on at life size. In video work macro lenses are great for small details like shooting a ring on a hand and for product shots where you want to see the tiniest of details.

Fisheye lens: A fisheye lens is an extreme wide-angle lens that doesn't even try to correct for the geometric distortion that you can get with wide-angle lenses. For video work a fisheye lens can create a cool effect in tight spaces like a car or in situations where a stylized look is what you're going for, such as when shooting a skateboard or extreme sports video.

Lensbaby: A Lensbaby is a selective focus lens that uses a bellows system to add a smeared effect to the out-of-focus parts of an image. These lenses are very affordable and can produce very cool stylized shots with little effort.

Tilt/Shift lenses: Although they are not often used in video work, Tilt/Shift lenses can create an intriguing effect that makes a scene look like it was shot in miniature. They are very useful for achieving shots like looking into a mirror without seeing the reflection of the camera or looking straight up a building and eliminating the keystone effect of the building's lines of convergence. They can also be used to create captivating selective focus looks.

VIDEO #13: FOOTAGE DEMO ILLUSTRATING THE LENS SELECTION PROCESS

Check out this video to see demonstrations of how different lenses are utilized for different purposes. We show you several shots from the music video and identify which lenses were used.

Using a Follow Focus

Although much of the equipment we talk about in this book is the same or similar to equipment you may have used in photography, the one piece of equipment that is most likely completely foreign is a follow focus.

As its name implies, a follow focus allows you to "follow" the focus using gears that attach to your lens and a focus knob. There are two main reasons to use a follow focus system: First, it allows for more granular and precise focus; second, it allows you to measure out-of-focus distances, which makes dealing with scenes that have mixed focus ranges much easier.

Setting Up a Follow Focus

The first step when using a follow focus on your camera is to properly install the system. Although every system differs slightly, most systems attach to standard 15mm rods that attach to the camera body (we talk more about rod systems in Chapter 12).

Once the follow focus is attached to the rod system, the next step is to attach gearing to your lens. The gearing that comes with many focus systems is simply a notched piece of hard plastic that is secured around the focus ring on the actual lens. You can usually purchase extra rings from the follow focus manufacturer. These rings can be left in place when you're shooting stills and when you're not using the follow focus system. If you've converted a lens to a cinema style lens, the gearing may already be built into the lens.

After attaching the gear, simply line up the follow focus and the gear notches. It's always a good idea to test the follow focus by turning it to the extreme ends of the focus range a few times to make sure the gearing doesn't slip.

▶ Most follow focus systems use gearing that consists of a hard plastic ring that is attached to a lens by measuring and then cutting the gear to length. Make sure the gearing fits snuggly on the lens to avoid having it slip.

Marking Focal Distances

Once the follow focus is set up, using it is pretty simple. Just turn the follow focus knob to adjust the focus range. What's nice is that when using a follow focus, it's much easier to adjust focus because you don't actually have to put your hand on the lens. This lack of contact prevents vibrations and any slight shifts in the lens position.

GET A FOLLOW FOCUS
Some Follow Focus manufacturers include:

› **Zacuto** (www.zacuto.com)
› **Red Rock Micro** (www.redrockmicro.com)
› **Cinevate** (www.cinevate.com)
› **D Focus** (www.dfocussystem.com)
› **Indi System** (www.indifocus.com)

USING A FOLLOW FOCUS ON A LONG SHOT
If you have a long shot, it's OK to set many different points to mark focus. As a general rule, marking these points at every 5–10 feet allows you to keep a consistent sharp focus.

The greatest advantage of a follow focus system is its ergonomic advantage. However, another benefit is that you can precisely set focus. How?

Well, it's a two-step process. You should first mark or block out places in the scene where you need to be in focus. A good rule of thumb is use the start, middle, and end of the shot. You can mark these positions with tape marks, cones, or chalk if they won't be viewable in the scene. Otherwise, you can go low tech by selecting something like a few fence posts next to your scene as points where you need to mark focus. Then, on the actual follow focus system, use the marking disc around the follow focus knob to mark focus points. Focus points can be marked with a dry erase marker, a grease pencil, or points of tape. You want to mark focus at each point (cones, fence posts, etc.) that you set up in the actual scene.

For example, let's say you have a scene in which someone is walking toward the camera. To precisely mark focus, mark a point on the marking disc where focus should be set at the start of the shot (first marker), middle of the shot (second marker), and end of the shot (third marker). Rehearse the shot a few times, adjusting focus to the preset points. When you actually record the shot, you'll get precise focus.

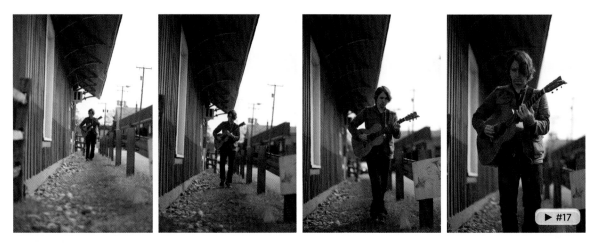

▲ By using cones or other types of marks along a motion path you have focus reference points that you can mark on your follow focus system.

▲ By marking focus points on the marking disc of the follow focus system an operator or assistant can precisely focus during a shot.

Using an Assistant on a Follow Focus System

You've purchased a follow focus system, hooked it up to your camera, and gone out to the field, only to find that operating a follow focus when you must be precise about the focus distance is a bit awkward. If you have the crew to support it, you can have a crew member turn the follow focus. On big budget feature films, this person even has a title—a focus puller.

Although you, as the camera operator, have your hands full, constantly assessing framing, performance, lighting, and all the other information coming in through the viewfinder, your assistant takes on the focus pulling duties for you. This person generally assumes a position close to the camera, has a hand on the focus knob, and simultaneously watches the moving subject and the marks on the follow focus knob or the lens barrel. It's important for this person to be able to develop the skill to watch both, and in time look less and less at the lens and more at the subject. Why? As a focus puller, if you are looking at the lens, you can't react fast enough to sudden or unpredictable changes in motion. Your eyes should be watching the scene, and your hands, with practice, should memorize the physical throw of the lens barrel so you don't have to look at it as much. Good peripheral vision is critical here, and using bright, contrasty colors on the floor marks as well as the lens marks helps to pick up the delineations much easier.

Rehearsals are advantageous to get everything in sync. If the shoot involves a moving camera that requires cooperation from another crew member, like a dolly grip or jib operator, the person moving the camera also needs to get accurate focus points relative to the actual focus marks on the follow focus system. A focus mark doesn't mean much if the person moving the camera doesn't also hit the correct marks!

It's important that the shooter and the focus puller practice the shot a few times, not only for focus distances but also body position. Unfortunately, we've witnessed a few rare situations where the focus puller and the camera operator have gotten their legs crossed, and the next thing you know both people and the camera ring are on the ground! It's not pretty.

WHIP IT!
A fantastic accessory for a follow focus system is a whip. A whip attaches to the follow focus knob and typically comes in lengths of 12–24 inches to allow a focus puller to operate from a distance. This allows the camera operator to be more comfortable and is useful if the camera is moving.

VIDEO #14: SETTING UP AND USING A FOLLOW FOCUS
A follow focus is an essential piece of equipment for a video-enabled DSLR to achieve sharp focus. Check out this video to see how a follow focus works.

Get a Steady Shot

Basic Camera Support

Although it may seem contradictory at first, a primary theme of this book is to make the camera invisible. After all, you're trying to create an engaging story that wraps the audience in the narrative and emotional arcs of that story. However, you'll need to add more gear (like a tripod or monopod) to keep the camera stationary.

If your video shows any visible camera movement that your viewers notice, they are often pulled out of the story and into the technical or even awkward details of your production. You don't want your viewers distracted by technical flaws. You want them to notice the subtle and dramatic details that you've composed for them. Keep in mind that it doesn't take much to take your audience out of the moment.

The goal to strive for is that of an invisible observer of the action. Anything different and you'd better have a very good reason for it. This objective is no different than the technical expertise most photographers strive for when shooting stills. We've all seen the negative effects of image blur caused by low light or a shaky grip. The blur makes your audience think less about the subject or scene and more about, well, something else.

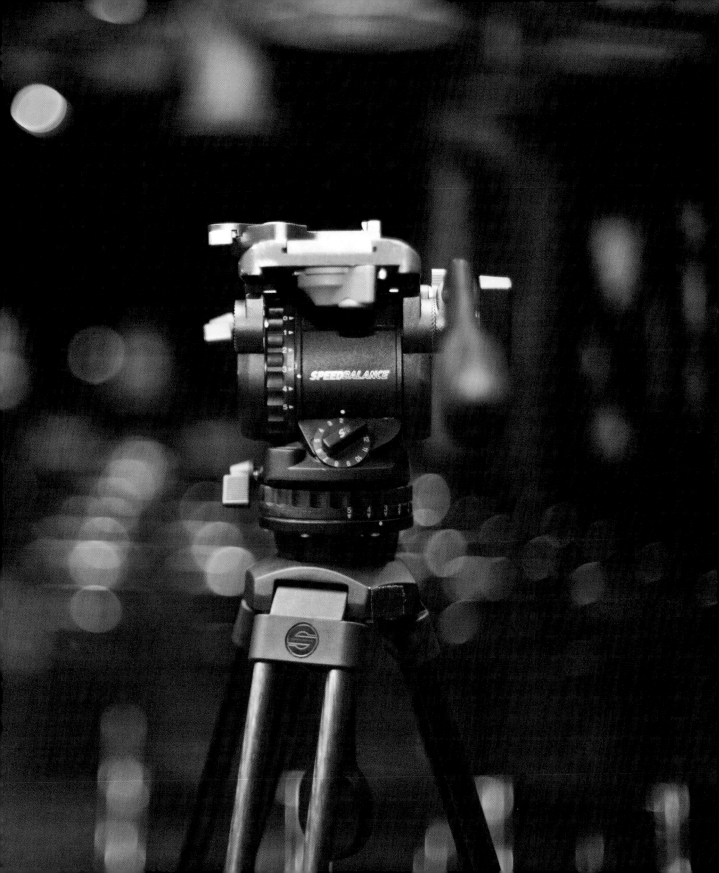

While shooting stills, you can freeze the moment with a fast shutter. But with video you get all the wiggle and ugly bumps.

One tenet that is literally drilled into those studying videography and cinematography is to *use a tripod*. It cannot be said enough times (use a tripod). Sure, there'll be times when you'll need to break this rule and put the camera in motion, but you can't go wrong with a steady shot (even systems like shoulder rigs and Steadicams are designed to produce smoother shots).

Supporting a camera while shooting video (and keeping it steady) is much more difficult than you think. While shooting stills, you can freeze the moment with a fast shutter. But with video you get all the wiggle and ugly bumps.

You might think it's easy enough to just lock down the camera. But that often doesn't work. When shooting video, you not only need to keep the camera steady for the duration of the shot, but also for any movement. All camera moves, such as pans or tilts, need to be executed precisely and with a degree of steadiness.

Going Handheld

Before we explore mechanical support, let's start with a more organic support—one we all know. DSLR cameras keep getting smaller and lighter. From a weight standpoint, it seems easy (and even natural) to just hold the camera in your hands.

The camera you've chosen probably even feels good resting in your hands, perhaps a bit powerful. Most likely you can imagine yourself scoping the scene, waiting to spring to life and catch the shot. Although that works well for many still shooters, you may be surprised with the results you get when shooting video.

In this age of high-energy shooting and fast-paced editing, we all shoot handheld. In fact, there also seems to be lots of requests for natural-feeling video. In these cases, shooting handheld is the way to go.

Another advantage is what we like to call "stealth mode." Just about every photographer knows the feeling of being chased down by the "tripod police." These days, people are very camera conscious. Keeping your gear compact attracts less attention. There's something to be said for blending in with the crowd as "just another tourist."

Why Shoot Handheld?

We know you'll do some handheld shooting (even if you might suffer in terms of steadiness). The main reason to shoot this way is the extreme versatility you get by being able to move and adjust on the fly. In fact, nothing is faster than handheld shooting. There is no extra gear to set or weight to carry (which makes the option seem hard to beat).

Handheld Techniques

If you talk to several shooters, you'll find out that they often disagree on handheld techniques. Some swear by a strong grip that crosses the body. Others wrap the camera strap around their arm for additional support. We'll even use the neck strap as a point of contact to get a wider brace for handheld shooting. The simplest advice is to go with what you know. Use your existing technique and shoot like a still photographer.

▼ Matt braces the camera using the neck strap as a point of contact.

▼ Shooting handheld is passable in situations with adequate lighting.

▶ #18

▲ Using a loupe for your camera (like this one from Hoodman) can provide an additional point of contact to stabilize the camera.

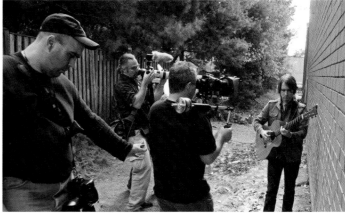

▲ Rich keeps his hand outreached to "spot" for Jim as he walks backwards. A fall is not good for the camera or the photographer.

Unfortunately, you'll quickly see the limitations of the handheld approach. Normally, when shooting stills, your eye will view images through the DSLR viewfinder. This provides a point of contact (generally your forehead) that provides a great deal of stability. When shooting video, the viewfinder is taken out of commission.

Enabling the Live View or Live Function on the camera shuts down the viewfinder and shifts the image to the LCD screen. This is not the natural place to direct your eyes when trying to operate a smooth continuous video shot. You are forced to hold the camera away from your body to properly see the image on the LCD.

Quickly, that comfortable grip becomes awkward. The camera feels heavier (especially if it's equipped with a long lens). Oh yeah; hold that position for a 3-minute shot (without shaking).

If you're shooting handheld, the absolute best addition to your kit is an optical viewfinder (mentioned in previous chapters). The viewfinder essentially magnifies the LCD screen so you can see critical focus. It also provides a soft eyecup. Although it's true that the main purpose of a viewfinder is to isolate the image surface from outside light, there is a secondary benefit. Resting your eye against the eyecup provides a stabilizing point of contact and improves your ability to comfortably operate the camera handheld.

Minimizing the Human Element

For all the advantages you gain in the versatility of being a human camera platform, there are some strikes against you. The human eye can compensate for all sorts of undesirable movement. You probably don't notice the gentle undulations caused by breathing. Running is not a jarring experience for most, even though the path may be bumpy. Unfortunately, the camera sees it all!

One of the most noticeable effects of handheld camera work is the jolt of footsteps. As you walk with a camera, there will be subtle (and possibly dramatic) "bumps in the road." You might choose to operate this way for a specialized look, but you'll usually want to smooth out your shot. Here are a few ways you can steady the camera while walking.

A STABLE STRAP

We'd like to thank Scott Kelby for turning us on to this little gem. The Black Rapid R-Strap allows you to comfortably hang your camera from your shoulder and provides a nice level of additional support (without neck strain). Be sure to check it out at www.blackrapid.com.

Use your upper body: As you walk, try to "separate" your body into two parts, using your arms and shoulders to absorb some of the up and down motion of your steps. It's a subtle adjustment, somewhat like a shock absorber on a car.

Take soft steps: Try to take softer steps as you walk, and place the weight on the balls of your feet. The movement is almost like a dance step, light and deliberate.

Focus on your subject: Pay close attention to the subject or subjects you are following. Your movement should be in concert with them. Start and stop with them. This will let you hide your action in their movement. If you land in an awkward position when they stop, you can dampen the impact with your upper body, and subtly adjust position after you stop.

Pace your breathing: Breathing must be considered as well. You should think about the pacing and size of your breaths as you operate. Take larger, more frequent breaths as you move and smaller, more controlled breaths as you remain static. As you learn to control your breathing, you can actually increase your steadiness with longer lenses.

Stabilizing with a Tripod

This chapter began by drilling in the need for a tripod, which is one of the most important pieces of equipment you'll add to your toolbox. A professional tripod is actually two separate pieces: the head, which holds the camera, and the legs, which support the head. Unfortunately, we see many users rush to purchase a tripod (often underestimating its importance). We're not saying that you'll spend as much on a tripod as your camera, but you could!

Why Use a Video Tripod?

Eventually, you'll to need to put the camera on a solid platform. This is the best way to make the camera "disappear" from the story. By stabilizing the camera, it can operate more as an invisible window through which the audience can observe the action.

You probably have a tripod, since it is a standard piece in any serious still photographer's kit. However,

▼ A tripod provides a solid platform for your DSLR. While you can still use your photo tripod, a fluid head can make camera movement smoother.

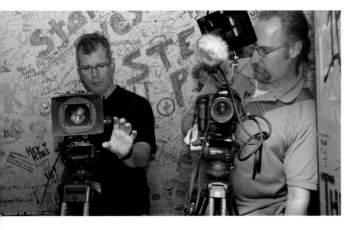

it's likely that your still tripod is not up to the task of handling a video shoot. Still tripods tend to be lightweight with heads that are easily locked into one position. These traits are not necessarily ideal for video.

Here are a few reasons you'll want to step up to a professional video tripod.

Fluidity: Ball sockets and cheaper friction heads are great for locking in your camera to snap a still frame, but are not good for the smooth pan and tilt movements needed to capture a moving shot. A fluid head with good hydraulic dampening is an option you want to invest in.

Precise movement: Accuracy comes at a price. You want a fluid head with smooth action all around. It should move with the slightest pressure, evenly, without sticking. When you stop, there should be no backlash or overshooting that comes with the slop or give in a cheap tripod head.

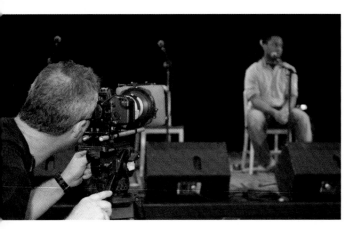

Sturdiness: You won't need to invest in a heavy-duty tripod because your camera is lightweight. But you'll likely want a tripod that is a little more solid than you currently have for shooting stills. A long lens on a larger tripod will be less subject to unwanted influences from touching, wind, or camera bumps.

Selecting a Fluid Head

In the world of cinematography, there is a huge range of tripod head choices. These heads can cost upwards of $15,000 and are designed to support heavy-duty film cameras that weigh as much as 100 pounds (or more). For the practical purposes of DSLR cinema, we'll discuss a fairly narrow family of fluid/friction heads.

Small still photography heads are limiting when it comes to smooth movement. But a bigger tripod head isn't always better. You need to match the weight of your camera rig to the head you are selecting for balance.

Most video tripod heads contain springs to counterbalance the fore and aft loads of a camera. When properly calibrated, you should be able to let go of the camera head without the head tilting one way or another.

▲ A rod system can provide flexibility when shooting on a tripod. You can adjust the camera's position as well as support longer lenses for proper balance.

Although these springs are often adjustable, they still have only a certain load capacity. For example, if you use a fluid head designed for a 20-lb camera and you have a DSLR aboard weighing in at 5 lbs, the result is a very stiff feel in the tilt function. You'll need to exert considerable pressure to tilt the camera up and down to overcome the power of those springs.

The ideal range of fluid heads for DSLR cameras can be found in tripod heads created for the digital video (DV) world. A few years back, a new class of cameras rocked the video world, shooting video with formats such as DV, HDV, and AVCHD. These cameras were often much smaller and lighter than their film and full-size professional brethren. A new breed of tripod heads was developed specifically for lighter cameras (and tighter budgets).

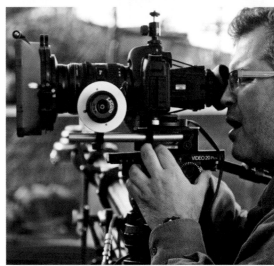

These smaller heads are mini versions of world-class, cinema-style heads produced by the industry's top manufacturers. You can spend as little as a few hundred dollars and as much as several thousand dollars on one. The difference in cost is based on the overall quality of the head, the weight it supports, and additional features that make the head more convenient to use.

Consider some of the following options when shopping for a tripod head.

Varying stages of counterbalance: DSLR cameras don't have the same profile as video cameras. As such, their weight often varies depending on how you've built your rig (lens choice, monitor, etc.). Being able to adjust the counterbalance lets you adjust the head so the camera rests in a neutral position.

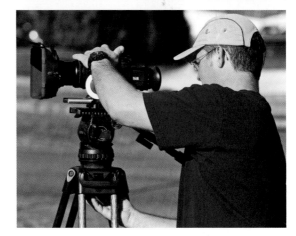

 TRIPOD HEAD MANUFACTURERS:

> **Cartoni** (www.cartoni.com)
> **Gitzo** (www.gitzo.us)
> **Manfrotto** (www.manfrotto.com)
> **Miller** (www.millertripods.com)
> **O'Connor** (www.ocon.com)
> **Ronford Baker** (www.ronfordbaker.co.uk)
> **Sachtler** (www.sachtler.de)

▲ A professional tripod head offers many options. You'll find tension controls (top) as well as a sliding base plate to balance the camera (middle). Having a ball level can be useful for shooting on uneven surfaces (bottom).

▲ Matt stages a variety of tripods for the day's multi-camera shoot. Fluid head tripods are mixed with standard photo tripods according to needed coverage.

▲ While a professional video-style tripod is an invest-ment, it provides the best shooting platform for most of your work.

A sliding base plate: Being able to slide the camera forward and backward on the plate is a great stability feature. As you change the length of lenses, this forward and backward positioning is essential to balance the camera.

Multiple stages for drag and dampening: Many shooters enjoy being able to tighten or loosen the resistance for drag and fluid dampening in the pan and tilt stages. This option lets you set the resistance so the tripod adjusts to you (instead of the other way around). With some of the more expensive models, you can actually make adjustments during a camera move.

Expanded tilt range: More expensive head models allow you to actually tilt the camera all the way up or down 90 degrees. You can also set the counterbalancing at any tilt angle so the camera has a new resting point.

Ball leveling: Ball leveling allows you to adjust the camera position right at the head. A ball level is identical to the bubble level you may have on your photo tripod head. It lets you adjust the head at the base rather than having to constantly raise or lower the tripod legs. This is especially useful on uneven terrain or when quick adjustments need to be made.

With practice, you can get pretty good movement from inexpensive heads. But as you shoot more, you'll likely see the value in having some of the other features included with more expensive heads. Keep in mind that gear exists to help you get the shot you want in the most efficient way possible. The less futzing you have to do to get the camera in the desired position the more productive your day can be.

Tripod Selection

Your fancy fluid head needs a platform to rest on. Tripods come in all sizes, and very often the manufacturer of your head makes a matching line of tripods as a system. In some cases you may be able to reuse your tripod legs from your still package, but be sure to at least look at the additional options available to you.

Multipurpose tripods: Ball level tripods are the most versatile. The fluid head mounts directly to the tripod. The ball diameter comes in standard sizes, and the relevant measurements for DV heads are usually 60mm,

MATCHING HEAD TO BASE
You can switch out any ball head with any bowl tripod as long as the diameter is the same. Adapters are available to accommodate a discrepancy if needed.

75mm, and 100mm. The matching bowl should match the ball of your head. Again, this style allows for quick camera leveling on any terrain.

Low-cost tripods: Flat base tripods are less expensive than ball level tripods. The head mounts to the tripod's flat surface via a notched key or a threaded screw. However, it takes a bit of skill to level the head by twisting, raising, and lowering the tripod legs to level them into position. Cheaper DV heads that use a flat base are not as modular as the ball level systems.

Tripod material: Tripods are made of a number of materials. The variations are based on weight and durability. Heavier steel and aluminum tripods are meant for durability, but they can be a drag to carry around. Lighter materials are often preferable, from lightweight aluminum to the very popular carbon fiber. Carbon fiber is tough and lightweight, and is also the most expensive. But how can you put a price on your back and knees?

Tripod height: Depending on your price point, you can vary the number of stages in your tripod. The stages determine the height range of your camera. Two-stage tripods are the most common. They allow for a lens height in the range of approximately 3 feet to 6 feet. Some models have an additional central post for added height, just like some of the still tripods. This center column should be avoided if at all possible because it makes the tripod less stable. The idea is to get an average height range; for the extremes, there are other tools available.

Short tripods: On the other end of the spectrum, several tripod models have the ability to "unlock" their legs and splay them out, allowing your head to be as close as mere inches from the ground. This is an extremely great option to have on your tripod, so keep a lookout for this feature if it is important to your shooting style.

VIDEO #15: SETTING UP A TRIPOD
Watch this video to learn how to build and stage a tripod for maximum stability.

Tripod stability: A feature known as a spreader is absent from most still tripods. This is simply an attachment near the bottom (at the tips or somewhere in the middle of the tripod) that connects each leg to the other and is great for added stability. When you set the spreader, it actually allows you to securely raise or lower the camera beyond its normal height range. As the legs move beyond their normal equilibrium position, the spreader adds just enough stability to often get a greater range.

Tripod Techniques

We assume you've used a tripod for your still work. The good news is that adapting to a video workflow is (for the most part) pretty intuitive. Remember, you need to follow the action. This means you'll be panning and tilting to maintain good composition throughout the shot, perhaps because your subject moves or you want to reveal an element in the scene.

▼ Many tripods offer spreaders to connect the legs to each other. This option greatly improves stability of the legs.

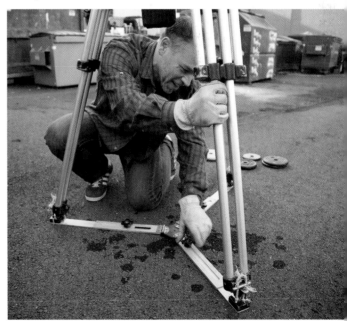

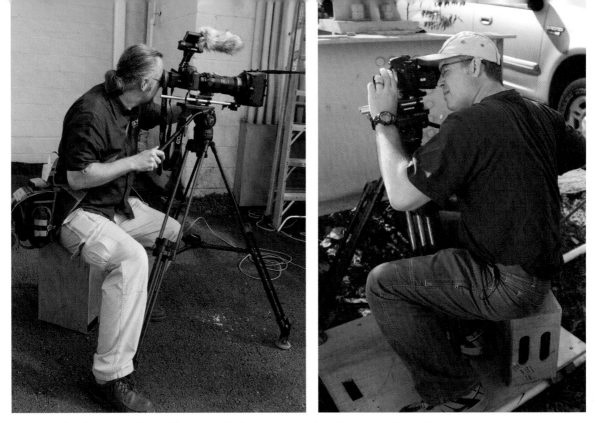

▲ When choosing a tripod, consider one with three stages such as the one on the right.

Here are a few practical pointers to optimize your performance.

Adjust the drag settings: Adjust the drag settings on your pan and tilt stages to match the action. Try using heavier friction for slow, precise moves. On the other hand, use a light drag for situations where you need to react fast or follow something moving at a fast pace.

Avoid fast pans: Fast pans create a "jello" effect. If you move the camera quickly, you need to be aware of the rolling shutter jitter (also called jello) that can happen. Because of the way the sensor scans an image, you might see vertical lines bent into diagonals by a fast pan. Be sure to pay attention to pan speed when shooting DSLR video.

Determine your primary angle: Properly counterbalance the head for whatever tilt angle you'll be using the most. If you'll be shooting a mostly aerial event,

you don't want to exert any extra pressure to keep the head in this position.

Be comfortable: Comfort is a necessity if you have to be in one position for a prolonged period of time. Position your eye at the viewfinder with a minimum amount of contortion and neck bending. This is not just for comfort. Ideally, you can be looking through the camera in such a way that you are also facing your subject. You can then see things outside the viewfinder coming your way. This position essentially lets you use both eyes (although you may need to alternate "winking" to keep the images straight in your head).

VIDEO #16: TRIPOD TECHNIQUES
Learn how to perform smooth pans and tilts using a video tripod.

Using Monopods

A monopod is really a compromise option between going handheld and using a tripod. As you know, a monopod offers a single-leg stabilization platform. The benefit of a monopod when shooting video is that you get a much more stable camera without all the fuss associated with a tripod.

A single leg is extremely portable and can add just the right amount of stability for what is generally a handheld shooting style. This is a good example of using a piece of equipment from your still photography bag of tricks that may save you at the opportune moment on a shoot.

The monopod works best for minimizing unwanted bouncing, because its leg limits the camera from moving up and down. Unfortunately, the camera can still move side to side because of the single leg support. A monopod is a great option to reduce body strain when a tripod is impractical.

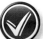

ADVANCED MONOPODS
Some of the more expensive monopods (such as the Giotto's MV-825) even have a simple pan and tilt head. You won't get the same precision as you would with a tripod and fluid head. But it might be the right tool for that in-between situation you find yourself in. You can also purchase a monopod with small, foldable tripod legs that extend for extra balance.

Recommended Tripod and Head Combos

Several different tripod and head models are on the market. Models constantly change and there are many options available. Here are a few possible combinations you can use as a guide that may match your budget.

Budget combos

> Manfrotto 190CX3 Carbon Fiber Tripod System with 501 HDV Head

> Cartoni SPD2 STATUS Pro Video Tripod System

> Manfrotto 055XDB Pro Tripod with 503HDV Fluid Video Head

Mid-range combos

> Sachtler 0375 FSB-4 Carbon Fiber Tripod System

> Vinten V3AS-AP2F Vision Pozi-Loc Aluminum Tripod System

> Cartoni F101 Focus Aluminum Tripod System with F100 Focus Fluid Head and Mid-level Spreader

High-end combos

> Sachtler Video-15SB ENG Carbon Fiber Tripod System consists of Video-15SB Fluid Head, ENG 2CF 2-stage Tripod, On-ground Spreader, and Hard Case

> Cartoni Z105 Laser Aluminum Tripod System consists of Z100 Laser Head, L502 2-Stage Tripod, Mid-level Spreader, and Soft Case

> Sachtler 1062 DV-10SB SpeedBalance Carbon Fiber Tripod System

▲ Getting the camera lower than your subject can offer additional dramatic shooting angles to choose from. Jim attaches the tripod head to a Hi Hat to get precise camera placement.

Other Tools

By design, your tripod can cover a standard range of shots that you'll encounter during the course of production. The tripod works well for covering events that occur from a waist level to eye level perspective.

Of course, your mind may be more creative than that. While trying to find interesting ways to cover a scene, you'll discover that to get the shots you want you'll need to move your camera outside the standard range, whether to position it low to the ground or high overhead. Perhaps you'll want to shoot from the hood of a car or at a funky off angle in the corner of a room. A number of tools are available to help you set up the camera in a dynamic and interesting location.

Low-angle Shots

From the shuffling of feet to the whizzing of traffic, there just always seems to be lots of interesting movement going on at ground level. Unfortunately, your tripod usually doesn't go that low. So what do you do? Well, here are a few options to consider.

Use a Hi Hat: A Hi Hat is essentially a short platform that holds the tripod head. Typically, it's a tripod bowl without a tripod. You can mount a Hi Hat on a flat piece of wood or aluminum and place it on the ground. Once you mount your compatible fluid head, you've created a flexible camera platform about a foot off the ground. This option is a great way to really get into the action at the lowest possible position.

Use a bag: If a Hi Hat is still not low enough for the shots you want, you may need to put the camera directly on the ground. We recommend using a sand bag, or better yet, a moldable bag like the Cine Saddle, which conforms to the contours of your camera. This protects the gear while providing you with a stable platform low to the ground. Remember our rule about operator comfort: This is a case where you'll want to monitor framing from an external monitor. Your neck muscles will appreciate it.

Try a rocker plate: Bags and wedges basically lock you into a camera position, but if you need to move the camera to maintain a certain composition, you might want more precision than just holding the camera in your hands. This is where a rocker plate can come in handy. They're also a great way to get Dutch angles when shooting.

The support is basically a flat metal or wood platform with a half-moon shaped mounting plate that "rocks" back and forth over the platform. From a ground-level angle, you can pan and tilt a subject into a close mark, literally standing over the camera.

Off-angle Shots

Although a level shot is often ideal, you may need to tweak the angle of the camera to overcome a difficult angle or an uneven mounting surface. Fortunately, you can take advantage of lots of equipment in your still photo kit.

Use the gear you have to get an imaginative angle for your video production. Many photographers already have a collection of grip gear for mounting lights and reflectors. Justin clamps, magic arms, and Mafer and Cardellini clamps can all be used to get the camera in just the right spot. If whatever you use can be mounted securely and hold the camera, give it a shot.

If you're in the market to buy some new gear, we've found some useful pieces that are affordable and versatile.

Gorillapod: Joby makes a wide range of Gorillapods that offer a camera mounting plate with bendable legs. The versatile SLR-Zoom and Focus models are

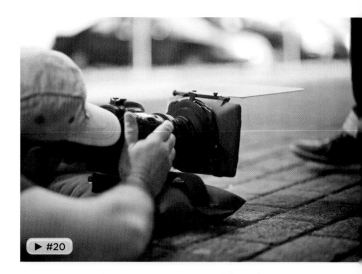

▶ #20

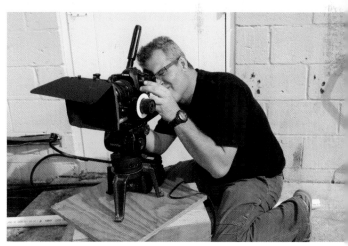

▲ Jim uses a sandbag to cushion the camera when shooting at ground level (top). An apple box is also a useful way to adjust the height of the camera platform (bottom).

WHAT ABOUT IMAGE STABILIZATION?
Although some lenses offer image stabilization, this can be tricky to utilize while shooting video.

FOLLOW THE ACTION. THIS MEANS YOU'LL BE PANNING AND TILTING TO MAINTAIN GOOD COMPOSITION THROUGHOUT THE SHOT, PERHAPS BECAUSE YOUR SUBJECT MOVES OR YOU WANT TO REVEAL AN ELEMENT IN THE SCENE.

robust enough to hold a DSLR camera with lens and allow you to mount the camera from a variety of surfaces (from tree limbs to doorways). Joby even offers a ball head with level and spike feet accessories to get more flexibility from its support system.

Dutch head: This head attaches directly to the quick release plate of your regular tripod fluid head. You might have a similar version of this with your still tripod. But this version allows you to move the camera on multiple axes during a shot, creating some cool effects. Although price ranges vary, we find the Cartoni APDH Digi-Dutch Head to be priced in line for DSLR video work.

Suction mounts: Found on the simple end of automobile mounts, suction mounts traditionally involve a lot of grip hardware to safely mount a camera to a vehicle. But with a good cup design and a safety strap, they can be reliable when you're trying to get an interesting shot. You can really take advantage of the small size of a DSLR to get these alternative angles in a timely fashion. One highly affordable option is the Fat Gecko Camera Mount by Delkin Devices.

High Angles

The easiest way to get a high-angle shot is to take your tripod and head to higher ground. This might be as simple as fully extending a three-stage tripod and standing on a stepladder. If that's not enough, you might need to actually raise your tripod higher off the ground.

Spider Pod and Scorpion Pod: Designed with mobility in mind, these two platforms help raise the operator and tripod a few feet above the action. They also fold flat for easy transport. Check them out at www.spidersupport.com.

Ladder Pods: Several different ladder pod models are on the market (including those designed for hunters). They consist of a simple platform and use actual ladders as legs. This lets the camera operator climb up and position the camera at a high angle above the action. Does this sound like overkill? Well, not when you consider the cost of renting something like a Genie Lift.

Image courtesy Delkin Devices

Image courtesy Joby

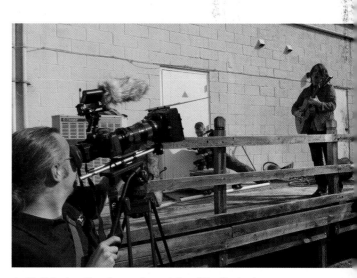

▲ Matt is shooting from a low angle while Jim is shooting off-angle. These two shots cut well together in the finished video.

Great Support

Putting the Camera into Motion

It's exciting to record action with a video-enabled digital SLR. You no longer have to freeze the moment, but you still may need to follow the action if you want to capture it. In the previous chapter you learned about basic camera support techniques like using tripods and monopods, but those are just the basics.

As you advance your career, you'll start to attract projects that will require higher-end production values. Great lighting and locations will be essential, but so will your camera handling abilities. Images will need greater polish. You'll quickly need to move beyond simple camera movements such as panning and tilting a tripod.

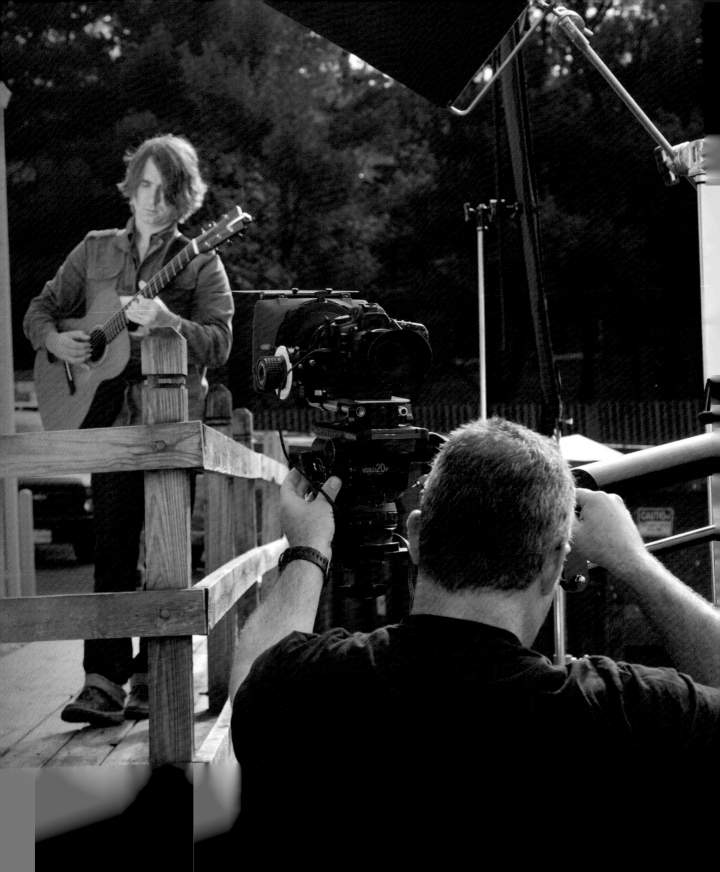

MANY DIFFERENT KINDS OF CAMERA STABILIZERS ARE AVAILABLE THAT LET YOU ACHIEVE THAT SMOOTH, GLIDING CAMERA MOTION THAT ADDS DYNAMIC ENERGY TO YOUR VIDEO.

You might want the freedom of walking through a scene to produce a photojournalist or documentary approach. Or the story may require a camera moving smoothly through space (not one that is limited to the organic bumpiness of a handheld shot).

Many different kinds of camera stabilizers are available that let you achieve that smooth, gliding camera motion that adds dynamic energy to your video. These types of moves greatly minimize the audience's awareness of the camera, allowing your viewers to fall deeper into the story being told.

In this chapter we explore several rigs and options. Keep in mind that much of this equipment can be rented from a local grip house; you won't need to invest in all this gear just to "get the shot."

Handheld Rigs

Photographers are drawn to shooting handheld. The rush of adrenaline from the ability to move quickly and find the shot and angle is liberating. But as discussed in Chapter 11, a video-enabled DSLR just doesn't have the ergonomics to shoot handheld. The form factor of the camera and location of the LCD screen make it difficult to balance in your hands.

A whole side industry has cropped up offering a number of rigs to help you further refine and expand your abilities to shoot handheld. Most of these rigs are designed to help distribute the weight of the camera (putting more of it on your shoulder, arms, or body). Good handheld operation is made easier by having a balanced rig close to your center of gravity, because movements are smoother if they originate from this center.

Try doing a slow, sustained pan with the camera held at arm's length, and then try it again with a shoulder-mounted rig. You should notice increased steadiness and comfort as you turn with your torso rather than your arms. Less moving parts essentially means less unwanted bumps and jumps.

Rigs vary greatly in price and features. Some are quite simple and provide a gunstock-style rig attachment that you fasten to the camera so you can brace it against your shoulder. Others offer features like shoulder pads and weights to help balance the camera and lens. These rigs typically require the shooter to keep one hand on a grip and the other on the lens controls.

Some rigs have an additional rod support at the waist or actually suspend the camera from a boom-type structure. The major benefit with these rigs is that they free up at least one hand to do other things rather than just supporting the weight of the camera. In some instances you may need two hands to operate the iris and zoom, or perhaps you might want to pull focus during a shot. You also may need a hand to brace or support yourself for safety. It's truly handy to have your hands free.

▲ Shooting rigs are a very personal choice. We highly recommend trying out different rigs to find one that's comfortable to your shooting style.

HANDHELD RIG MANUFACTURERS:
Lots of camera rigs are on the market. Start your shopping at the following places:

› **Cavision** (www.cavision.com)
› **Cinevate** (www.cinevate.com)
› **iDC Photography** (www.idcphotography.com)
› **Redrock Micro** (www.redrockmicro.com)
› **Switronix** (www.switronix.com)
› **Zacuto** (www.zacuto.com)

Stabilizers

The versatility in physically carrying the camera to get coverage is hard to beat. But even when using a hand-held rig, quite a bit of human movement in the image is still noticeable. As you walk, the camera will bob up and down (unless you learn to levitate). In this section we discuss workarounds in the form of stabilizers to reduce unwanted camera movement.

Smoothing Motion

How can you preserve mobility, yet remove even more motion influenced by the human body? The answer is to isolate the camera from the body's movement, which can be achieved by mounting the camera to a stabilizing rig. This device essentially distributes the mass of the camera in such a way that it allows you to actually operate the camera at its center of gravity. This greatly minimizes the shakiness of the image even when you touch the stabilizer.

To further isolate the bumps in the ground and operator unsteadiness, the entire rig can be mounted on a three-axis gimbal to balance the camera rig. Once separated from operator influence, the rig will float gracefully throughout your move, simulating more closely the perception of the human eye.

Choosing a Stabilizer

Camera stabilizing rigs vary in complexity and performance. They all generally have the sled and the gimbal system. You can classify rigs into two groups—handheld and body-mounted systems—based on how the rig isolates the body's movements.

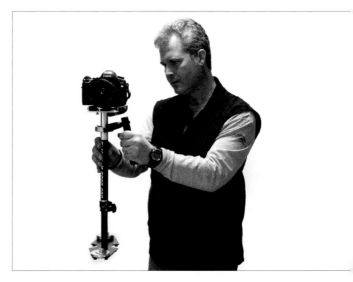

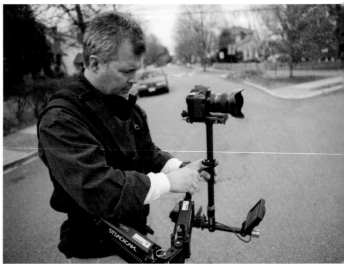

▲ The Steadicam Pilot in action. The photo on the bottom is of a vest- and arm-supported model designed to handle very lightweight cameras.

WHEN IS A STEADICAM NOT A STEADICAM
You'll often hear camera stabilizers referred to as "steadicams." In fact, a Steadicam is a brand name of the most popular (and original) camera stabilizer. It's similar to how folks refer to Kleenex or Xerox instead of saying facial tissue and photocopy.

BUILD YOUR OWN STABILIZER?
Want to build your own stabilizer? Then check out www.steadycam.org.

The low-tech versions are considered handheld stabilizers and are literally supported at the gimbal by a handle. You carry the entire rig around using your arms and upper body. This obviously limits the load you can carry, which is not much of a problem with your lightweight DSLR.

HANDHELD STABILIZERS

One group of handheld stabilizers is relatively affordable. They are typically priced under $1000 and can go as low as $200. Some of these units offer multipurpose features, like the low mode and monopod functions of the FlowPod. If you are just getting used to a stabilizer or are budget conscious, purchasing a reasonably priced rig is a great place to start. Here are a few to check out:

› **Glidecam HD-1000, HD-2000, and 2000 PRO**
(www.glidecam.com)

› **VariZoom FlowPod and UltraLite**
(www.varizoom.com)

› **Tiffen Steadicam Merlin**
(www.tiffen.com)

› **SteadyTracker UltraLite**
(www.steadytracker.com)

One handy feature with some of these handheld stabilizer rigs is that you can actually convert them into a body-mounted version (discussed next). You'll need to purchase a specially designed arm and vest so you can attach the rig to your body. Steadicam makes such an arm and vest combination for its Merlin. You can use the Sportster arm and vest by VariZoom, which will work with the Merlin and VZ FlowPod or VZ UltraLite.

 NO LCD
When using a stabilizer, you won't easily be able to see the back of your DSLR LCD screen when operating. For a body-mounted system, try using an attached larger monitor so you can frame your shots. Some kits include monitors, or you can add one from Marshall Electronics or Small HD.

VEST AND ARM STABILIZERS

The other group of rigs uses a higher-tech mechanical arm to support the load. This arm attaches to a body vest that the operator wears. These rigs are much better at eliminating your body movements from the camera image, but they are pricier:

› **Tiffen Steadicam Pilot and Flyer-LE**
(www.tiffen.com)

› **Glidecam Smooth Shooter and X-10**
(www.glidecam.com)

› **VariZoom ProLite and GT**
(www.varizoom.com)

BUYING ADVICE

The vest and arm rigs can cost up to several thousand dollars. However, the major draw is that they can boost your operating capabilities like no other piece of equipment. How else can you achieve an extended, smooth shot running up stairs, through a forest, or across a sandy beach?

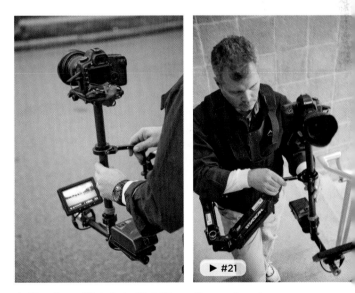

▶ #21

▲ Steadicam Pilot sled with LCD monitor, vest, and isoelastic arm. Note that the hands grab the sled just below the gimbal, near its center of gravity.

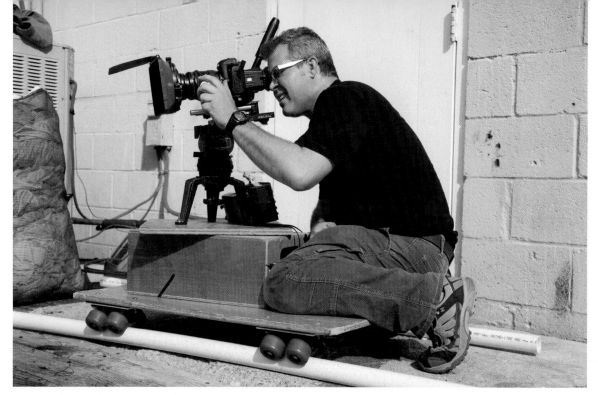

▲ You don't need much to make a dolly for your lightweight DSLR. A piece of plywood and some skateboard wheels will do the job.

When it comes to stabilizers, many models are offered by established manufacturers. Be sure to look carefully at the recommended weights for each stabilizer. You need to choose a model that handles lightweight cameras like your DSLR. The previously mentioned models are perfect for cameras in the 2 to 6 lb weight range, but there are many more on the market.

You'll also want to ensure that the rig fits your body type and is comfortable to use, especially if you're bigger or smaller than average. Do your best to rent or borrow a rig first so you can try it out.

VIDEO #17: STABILIZING A CAMERA IN MOTION
See how the different camera stabilizers work. In this video, you'll see footage acquired with each of the stabilizers mentioned in this chapter. You'll also learn how to set up the devices for proper use.

Dollies

The camera dolly is one of the more traditional methods used to execute smooth tracking shots. Several established manufacturers—such as Fisher, Chapman, and Panther—produce very heavy, precision dollies in the film industry. All these are way too big for your DSLR! They are designed for larger motion picture and video cameras. However, a number of portable dollies are available to meet your needs. They all consist of the basic elements: a platform and wheels.

The Platform

The platform is where you mount your camera so you can roll it through your shot. It can be as simple as a flat surface on which you place your tripod, or it can have a pedestal-type column. You may also find that your fluid head tripod may simply move from your tripod sticks to a bowl adapter.

Some platforms are large enough for the operator to sit on and ride along with the camera. Others are much smaller and compact but require the operator to walk next to the camera. Some versions are so small that they have no height whatsoever. In this case you'll need to elevate the track and platform off the ground to your desired height.

Many shapes and forms are available to choose from:

> **Long Valley Super Track Dolly**
(www.longvalleyequip.com)

> **Molly Manufacturing Smooth Pro**
(www.mollymanufacturing.com)

> **CamTramSystem** (www.camtramsystem.com)

> **Indie Dolly Systems** (www.indiedolly.com)

> **VFGadgets Shooter Scooter**
(www.vfgadgets.com)

The Wheels

The business end of your dolly is the wheels. They run on a rail track that you set and level to the specifications of your intended shot. It's important that the wheels provide smooth rotation so that the dolly maintains constant contact with the track. Even the slightest vibration will show up on camera.

In lower-budget designs, a sled dolly system uses a series of skateboard wheels built onto a slanted block. Four of these blocks mount onto a rectangular platform, or three mount onto a tripod frame. The wheels are soft to absorb any of the dirt or defects on your track.

The more pairs of wheels you put into contact with your track the smoother the move will be. So, you will see block sets in two, four, six, and even eight wheels. The heavier the camera the more wheels you'll need. For DSLR cameras, your dolly will work well with the smaller block sets.

RIDING A DOLLY?
The more weight on your dolly the more wheels you'll need for a smoother ride. Your extra weight can help stabilize the shot.

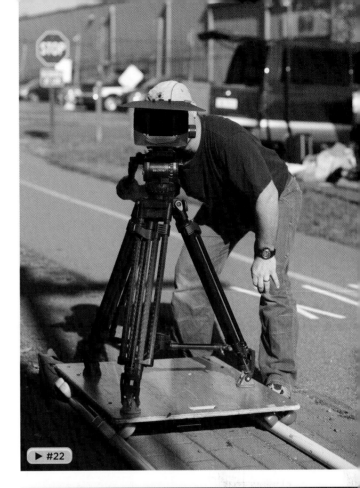
▶ #22

▲ A low budget dolly constructed with a slab of plywood and some skateboard wheels attached to a floating angular block. It can run on any length of tubing you like; in this case, PVC pipe.

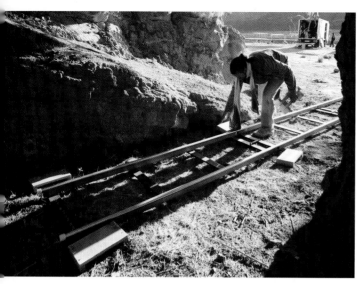

▲ Standard steel track being leveled with step blocks and wedges.

▲ The CamTramSystem will roll smoothly on just about anything, including the extension ladder in your garage!

The Track

The wheels of a dolly are constructed on angled blocks to mesh with the dolly's tubular track, which is a more precise surface than most floors. One benefit is that the track provides a no-bump surface. It also allows for a fixed route for the camera. As a result, there is less deviation when you are trying to hit marks accurately during your camera move.

The industry standard for track is a round anodized steel track that runs in eight-foot and four-foot sections. There is also curved track in a couple of different turn radii, depending on how tight the route needs to be. To use curved track, your wheel assembly must also be able to rotate along the curvature of the track.

A box of wooden wedges and risers (called step blocks) can be used to level the track on uneven surfaces. The sections join together with guide pins and locking levers. The track is heavy, durable, and reliable but not always practical to carry around.

Several of the skateboard dolly makers have a version of lightweight round track to complete their kit. These tracks can be made of lightweight anodized aluminum or tricked-out PVC pipe. They are convenient

but overpriced. Figure on paying up to several hundred dollars for PVC pipe that's been painted black and put in a fancy carry bag. So, it's best if you pick up some pipe at a nearby hardware store for $10 to get the same results.

Some systems, like the CamTram, actually allow you to be even more creative with your tracking surfaces. The wheel system is designed so you can use all kinds of easily available items to track on, from 2 x 4 sections of lumber to your basic aluminum extension ladder.

NO DOLLY TRACK?

Some dollies are designed to roll over available floor surfaces by using wide, inflatable or hard tires. What you may lose in precision and smoothness you gain in the freedom to roll beyond the confines of laid track. This is also important if your move is such that you might have a hard time concealing track as you continue through the camera move. These dollies almost always have the ability to switch to track wheels for flexibility. You can also find small dollies that can attach directly to a tripod.

Dolly Technique

It seems simple enough to execute a dolly move, right? Push the thing from point A to point B. But there are people who actually specialize in this job; they are known as dolly grips. You'll see them wearing radio headsets, watching their own video monitor, and hitting marks just like the actor performing in front of them. So what do they know that's so special? Here are the techniques you need to know to move a dolly like a pro.

Follow the action: Dolly moves are the same as any camera move. The action should be motivated by the story or the performance. There is always a sense of purpose to the move. You'll either move or stop with the actor (with gradual acceleration) or deliberately track in and out of position to advance the intent of the designed shot.

Add dolly precision: The most precise moving camera work can be done on a dolly. This is especially true with long lens work where camera shake is most noticeable. It's very hard to match the steadiness of a tracked dolly move on a telephoto lens with anything else.

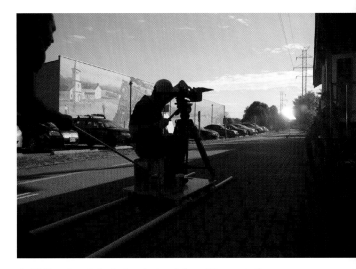

▲ Riding the dolly instead of walking allows you to focus on other aspects of operating your shot.

Camera Sliders

This type of mini dolly is another handy tool that has appeared in recent years. The original camera slider was developed for large movie rigs but has been adapted for smaller cameras like DSLRs. Camera sliders are very useful for tight spaces where a traditional dolly will not fit.

The sliding rods are made of lightweight materials like carbon fiber, aluminum, or chrome-plated steel. The camera plate has a bowl adapter to accommodate your fluid head from your tripod. These sliders travel well and can really add production value.

Several sliders are worth checking out:

> **Glidetrack SD & HD Range** (www.glidetrack.com)
> **indiSLIDERpro** (www.indifocus.com)
> **Kessler Pocket Dolly** (www.kesslercrane.com)
> **Pegasus Heavy Lifter** (www.cinevate.com)

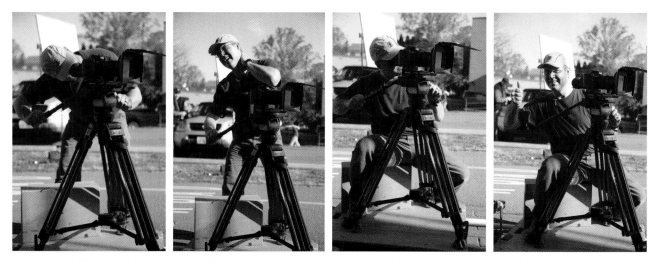

▲ Jim offers a practical demonstration that "comfort is king" when operating on a dolly. Be sure to keep your body position fluid and comfortable and that will translate into smoother camera movement.

Allow for dolly moves only: There's a reason to "just" dolly. It may seem like an obvious statement, but the best kind of camera move on the dolly is by the dolly. So, let it do your move. The purest tracking shot should have no back panning or compensation via your pan head.

Rather than chasing the action, try to block your scene to allow it to happen in front of the camera as it tracks by. This is where the dolly grip actually plays a key role in operating the camera. This technique helps to minimize the presence of the camera. It can also help minimize the rolling shutter problems with DSLR CMOS sensors.

Plan ahead: As operators, introducing a dolly move requires some planning for positioning your body. Whether you are riding or walking, be aware of the full range of motion you may need to put your body through to execute the shot. If you have to follow the action 180 degrees or more, make sure you can get your body through that range while keeping your eye on the viewfinder or on the monitor for critical framing. It's best to rehearse these moves.

Use a dolly operator: You might need another member of your crew (or a dolly grip) to push the dolly. On our shoots, we've found that with a little rehearsal, almost any crew member can be drafted. Keep in mind that systems like the Pocket Dolly and CamTram allow you to push the dolly yourself and walk alongside.

Still, there will usually be a shot where you'll want some help. Once you get the grip in sync with what's going on in the shot, you can hand off the dolly movement. This will allow you to concentrate on operating, framing, and all the other details going on to get the perfect shot.

Add a monitor for framing: Seeing your image is tricky while using a dolly. Just like a stabilizer, you'll likely need an additional monitor plugged into your camera for framing. Because the camera is often at a different height, you won't easily be able to see into a viewfinder, or the LCD screen will be too small to accurately evaluate focus. By using a monitor, you'll have greater flexibility with your body movement. It also gives you maximum control over your move, which allows you to react to a performer much like you were shooting handheld.

Jibs and Cranes

If you're looking to further liberate your camera from earthly limitations, try suspending it from a boom arm. Why in your right mind would you suspend a camera in midair from a jib or a crane? Well, it gives you a great range of motion for all sorts of shots.

You can imitate a dolly with some fluid side-to-side tracking movements. But the greatest benefit is the option to smoothly change camera height. With a jib arm you can extend the range of the height change from ground level to a dramatically high angle. This can put a camera beyond the normal viewing position of a standing person, so it immediately adds visual interest to your shots.

Jibs come in all shapes and sizes. Most strive to be lightweight, compact, and quick to assemble so they are easy to integrate into your shooting style. You can choose from two categories: manually operated and motorized remote heads.

Manually Operated Jibs

Manually operated jibs tend to be cheaper and lighter than motorized remote heads. They are also shorter in length, by necessity, because you have to be able to get your hands on the business end of the rig. Panning and tilting are still done with a fluid tripod head that attaches to the end of the arm.

Framing requires a video monitor mounted in a viewing position that works for the range of motion your body takes to execute the shot. You may need to be pretty flexible, starting down on your haunches or up on a couple of rungs of a stepladder. It's best to put the monitor right on the arm with the camera, so the frame of reference doesn't change as the arm moves through its range.

RENT, DON'T BUY
Unless you're in the gear rental business or regularly work as a jib operator, we strongly recommend renting a jib. You can also hire a grip or a jib operator to help you set up and run the equipment if needed.

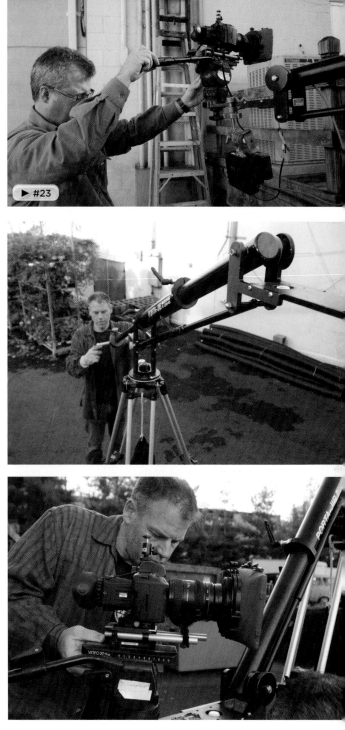

► #23

▲ Your camera on a jib arm can explore a range of movement both vertically and horizontally that can have great dramatic impact. Above: the Porta-Jib Traveller Arm.

Some notable brands (prices range from $400–$4,000) include:

> **CobraCrane I or Backpacker**
> (www.cobracrane.com)

> **Glidecam Camcrane 200** (www.glidecam.com)

> **Kessler Crane Pocket Jib**
> (www.kesslercrane.com)

> **Long Valley Seven Jib Compact XL**
> (www.longvalleyequip.com)

> **Losmandy Porta-Jib Explorer or Traveller**
> (www.porta-jib.com)

> **VariZoom QuickJib with Zero Gravity Head**
> (www.varizoom.com)

Remote Operated Jibs

Remote operated jib arms are longer in length than manually operated jib arms, which makes it difficult (if not impossible) to operate them manually at the camera's position. They require a system to control the pan, tilt, and roll remotely from the ground. You'll also need to run your monitor signal from the camera to a ground position for framing.

To control the camera and jib, you use a motorized controller, which affixes to the weighted end of the jib (near the ground), and you control pan and tilt using a joystick. Remote heads add to the cost of a jib or crane, adding several thousand dollars to the total.

Although these units work great for film and video cameras, they aren't designed to work with DSLR lenses. So, you'll need to look at using adapters or cinema-style lenses. You'll also likely find that you'll need to raise and lower the camera often to access power and menu controls (and to press record). With the rising popularity of DSLR cameras, we hope to see compatible remote jib heads become more available.

Jib Setup

When assessing the placement of a jib, you'll need to make a few tricky decisions. You must first determine where to actually place the jib. Unlike a traditional tripod shot, the camera is not in the same location as your tripod or jib base.

Next, you must consider where you want your lens to shoot and evaluate the range of height. The high and low points will determine how far you need to raise your tripod. You set the tripod before you mount the arm (if you can), because it is much easier to do without all the weight onboard. Also, be sure to level the tripod at this point. An off-level base will magnify unwanted sway in your arm once all the weight is on it.

Then you need to consider where you want the base (tripod) in relation to how you will operate the camera. Generally, you want the arm and base to extend to the camera in such a way that it doesn't interfere with your pan and tilt motion. For example, having the arm extend to your left will prevent the arm from hitting your pan handle. Placement will depend on the shot, and experience will help you assess what's best for each situation. Be sure to set up and practice with the jib before you arrive on set.

Once the arm is on your tripod, you need to balance it. You counterbalance the camera end with weights on the opposite side. Most jib designs accommodate simple barbell weights you can find in any sporting goods store. You won't need much for a DSLR camera, so you probably won't need to carry more than 20 or 30 lbs, depending on the weight of your fluid head, lens, and other accessories. Keep the weights in small increments; generally, 5 lbs and 2.5 lbs are most common.

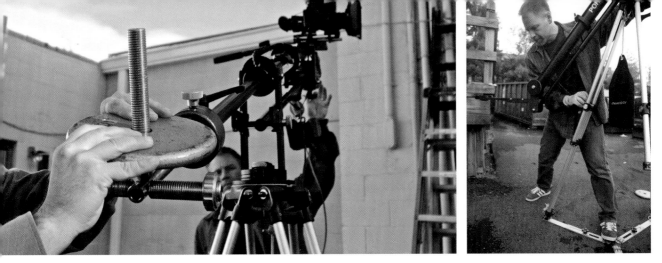

▲ Raising, leveling, and counterbalancing a jib arm all serve to create a floating camera that requires little force to get moving. A jib is an investment in time and money, but it adds a magical quality to the shot.

Before you add the weights, be sure to first mount all accessories to the camera end. Then slowly add incremental amounts of weight to the other end until the arm effortlessly maintains a neutral position when you (slowly) let go. Depending on your move, you might want to alter the balance slightly in the positive or negative to make movement easier. For example, if your boom moves from a low position to a high one, you can counterbalance the jib to make the camera end slightly lighter than the weighted end to aid you when raising the boom. Your moves will be more precise and elegant when you don't have to push or pull the rig.

Jib Safety

A jib is essentially a giant metal pole that's designed to easily swing from side to side as well as up and down. Gee, do you see any potential safety issues? Very often you may have a fully extended arm positioned over a subject, and you certainly don't want any accidents to occur. Here are a few practical safety checks to reduce the chance of injury:

> When setting up the jib, look carefully for any environmental hazards like power lines, lighting fixtures, or inclement weather. Keep in mind that you're handling a potential lighting rod.

> Be sure to check the path of the arm to avoid hitting the talent or crew.

> As you release the jib, keep a hand above and below the arm as you slowly let go to ensure that it doesn't crash one way or the other because of balance issues. This is also a good way to avoid catapulting your gear into the air.

> Make sure all locks, joints, and tripod stages are locked down.

> When orienting the arm to the tripod, be sure a weight-bearing leg is in line with the arm. In other words, the arm should line up with a pointing leg of the tripod, not a gap between two legs. This minimizes the chance of the whole jib toppling over.

> Weight down the tripod using several sandbags.

> Be aware of your surroundings. The profile of your camera platform is considerable when using a jib, with parts moving in opposite directions. Practice the range of motion at half speed; be sure you aren't running into ceilings, walls, furniture, or people!

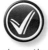

FIND THE BALANCE
Some jibs (like the Porta-Jib) offer a small, sliding counterweight that moves up and down the arm for fine-tuning the balance. Without it, you can use a Maffer or Cartellini clamp, which can be moved up and down for adjustment.

Profile Bill Frakes

Bill Frakes/Straw Hat Visuals

Chances are, if you've opened a copy of *Sports Illustrated*, you've seen the work of the prolific photographer Bill Frakes. A staff photographer for *Sports Illustrated* and founding partner of Straw Hat Visuals (www.strawhatvisuals.com), Bill Frakes has worked in over 125 countries, not only shooting sports, but also a variety of genres including documentary, advertising, and photojournalism. For his work, Frakes has received numerous national and international awards, including the prestigious Newspaper Photographer of the Year award in the Pictures of the Year Competition and was part of the *Miami Herald* staff that won the Pulitzer Prize for its coverage of Hurricane Andrew.

An early adopter of video DSLR technology, Frakes sees power in being able to shoot still photos as well as video. "I love the freedom it gives me to tell stories my way."

Bill Frakes/Straw Hat Visuals

A consummate storyteller, Frakes sees shooting video with a DSLR as another way to document a moment. "We combine high definition video with ambient audio, music, interviews, text, and high-resolution stills to tell stories. Every situation demands a different application." For Frakes there is no right or wrong when it comes to using video to tell a story. "We have done stories fully integrating stills and HD video, stories with ambient sound, and stills and stories completely with video. There are really no hard and fast rules; you can be as free as your imagination will allow. Anything that gives me more storytelling options I find enjoyable."

Although they are often used together, Frakes believes that still photography and video are different and each is unique. "Video allows different compilations for storytelling materials. The pacing is different; the connection between the subject and the viewer is different," says Frakes.

Bill Frakes/Straw Hat Visuals

Wanting to tell stories with a variety of tools has brought its own challenges for this seasoned pro when he's trying to decide whether to use stills or video to tell a story. "Deciding when to concentrate on the video and when to focus on stills, there are no rules; it's a game-time call every time," says Frakes. This statement echoes what we've heard from other photographers moving into video—some even refer to video as intimidating. But Frakes has a different take: "Intimidating is the response I hear from most photographers. Personally, I find it a lot of fun."

Another challenge Frakes has faced when shooting video is increased setup time to get a shot and the need for specialized camera support. "[I'm] Always taking the time to set up the shots properly and using the right supports and lights. It's a slower process. It doesn't require more thought, just more time to implement the thought process," says Frakes.

Even with its challenges, Frakes sees many benefits of shooting video with a DSLR, including the use of 35mm optics, the ergonomics of using a small camera package, and the ability in one unit to transition easily between stills and video. Frakes also sees the fast pace of development for video-enabled DSLRs as a positive. "I believe that the merger [of still and video capabilities on the same camera] will not only continue but will accelerate." As with any other storytelling tool, Frakes acknowledges there is room for improvement with the current crop of video-enabled DSLRs. "I would like to see more manual control of audio recording functions, the ability to record HD video in different file sizes, and the ability to change frame rates while recording video. I always want the technology to be better, but I can do more now visually than ever before."

Photographers starting to shoot video face some steep and unique challenges as they translate their photography skills into the world of video. Logging time, of course, is the biggest factor in having success shooting video, but Frakes also adds a few additional points for those wanting to improve their shooting: "Practice, education, hard work, thought, and basic dedication to the craft."

Although it might seem that shooting video on your DSLR is as simple as learning technical and aesthetic approaches, Frakes sums up our interview with a simple thought. "Work from your heart, the rest will follow."

GEAR LIST

- Nikon D3S, D3X, D3, D700, D300S, D300, D700
- Nikon 14-24mm f/2.8
- Nikon 24-70mm f/2.8
- Nikon 50mm f/1.4
- Nikon 70-200mm f/2.8
- Nikon 200mm f/2
- Nikon 300mm f/2.8
- Nikon 400mm f/2.8
- Nikon 600mm f/4
- Wide array of audio gear
- Manfrotto and Gitzo tripods and supports
- Cinevate DSLR rigs and slider systems
- Kata backpacks
- Chimera lights and light modifiers
- Elinchrome strobes and light modifiers

Bill Frakes/Straw Hat Visuals

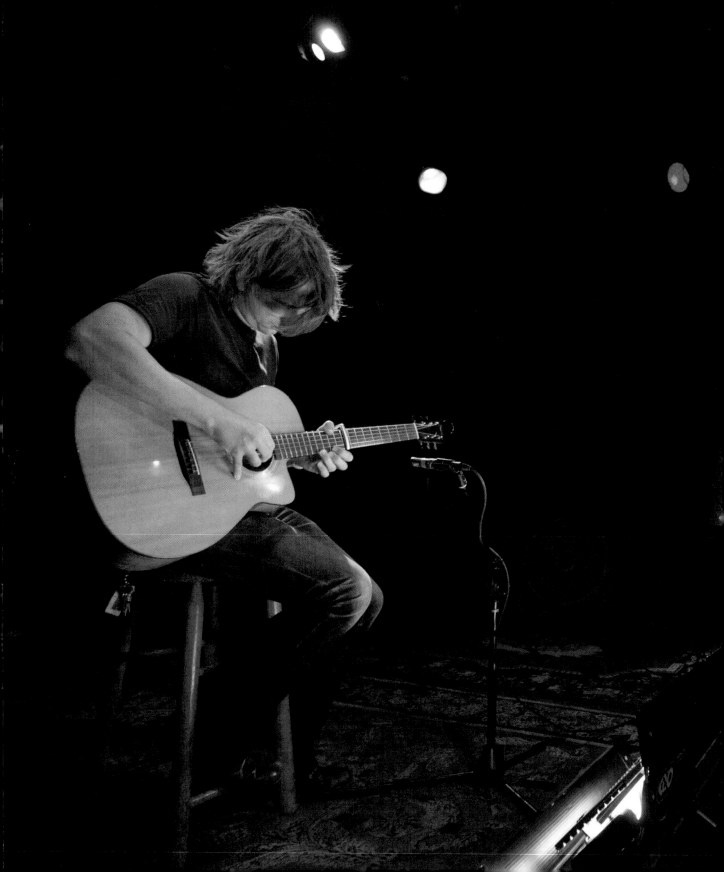

Audio Is Half the Story

Great Sound Is Essential

You're used to spectacular pictures. In fact, you've honed your photo skills and invested in the best gear. One of the greatest joys of photography is capturing images that engage the viewer. But when it comes to video, great images are only half the equation to telling a great story.

In the film and video world, capturing quality audio is just as important as striking images (and in many cases more important). Think about it this way: Although you might be able to tell a compelling story in pictures alone, audio gives your story a voice. Whether it's the roar of a fire or the sound of an ocean, these sounds provide context. Even if the video is as simple as an interview or a musical performance, bad audio can just ruin the audience's experience.

We know that many photographers argue that their images should be able to stand on their own. But let us present you with this challenge: Imagine how much better strong images are when you add compelling dialogue, wonderful environmental sounds, and powerful music.

Audio reinforces a captivating visual story. In most cases you only have one chance to get it right.

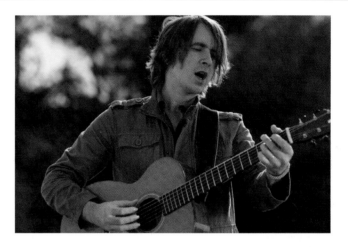

Although an audio mix often comes together in postproduction, you should never underestimate the importance of capturing good audio in the field or in the studio. Recording audio with improper volume or audio that has noisy interference can detract from your valuable content. In our experience, viewers are more likely to forgive a slightly soft image (chalking it up to a creative decision) than they are poor audio (which they usually interpret as a mistake). Although dynamic pictures are essential, inferior sound is deadly.

Recording good audio is part science and part artistry. The good news is that as a photographer you're already familiar with this mix. Even though you might be new to audio, the best practices are relatively easy to learn. At the end of the day capturing good audio can be simple if you understand the equipment and techniques involved. Let's explore several approaches for getting high-quality audio in any situation.

Capturing Quality Audio

Photographers are used to telling a story solely through images. But you're no longer bound by that constraint. You can now hear your subjects tell their own stories, hear the sounds of the great outdoors, and even let music shape the emotional response to your story. But if you mess up the sound, your whole piece loses its impact

So, carefully consider your audio when you're capturing video. What sounds do you want the audience to hear? How many microphones do you need and where should you put them? What environmental sounds will create an immersive viewing experience? The audio portion of a program provides important and subtle details, which unlike images, often give context to the story. After all, no matter how well shot a movie is, you'd probably leave the theater if the speakers went out.

Making Audio a Priority

It's very easy for audio to become a secondary concern. Even seasoned videographers can forget about capturing good audio. Here are a few guiding principles to ensure a quality production.

Get it right in the field: Although your final project can be a combination of field audio, music, and sound effects, you often have only one chance to capture that perfect interview bite.

Always listen: If you aren't listening, you can miss audio problems like pops and clicks and over-modulated audio. If you're in charge of sound, always wear headphones (no matter how silly you think they look).

Capturing audio is just as hard as capturing video, and at times can actually be harder. Although many times you can control an exposure and lighting, often you cannot control the audio in an environment. In situations where getting good audio is a challenge, you'll have to do a bit of work to make it happen.

Minimize noise: If you're shooting in an environment where there is lots of noise (such as an HVAC system or street noise), you'll need to eliminate that noise by finding and disabling its source. If that isn't an option,

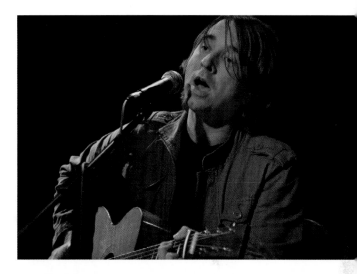

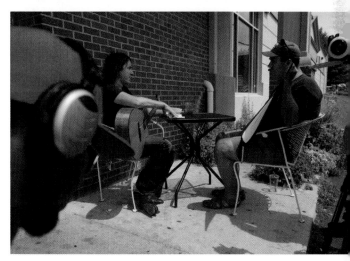

▲ The simple task of monitoring audio can help you avoid many potential problems on a shoot.

▲ Having a dedicated audio person on set can help you avoid common audio problems, especially if you're focused on other tasks.

you'll need to isolate the shoot from environmental noise that you can't control.

Be willing to stop: Always be willing to stop shooting if the audio is of poor quality. Ideally, you'll have surveyed the location and done a test recording before the actual shoot, but you can't always identify audio problems right away. You may notice issues like microphone rub, a background noise, or even an actor with a gravelly throat, which can all be reasons to stop recording. The key point is don't wait until the end of the day before realizing an audio problem. Try to always work in the moment and pay attention to the current scene and its audio. If you hear a problem, stop!

Using a Dedicated Audio Person

In a lot of respects a video shoot is more complicated than a photo shoot. On a photo shoot, you're trying to capture a single moment in time. On a video shoot, scenes happen and develop over time. Therefore, you need to strive for consistent audio quality throughout the shooting day. You also need to constantly monitor for changes in audio (such as a plane overhead or electrical interference).

If you're shooting, directing the talent, and answering the crew's questions, will you really be able to pay attention to the audio? Our bet is no. Audio awareness is the first thing that goes by the wayside when you're a one-man band or trying to juggle several tasks on set.

For most shoots you should strongly consider hiring a dedicated person whose sole job is to set up and monitor audio. This would include three key tasks:

› Setting up and positioning microphones.

› Mixing the audio (if appropriate) and setting proper levels before sending it to the camera or recording device.

› Monitoring audio from the recording device to ensure that proper sound is being recorded.

Although you, as photographers, are used to being in charge, you need to empower the audio person. Make sure the audio operator knows to speak up if there are audio problems. We've seen too many shoots ruined because the audio operator was treated as a bit player.

Technical Essentials of Audio

Our belief is that before you can master an art like photography or video, you need some basic technical knowledge. In many ways photography and video share a common technical background (video consists of sequential still images), but for a lot of people, the technical aspects of audio are pretty foreign. In this section we explain some fundamental concepts of audio, and then further explore audio hardware later in the chapter.

Channel Configuration

Do you remember the days of mono records and tape? Of course you're probably familiar with the stereo audio you get from most TV broadcasts and music. You're also probably familiar with multichannel audio (commonly called surround sound) that you hear in the movie theater or in a home theater setup. Mono, stereo, and surround describe the channel configuration of recorded audio. Here are the details of each configuration.

Mono: With mono, only a single channel of audio is recorded. For example, if you plug one microphone into a recorder, that microphone is recorded to one channel.

Dual mono: Often confused with stereo, dual mono systems record individual separate mono channels to the left and right channels of a camera.

Stereo: Stereo recording allows for separate left and right channels, and a mix between them. For example, if you plug a stereo microphone into your camera, the microphone records evenly to both the left and right channels. Using external gear you can also change the mix (split) of what goes onto each channel. Controlling your recorded audio is an important component of a professional production. We'll talk more about devices like mixers later in this chapter.

Multichannel: Multichannel is also sometimes referred to as surround sound and usually records two or more channels of audio. This type of audio is often created during the postproduction stage.

Most video-enabled DSLR cameras are capable of recording either mono (single channel) or stereo mixed audio. If this sounds limiting, don't worry; in postproduction you layer and mix multiple channels of audio to create a final mono, stereo, or even surround sound audio mix of your project.

Sample Rate

Numbers like 44.1 kHz or 48 kHz refer to the sample rate of an audio clip. In other words, sample rate is the number of times per second a recording device is "listening" to the audio. As a general rule of thumb, the higher the sample rate the better the audio quality. For example, audio made for a web presentation might use a sample rate of 22 kHz and as a result will sound somewhat muffled. But audio recorded at a sample rate of 48 kHz will sound clear.

The science behind this difference in quality is surprisingly simple. The highest frequency that any device can record or reproduce is half the sample rate (this is called the Nyquist-Shannon sampling theorem). So, the highest frequency possible of audio recorded at a sample rate of 22 kHz is 11 kHz, but at 48 kHz it's 24 kHz.

◀ **Most DSLRs offer a 1/8th-inch stereo input allowing you to use mono or stereo microphones.**

▲ Many dedicated audio recorders allow you to record at high sample rates and bit depths, usually up to 96 kHz 24 bit; some can even record 192 kHz 24-bit audio.

Microphone Technology

You might think of microphones as just being utilitarian and not all that sexy. But choosing the right microphone for any given situation is essential to getting the audio quality you want. Understanding the basic science and technology behind microphones will help you make good decisions about which microphones to use in your projects. Although several types of microphone technologies are in use, two are most common: condenser and dynamic.

Condenser Microphones

Condenser microphones are used in many applications. These types of microphones generally produce a very high-quality signal.

A condenser microphone has two plates that when vibrated by sound results in a change of distance in the plates. The movement results in an increase or decrease of electrical current, which in turn creates a signal that can be recorded.

It's important to note that condenser microphones require a power source. Some field recorders or video cameras can provide power. However, most often a field mixer with phantom power or a small battery is used.

If you factor in that the range of human hearing is about 20 Hz to 20 kHz, audio sampled at 44.1 kHz or 48 kHz can produce frequencies that are much higher than people can hear—thus the perceived clarity. But audio sampled at 22 kHz for example, can only record a max frequency that is at the middle of people's hearing range—thus the muffled, cloudy sound.

The sampling rate your camera can record largely depends on the manufacturer and model. Just keep in mind that even if your camera can record at a high sample rate like 48 kHz, you still should use external audio gear to get the most out of your audio.

Bit Depth

As with video, audio has a bit depth too. In video a high bit depth allows for a broad range of lightness and color values to be used for each pixel. With audio, a high bit depth leads to smoother blending between frequencies and the possibility of an expanded dynamic range.

The maximum bit depth for a DSLR camera is often 16 bit. If greater bit depths are needed, many pros turn to dedicated external recorders. Many of these tools are capable of recording 20-bit and 24-bit audio. This is usually overkill for dialogue and a spoken word performance but can help with musical performances or complex audio.

Dynamic Microphones

Dynamic microphones use a simple design with very few moving parts. They are relatively sturdy and resilient to rough handling.

Dynamic microphones are also better suited to handling high volume levels, such as from musical instruments or amplifiers. Usually, they have no internal amplifier and do not require batteries or external power. Due to their simpler requirements and sturdier construction, these microphones are very popular for field recording.

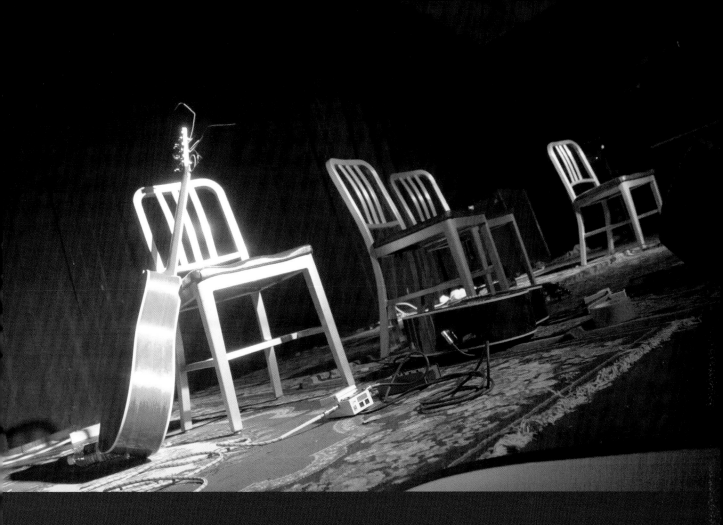

Our Standard Audio Kit for Field Productions

- ☐ 2 over-ear headphones for monitoring sound
- ☐ 1 Sound Devices 2-channel mixer to control levels
- ☐ 1 RØDE on-camera microphone with wind cover
- ☐ 1 Sennheiser shotgun microphone with wind cover
- ☐ 1 Matthews grip head to attach boom to a C-stand
- ☐ 1 boom pole mount to attach boom to a C-stand
- ☐ 1 Sennheiser wireless microphone for interviews

- ☐ 1 breakaway XLR mic cable to attach the mixer to the recorder
- ☐ 4 10-foot XLR cables
- ☐ 4 20-foot XLR cables
- ☐ 6 spare batteries (because power fades)
- ☐ 1 box of assorted audio adapters
- ☐ 2 Tram lavaliere microphone sets
- ☐ 1 Zoom H4 audio digital recorder

Microphone Selection

Microphones come in many different configurations and are designed for specific applications (recording voice, drums, etc.). Making the right microphone choice for your DSLR is important for recording high-quality audio. Let's take a look at a few different types of microphones and their applications.

Built-in Microphone

Sure, your DSLR camera has a built-in microphone, but don't count on it for much. The camera microphone is good for reference audio that you can use when syncing camera angles or sound sources, and that's about it.

You should always use a microphone other than the one built in to your camera to get the best sound for your production.

On-camera Microphone

Several manufacturers make external microphones that are designed to attach to your camera. Manufacturers like RØDE offer specialty microphones that mount on your hot shoe. The microphones can be plugged into the "mic" port on your camera.

Although these mics need power (because they are condenser mics), you don't have to worry about draining your camera batteries because the mics are usually self-powered with a battery. Just be sure to pack some extra 9-volt batteries so you don't lose your sound source. On-camera microphones are often available in mono and stereo varieties.

▲ A dedicated microphone can overcome the weaknesses of your camera's built-in mic.

Auto Gain Control

Many of the current crop of DSLRs use Automatic Gain Control (AGC). This technology automatically sets your audio levels based on the relative level of sound that the camera "hears."

In our opinion, this technology makes for noisy audio because the AGC circuits are constantly adjusting audio level, and in extreme cases you can actually hear the audio level "breathing" or changing rapidly enough so the change is noticeable. We recommend an external audio interface that can provide clean preamps and phantom power before sending the signal to your camera and in some cases override the camera's AGC circuitry. Many manufacturers offer these interfaces, but two stand out as providing quality, affordable audio interfaces: juicedLink and BeachTek.

If you're using a Nikon camera, you'll likely find an option for turning off AGC. Most other cameras don't offer this option. One attempt to circumvent these controls is the Magic Lantern Firmware hack (http://magiclantern.wikia.com). Besides disabling the AGC, it also provides many other useful visual controls for audio and picture. This firmware hack is *not* supported by Canon and may void the warranty on your camera.

► A shotgun microphone on a boom pole allows you to "reach" into a scene to capture audio. These setups are common for capturing high-quality audio without having to use wireless systems.

Shotgun Microphone and Boom Pole

The first time you see a boom pole in use it may look a little funny. But trust us; the operator isn't really fishing, and that "dead cat" at the end of the pole serves an important purpose—it blocks wind noise. When used correctly, a shotgun mike and a boom pole can improve your ability to capture great sound.

WHAT ABOUT WIRELESS MICROPHONES?

Wireless mics are ideal for wide shots when you can't get a boom microphone into the scene. Most of the newer wireless systems also have the ability to change frequencies, which is especially useful because you might experience a variety of crosstalk or interference from other sources.

NEED TO HIDE A LAVALIERE MIC?

An old trick of the trade is to hide lavaliere microphones inside clothing. An easy way to do this is with an adhesive bandage. Just leave the microphone sticking out a bit above the top of the clothing when you adhere it.

Shotgun microphones are highly directional. They are engineered to reject sound from the side and behind the microphone. Because shotgun mics primarily pick up audio in the direction that they're pointed, they are the preferred choice when recording dialogue.

By using a boom pole, the boom operator can be a good distance (and out of frame) from the action. The telescopic boom poles are made of either aluminum or more often carbon fiber, which vastly reduces the vibration or "handling noise" of the operator as the mic is turned to pick up the audio from various actors. This means that there are no visible microphones on talent, no cables, and no communication packs that have to be managed.

To further reduce noise, the mics are also mounted to the boom pole on special shock-absorbing mounts. A boom and microphone kit starts at around $400, but costs can increase significantly depending on the quality and manufacturer.

Lavaliere Microphones

Using a lavaliere microphone (or lav mic) is a great way to isolate the sound from a subject you're recording. This mic is usually placed on the front of a subject's clothing or collar (be sure to keep it from rubbing).

Because the mic is located on the subject (instead of near it like a boom mic), it provides a good separation from other audio sources that you don't want to record. Lavs are perfect for interview setups of any type.

Lav mics can be purchased as wired (cheaper) or wireless (more expensive). The advantage of a wireless microphone is that your subject is free to move around.

Lav mics usually have a remarkably different sound and "presence" compared to shotgun mics. For most productions, both can be used for recording. During the editing stages, the different audio tracks can be mixed together to achieve the best sound.

▶ If your subject doesn't have a lapel, you'll need to get creative. You can use adhesive tape or a tie-tack style clip.

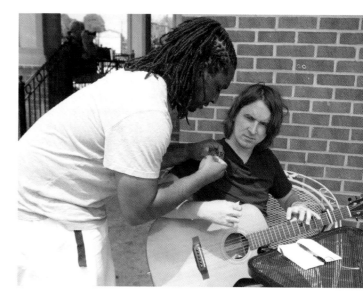

There's No Replacement for Mic Placement

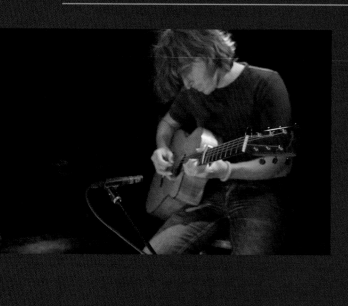

With any kind of microphone, placement is critical. The closer you can get the mic to the source of the audio the stronger the signal. Taking the time to place mics accurately is the answer to audio problems like noise and hollow sounding audio. Here are a few details to consider when it comes to microphone placement:

› **Microphone rub:** Although lavaliere mics let you get very close to record clean audio, try to avoid having the microphone rub against clothing.

› **Getting too close:** Proximity is important, but there is such a thing as getting too close. If a microphone is too close to an audio source, the audio signal can become overloaded and distorted. If you're trying to get a sense of the environment in the recorded audio, back the microphone away from the source so you can capture more ambient sound.

› **Utilize the pickup pattern of the mic:** If you're using an omnidirectional microphone, be sure to place the microphone in a place where you can best capture the "whole" scene. Likewise, if you're using a shotgun microphone, position it so it can capture the directional audio it's capable of recording.

Microphone Pickup Patterns

All microphones have an area that defines where they are most sensitive to sounds. Be sure to consider the pickup pattern when selecting microphones to use. If you were to "map" this pattern to a visual image, you would see what is known as a "polar pattern."

Here are the most common polar patterns for microphones.

Omnidirectional: If you need a microphone that picks up a lot of sound, choose an omnidirectional microphone. An omnidirectional microphone's response is equally sensitive to audio coming from all directions. This style of microphone picks up sound in a spherical pattern and works best for controlled sets without much background noise.

Hypercardiod: This mic pattern is an exaggerated version of the cardiod pattern. It is very directional but allows a little more audio to the rear of the microphone to be picked up compared to a cardiod pattern. Hypercardiod as well as the previously mentioned cardiod pattern are commonly used as vocal or speech microphones, because they are good at rejecting sounds from other directions.

Cardiod: The most common style of microphone has a cardiod pickup pattern (named for its heart-shaped pattern). The benefit of this mic is that it is mostly unidirectional, which means it is more likely to pick up the sounds in front of the microphone instead of sounds coming from the back (like the crew).

Shotgun: Shotgun microphones are highly directional. They have small areas of sensitivity to the left, right, and rear but are significantly less sensitive to the side and rear than other directional microphones. Due to the narrowness of their sensitivity area, shotgun microphones are commonly used on television and film sets, and are almost always at the end of a boom pole.

Monitoring Audio

We get it; we know you can capture amazing pictures. But are you so good that you can take great shots with your eyes closed? The same holds true for audio. Just because you're recording sound doesn't mean it's quality sound.

You'll never know how your audio sounds unless you actually *listen* to it when you're recording. You may never hear that passing car with the 3-inch exhaust, that annoying buzz from the fluorescent lights, or the hum from a power cable crossing your microphone cable until you get back to the edit suite.

Don't assume that all you have to do is plug in a microphone, set levels, and walk away. That is a recipe for disaster! If you aren't listening during the shoot, you'll waste even more time and money trying to fix audio problems during your editing stage. Fortunately, you can purchase a good set of headphones, or "cans," for under $100. Just keep in mind most DSLRs do not have a headphone output, so you'll need to monitor through a dedicated recording device (like a digital audio recorder) or microphone preamp.

Although you might be tempted to try to use the earbuds from your iPod, their design will prevent you from isolating the audio of your recording. We strongly recommend closed-ear or over-ear headphones. Sony and Sennheiser are the best we've used. By actively monitoring your audio, you'll be able to adjust for problems when they occur.

You might also consider headphones with a "noise cancelling" feature, which helps reduce ambient audio pollution as well. Just make sure you can switch off this feature because there will be times you may not need or want to use it.

LOOKING FOR HEADPHONES?
There are a lot of great companies making high-quality headphones. Here are a few of our favorites:

› **AKG** (www.akg.com)
› **Senheiser** (www.sennheiserusa.com)
› **Ultimate Ears** (www.ultimateears.com)

Recording Professional Audio

Armed with the preceding microphone and monitoring information, you now need to actually record audio. Let's first look at using a dedicated audio interface to record professional audio with your camera and then look at employing a bit of technology called a mixer.

My DSLR Records Audio, Right?

If you ask the manufacturers, they'll tell you the answer is yes, your DSLR records audio. But the truth is that most video-enabled DSLRs are pretty limited in how they record audio. In fact, recording audio on a DSLR is equivalent to using your cell phone for capturing photos.

Most DSLRs can record audio but do so via small built-in microphones. These microphones tend to pick up lots of on-camera noise like autofocus movements and your hands manipulating the camera.

Adding to the problem is that DSLRs have limited connectivity to professional audio equipment like microphones and mixers. Even the best cameras on the market use only a mini stereo plug, which can barely transfer a clean audio signal.

Even if you feed good audio into the camera, your DSLR records audio in a highly compressed format. The sound quality will deteriorate as you move the audio to high-quality playback like home theaters. The film and video industry is skilled at capturing great audio. Although you may need to rethink your approach, the changes we'll suggest are straightforward. Let's focus on how to supplement (or even replace) the poor audio recorded by your DSLR camera.

GREAT READ ON GETTING GREAT FIELD AUDIO
Recording audio in the field can be tricky. Be sure to check out the excellent book titled *Producing Great Sound for Film and Video, Third Edition* (Focal Press 2008) by Jay Rose. This practical guide is full of tips and tricks for getting great audio in the field.

▲ A video camera offers a lot of control over recording audio and includes professional microphone inputs, precise level control, and audio meters.

Dual System Recording

Dual system means that you have two "systems" for recording: one for audio and the other for video. Dual system recording stems from the motion picture industry where film has traditionally been used, and film of course doesn't record audio. So the camera is responsible for recording the visual part of a shoot, whereas another system like a tape recorder, DAT machine, hard disk, or solid-state recorder is used to record audio.

Using a separate, dedicated system to record audio is also a good idea when the visual tool (in this case a DSLR) doesn't do a particularly decent job of handling audio. This doesn't mean you must record audio to a different system, but in our experience doing so will produce superior results.

RECORDING AUDIO WITH A VIDEO CAMERA

Recording audio on DSLR cameras is in its infancy. Traditional video cameras offer important features like professional audio inputs, microphone power, and precise audio controls.

One of the easiest solutions for recording audio is to use an entry-level, professional video camera. Chances are that you may have a video camera on set anyway, and most video cameras have connectivity for attaching professional microphones and peripheral gear.

There is no need to waste a lot of money on a video camera. You can even choose an older model digital video (DV) camera because you'll be capturing fantastic HD images with your DSLR. We're big fans of the Panasonic DVX-100 and HVX-200 series cameras. Here are the essential features to consider when selecting a video camera to record audio.

Digital audio meters: Video cameras offer meters, which can be displayed on the camera LCD or viewfinder. These meters make seeing your average and peak levels a snap. On many cameras you can even set visual markers at a user specified level so it's extremely easy to see if audio peaks beyond that level.

Manual controls: Another advantage of using a simple video camera to record audio is the ability to manually control channel assignment (to designate which attached microphone goes to which channel) and level.

Balanced audio and phantom power: Most entry-level pro video cameras support balanced audio, meaning that professional XLR audio connections can be used. These balanced XLR connections offer clean audio and provide phantom power to condenser microphones.

RECORDING AUDIO WITH A DIGITAL AUDIO RECORDER

Although video cameras provide an easy way to record audio in the field, they can be expensive and cumbersome. If you need to purchase a dedicated recording device, we recommend a portable field digital audio recorder.

▲ Digital audio recorders come in various shapes and sizes. Most have multiple inputs and the ability to record high-quality audio to dedicated on-board storage.

These units (unlike a video camera) are designed to do one thing—record pristine audio. Because they're dedicated to one task, most units are very sophisticated in how they handle audio. Some features of a dedicated field recorder include the following:

Multiple inputs: Although most video cameras have only two audio inputs, many dedicated audio recorders have the ability to record four or more separate channels of audio. Additionally, most digital audio recorders have multiple input type connections including XLR, ¼ inch, and sometimes even RCA type connections.

High-quality audio: Although most cameras including your DSLR top out at recording audio at 48 kHz 16-bit audio, many digital audio recorders are capable of recording 24-bit audio at sample rates up to a whopping 192 kHz. Some recorders let you choose WAVE, AIFF, or even MP3 formats.

Integrated storage: Most of the digital audio recorders on the market today include integrated storage for recording audio to. This storage generally comes as either a hard drive or some type of solid-state device. When you're done recording, you simply plug the unit into your computer like a hard drive and transfer audio.

Timecode support: With your DSLR, you won't be able to take advantage of timecode (yet). Most field recorders have deep timecode support at various frame rates. If you're not familiar with timecode, it's simply a way of identifying frames in a clip. An example of a timecode is 01:00:05:09, which translates to 1 hour 5 seconds and 9 frames. We'll talk more about timecode in Chapter 16.

There are many manufacturers of digital audio recorders, but we've had great experiences with the 7 Series family from Sound Devices (www.sounddevices.com), the H4N from Zoom (www.zoom.co.jp), and the DV, HD, and HS series from Tascam (www.tascam.com).

SYNCING AUDIO IN THE FIELD

If you do use a separate system to record audio, you'll have some extra work to do to make sure that audio stays in sync with your picture. During postproduction you'll need to synchronize your audio with the video you've shot on your DSLR, but the process actually begins in the field. There are several methods you can use to do that but the two easiest are pretty low tech.

Clapboard: Professional clapboards serve two purposes: They allow for information about your shot to be recorded on them, and they have a clapper. During post you find the point at which the clapper closes in your video and then find the same point in the recorded audio (just be sure when shooting the scene that the "clap" is actually loud enough to be recorded). You then use the two points to synchronize the scene. This well-proven method has been in film production since its start. A good quality clapboard will run you about $35, and it's money well spent (plus you'll feel official).

Your hands: A clapboard is nice to have, but it often gets forgotten or misplaced on set. In a pinch you can make your own visual and audio reference sync points. The easiest way to do this is simply by clapping your hands and recording the sound to video and audio.

If you have any experience with video or dual system recording, you may be familiar with an additional way of syncing audio—timecode. Timecode is a system where every recorded frame has a unique identifier. Many video cameras are capable of "jamming" or synchronizing timecode between cameras and with a separate audio recording device. Unfortunately, at the time of this writing DSLRs do not support timecode data.

Getting the Right Audio Level

Recording clean, usable audio at a proper level is critical to increasing your production's quality. Here are a few important details to keep in mind.

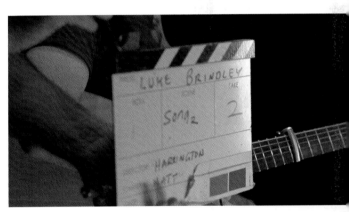

 VIDEO #18: UNDERSTANDING AUDIO SAMPLE SIZE AND SAMPLE RATE
Depending on the gear you use, you'll choose different audio sample sizes and rates (they should always match between different devices). The easiest way to understand the impact of your choices is to listen to the audio clip.

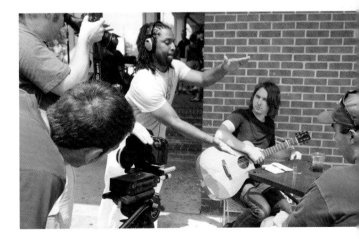

▶ Using either a clapboard or a hand clap you can create a point in your audio recording that can be used to sync your audio in postproduction. The large spike in the audio waveform (top) shows where the clap occurred.

Digital audio headroom: Unlike the days of analog recording, digital audio recording has less "headroom" or safety near the peaks. Since the audio is basically a binary one or zero, once you cross the 0 dBFS threshold you *will* experience distortion or clipping. To avoid this, try to keep your hottest peaks at about -6 dBFS on your audio recording device, with average levels around –20 dBFS to –10 dBFS. This will create some space for transient audio to go above that level without clipping

Record a second channel: If you are recording a single subject, try recording the same audio signal into the second channel of your recording device at a lower level of about –3 dB. That way, when your subject suddenly decides to get more animated, your first channel may distort, but your second channel will still have an unclipped, usable audio recording.

Using a Microphone Preamp

As discussed earlier, it's possible to simply plug in a microphone to your DSLR and let it roll, but we've had much better results using a dedicated microphone preamp. A preamp, like those made by BeachTek and juicedLink, provide multiple XLR inputs to connect professional microphones to the unit. Additionally, these units allow for level control, pan control, input gain, and phantom power.

Because of their size and because they have a tripod screw hole on them, you can mount a unit to the tripod screw hole on the bottom of your camera and then mount the unit and the camera to a tripod. After securing everything together, the preamp outputs a signal on a 3.5mm stereo cable, which can connect directly to your camera.

DB VS. DBFS
You many have seen both dB and dBFS used to describe audio level. What's the difference? Decibels, or dB, is used for analog audio level and is used on analog audio scales. Decibels relative to full scale, or dBFS, is used to describe digital audio and is used on digital audio scales. Confusion occurs because many people just use dB when talking about digital audio; the correct term would be dBFS.

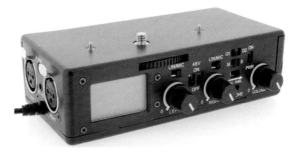

▲ A microphone preamp like this one from Beachtek allows you to connect professional microphones to your camera and control their levels. © BeachTek Inc.

Why use a microphone preamp instead of simply using an on-camera microphone? Well, here are a few reasons.

Flexibility: A microphone preamp gives you expanded options for whichever microphones you use. Just about any microphone can be connected to a preamp and then fed to your camera.

Less noise: Unlike using the camera's built-in microphone or relying on an on-camera microphone, which can both pick up lens noise, you touching the camera, and so on, when using a preamp, you can move the microphone away from the camera to avoid these sounds. Additionally, the amplification circuitry is generally less noisy on an external microphone preamp than the internal microphone on most cameras.

Minimal footprint: Many on-camera mics add a pretty significant footprint to the overall camera package. A preamp can simply attach to the camera. Also, because many preamps have basic mixing functionality, you don't necessarily need to carry around a mixer.

Using a Mixer

A mixer is a device that lets you connect multiple microphones or even line-level instruments; "mix" them together by adjusting level, pan (left or right channel assignment), and EQ (bass, mid, and treble frequencies); and then output that mix to your camera or other recording device like a hard disk recorder.

For most video shoots, a compact mixer like those from Mackie, Tascam, and other manufacturers should work well. You can use a mixer to EQ and pan connected microphones and then feed those channels directly to your camera. But if you have more than say four inputs, you can also use a mixer to mix together similar channels of audio and then feed a video camera or dedicated audio recorder. Having a dedicated mixer on set allows for the following:

Input flexibility: Because a mixer allows you to take 8, 12, 24, or more inputs, you never have to worry about having enough audio inputs on your camera. This is crucial at events like a concert.

Ability to EQ: Besides basic mixing functions like controlling level and pan, most mixers also allow you to

EQ, or equalize, certain frequencies. This means you're able to boost highs, mids, and bass frequencies to make your audio sound its best. Additionally, some mixers also allow for effects like reverb directly on the mixer, allowing you to create ambience or a feeling of space where there might not be any.

Although a mixer is not a requirement, you should consider one if you have multiple audio sources.

 VIDEO #19: GETTING UP TO SPEED USING A MIXER
If you are new to mixers, check out this video about the basics of operating a mixer in the field.

Essential Extras for Recording Sound

Perhaps you've been on a photo shoot and encountered a situation where you need a filter, a Compact-Flash card, or even a lens, but you didn't have it with you. Well, when you start recording sound for video, there will always be situations in which you'll need an additional item to get the recording you need. Here are some items that we *always* bring along when we need to record audio in the field.

> **Extra microphones:** Bringing a backup lav or shotgun microphone with you is always a good idea. We've witnessed plenty of shoots that have gone bad because of a malfunctioning microphone.

> **Windscreens:** Many microphones ship with dedicated windscreens, but some do not. A windscreen is essential if you know that you'll be shooting outside and there's a possibility of the wind distorting your audio. Windscreens are cheap, and you can easily find them by searching the web.

> **Extra XLR to XLR cables:** Always bring additional XLR to XLR cables of various lengths. You never know when you'll need an odd run length. Also, XLR cables can get pinched or stepped on, so having a few extra will minimize any downtime.

> **¼ inch to XLR adapters:** These handy little adapters will let you take a ¼ inch source, like the output of a guitar amp or even the output of a soundboard or mixer, and convert it into an XLR connection so you can connect to your professional gear.

> **Extra batteries:** Condenser mics and lavs need power to run. If phantom power is not available, and often it's not, you'll have to power these microphones with batteries. Always check your battery level before going out into the field, and then test that level throughout the day. Having extra AAA and AA batteries on hand can be essential to avoid downtime.

> **Lavaliere mic clips:** These simple clips hold a microphone in place on a collar or shirt and always seem to go missing. If one goes missing, it's a real pain to secure the microphone.

Capturing Securely

Field Storage

Nothing is more vital than the images you capture. Losing data can mean a ruined project and even a lost client. Your objective is not only to capture great images, but

also to safely store those digital files so they can be archived and post processed.

So how is video different? Well, you have a whole lot more data to worry about. Many photographers have enough memory cards to allow them to shoot for several days at a time. Every second of video contains between 24 and 60 still images. Although these aren't high-resolution, raw files, the file sizes do add up quickly. Even if you have bottomless pockets, your storage will run out quicker in the video world.

HAVING A GOOD BACKUP AND ARCHIVING PLAN FOR YOUR IMAGES IS JUST AS IMPORTANT AS GETTING THAT "MONEY SHOT."

You might be used to taking an entire day to fill up an 8 GB card, but on a video shoot you could fill that same card in just 25 minutes. So it's vital to have plenty of storage with you in the field or on set.

You might think the solution is to just stockpile a bunch of cheap memory cards, but that won't work. The main difference between still and video storage is that you'll need faster cards to maintain the data rate required for video.

Capturing your video is the part with all the glory. But having a good backup and archiving plan for your images is just as important as getting that "money shot." In fact, we'd argue that it's more important. Fortunately, you can transfer most of your knowledge of managing storage for photos to the video world.

Selecting a Storage Format

You'll often feel as though you don't have many choices when it comes to choosing your camera storage format. Most cameras only allow one or two card formats, so the camera manufacturer generally chooses the storage format you'll use.

Knowing what each format is and what it is capable of is important. All modern storage formats have their advantages and limitations. You can use this knowledge when choosing a new camera body. It may also influence which slot you choose to use with certain cameras that offer both a CompactFlash (CF) and a Secure Digital (SD) option.

Although card format and quality can slightly impact the way you capture photos, the memory card you use when recording video is an essential choice for your kit. Recording video on your DSLR requires that data constantly be written to storage. This means you'll need fast storage that can keep up with the data rate of video. If the cards you use are inferior, the video may stutter (called dropping frames). In many cases, a second-rate card can lead to video that doesn't record at all.

About CompactFlash

CF cards are a mainstay for professional storage for digital photography. These cards are also the most robust option for capturing video with a DSLR. The good news is that large CF cards are becoming commonplace. You'll find that higher capacities are suitable for capturing video, and the market keeps growing with readily available 16, 32, and even 64 GB cards.

Most professional DSLR models offer CF, either as the only storage or as a secondary storage option. CF has historically offered a better price/capacity ratio and faster transfer rates than other types of in-camera storage.

CF cards are typically formatted using the Windows FAT32 system. This can limit the amount of video you can record before the camera either starts a new file or stops recording completely. For example, on a

FAST ENOUGH FOR VIDEO?

When selecting a memory card for video you need to make sure the card you choose can maintain a constant data rate. Fortunately, for most DSLRs this data rate is around 5 megabytes per second. It's still a good idea to choose a card that exceeds that by 4 or 5 times (133x-plus speed cards) as you'll probably want to use that same card for shooting photos, including in burst mode.

TWO CAMERA SLOTS?

Some camera manufacturers offer both CF and SD slots in the same camera. You can often choose to route your video to one slot and stills to the other.

Canon 7D this means you can only capture about 4 GB or 12 minutes of continuous video.

When selecting a CF card, be sure to get a name brand card with a minimum speed of at least 133x (see the section "Demystifying Card Speeds"). Fast cards ensure that no frames are dropped during video recording.

About Secure Digital Cards

SD cards are most common in consumer electronic devices—in everything from music players and photo frames to GPS units. You'll also find SD cards in many entry model DSLR cameras (including those that shoot video). An added benefit, unlike CF cards, is that SD cards have a "write protect" tab that can be locked to protect your media.

SD cards can be confusing because they come in two types: SD and Secure Digital High Capacity (SDHC). Standard SD cards usually have capacities up to about

BUFF IT

DSLRs use the built-in image buffer in the camera in different ways when shooting stills and recording video. When taking stills, if the buffer becomes full, you won't be able to take additional stills until the memory card clears the buffer. With video, however, you'll be able to keep recording: But if the memory card can't keep up, you'll drop frames, resulting in video that stutters.

4 GB. The newer SDHC rated cards can have higher capacities, usually up to 32 GB. These larger cards can handle video very well, provided they are rated at a high enough speed.

Demystifying Card Speeds

Like you, we search websites looking for the fastest and highest capacity CF or SD cards available. But we're always frustrated by the time and effort it takes to wade through the marketing and technical aspects of storage. Different manufacturers use all sorts of creative language to make memory cards sound faster than a race car and more reliable than your best friend. Such jargon can really get confusing when you're shopping for storage that's fast enough for video files.

Remember, stills and video have very different requirements in terms of speed. Generally, for stills you need a card that is capable of keeping up with the frame buffer of the camera. A fast card allows you to shoot at high burst mode (typically a range of 3–10 frames per second) for covering fast action. Using slower cards means you'll have to wait longer for an image to appear on the camera's LCD. It also means slower import when you transfer images from a slow card to your computer. These three issues are the only major problems with slower cards and still photos.

With video, slow cards can spell disaster. The reason is that video requires a sustained throughput to the card because the camera's buffer is constantly being written to and then cleared to the card. If you attempt to use a slow card when recording video (which results in the card not being able to clear the camera's buffer fast enough), at best you'll drop frames and stutter; at worst, the recording will likely fail and you'll lose the shot.

CARDS NOT MOUNTING?

Some older devices that were built for reading SD cards cannot read SDHC cards. Be sure to invest in a newer card reader.

In the simplest terms this means that choosing a fast card is essential. But what do the different card speeds really mean? A speed of 300x is pretty meaningless if you don't know what x stands for.

Manufacturers decided to use a baseline standard of 150 kB/s of throughput to describe their cards. So a 1x card can only record and play back data at 150 kB/s. Obviously, that's pretty slow. Slow cards, as you probably know, can be frustrating to work with.

For video you'll want the fastest card you can afford. We've found that cards in the 133x and above range work well in video-enabled DSLRs. But we don't recommend scraping the bottom of the barrel. You should consider faster cards if you'll also be shooting photos in burst mode or you want to transfer your video to your computer using faster speeds. We think the sweet spot in terms of price and performance are 300x cards. **Table 14.1** contains the most common card speeds.

Table 14.1 Common Storage Card Speeds

SPEED RATING	ACTUAL SPEED
133x	20 MB/s
200x	30 MB/s
266x	40 MB/s
300x	45 MB/s
400x	60 MB/s
600x	90 MB/s

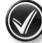

USE UDMA CARDS

UDMA (Ultra Direct Memory Access) cards are quickly becoming the de facto standard for CF and SD storage. The UDMA standard has multiple modes with each higher mode allowing for faster data throughput. If you have a choice between a UDMA and a non-UDMA card, always choose the UDMA card if you want to capture video.

More Cards vs. Larger Cards

The more cards versus larger cards debate has seemingly been going on forever. As a photographer, you might choose more cards at smaller capacities because you're not putting all your eggs (umm, photos) in one basket, and if one card should fail, you still have most of your photos on other cards and can continue to shoot.

The problem with this tactic when it comes to video is that you'll be changing cards a lot. Take for example a Canon 5D MK II: You'll only get about 12 minutes of video per 4 GB card. So if you're using smaller cards and shooting a music video, a feature film, or an interview that lasts for hours, you'll quickly experience what we call "card swap mania."

For most video productions, it's best to use large cards so you can record for longer durations. We've found that a 16 GB card offers a nice recording space to dollar ratio. At the time of this writing, 16 GB cards are as cheap as $40 per card. Although 32 GB cards are more expensive, they can also be purchased for a good price, and they have the advantage of allowing you to record almost an hour of video.

Backing Up in the Field

You've successfully planned your shoot and made all the right equipment selections to get your shots. Wouldn't it be a shame if that great footage was lost before you even got back to your studio to work with it?

Just about every photographer we know has lost some photos inadvertently. Sometimes it was an accidental erase; other times it was the loss of a card. The pain in losing video is just as great, and likely even more costly. Generally speaking, a lot more labor goes into getting a great video shot. And in the case of an interview, you might have only one chance of getting the perfect clip.

Although some data loss can happen because of technical issues like card failure, most data loss is due to human error. With a little effort and foresight, you

can avoid these errors. Let's explore backing up in the field so you can minimize any data loss.

Using a Card Reader

A card reader is an essential device to have with you in the field. Even though a camera may have a USB port, you don't want to tie up your camera to transfer stills and footage. Even more important, why risk damaging your camera through wear and tear on a mini-USB connection that's directly attached to the core circuit board?

Some newer portable computers have built-in card readers, but most do not. So having a small, fast card reader is vital.

Card readers are ubiquitous these days. Although there are several to choose from, not all card readers are well suited for the task of field backup.

Bus power: Look for a reader that is bus powered, which allows for the card reader to run off the FireWire or USB port.

Speed: Transferring stills and footage quickly largely depends on card speed, but even a fast card can be handicapped by a slow card reader. We've found when transferring large video files that FireWire 800 card readers and new ExpressCard adapters that fit into ExpressCard slots on portable computers are your best bets.

Multiple slots: Many card readers offer two or even four slots, which are handy for loading additional cards. Archiving often happens in short bursts on set. Being able to load up a few cards and walk away from the machine lets you get back to shooting without delay.

Offloading Cards to a Portable Computer

We'll admit we're joined at the hip to our portable computers. We bring them with us everywhere including in the field. But having a computer in the field is not just for surfing the web and checking Facebook. The

▲ Carrying a portable computer and a memory card reader allows you to perform many functions in the field.

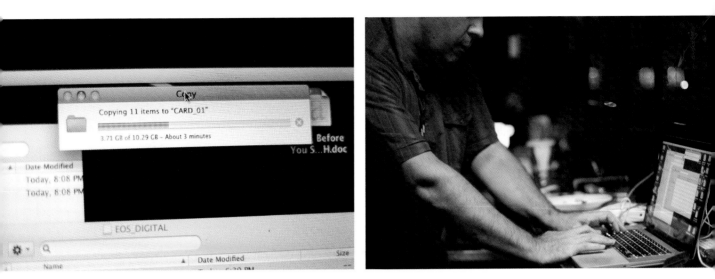

▲ Using a high-speed card and a fast card reader allows for quick backups in the field.

real benefit of having a computer in the field is that it can serve as a tool to offload memory cards and check footage quality. Doing both has a lot of benefits. Here are just a few.

Card rotation: When a card fills, you can start transferring footage to your computer while you pop another blank card into your camera. When the footage being transferred from the original card is done, it can then be popped back into the camera again. Rotating cards is essential for long shoots like in-depth interviews or multicamera coverage.

Data backup: It might seem obvious that a critical reason to have a portable computer in the field is to ensure data integrity. We've seen plenty of productions disintegrate because of data loss that could have been

avoided by transferring the contents of a card(s) to a portable computer in the field. It's a good idea not only to transfer data directly to your computer, but also to one or possibly two additional portable external drives.

Visualization: Many photographers have learned the benefits of tethered shooting. Photographers often find that seeing the shot on a large monitor is a useful way to check focus and critical detail without having to wait to get back to the studio to see if they got the shot.

Currently, you can't do a tethered or a direct to disk shoot with video DSLRs. However, you can transfer video to your portable computer and make sure content, focus, exposure, and lighting are all on target. Additionally, you can do a simple edit to see if a scene will work with the coverage you have.

USE SHOTPUT PRO

When you're trying to back up to multiple places, it can be a time-consuming and somewhat tedious process. We recommend using an application like ShotPut Pro from Imagine Products, Inc. (www.imagineproducts.com), which lets you automate your backup to three places simultaneously.

DON'T HAVE A PORTABLE COMPUTER?

If you don't feel like lugging a computer around in the field, a good alternative is an offloading device like those from XS-Drive or Nexto. These devices combine a card reader, battery, and hard drive into one package.

Creating Disk Images

Most photographers choose to transfer individual clips to a computer or copy entire folders directly to a drive. Although this works just fine for a stills work-flow, we recommend a different approach for video. To transfer video, it's best to create a disk image of a card mounted to your computer.

The common workflow in the video world is based on the traditional process of handling tape. The standard practice with videotape is straightforward:

1. Shoot footage to tape.

2. Bring that tape back to your studio.

3. Ingest the footage on that tape.

4. When you're done ingesting the tape, store the tape on a shelf or in a box. You then have a re-cord of your production, which is available to use again in the future if you need it.

Creating a disk image is much like storing a tape on a shelf. A disk image is a carbon copy of the original memory card and makes it much easier to archive your footage and manage your assets.

The cool thing about a disk image is that instead of having separate folders and individual files, a disk image is a single file. And because it's a single file, it's much harder to tamper with its contents and poten-tially lose files.

▶ A disk image like this DMG file is a copy of a Camera Memory card that can then be mounted on your com-puter to emulate the original memory card.

Canon7D_32GB_Card 1_Shoot1.dmg Canon7D_32GB_Card 1_Shoot1

Archival Backup

Over time, you'll have backed up lots of photos and videos to additional storage. You might think you've covered all your bases, but even the best hard drives fail.

Instead of losing your hard work, consider a more robust and long-term archival system. When it comes to a time-tested archival format, look no further than linear tape-open (LTO) tape. Did we just say tape? We did, but not videotape. LTO comes in different forms, like LTO 3 and LTO 4. The number represents the gen-eration of the format (the higher the number the newer the format).

Currently, LTO 4 is the fastest and highest capacity LTO format, and can store about 800 GB of data on one cartridge. The best news is that LTO is robust. In fact, chances are your bank records are backed up on this very technology.

An investment in LTO technology is not cheap. Single LTO drive systems average $2,000–$3000; cartridges cost about $50. An investment in LTO pays for itself. LTO tapes can last for more than 75 years, which means your footage will probably last your lifetime.

You probably wouldn't bring an LTO drive out in the field, but once back in the studio, you can use it to archive the footage you transferred from your memory cards to your portable hard drives in the field.

Another good choice for archival backup these days that is cheaper than LTO solutions and is portable is Blu-ray. Blu-ray discs can hold up to 50 GB of data. In addition, Blu-ray burner prices have come way down over the past year.

Many specialty programs are available for creating disk images. The Mac OS contains the built-in Disk Utility to create DMG files. Several additional utilities are available for Windows to create ISO and UDF files.

Redundancy Strategies

When it comes to backing up photos and movies in the field, redundancy is the name of the game. What if your portable computer dies? What if you lose your external drive or it gets damaged (we've seen a number of drives get beaten up in the field)?

Well, that's why it pays to be redundant; that's why it pays to be redundant. The goal of redundancy is to have identical copies of data (in this case video) on separate, independent systems. Here are a few ways you can do this.

Copy to multiple places simultaneously: We often carry two external portable drives with us in the field, not because we like carrying around more stuff, but to be redundant. After mounting a memory card, simply copy the contents of that card to two or more different drives.

Create once, copy twice: If you'll be making disk images of your memory cards, create a disk image to your local drive but then copy that disk image to two or more places.

Use a dedicated utility: Several specialty programs are on the market, but our favorite is ShotPut Pro from Imagine Products, Inc. (www.imagineproducts.com). This versatile program (for Mac or Windows) offers several great features. It can create up to three automated copies, verify the data, and burn archive discs.

VIDEO #20: CREATING A DISK IMAGE
Check out this video for more information about how to create a disk image of a memory card.

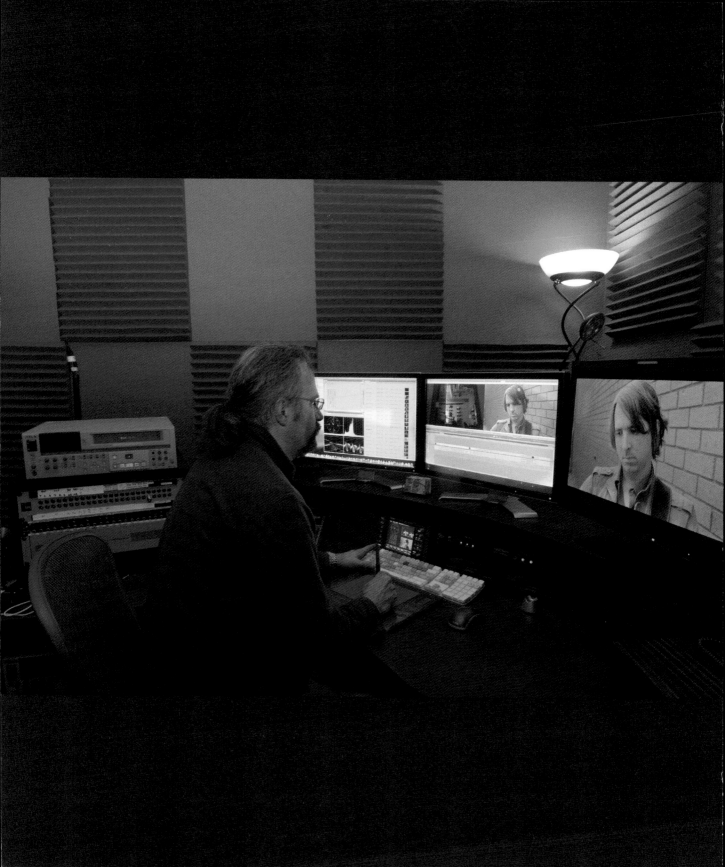

Part IV

Postproduction

You've put in a lot of effort to get to this point. You've planned the project, lit the shots, captured great sound, and used artistic composition. Now it's time to do something with all that effort. That's where postproduction kicks in—and truly it's a vital stage of the project. When finished, you'll be able to view the completed project that you've imagined in your head.

Postproduction can seem intimidating but if approached in a methodical way it can be straightforward. Like photography, the process begins with media management and then takes you into the heart of postproduction—editing. From there you can polish your video and audio by color correcting clips and mixing audio and then finally you'll be ready to publish your project. That can be the most exciting part—learning to share your work with others through the Internet and additional digital distribution options.

Postproduction is an exciting journey so let's get started.

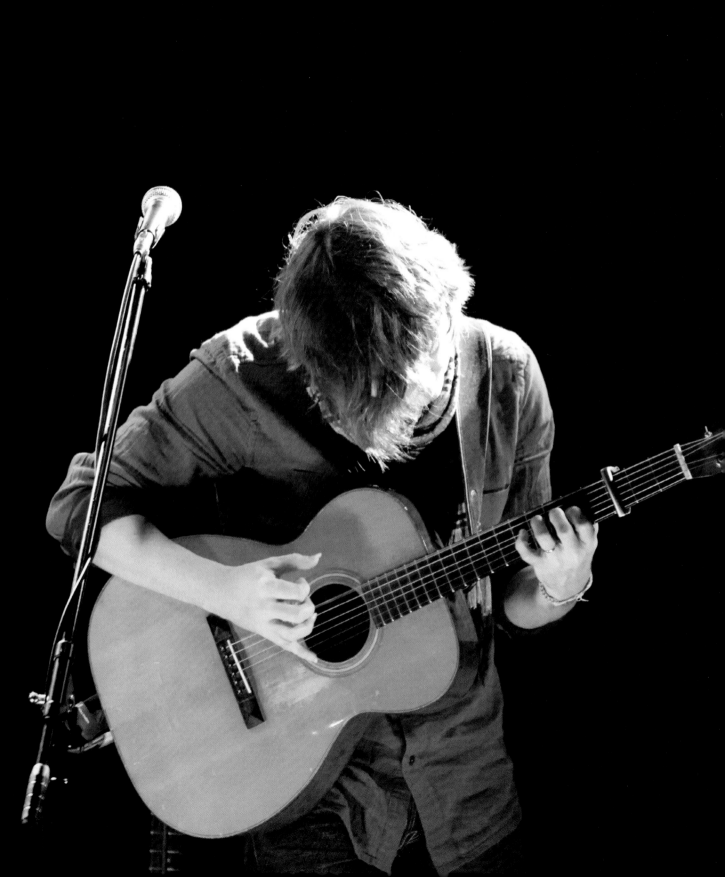

Get It Together

Media Management for DSLR Video

Whether you are a photographer, a videographer, a cinematographer, or all of the above, you take pictures and record video because it allows you to express yourself. Simply put, shooting stills and video allows you to be artistic.

But deep down we know you have a secret desire to be an IT professional. We're right, aren't we? Of course not. Thinking about and then executing good media management is probably at the bottom of your list when it comes to planning for your next project.

Media management is not very appealing. But ask most seasoned professionals and they'll all tell you that having a reliable media management strategy and workflow is critical. Considering all the time you spend in just a week putting in a ton of work to capture your images and footage, why would you skimp on transferring them and staying organized in postproduction?

ASK MOST SEASONED PROFESSIONALS AND THEY'LL ALL TELL YOU THAT HAVING A RELIABLE MEDIA MANAGEMENT STRATEGY AND WORKFLOW IS CRITICAL.

By planning your media management approach and developing a workflow that you can stick to, you'll ensure all goes smoothly after the shoot. Dependable media management ensures that you won't lose footage. You'll also be able to transfer your footage to your computer in a logical and organized way so you can work efficiently. In addition, you can back up and archive your footage so that you can reuse it in the future when additional changes or new deliverables are requested.

Even though all these tasks are pretty straightforward, we've been constantly surprised throughout the years by the staggering number of creative types who don't take media management seriously. Rather than focusing on a solid media management and postproduction strategy, they focus all their time and effort on the latest and greatest gear, and getting the shot. Although both are important, the inattention to media management can destroy a professional career.

When it comes to media management, your workflow is uniquely personal. Therefore, organizing your footage must be customized to include your unique configuration of equipment and resources while balancing effort. It's impossible for us to suggest all the media management steps that you should follow. So in this chapter we'll cover media management and workflow using approachable techniques that work for most users.

Choosing a Media Drive

Through the years you've certainly filled up a hard drive (or a few) with still images. So you go online or visit your local bricks and mortar electronics store to pick up a new FireWire or USB hard drive, and all is right with the world again. This seems simple enough.

But when working with video, you'll be making that trip to the online or local electronics store more often. Video can take up considerably more space than you're used to with photos. Because you're shooting sequential images, you fill up memory cards more quickly.

If you also consider you'll probably want to store photos, music, and other items on a drive, you'll need even more space when working with video. Taking all these files into account, choosing the right drive for your workflow in terms of size and speed is very important. In this section we explain some of the technical topics you'll need to understand when choosing a media drive.

Size Considerations

Your hard drives will fill up much faster than you'd like, so size does matter.

Consider the following situation: While working on a long-format project, you record 20 hours of 1080p 24 fps video (interviews, b-roll, etc.). If you use a camera such as the Canon 7D (which records video at a rate of about 5 MB per second or about 300 MB per minute), you'd have about 360 GB of raw video.

Although you can work with the footage natively on your system, you might transcode (discussed later in this chapter) to a format that is friendlier to your edit system and more robust for compositing and color manipulation. So, let's say you're working on a Mac and you transcode the footage to Apple ProRes 422. That 360 GB of raw video becomes almost 1.2 TB of data!

Of course, you'll probably also want to include photos, music, and sound effects in your project, so you'll need even more space. With 1, 1.5, and even 2 TB drives commonplace these days, your best bet is to

purchase the largest drive(s) possible. These can be internal computer drives or an external RAID solution (see "RAID for Speed and Redundancy" later in this chapter).

Speed Considerations

When you're working with photos, you often won't notice drive speed as a performance factor. Sure, a fast drive allows you to load a photo faster, but after it loads, a constant demand is not placed on the drive. However, with video it's a different situation.

When you play back video, you're essentially telling the drive to load hundreds or thousands of frames sequentially. When this rapid playback is combined with decompressing the various codecs applied to video, an amazing load is put on a drive. This load is known as data rate. The higher the data rate of a clip the faster the drive has to be. So if your clip has a data rate of 5 MB/s, the drive has to be able to load or play back at least 5 MB/s.

In most video DSLR workflows you'll be dealing with data rates between 4 MB/s and 30 MB/s. The hard drive speed requirement that's not so obvious is that when editing, you'll often be working with multiple

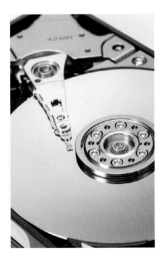

◄ Choosing a large drive gives you more room for large video clips and other files you may use in a project. ©iStockphoto

layers of video and audio simultaneously. So, if you have a file with a data rate of 20 MB/s but you are compositing five clips together to create a look, the drive has to be able to play back 100 MB/s because the video clips are playing simultaneously. These demands become very visible as you try to edit together video from multiple clips, apply transitions, or use special effects.

Fortunately, most modern hard drives (especially SATA drives) can handle this load. For the fastest speed, consider investing in a RAID solution in which multiple drives can be paired together for performance.

Connection Types

It seems like the one detail that's always discussed when it comes to drives is connection type. In fact, many define a drive by its connection type, for example, a FireWire drive. Most drives nowadays, including those installed internally on your computer, use a connection known as Serial ATA (SATA).

However, external drives offer users a few different connection types.

FireWire 400 and 800: Developed by Apple, FireWire is a standard connection type you'll encounter (sometimes called IEEE1394). FireWire 800 transmits data faster than FireWire 400 connections but is not quite as ubiquitous as FireWire 400. FireWire connections offer a good balance of stability and speed. Its major advantage is that it allows you to daisy chain multiple drives as storage needs expand.

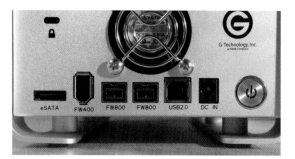

▲ Many drive units offer multiple connection types like this unit which has eSATA, FireWire 400 and 800, and USB 2.0.

USB 2.0: While USB connections are available on pretty much any computer (Mac or Windows). We tend not to like drives that are USB based for video work because the USB protocol steals resources from the computer's processor. This can result in video that stutters or skips frames. But USB-based drives are very useful (mainly because of their price) in the field to back up memory cards or to transfer media from one place to another. You can use an inexpensive USB drive to store a mirror of your data; just don't try to edit from it.

eSATA: External Serial Advanced Technology Attachment (or eSATA for short) is a very fast connection type and protocol. eSATA is available on many external drives but requires an eSATA interface on your computer. You can also purchase an eSATA interface card that installs in one of your machine's PCI slots or via a Card Slot or Express 34 slot on a laptop. eSata equipped drives provide faster throughput than USB 2.0 or FireWire 800 connected drives.

USB 3.0

An emerging new standard, USB 3.0 offers dramatically increased speed compared to USB 2.0 and FireWire equipped devices. At the time of this writing, USB 3.0 equipped storage is just coming to market but promises to be extremely fast. For more information on USB 3.0, be sure to check out this article at www.everythingusb.com/superspeed-usb.html.

HARD DRIVE RPM

You'll often see drives describe by their RPM speed such as 5400 RPM, 7200 RPM, or even 10,000 RPM and 15,000 RPM. The faster the RPM of the drive the faster you'll be able to access data on the drive. However, this speed comes at a financial cost as well as the cost of added noise and a shortened lifespan inherent to faster drives. For video work, 7200 RPM drives offer a nice balance of speed, cost, noise, and lifespan.

▲ A high speed RAID like this one from G-Technology offers very fast, high capacity redundant storage. ©G-Technology by Hitachi Global Storage Technologies

RAID for Speed and Redundancy

Two issues come up when talking about storage solutions that rely on only a single drive. First is speed: A single drive is simply not capable of supporting very high data rates. Second is redundancy: If a drive fails, all the data stored on that drive is gone. A solution to both issues is RAID (Redundant Array of Independent Disks).

Put simply, a RAID configuration lets you connect multiple drives to your system but have them act as a single volume. Because the drives work together, you get the dual benefits of speed and redundancy.

RAIDs use different levels of protection and performance (as indicated by a number like RAID 0, 1, 5). Each level dictates the speed and redundancy scheme that is possible. **Table 15.1** compares different common RAID types.

The all in one RAIDs that you typically find in a computer store are RAID 0, which offer great speed with zero redundancy. You may also encounter all in one RAID 5 units, but typically RAID 5 and above requires the use of a dedicated RAID controller card that can be installed in your system. The RAID card acts as a traffic cop for redundancy data and in the process increases data throughput to drives by releasing the CPU in your computer to handle other tasks.

SAS: Serial Attached SCSI (SAS) connected drives and drive units offer amazingly fast speed and are much cheaper than Fibre Channel connected storage (discussed next). Like eSata or Fibre Channel you'll need an SAS interface card for your computer to use SAS connected drives.

Fibre Channel: At the high end of connection types is Fibre Channel. Using fiber optic technology, Fibre Channel equipped devices can transfer data at an incredible rate (approximately 800 MB/s). However, this speed comes at a premium. Fibre Channel equipped drive systems are expensive and require an installed Fibre Channel interface card in your computer. For most working with DSLR material, a Fibre Channel drive is overkill (but speed is nice if you can afford it).

Table 15.1 Comparison of RAID Types

RAID TYPE	MIN # OF DRIVES	SPEED	HOW IT WORKS & REDUNDANCY
0 (striped)	2	Very fast	Harnesses the speed of all drives in the RAID. More drives mean more speed. No redundancy.
1 (mirrored)	2	Slow	Data is written to two drives at the same time, which results in available storage equal to half that amount of total storage. Good redundancy because data is written to two drives simultaneously. A drive can fail with no loss of data.
5	3	Fast	Redundancy data is written across all drives so it is faster than a RAID 1. Any single drive can fail with no loss of data.
6	4	Fast	Redundancy data is written across all drives (2 parity blocks). Two drives can fail at the same time with no data loss.
50	6	Very Fast	Redundancy data is written across each RAID 5 collection of drives, and those RAIDs are "striped" (RAID 0).

▲ You should always copy footage from a field backup to a high speed media drive rather than working off of the field backup. This way in case your media drive should fail you still have your backup drive.

DROBO OFFERS FLEXIBLE STORAGE FOR VIDEO USES

Many photographers have used drive units from Data Robotics. These units offer RAID storage with the ability to expand easily. The DroboPro is a good unit for video because it offers eight slots for drive expansion and protection schemes in which up to two drives can fail without data loss. Check out www.drobo.com.

Transferring Media

In the previous chapter you learned a number of ways of transferring and backing up media while in the field. When your footage is on the line, it's always good to back up in the field. Should you lose a card or your laptop crash, you'll have your footage backed up in a few different places.

But what happens when you get back to the studio? How do you transfer footage from those backups? That's what we'll discuss in this section.

Transferring from a Field Backup

You've done the due diligence and created a backup (or perhaps a couple) in the field; now what? As a general rule of thumb we never work on the drives that we use in the field as backup. Instead, we transfer media from backup drives to what we call a media drive, which is a high-capacity, fast drive ideally set up to be redundant using RAID 1 or RAID 5. It's from this drive that we work in postproduction.

Copying to your media drive is easy. It just depends how you archived content in the field.

Copied memory card contents: If you copied contents from a memory card directly to a portable hard drive (or multiple drives) in the field, your next step is to plug in that backup drive and transfer the backed up folders (usually one folder per transferred card) to your media drive. After you've copied the footage from your field backup, unplug that field backup but don't erase it, and then store it on a shelf. If something should happen to the media drive you're working on, you'll still have the field backup.

Created a disk image: If you created a disk image of the memory card in the field, you should first mount that disk image from your backup drive and then copy the contents (just as if it was a memory card attached to your computer) to your media drive. When the transfer is complete, simply eject the disk image and then unmount the backup drive. Again, don't erase the backup drive; hang onto it in case something should happen to your media drive during postproduction.

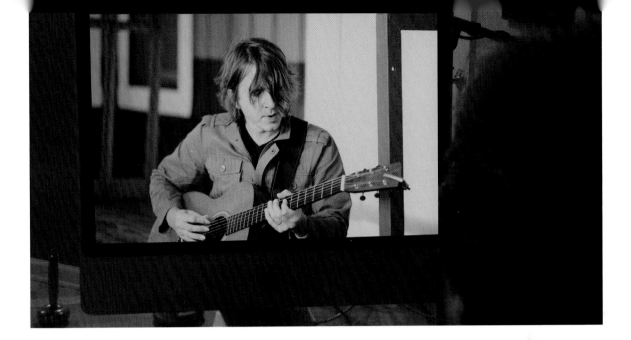

Another Chance to Create an Archive

If you don't have the time or equipment to create backups from your original memory cards in the field, you have an opportunity to do so when you get back to your studio.

Although we prefer archival tape formats like LTO to hard drives, you have a few other options to consider for backing up and archiving if you didn't do so in the field.

RAID local or network volume: You can back up your original memory cards to a local or network volume that uses a RAID scheme like RAID 1 or RAID 5. Just make sure this volume is not your media drive. If they are one and the same, and a crash occurs, you'll lose all your footage.

DVD or Blu-ray disc: Although this is not our favorite option because optical discs tend to go missing or get scratched, the fact is you can fit a lot of data on these discs. With a Blu-ray disc you can fit just up to 50 GB on a single disc. That's a lot of footage. You will find that the 25 GB discs are much cheaper, but both work well to archive your original clips. If your computer doesn't have an internal Blu-ray burner, you can purchase an external USB or FireWire based unit for just a few hundred dollars. Be sure to take good care of your discs and keep them in binders.

The cloud: Also known as storage (or a host of other services) on the Internet, the "cloud" is often a good alternate choice to other backup and archiving media. Many services in the cloud give you plenty of storage space to back up footage. The best part of the cloud is that the services that are available use redundant storage and archive "your" storage too. So it's very hard to lose media. And when you need more storage, you can upgrade pretty easily.

Organizing Media for an Edit

When you first transferred footage, you probably transferred one folder for each memory card. If so, you're already pretty organized. But what about deciding which shots you like or which ones are garbage? In the video world, this is known as making selects, and it can happen at a few different stages in post.

In this section we'll explore the basic selects process. The goal is to get media organized for editing, allowing you to be more efficient when it comes time to start editing.

Viewing Footage

After you've transferred your footage to your media drive, you'll probably want to look at those clips in real time. Here are a few ways to do this.

Use the operating system: The easiest way to view your footage is to use your computer's operating system to view the clips. On a Mac, you can often watch video clips using the Quick Look option (just select a clip and press the spacebar). You can use the Column or Cover Flow views in the Finder to view clips. With Windows 7 or later, you'll find a similar Quick Preview feature.

You can also open a file and play it back using a media player. The most common one for professional video is the QuickTime player software. Many other media players are on the market as well, including the versatile VLC player, which allows you to open several clips into a playlist.

Use digital asset management software: Digital asset management software (like Adobe Bridge) can often make organizing footage easier. You can quickly browse, preview, organize, and annotate your footage. The nice thing about an application like Adobe Bridge is that you can easily preview large amounts of footage without having to open each clip individually on the system level.

Use your editing application: Another method you can use to view footage is to import all the transferred footage directly into your edit application to view it. The advantage of this method is that you can start to sort clips into bins and add annotations, notes, and labels. If you're not transcoding the footage, you can also start building your story.

Making Selects

Now that you've viewed your footage, the next step is to make selects, meaning you choose the clips you actually want to use. The reason for doing this is simple: By the time you start editing your project, you don't want to have to search through a huge amount of footage to find exactly what you want.

If you've shot a scripted piece, you may have multiple takes of the action to work with. By selecting the best options, you'll have less footage to fuss with, which can greatly speed up the editorial process. Additionally, in some workflows, making selects is a good way to choose exactly which clips you'll transcode to another format instead of wasting time transcoding clips you know you won't use.

Copy selected footage to a selects folder: Once you've identified a clip as one you want to use, create a selects folder on your media drive or use the Selects folder in your project's Common Media folder (discussed next), and copy that clip into the selects folder.

Use a digital asset management program to copy selects: If you're using an application like Adobe Bridge, simply label all your selects, sort your footage by label, select all your labeled clips, and then move them to a selects folder.

Make selects in your edit application: In your edit application, simply make a new folder (or bin) and move selects into that folder. Then remove all other clips from the project. Once you have a selects bin, you can export and transcode those selects.

◀ Viewing footage and then making selects is an essential part of the media management and editing process.

The Common Media Folder

Working with photos, video, audio, motion graphics, and all sorts of other files (like scripts) over the years, we've devised what we call the Common Media folder to help organize every project. Although the Common Media folder is not a requirement, it's a good way of staying organized.

The Common Media folder contains a number of subfolders assigned to specific parts of a project. Using this structure, it doesn't matter which application you use to create and modify media. Here are the subfolders that make up the Common Media folder. (We've included a Common Media folder template on the DVD that you can use for your own projects.)

01 Original Footage: This is the folder where you copy footage from your memory cards to perform your field backups. You can copy as folders or as disk images.

02 Selects: After viewing your footage, you can copy selects to this folder or you can import this folder directly into your edit application if you won't be transcoding the footage contained within this folder.

03 Transcoded Footage: If your workflow requires it, you'll transcode footage to this folder. You can then import this folder directly into your editing application.

04 Project Files: Save project files from editing, audio, and motion graphic design applications into this folder.

05 Graphic Sources: This folder contains any graphic or motion graphic sources (like logos and animated textures) that you'll use as sources for creating a layered composite or animated file. It shouldn't contain exports; those should be saved in the next folder.

06 Graphic Exports: This folder contains any exports from applications like Adobe After Effects and Apple Motion as well as Adobe Photoshop and Adobe Illustrator. These files should be ready to import directly into your edit application for use in your project.

07 Audio Sources: If you've recorded audio to a separate recorder, place those files in this folder. Additionally, if you're using an audio editing application like Adobe Soundbooth, Digidesign Pro Tools, or Apple Soundtrack Pro, put those audio files in this folder.

08 Stock Footage: Put any stock footage in this folder. Stock footage means any footage that you buy as well as footage from other projects that you'll be using as "stock" for this project.

09 Exported Files: Keep your exports from a project in one place. This means any files that you create from your final project or intermediate files like a web compression for a client to view. Future deliverables to the client are effortless if you keep these exports readily accessible.

10 Production Paperwork: Most projects have lots of additional files that are not media files. Items like scripts, budgets, and even lighting and blocking diagrams should go in this folder.

VIDEO #21: THE COMMON MEDIA FOLDER IN ACTION
Learn how to use the Common Media folder approach for your editing workflow.

▲ The Common Media folder is a great way to stay organized. You can modify the file structure of the folder to suit your own projects.

Transcoding Footage to Edit

Video-enabled DSLRs are capable of recording amazing looking footage, but they all have one major downfall—the compression schemes they use. Video-enabled DSLRs use heavy-duty compression—like H.264, AVCHD, and Photo JPEG—so more HD footage can fit on relatively small memory cards. Without the compression that these cameras apply to clips, you'd need a ton of fast field storage to record even a few seconds' worth of footage.

The transcoding process for DSLR video is similar to the evolution of digital photography. Recall that early on you *had* to shoot to JPEG files. This need was driven by the limits (and costs) of storage technology. Once you got the file back to your studio, you'd generally convert it to a TIFF or Photoshop file that was more robust and allowed greater flexibility for manipulation and editing. Well, the same principle holds true for video.

These modern compression schemes work well in the field and allow you to fit several minutes of video on a video card. But if you try to edit clips that use codecs such as H.264, they can be very processor intensive to work with on your computer. However, many editing tools are expanding their support of native DSLR files. The benefit of this workflow is that it reduces the time from shoot to edit. Although in the future we expect many edit tools to better support native editing.

The compression schemes that video-enabled DSLRs use are not particularly suited to tasks like compositing and color correction. You'll notice that the footage quickly starts to pixelate or shows visible noise during manipulation. For this reason some professionals decide to trancode to a more robust editing codec either before editing or before additional postproduction steps like color grading.

If you're scratching your head wondering what transcoding is, you'll be pleased to know that most likely you're already familiar with the process in the photography world. Even though you shoot a JPEG or raw file, you likely transcode it to another format (like Photoshop) for editing. The idea is the same in the video world.

Software Tools for Transcoding

When transcoding footage, you'll be using different software tools for the conversion. A plethora of tools are available, but we'll highlight some of the most popular. Just keep in mind that whichever one you choose should not only be a matter of preference but should also offer the flexibility to create the files you need for your edit system.

Here are some of our favorite tools.

 Apple Compressor: This Mac-only compression tool is part of Final Cut Studio. It is a full-featured compression and transcoding application that allows you to easily transcode footage from your DSLR. If you're using Compressor, you'll most likely use the Apple ProRes codec to transcode to. This codec can work on Windows machines too. Check it out at www.tinyurl.com/prorespc.

 FINAL CUT PRO LOG AND TRANSFER PLUG-IN FOR CANON DSLR CAMERAS

Canon recently announced a new log and transfer plug-in for Final Cut Pro that allows users to ingest and transcode footage from Canon DSLR cameras directly inside of Final Cut Pro. This plug-in speeds up ingest considerably because you don't have to transcode in a separate application. You can download the plug-in from Apple by visiting www.apple.com/downloads/macosx/finalcutstudio.

TRANSCODING PRACTICE

On the DVD we've included a file called MVI_3745.mov in the Chapter 15 folder that you can use to practice transcoding with your application of choice. Use this file for the training video exercises associated with this chapter.

 VIDEO #22: TRANSCODING WITH COMPRESSOR

If you're transcoding your footage on a Mac, be sure to check out this video about using Apple Compressor to transcode your clips.

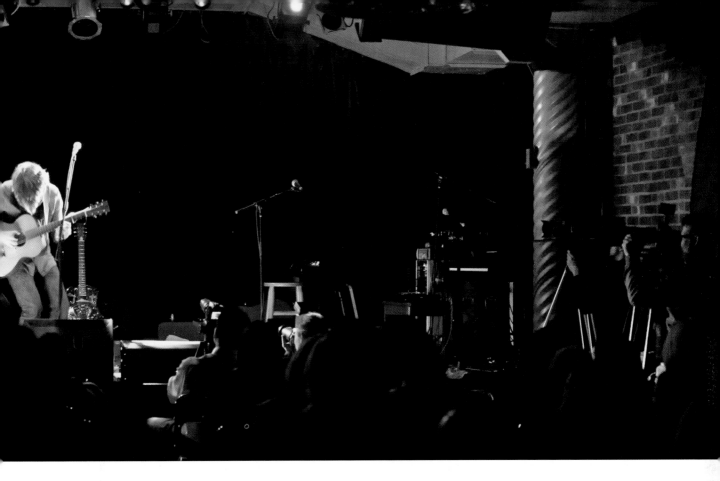

 Adobe Media Encoder: Available as both a Mac and Windows application, Adobe Media Encoder is a powerful, feature-rich compression and transcoding application. Adobe Media Encoder allows you to create AVI and QuickTime files using codecs like the CineForm codec (discussed later in this list) or any QuickTime compatible codec like Apple ProRes.

 MPEG Streamclip: We really like MPEG Streamclip. First, because it's free, and second, because in our experience it has been able to transcode footage from our DSLRs faster and at better quality than many software transcoding applications. It's available for both the Mac and Windows.

 APERTURE 3: NOW WITH VIDEO

If you're using Aperture to organize your photos, you can now add video too. In this tutorial, learn how to organize, trim, and export your media for editing in Final Cut Pro.

 CineForm Neo Scene: Part utility, part compression scheme, CineForm Neo Scene is a popular compression utility that processes files into the CineForm HD codec, which is a popular choice in many cinema workflows. After installing CineForm Neo Scene and transcoding files, you can edit the files in edit applications on both the Mac and Windows, which makes it one of the simplest tools for cross-platform HD workflow.

 VIDEO #23: TRANSCODING WITH MPEG STREAMCLIP

MPEG Streamclip is a full-featured, powerful compression and transcoding application that works on both the Mac and Windows. Best of all it's free! Check out this video to learn how to use it to transcode your DSLR footage.

Converting and Conforming Frame Rates

We urge you to try to use one frame rate for all the footage you have in a project—preferably a standard video rate, such as 29.97 fps or 23.98 fps. Sometimes, you'll have clips that use a different frame rate due to hardware choices or a mistake in camera setup. During the media management phase of a project, converting or conforming frame rates means changing the frame rate of your footage to match the frame rate of your edit sequence. This is an important step because it reduces rendering and improves overall consistency.

Frame rates in DSLR cameras vary a great deal but sometimes the difference might be small. For example, when shooting for NTSC, you'll find cameras that

shoot at 30 fps and 29.97 fps (even from the same manufacturer). With these slightly different frame rates, you might be thinking, what's the big deal? Well, the issue is that in most editing software you'll have to render or process clips that don't match the frame rate of your sequence.

To avoid problems with frame rates, use the following procedure:

1. Determine which frame rate your deliverable needs to use. If your client doesn't know, ask to speak to someone who does.

2. Identify clips that do not have the desired frame rate.

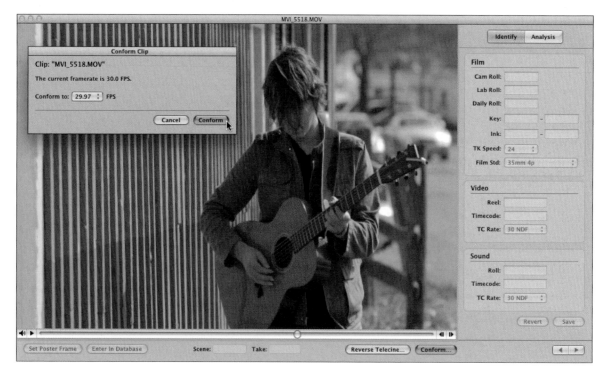

▲ Tools such as Apple Cinema Tools can be used to conform or change the frame rate of a clip to the frame rate of your project. Just be aware that conforming a clip will also change the speed of any audio associated with a clip.

3. Use transcoding applications like Apple Compressor or Adobe Media Encoder to convert non-matching footage to the frame rate and codec of your project. You can also interpret clips in Premiere Pro or After Effects using the Interpret Footage command. Additionally, using a utility like Apple Cinema Tools, you can conform a clip to a particular frame rate, which permanently changes the clip's frame rate rather than making a converted copy like transcoding does.

If you've shot some clips at a much faster frame rate than your project, after conforming the footage, it will look slowed down. This allows you to simulate "overcranking," which is a technique used with motion picture film cameras. Keep in mind that any audio you have on the clip will also be slowed down, rendering it pretty much useless. We'll talk more about speed changes in general in the next chapter.

Although many modern edit tools such as Apple Final Cut Pro and Adobe Premiere Pro can perform frame rate conversion in real time, you're often better off converting footage prior to editing it. By converting the footage first, you'll lessen the demands on your system for real-time conversion and playback. This means a more enjoyable and efficient editing experience.

Backup and Archive

Recall that in Chapter 14 we talked about backing up memory cards to additional portable hard drives or Blu-ray discs in the field and then backing up those backup drives to LTO tape when you return to your studio. But what about transcoded media you may have created or any items like scripts, audio, or graphics that you may have added to your Common Media folder?

When you're back in your studio, archiving should be done to back up the progress you've made. The postproduction and media management phases are costly, so you'll want to back up any transcodes you've made as well as your editing project files.

Also, you should think about backing up your files on a schedule. We prefer backing up media files on a weekly basis but recommend backing up any project files like Adobe Premiere or Final Cut Pro project files on a daily basis.

Here are three ways to back up and archive a project in progress.

Back up to a dedicated backup RAID: Running alongside our media drive (which is also usually a RAID system) is a backup RAID that is the same size as the media drive. This allows us to copy our entire Common Media folder to the backup RAID. If you're using a Mac, this can also be done using the Time Machine function. The backup RAID doesn't need to be superfast because you're simply using it for backup. Simple FireWire equipped external RAIDs in capacities between 4 TB and 8 TB can be purchased pretty cheaply.

Back up to a network or shared storage: If you have plenty of network storage available or work in a shared storage environment (NAS, SAN), you can back up to those volumes. The advantage of a network or shared storage volume is that if you work with other folks, they can access any backups/footage that you've placed there.

Back up to LTO or Blu-ray discs: Not only can you archive field backups to LTO and Blu-ray discs, but you can also use them to back up your Common Media folder and media you've created during the media management stage of postproduction.

TO THE CLOUD
You can easily set up backup utilities to back up project files to an offsite location. Several cloud computing services are available that offer offsite storage for your projects. We recommend backing up your project files to the cloud at least once a day.

Profile Scott Bourne

Photo © Marc Katz

Follow Scott on Twitter:
@ScottBourne

GEAR LIST

Selected lenses:

> 1D MK IV and a Canon 1D MK II
> Canon 800mm f/5.6 L
> Canon 400mm f/5.6 L
> Canon 24mm f/1.4 L
> Canon 50mm f/1.2 L

> Redrock Micro Event with Follow Focus and Matte Box
> Zacuto Z-Finder
> Zacuto Sharp Shooter
> Miller DS20 fluid head and tripod
> AT 897 shotgun microphone
> Two Countrymen E6 lavaliere microphones
> Zoom H4N
> Sony PCM-D1 recorder

Scott Bourne is a photographer who specializes in shooting wildlife and nature. But he's equally known for his generous contributions to the photography community as an expedition leader, blogger, podcaster, and technical author. Bourne quickly adopted HD video into his workflow because he believed it was an excellent creative outlet.

"I envision being able to create combinations of stills that I've shot with footage of the area that I worked and the animals in real time to give people a better sense of what it's like," says Bourne. "As a photographer, I'm catching 1/1000th of a second, and that's got its own value, but video can add context."

Bourne explains that it's the storytelling aspects of video that interest him most. Many of his clients are also keenly interested in video. "Clients are telling me point blank, if you can't give me video, I'm not interested," says Bourne.

Bourne believes that video is a great opportunity, however, and should be seen as such by both pros and amateurs.

"Don't dismiss video just because you don't have experience with it. There are new challenges using video that are fun and rewarding to engage," says Bourne. "People are afraid of what they don't know. They'd rather attack it than learn it. Pros need to understand that they'll be disintermediated if they don't learn it."

But Bourne stresses that video won't replace photography; pros will just be expected to do both.

"Video is not going to kill still photography; they're two completely different disciplines," says Bourne. "I just think the cool thing about the hybrid video cameras is that they give the still photographer a chance to see what can be done by mixing these mediums."

Bourne states that the evolution of shooting video with DSLR cameras is a welcomed challenge. But it is one that will continue to require a balanced approach to learning.

"I have one camera that I am using for stills and one that I'm using for video. Occasionally, I'll switch back and forth depending on my needs, but I'm having the best luck when I separate the two kinds of work," says Bourne. "It's very hard for me to think of both at the same time. My goal though is to be able to seamlessly move between them."

For Bourne, one of the greatest challenges was learning to deal with movement. He emphasizes the importance of putting the camera into motion with sliders or a fluid head tripod.

"The whole thing with movement is something that still photographers need to learn. I didn't get it at first. My first few videos were really pretty, but they were just stationary camera shots," explains Bourne.

Of course all that gear is a bit shocking to a photographer. "Video support gear requires a lot more than still photography (and I thought still photography took a lot). When I'm shooting video, I have to think about follow focus and matte boxes, and things to keep the camera steady," says Bourne. "You just can't do it alone anymore; this is not a one-person job."

But Bourne acknowledges that this is a great opportunity for collaboration. "The word *crew* has all-new meaning to me," says Bourne. "It's a lot more collaborative. A lot of still photographers' egos are going to have to make adjustments. You're not going to be able to go out there and say I got this great shot, look at me. You're going to say we got this great footage, look at us. There's a real great opportunity for people to team up."

The Challenge of Focus

Shooting video in focus is a challenge—one that everyone who's switched to DSLR video knows.

"The first ten hours of my footage was blurry," says Bourne. "I'm finding that once you learn how the focus works (in video) it's a lot easier. For those of us coming from camcorders where everything is in focus all the time, it does require a lot of thinking. I can see why in the movie business people run a tape from this point here to there and use markers. It's very precise."

Unfortunately, Bourne's primary shooting subject— nature—isn't ready for multiple takes. "When I'm shooting moving subjects, like birds that aren't standing still, I can acquire focus for a minute, and then they move and I'm out of focus," says Bourne.

To combat focus problems, Bourne offers three tips:

› "I'm using the contrast-based auto focus in the camera; then I'm planning the move to either keep the focus plane where it is or I'm having to pull focus to adjust for different subjects. I'm cheating a little bit and using a little more depth of field than I'd like to use."

› "When you're shooting with Live View (which you're doing with these cameras), it's tough to see, and if you're my age, it's impossible. I find that the Zacuto Z-Finder improves my shooting the most as it gives you a 3X multiplier so you can really see the viewfinder. It allows you to critically focus."

› Using a viewfinder also helps stabilize the camera. "It's another point of contact, making it a massive stabilizer. Trying to hold a DSLR in front of your face while you shoot—I don't care who you are—you aren't going to get anything steady."

A Cut Above

The Basics of Video Editing

Congratulations! You've made it to the heart of postproduction—editing. Editing is where a project comes together, where seemingly disparate items converge to create a cohesive story. The famous director Francis Ford Coppola once said, "The essence of cinema is editing. It's the combination of what can be extraordinary images of people during emotional moments, or images in a general sense, put together in a kind of alchemy."

The alchemy that Coppola speaks of is the beauty of editing. In any given project you'll probably have shot a ton of footage, which until you reach the editing phase of a project will not have been seen together and will not have collectively been able to tell the story you want. But once edited together, each clip takes on its own special meaning and scenes take form to make your project truly shine.

Editing is Where a Project Comes Together, Where Seemingly Disparate Items Converge to Create a Cohesive Story.

The process of editing has often been thought of as somewhat of a dark art—a secretive process that happens behind closed doors by "wizards" who know how to manipulate video in some magic way. Well, this is untrue. Editing video is an accessible task and not all that difficult once you know the basics.

Most likely you're already an editor, even if you don't consider yourself one. When working with photos or designing layouts, you often make editorial choices. For example, you decide how to crop photos or how to arrange certain photos in an album. Both tasks are part of the editorial process.

Editing video footage using modern applications like Adobe Premiere Pro and Apple Final Cut Pro is not magic and in a lot of respects is no more difficult than editing photos. We won't attempt to teach you everything you need to know about editing video footage in one chapter; instead, we'll outline the basics of working with a video editing application so you'll able to tell the story you want to tell.

Selecting an Editing System

You have several options when it comes to choosing an editing system. We know it can be hard to choose a system that is right for you, especially if you read all the marketing literature on each one. They all sound great, so the choices you have may be overwhelming. In this section we discuss specific criteria to help you make a choice.

Cost

Cost is often the determining factor when you're choosing an editing system. We certainly understand budget limitations, but don't let cost alone dictate your choice of editing software. For example, let's say you want to work with Apple ProRes or CineForm compressed footage as well as be able to animate effects. Well, these are tasks you simply can't do with free editing software. We're not saying you need to spend $10,000, but choosing a more capable software application even though it is more expensive is not a bad idea if it has the features you need.

Features

Although different tools offer (and the companies will market) different tool sets, we feel that the editing system you choose should include the following very important features:

Multi-format capability: The ability of a software app to work with various frame sizes, frame rates, and codecs is vital. You never know when you'll need to work with footage of various flavors.

Multi-camera ability: One of the benefits of shooting with a DSLR camera is that it is a low-cost option compared to a traditional video camera. So on any given production you might use two or more cameras. Not only does using multiple cameras give you the ability to get more coverage, but it also allows you to tell a story more dynamically. Therefore, the ability to edit multi-camera footage in an efficient way is essential in an editing system.

Export capabilities: In the course of a project you'll probably need to export a clip to various formats. It's

a good idea to make sure the software you have your eye on supports the ability to export to a format you need like Flash Video, H.264, QuickTime, or even Windows Media.

Customer service and training: If you search the web, you might find a tool that sounds fantastic and has all the features you want. But buyer beware! Just because a tool sounds great doesn't mean it is. It's a good idea to check out the support and training options available for the software you want before you purchase it. When things go wrong, you'll have the ability to right the ship by contacting the company that makes the software or by watching training videos or reading training manuals about that specific application.

Input/Output Options

No matter which editing system you choose, make sure that the software (and possibly supplementary hardware) can connect to additional pro video hardware (monitors, decks, etc.) so you can interface with additional equipment and tools. This includes the ability to attach professional video monitors, speakers, video tape decks, tapeless media formats, and archival devices like Blu-ray burners.

Three-point Editing Basics

It seems like editing software is constantly being updated with new features; workflow enhancements as well as new ways to manipulate audio and video seemingly develop on a daily basis. With all the bells and whistles that are continually added to video editing software, one thing remains the same—three-point editing.

The concept of three-point editing is simple and has been a constant since the early days of motion picture film editing. To make any edit, you must have three points or marks in time to join source footage to the sequence of separate shots that you're building. These three points can include two points (start and stop points also known as In and Out points) in the source and one point in the sequence of clips, or two points in the sequence and one point in the source.

VIDEO #24: EDITING WITH iMOVIE
iMovie is an application that comes with every new Mac. A simple yet powerful application, it's a great tool to try if you're new to editing on the Mac.

Different editing systems will implement the rule of three-point editing in different ways, but the overall concept of three-point editing is the same.

Previewing Clips and Marking Edit Points

The first step to making any edit is to preview a clip. Most edit systems have a window or a tool to preview clips. By previewing the clip you can decide what part of the clip you want to use. This might mean isolating an action or getting rid of extraneous parts of the clip like a director giving instructions to the talent. Once you decide which portion of the clip you want to use, you need to mark In and Out points on the clip.

As you probably can guess, an In point is where you want the clip to start and an Out point is where you want the clip to end. The part of the clip you marked will then have a new duration that is different from the original and will be ready to be edited into the sequence.

Adding In and Out points is not a destructive process, and there's no need to worry about marking an In and Out point on the exact frame. If you've marked an In

▲ Marking In and Out points is done in a similar way in most editing applications, including Apple Final Cut Pro (left) and Adobe Premiere Pro (right).

▲ The two most common ways of getting source footage into a sequence are an overwrite (or overlay) edit and an insert edit. In Final Cut Pro and Premiere Pro the controls to perform these edits are in different places but the functionality is the same.

and Out point on a clip but then change your mind, that's OK. You can always set new In and Out points. Also, once you edit the clip into your sequence of shots you can further refine a clip's In and Out point by trimming the clip (see the section "Trimming Clips" later in the chapter).

In addition, all modern editing software lets you use a clip multiple times with different In and Out points. Let's say you have a ten-minute interview clip. You preview that clip, find the sound bite you want to use, and mark an In and Out point around the bite. You then edit that clip into your sequence. By adding that clip to your sequence you've essentially saved the In and Out points you've placed on the clip. On the original interview clip, you can mark new In and Out points to define a different bite and then edit that clip into the sequence.

 A DIFFERENT WAY TO MARK CLIPS
For any edit, you need three points, but they can be in either the clip or the sequence you're working with. It's common to mark an In and Out point in the sequence to define a duration or "hole" you need to fill and then mark only an In or Out point in the clip where you want the clip to start or end. When you mark an In and Out point in a sequence and only an Out point in a clip, it is called back-timing an edit.

Editing Clips into a Sequence

After you've previewed and marked the clips you want to use, you'll need to put those clips into a sequence. Although terminology differs slightly from application to application, a sequence or Timeline is the container in which different clips you've chosen come together to tell your story.

Keep in mind that for any edit to happen you'll need to mark three points. However, many applications don't actually make you physically mark a point in a sequence. Instead, they use the position of the playhead (or current time indicator) in the sequence as an In point. In other words, the playhead position determines where in the sequence your clip will start.

There are many ways to edit clips into a sequence, such as pushing a button, dragging a clip, or using a keyboard shortcut to name a few. No matter which method you choose to get a clip into a sequence, there are two main edit types that you can perform.

Overwrite: An overwrite edit places the clip you're trying to add to the sequence at your sequence In point (or playhead position), overwriting any clips that might be in the way. Typically, when initially building a sequence, you'll use an overwrite edit, but you won't be overwriting any clips; you'll simply be overwriting black or parts of the sequence where no clips exist.

Insert: An insert edit places the clip you're working with into a sequence at the sequence In point (or playhead position) and pushes all other clips that might be present in the sequence farther down the sequence (to the right or further in time). Insert edits are useful when you need to add clips to a sequence without losing (overwriting) portions of other clips.

Most editing applications also allow you to place the video or audio of a clip on different tracks. Tracks are very similar to layers in Photoshop. You'd use multiple video tracks if you were creating a composite of some sort, and you'd use multiple audio tracks to layer different audio sources like recorded sound, music, and sound effects.

VIDEO #25: EDITING WITH FINAL CUT PRO

Final Cut Pro is one of the most popular editing systems in the world. Check out this video to learn the basics of editing with this powerful software.

VERSIONING

It's a good idea while editing to duplicate the sequence you're working on at major points of the project (after an initial string out, a rough cut, and so on). This will allow you to easily step back to a stage in a project. It's also good practice to color code sequences (in progress, finished, etc.), initial sequences (if there are multiple people working on a project), and date sequences. You'll then know exactly what a sequence is, who worked on it, and when.

Trimming Clips

So you've marked a clip and edited it into a sequence; now what? Well, unless you have the uncanny ability to have edited your clips together perfectly, you'll probably need to do a bit of refining, or *trimming*. Most editing applications have several trimming tools, and they all do the same thing in different ways—adjust the In and Out points of a clip or surrounding clips. Here are some common ways of trimming a clip in a sequence (keep in mind that your application might have a specific name for the tool you use to make these types of trims).

Lift: Sometimes you'll just want to remove a clip from a sequence. A lift edit deletes a clip from the sequence, leaving a gap or hole.

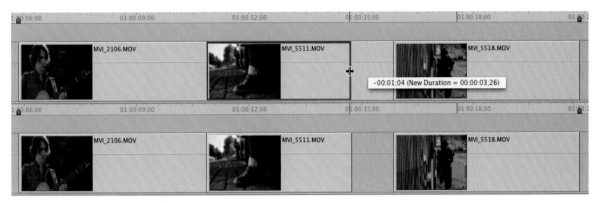

Simple trim: Most editing applications allow you to use the cursor to grab the start (In point) or end (Out point) of a clip and drag to trim. When you drag an In or Out point closer together, you make the clip shorter; when you drag them farther apart, the clip becomes longer. Keep in mind that if you drag either an In or Out point to make the clip shorter and there are other clips in the sequence surrounding the one you're trimming, you'll leave a gap or a hole in the sequence.

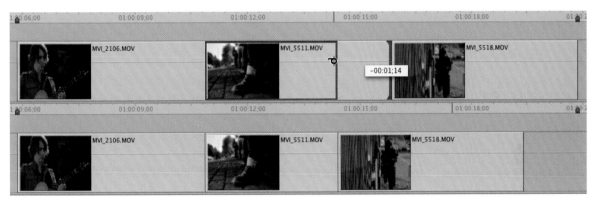

Ripple: A ripple edit allows you to trim either the In or Out point of a clip. But instead of leaving a gap like a simple trim does, clips that come before or after the clip you are trimming move to close the gap that was made by the trim, thus affecting the overall duration of the sequence. Ripple edits are an extremely fast way to tighten up a sequence without having to push too many buttons or move lots of clips around in the sequence.

TRIMMING WITH THE KEYBOARD
A seasoned editor will tell you she seldom uses the mouse and cursor to trim clips in a sequence. Why? Most applications have keyboard shortcuts that will not only activate a particular trimming tool or function but also trim clips. If you want to trim faster consider using the keyboard.

WHAT ABOUT TRIMMING AUDIO?
Trimming tools are often used with video but they can also be used to trim audio. You'll often trim audio to clean up interview bites or edit out a section of music. Many applications automatically link video and audio in the same clip, so when you trim either audio or video you'll be trimming its counterpart.

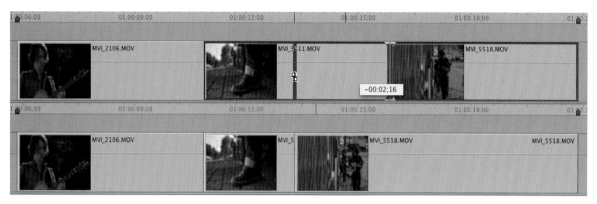

Roll: A roll edit happens between two adjacent clips. It effectively changes where in the sequence the edit happens or where two clips meet. If you roll an edit point to the left, you'll make the clip on the left shorter because you're moving its Out point closer to its In point, which in turn makes the clip on the right of the edit longer because you're moving its In point farther away from its Out point. A roll edit doesn't change the duration of a sequence, and it's often used to polish action between two clips.

Slip: A slip edit lets you redefine the In and Out points of a clip at the same time without changing the duration of the clip. Say, for example, you preview a ten-second clip, mark an In point at four seconds, and mark an Out point at seven seconds, giving the clip a duration of three seconds. You then edit the clip into the sequence. Well, when you slip that clip, you keep its duration the same but adjust where the In and Out points happen in the clip. So if you slip the clips three seconds to the right in the sequence, the new In point of the clip would be at seven seconds in the original clip and the new Out point would be at ten seconds in the original clip. A slip edit doesn't change the duration of a sequence, and it's a very useful way to change action in a clip without affecting other clips around it in a sequence.

Slide: A slide edit is a powerful way to change how a key shot cuts with shots around it. When you slide a clip, the clip you're sliding keeps the same duration but the clips to the left and right change duration. So, let's say you have a three-shot sequence and you slide the middle clip. When you slide to the right, the first shot becomes longer (you're moving its Out point), the middle clip stays the same (because that's the clip you're sliding), and the last clip becomes shorter (you're moving its In point).

✓ MATCHING SEQUENCE SETTINGS TO A CLIP

It's very important that a sequence be properly set up. If your sequence settings (frame size, frame rate, etc.) don't match the clip, performance will take a hit. You may even have to render a clip before playing it back. To avoid performance problems, make sure your sequence settings match the format of the clips you are editing.

VIDEO #26: EDITING WITH PREMIERE PRO

Adobe Premiere Pro works with a Mac and Windows, and is a fantastic editing application. Check out this video to learn more about cutting with this great tool.

Editing Audio

You'll probably spend a ton of time editing video in your project, but you might spend just as much time editing audio. Although the tools you use for editing audio are the same (for the most part) as video, the goals are sometimes different. Here are the most common approaches for editing audio.

Dialogue and narration: Often, you'll need to patch audio together to form a story or in some cases coherent thoughts. If you work on dialogue or narration driven projects, this will be most of the work you do with audio. In fact, you'll often take audio from different sources and weave it into a patchwork quilt that tells a story.

Music: On many projects, music plays a pivotal role. When editing a project, you'll often need to edit music

to fit a specific time duration. You may also need to edit music to remove parts of a song (verses, choruses, etc.) so the song does not compete with other audio elements.

Mixing: Keep in mind that you'll also want to mix all your audio so that the disparate audio elements in a project work well with each other. During this stage, you'll adjust the audio levels so they blend well together.

For more on postproduction audio editing and mixing, be sure to check out this excellent book by Jay Rose: *Audio Postproduction for Film and Video, Second Edition: After-the-Shoot Solutions, Professional Techniques, and Cookbook Recipes to Make Your Project Sound Better* (Focal Press, 2008).

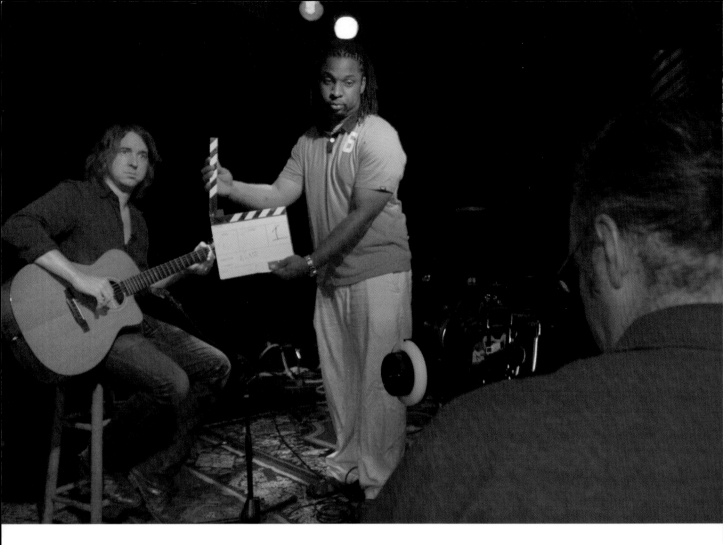

Syncing Picture and Sound

Earlier in this book we mentioned that the built-in microphone on most DSLRs provides poor quality at best. Attaching an on-camera microphone (although it sounds much better) is still subject to the limitations of the DSLR, such as automatic gain control and the inability to assign input channels. That's why we prefer recording audio to a separate recording system, such as a digital audio recorder like the Zoom H4n.

It would be great if DSLRs supported timecode, and we could sync timecode between our DSLR and a digital audio recorder, but this functionality as of this writing is in its infancy. So what to do? Well, you'll need to

sync the audio you recorded to a digital audio recorder to your video recorded on your DSLR. There are two main ways of doing this: manually and using syncing software. In this section we'll explore both methods.

Manual Method

In Chapter 13 we discussed using a clapboard or even a clap of your hands while recording (both video and audio) so that you can have a reference point to sync your video with audio in post. Well the time has come to do that, so let's see how it works:

1. Load the video clip you want to sync into your editing software so you can preview it.

2. Find the point in the video where the clapper or your hands come together and mark an In point. If you also recorded audio on the camera (which we suggest you do for reference), you can look at the audio waveforms of the clip to more precisely find the point where the clapper or hands hit.

3. Edit the clip into a blank sequence (your editing software will use the last frame of the clip as the Out point).

4. Load the audio you've recorded on your digital audio recorder that matches the video clip in your edit system so you can preview it. Repeat step 2, finding the exact point at which the clapper or hands come together.

5. Edit the audio into your sequence, making sure that the start of the video clip (and reference audio) and audio clip are aligned. You'll need to use an additional set of audio tracks. Play back the sequence to ensure the clips are in sync. Once you're satisfied that the clip is in sync, delete the reference audio.

6. Link the audio and video. Most editing software allows you to manually link audio and video together. So it's a good idea to link the high-quality audio you recorded and the video clip to keep them together throughout the project.

7. After you've linked your audio, it's best to drag the newly linked clip back into your project window. We usually create a new folder or bin called synced clips. Then anytime you want to access the synced clip you can without having to repeat the syncing process.

Chances are you'll have lots of clips to sync. It's OK to use the same sequence and just string out all the clips, syncing each clip with its corresponding audio. It's also not a bad idea to keep this sequence in your project in case you need to go back and adjust the sync of a particular clip.

HOW DO YOU KNOW WHICH AUDIO CLIP TO USE?

Most digital audio recorders record files with a machine name (similar to how a DSLR names a clip). So how do you know which audio clip goes with which video clip? It's important when using a clapper or your hands to actually say the name of the shot or take. This way you can be confident that the audio belongs to the video clip you're working with. Also, make sure you've enabled audio recoding on the camera, The camera recorded audio can act as a reference, so you can compare the reference audio to the audio from your digital audio recorder.

▲ You can use a reference point in both your audio and video (such as a clap point) to sync footage from your camera with audio from a dedicated digital audio recorder.

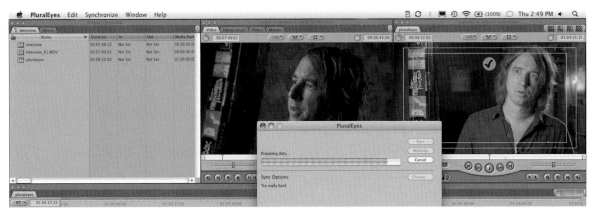

▲ PluralEyes from Singular Software allows you to automatically sync clips. The software compares audio from different clips and syncs them, but we think it's kind of like magic.

PluralEyes

We'd be lying if we said we didn't think that PluralEyes from Singular Software (www.singularsoftware.com) was magic. The software is truly amazing!

Although manually syncing video to audio is not that hard, it can be a time-consuming process. Worse yet, what do you do if you forget to use a clapboard or some other sound as a reference sync point? Well, that's where software like PluralEyes comes in.

PluralEyes works by analyzing audio in any clips you want to sync and automatically aligning and syncing those clips. For PluralEyes to work properly, you need to record audio to a digital audio recorder and also record audio to your DSLR (using the built-in microphone is fine). PluralEyes uses the camera-recorded audio as a reference to sync to the high-quality audio.

Actually using PluralEyes is simple; just follow these general steps (for specific steps for each editing platform, visit www.singularsoftware.com):

1. Create a new project and save it. Then create a sequence called *pluraleyes*.

2. Edit a video clip (with the reference audio) into the sequence, and also edit the high-quality audio from your digital audio recorder into the sequence. It's not important that you set In or Out points or where in the sequence you place these

clips. Be sure to place all your camera clips on one track and all your synced sound on another.

3. Invoke PluralEyes. When PluralEyes starts, click the Sync button. In a few moments, just like magic, PluralEyes will sync the video clip and high-quality audio! Keep in mind that PluralEyes creates a new sequence with the synced clips on it called pluraleyes ### (synced). The # sign indicates the number of the synced sequence in that project. Your original sequence name remains the same.

4. After the clip is synced, you can delete the reference audio and manually link the video with the high-quality audio. Then drag this clip to your Browser or Project panel so you can use it in the rest of your project.

Syncing Multiple Cameras

Many productions can benefit from the use of multiple cameras: Sporting events, concerts, and other theatrical events are just a few that come to mind. Even though multi-camera productions give you a lot of coverage and several more options, there is one issue. You'll have to first sync the multiple clips or cameras together so that when you edit, you don't have to constantly deal with syncing audio and video.

Just like syncing a single video clip to high-quality audio, the process of syncing multiple cameras to audio from a digital recorder can be done in one of two ways: manually or with syncing software.

To manually sync multiple cameras, you need to find a reference (clap point) in each video source as well as the audio clip. Once you've found that point, many editing applications allow you to create a multi-clip, or multi-cam sequence. A multi-clip acts as a single clip but contains all the different camera angles as well as audio from each angle and the audio from your digital audio recorder.

When you preview a multi-clip, you can choose the audio you want the clip to use (this should be the high-quality audio from your digital audio recorder) as well as switch between different angles. After the multi-clip is edited into a sequence, you can continue to cut or switch to different angles as well as use trimming tools to adjust cut points.

We use PluralEyes to sync multiple cameras. How you do this is the same as working with a single video clip. You first layer all the angles on top of each other, making sure to also layer reference audio and the high-quality audio from your digital audio recorder, and then use PluralEyes to sync everything together. Depending on the editing application you're using, you even have the option of PluralEyes creating a multi-clip for you.

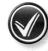

OOOPS! A PLURALEYES PROBLEM

Sometimes PluralEyes will have trouble syncing clips together. In those situations you can use the Try Really Hard option to do further analysis on the clips. Additionally, if you're using Final Cut Pro, you'll have to jump through a couple more hoops to automatically have PluralEyes create a multi-clip for you when you have a clip in a group of clips that's audio only. Be sure to check out the PluralEyes website for more information about both situations. Excellent video tutorials are available to help you use the software.

◀ A multi-clip like this one in Final Cut Pro lets you switch between different video angles and different audio sources.

Transitions, Effects, and Speed Adjustments

You've built the framework of your edit; the next step is to polish it and smooth out any rough edges. Although this might mean trimming clips, there is only so much trimming you can do. You might need to smooth transition points or add effects to adjust the look of a clip, or even adjust the speed of a clip to put it into slow motion or speed it up. In this section we'll look at adding transitions and effects, and applying speed adjustments.

Adding Transitions

In a sequence, every clip has a transition—a cut. But sometimes cuts look weird or they don't properly convey the story or passage of time, or might even make a project feel rushed. In these situations (or any other multitude of situations) adding transitions can help.

Depending on the software you're using, transitions are applied in slightly different ways. But there are some classic transitions that can be used to advance your story. With that said, we'll step up on our soapbox for a second. Many edit systems have a ton of transitions—some of them classic and cool. But many of them are, well, cheesy. When is the last time you saw a star wipe that wasn't used in a cheesy infomercial or game show? Just because it's there doesn't mean you should use it. Instead, try out these transitions in various situations.

Cross dissolve: A cross dissolve is a standard type of transition that can be used to smooth the abruptness of a cut or to "mix" two clips to create a soft composite of the two clips.

Dip to color: Dips often take on two forms, the dip to black or the dip to white. A dip to black is often used to signify that time has elapsed. As the picture dips to black, it also allows viewers to pause for a moment and "reset" before the next scene. A dip to white or flash is often used to create energy and a sense of speed in a sequence of clips. Dips to white are often very short (ten frames or less) and should be used sparingly.

▼ Every type of editing software allows you to add transitions and video and audio effects, as well as change the speed of a clip.

Wipe: Wipes, when used correctly, can let the audience know that you're changing from one scene to another or from one subject to another. Typically, wipes are used horizontally or vertically, but they can also be used diagonally.

Blur: Instead of using a dip to black or a flash of white, another common transition you see is a blur between clips. Although a blur is similar to a cross dissolve, this transition is even softer and is a good way to hide details as the clips change.

Adding Effects

Video effects run the gamut, from fixes like color correction filters and restorative tools, to very stylized effects like blurs, keys, and more. Although many editing systems include a ton of video effects, avoid the temptation of using them just for the sake of using them. For an effect to be successful, it should be motivated by the content.

In a normal edit workflow we find that effects are generally one of the last elements we add. We want the story to hold together well on its own without depending on effects for eye candy.

Changing the Speed of a Clip

Changing the speed of a clip from its native speed to something different is a technique that is used all the time. Slow motion or sped-up clips are used when editing to isolate action or to quickly show the passage of time. Both techniques—slowing down and speeding up a clip—can be used in tandem to create a dynamic effect.

Think about a car commercial: You see a person standing on a street corner and all of a sudden a car comes out of nowhere going superfast. The car then slows to a crawl and maintains that slow speed as it passes the person. After it passes (as the person's jaw drops), the car once again zooms off at high speed.

Most editing applications have the ability to adjust the speed of a clip. Generally, making a speed adjustment happens in one of two ways.

Constant speed adjustment: With a constant speed adjustment the entire clip changes speed (generally along with the audio of that clip). Constant speed adjustments are great if you need to force fit a clip into a specific gap in a sequence (called a fit to fill edit) or don't care about making a sequence longer or shorter; you'll alter the duration of the clip when making the speed adjustment. Constant speed adjustments also change the speed of audio, potentially resulting in an undesired effect.

Variable speed adjustments: Variable speed adjustments allow you to alter the speed of a clip "inside" the clip without changing the clip's duration. Variable or speed ramp adjustments are great for things like the aforementioned car commercial or action sports. Variable speed adjustments don't usually change audio speed; however, audio may appear out of sync due to the change in video speed.

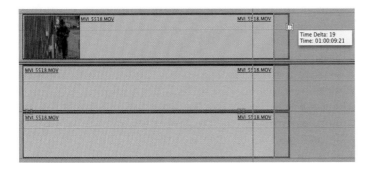

◄ Many editing applications have dedicated tools to change the speed of a clip like the Speed Tool in this screen shot from Final Cut Pro.

Overcranking and Undercranking Footage

You may have heard the terms overcranked and undercranked, but if not, here is what they mean.

The terms come from the motion picture industry and describe how a camera operator would crank a motion picture film camera faster or slower depending on the scene.

When footage is overcranked (recorded faster than the playback frame rate) and then played back at a normal frame rate (24 fps for film), the effect is footage that plays in slow motion. Conversely, objects in footage that is undercranked (recorded slower than a playback frame rate), when played back at a normal frame, appear to move at a faster than normal rate.

Many traditional video cameras have the ability to digitally overcrank or undercrank footage. But in current DSLR systems, this ability is not possible in camera.

Fortunately, you can simulate the overcrank effect in post using the following approaches. However, you first need to record footage faster or slower than your intended playback frame rate. But with the current crop of DSLRs, you can only record faster; some traditional video cameras can record slower than normal playback frame rates.

Transcode: Using a transcoding tool like Apple Compressor or Adobe Media Encoder, you can change the transcoding settings for a clip, adjusting it to a slower frame rate. Transcoding a 60 fps clip to 24 fps will give you nice slow motion. The benefit of this method is that you can transcode a clip to another codec while simultaneously conforming its frame rate.

Conform: You can conform or change the frame rate of a clip on disk. With DSLR footage, you do this by using a utility like Apple Cinema Tools (part of Final Cut Studio). Because frame rate is really just metadata, you can permanently alter the frame rate of a clip, meaning you can conform or change a clip to a frame rate that is different than the shot frame rate. With DSLR footage, we've had the best results by slowing down a clip shot at 60 fps to 30 fps or 24 fps. The beauty of this method is that the frame rate alteration is immediate, but the downside is you alter the original clip. If you plan on adjusting the speed of a clip this way, be sure to archive the original clip at its original frame rate. If you don't like the conversion, you can always revert to the original.

Interpret: Some applications like Adobe Premiere allow you to interpret footage to a different frame rate. Interpreting footage means that you can change the frame rate of a clip as it's used in that project, but you don't actually permanently change the file like you do with transcoding or conforming the footage.

No matter which method you choose to change the frame rate of a clip, you need to be aware that any audio you might have recorded along with the video clip will also change speed. So, if you know you'll be changing the speed of a clip using one of these methods, it's best to not use a clip from which you need to use the audio.

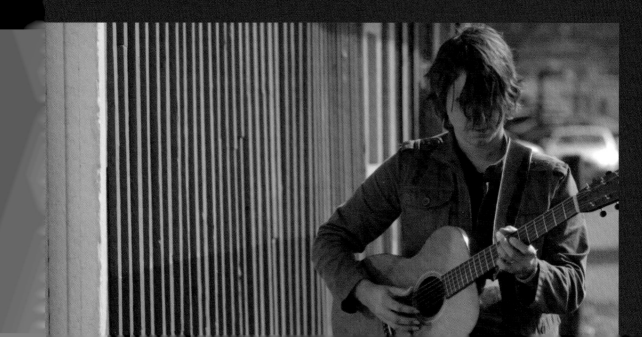

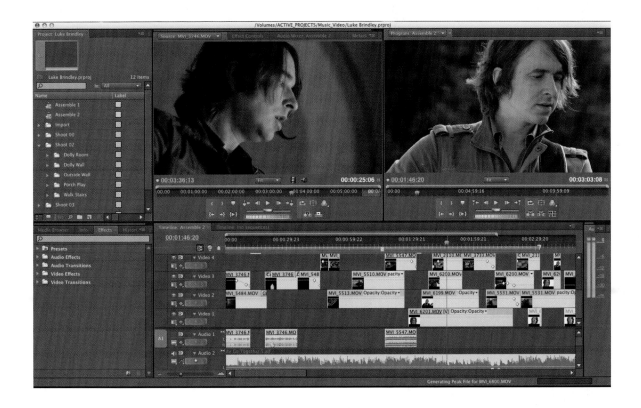

Editing Resources

Several sources are available to learn complex editing software like Final Cut Pro and Adobe Premiere Pro. Here are some of our favorites.

Apple Pro Training series: Covering not only Final Cut Pro but all the applications in the Final Cut Studio, the books in the *Apple Pro Training* series (published by Peachpit) are the best way to learn these sophisticated tools.

Adobe *Classroom in a Book* series: The Adobe Press series *Classroom in a Book* (also published by Peachpit) is an excellent way to learn Adobe's powerful tools.

Video Made on a Mac (Peachpit, 2009): Written by Rich and Robbie, this book explores preproduction, production, and post by integrating Final Cut Studio and Adobe Creative Suite. The book includes a ton of files for hands-on practice and five hours of video training.

Online training: Great online training resources include podcasts from Peachpit and Adobe, Lynda.com, Ripple Training, Kelby Training, and Creative COW. Most online training actually takes the form of a book (chapters with individual training movies), and the available titles provide a great way to learn editing.

VIDEO #27: COMMENTARY OF OUR COMPLETED EDIT

Check out this video to see all the authors discuss the editing and completion of the music video created for this book, featuring artist Luke Brindley (www.lukebrindley.com).

TRY THE EDIT

You'll find the completed rough cut edit on the DVD-ROM in a folder named Music Video Edit Project. Copy it to your hard drive and feel free to explore and modify.

Color Control

Color Correction and Grading

So far you've worked hard to get the
best footage you can. You've taken the time to plan shots, light them,
and use the right lenses and properly stabilized cameras. You've
done most of the post work too. You've successfully transferred

footage to your computer (possibly transcoded it) and then edited it. Take a deep breath. But don't relax quite yet! You've done a ton of work to get your project to this point, but there is one last step in most postproduction pipelines that can make your footage look exceptional.

Although you've worked long and hard to make your clips match your vision, chances are you can improve the look of each clip. You might even be able to add more cohesiveness between scenes in your project.

Enhancing the contrast and color of your footage can be thought of in two ways: correction and stylization. In fact, many people use two different terms to describe this end process of making footage look better: color correction and color grading.

YOU'VE DONE A TON OF WORK TO GET YOUR PROJECT TO THIS POINT, BUT THERE IS ONE LAST STEP IN MOST POSTPRODUCTION PIPELINES THAT CAN MAKE YOUR FOOTAGE LOOK EXCEPTIONAL.

Most of the time when you hear people say color correction, they're referring to just that—a correction. Corrections might consist of fixing a poorly white-balanced shot or removing a color cast. You're probably already familiar with correcting tasks like Levels and Curves adjustments. The concept is the same; only now you're dealing with moving images.

Color grading, on the other hand, often refers to stylizing or giving your footage a certain look. You might simply warm up a clip so it feels more approachable to your audience, or you might do a host of other things like adding vignettes, selectively removing colors, or even emulating traditional motion picture film development processes. What adds a bit of confusion to these processes is that people often use either correction or grading as a catchall term for fixing *and* stylizing clips. Most of the time they're referring to the overall process of enhancing the contrast and color of a clip.

It's impossible in a single chapter to give you all the information you need about color grading (you wouldn't expect to learn Photoshop in one chapter, right?). But throughout this chapter and in the accompanying video tutorials and PDFs, we'll cover some core concepts involving color grading and discuss some valuable tools and techniques. By the end of this chapter you'll be armed with the knowledge to enhance your clips so they better reflect the vision that you've worked so hard to achieve.

Color Concepts

People who are new to video and still photo color correction often start out by just twiddling with controls until the image or clip looks good. That approach is like sending a thousand monkeys into the wild with a thousand cameras. Sure, they'll get some photos, but it will take a lot of effort to find the good ones.

You can accomplish the task of correcting and grading your video clips faster and more accurately with a little knowledge. By understanding some important concepts like tonal range, contrast ratio, and the color wheel, you can get great results.

Tonal Range

Everything you do when correcting and grading a clip relates to the tonal range, which spans the tones between black and white (or dark and light). When you adjust the contrast or manipulate color in a clip, you're adjusting a value along the tonal range. Take for example these two scenarios.

ABOUT FIGURES FOR THIS CHAPTER
In many of the figures in this chapter we've intentionally altered the contrast and color balance of "before" figures to illustrate key concepts. In the field we were careful to achieve proper exposure and color balance.

Correcting a dark clip: Most of the lightness and color values in a dark clip occur toward the bottom of the tonal range. If you made a correction to lighten the clip, you'd redistribute values along the tonal range.

Correcting a green clip: In a clip that appears to be pretty green, the tint occurs only in the lightest portions of the clip. In this case, you could say that the tint or color cast happens toward the top of the tonal range. If you made a correction to remove the green, you'd do so for only the lightest parts of the clip.

Contrast Ratio

Related to the tonal range is the concept of contrast ratio. Contrast ratio can be thought of as the difference between the darkest and lightest portions of a clip. In other words, a clip that has a poor contrast ratio has most of its lightness values grouped together along the tonal range. On the other hand, a clip with a large contrast ratio has values distributed over the entire tonal range.

Most people prefer footage with a large contrast ratio, which tends to have more definition compared to low-contrast footage, which tends to look dull and flat. Keep in mind while shooting with a DSLR that you might want to shoot so the contrast is "flat." This will provide you with more latitude for correcting and grading

▲ Footage with a poor contrast ratio (left) tends to look washed out and flat compared to footage with a large contrast ratio (right) that looks more defined.

the footage in post. With that said, when grading a project, many of the corrections you'll make will be to increase the contrast ratio of the clip.

The Color Wheel

A color wheel visually depicts hue (primary and secondary), saturation, and lightness. Although there are other ways of visualizing these elements, the color wheel is commonly used to do so. Graphic artists use it most, but photography and video pros can get a lot out of it too. Here's how a color wheel works.

The angle around the color wheel represents hue (or actual color). The distance from the center of the wheel represents saturation for a particular hue. Most correction and grading tools mimic the color wheel with color balance controls.

Another aspect of the color wheel that's not readily apparent is the lightness of a hue. Think of lightness as the intensity of a particular color. So if you select a well-saturated blue color on a color wheel, its lightness determines how intense or bright that color is. Given the same hue and saturation values, a color

with different lightness values can appear to be a different color. Most color correction and grading tools allow you to make adjustments using lightness or contrast sliders.

Understanding the color wheel isn't as exciting as a new camera, but it's still very important. Just about everything you do when correcting and grading footage relates to the color wheel.

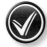

WHAT'S LUMA?

The black and white portion of the video signal is known as luma. When monitoring contrast with video scopes or adjusting contrast while grading, you're viewing and manipulating the luma part of the video signal.

WHAT'S CHROMA?

The color portion in a video signal is called chroma. When monitoring color with video scopes or adjusting color while grading, you're viewing or manipulating the chroma part of the video signal.

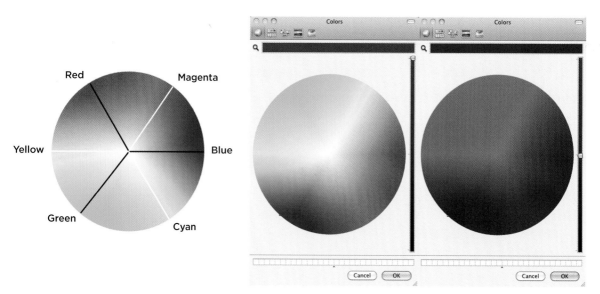

▲ The color wheel allows you to visualize primary and secondary colors (left) and to see the lightness or intensity of those colors (right).

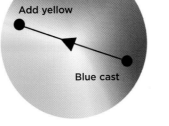

▲ Color casts are neutralized by adding in color from the opposite side of the color wheel from where a color cast occurs.

Add yellow

Blue cast

Color Casts

Now that you understand the color wheel, you need to think about color casts (and how to neutralize or enhance them). A color cast is simply the presence of a particular hue, at a certain saturation level, along a portion of the tonal range. Color casts happen for a variety of reasons including improper white balance, strong colored lighting on set, or even intense colored walls in the room you were recording in.

Color casts can sometimes be intentional (and when used as such often define a "look"). They can be used to give a clip a warm or cool feeling and be a storytelling device. In fact, you see this intentional use of color casts in films all the time. Steven Soderbergh's film *Traffic* is a great example of the use of intentional color casts. In the film, scenes set in Mexico are very warm, whereas scenes in the United States are very cool. Films like the *Matrix* trilogy (and its use

of green) or a television series like *CSI* (where everything is very warm) are additional examples of intentional color casts.

However, often a color cast in a clip is unintentional. So how do you get rid of it? To neutralize any color cast, you add color from the opposite side of the color wheel. For example, if you have an improper white balance, your clip can have a strong blue color cast. To neutralize the color cast, you would add yellow. How much yellow you add (saturation) depends on the saturation of the color cast.

Most color correction and grading tools let you control where you add the color on the tonal range. So if the blue color cast was affecting mainly the highlights (the lightest portions of the clip), you could add yellow only to those areas. Being able to isolate an adjustment is essential because problems are often not uniform.

Calibrating Your Video Monitor

At some point when working with photos, we know you've been frustrated with how your computer screen doesn't match your prints (or what you see on the web). Why does this happen? Well, there are a few variables, but most of the time the culprit is that the display you're using to view and evaluate images is not calibrated to standards of contrast and color.

To fix this problem, you might have purchased a computer monitor calibration probe from companies like X-Rite, Data, Color, or Pantone. The goal is to get color consistency from your screen to prints (and beyond). Sounds easy, right? Just calibrate your computer monitor. Well, when it comes to color correcting and grading video, it's not that easy!

See, the thing is, you *do not* want to use your computer monitor to evaluate video footage. It's OK to use your computer monitor to preview your footage, but you'll need a dedicated video monitor to accurately evaluate your footage for precise contrast and color. The typical computer monitor is incapable of reproducing the correct color space, contrast, and color accuracy of a dedicated video monitor. Additionally, when you're working with interlaced video, most computer monitors do a poor job of displaying this type of footage as well. To make matters worse, calibration probes for computer monitors won't work on your video monitor. Professional video monitors have a plethora of additional controls for properly calibrating the display and viewing different portions of the signal.

We're not saying you have to purchase a $20,000 monitor, but getting a professional video monitor is essential if you want to succeed in grading your footage and delivering consistent, good-looking footage.

Now that you know you need to use a dedicated video monitor, you've probably guessed that you also need to calibrate it. Let's look at how this is done.

Using Color Bars

The easiest way to properly calibrate your video monitor is to use standard SMPTE (Society of Motion Picture and Television Engineers) color bars. Most edit systems are able to create these bars, and some monitors have built-in bars. By using color bars, you can dial in the proper contrast for the monitor and adjust color accuracy and saturation.

If you've never seen color bars before, you might be wondering how they help you calibrate your monitor. Well, first you need to understand what the bars do.

VIDEO IN/OUT HARDWARE
To connect a professional video monitor to your system, you'll need a video I/O (input/output) device. These devices provide a connection from your computer to the monitor. I/O devices can go inside your computer (as a PCI card) or connect to your computer via FireWire. You have lots of different choices available to you, but the biggest manufacturers of these devices are AJA (www.aja.com), Blackmagic Design (www.decklink.com), and Matrox (www.matrox.com). Depending on their options, video I/O devices can range from $300–$3000.

▲ Color bars are a useful tool for calibrating the contrast and color of your video monitor.

CALIBRATING A VIDEO MONITOR USING COLOR BARS
Check out this PDF for a step-by-step tutorial on using color bars to set up the contrast and color of your video monitor.

At the top of the test pattern are bars for gray, primary, and secondary colors. The order is gray, yellow, cyan, green, magenta, red, and then blue. The middle of the pattern contains the same blocks but in reverse. You'll use both sets of bars to calibrate color and saturation of your video monitor.

At the bottom of the test pattern are several blocks. Those that are most useful are the white block, the black blocks, and (tucked in between the black blocks) three strips known as PLUGEs (Picture Lineup Generating Equipment). Each PLUGE has a different brightness that helps you set up the black level of the monitor. Collectively, all the blocks at the bottom of the pattern help you set up the proper contrast for the monitor.

For your convenience, we've created a step-by-step PDF that's included on the disc that accompanies this book. It explains all the steps you need to take to properly calibrate your video monitor. By printing out the PDF, you can keep it by your video monitor so you can easily calibrate your monitor. We recommend checking the calibration of your monitor every few weeks.

TRY YOUR HAND AT COLOR GRADING
You'll find hands-on files for all the video lessons included with this chapter. Be sure to copy the footage to your drive and try grading the footage.

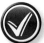

CALIBRATION ENGINEERS
To get your monitor contrast and color perfect, you may want to consider hiring a calibration engineer to calibrate your monitor. Calibration engineers use hardware probes and advanced software to properly calibrate the contrast and color of your monitor. Calibration engineers aren't cheap though; expect to pay a few hundred dollars per display.

Correcting and Grading On Set and in Post

Does every project need to be graded? We think so! Especially when you factor in that to have the most latitude in post you'll often shoot a "flat" image—one that has a low contrast ratio and is not overly saturated. Although video-enabled DSLRs are capable of capturing beautiful footage, by correcting and grading that footage you can enhance it so it really shines.

Color correction and grading generally happen at the end of the postproduction process; that is, after a project has been edited and all the project stakeholders agree that the project is "picture locked." It doesn't have to happen this way, but often it's best to wait until the project has been completely edited to avoid correcting and grading shots that won't be used in the final project.

Correction and grading can be categorized into two main areas: what happens on set with lighting and shooting, and what happens in post. In this section we'll talk about both.

Color Grading On Set

Color grading generally happens at the end of the postproduction pipeline, but the process actually begins on set. In Part II of this book, we discussed lighting for video at length. One of the goals of lighting a scene is to create an environment in which the contrast and color of the scene matches your creative vision. In essence, lighting a scene can be thought of as color correction since you're doing many of the same tasks that you might do in a software program. Often, you'll need to compensate for mixed lighting temperatures on set.

Besides using lights to grade on set, we're big fans of bringing a laptop on set and doing test grades on clips. These initial grades are not meant to be accurate but rather serve to let you know if the scene will work.

Scopes and Color Grading

In addition to having a properly calibrated video monitor, another essential tool to help you get the most out of your clips is a video scope. Video scopes measure the video signal in a variety of ways and allow you to see what's really going on (many do so in real time as the clip is playing). Why not just use your eyes? Well, your eyes are highly adaptable and compensate for color and exposure. Using scopes gives you an analytical tool to help you grade your footage. Although the following figures are all from Apple Color, the look and operation of scopes is similar from application to application.

Most editorial applications as well as dedicated color grading applications have built-in software scopes. The benefit of software scopes is that they come with the application, but the downside is that they're not as accurate as the more expensive external hardware scopes. Unless you're grading footage full time, software scopes work well in almost all situations.

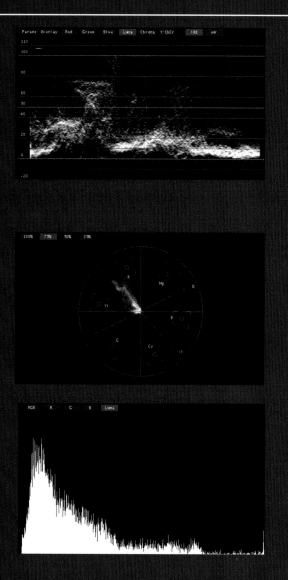

Waveform scope: A waveform scope is an essential tool for measuring the contrast of a clip. The video signal is displayed on the scope from black to white. Using the waveform scope, you can see if a clip is dark (large portions of the signal collected toward the bottom of the scope) or bright (large portions of the signal collected at the top of the scope). You can also use a waveform scope to measure the contrast ratio of a clip. The signal in a high-contrast clip spreads from black to white, whereas the signal in a low-contrast clip is more tightly bunched. In addition, a waveform scope can be used to see overall color balance between the red, green, and blue channels in a clip using the parade option that many waveform scopes offer.

Vectorscope: Using a vectorscope you can see the colors present in a clip. They are distributed around the vectorscope, where the angle indicates the hue of the clip. You can also see the saturation of a particular color represented as the distance out from the center of the vectorscope.

Histogram: You've probably used a histogram on your DSLR or in Photoshop. For color grading, it's a useful tool that is often used in conjunction with a waveform and vectorscope to measure contrast or color balance. The cool thing about the histogram is that it's very easy to see where in the tonal range a particular lightness or color value happens. Spikes in a histogram represent more pixels of that value. Being able to spot problem areas helps you fix them.

▲ Color balance controls like these in the Final Cut Pro Color Corrector 3-Way filter allow you to adjust contrast and color balance in three distinct areas of the tonal range blacks, midtones, and whites.

Let's say the goal is to create a dark and moody scene. After lighting a scene to create that look, we'll record a few test shots and transfer that footage onto our laptop. Using a color grading application, we'll apply a correction to enhance the look. This process provides instant feedback about the lighting setup and allows us to adjust it accordingly to aid in postproduction color grading. This back and forth technique is a great way to ensure that what you are shooting will work for your production.

Primary Corrections

With most clips, problems are usually global. A primary correction affects the entire image. Primary corrections account for 95 percent of all the adjustments you'll do during postproduction and affect the following two areas the most.

Contrast: Primary corrections affect the contrast of a clip by making a dark clip lighter or an overexposed clip darker. They can also increase the contrast ratio of a flat clip. Primary corrections that affect contrast can also be used to help set the mood of a clip.

Color casts: Primary corrections can also neutralize color casts that are present in a clip. They can make the clip look natural (essentially a post white balance). You can also introduce a color cast to warm up a clip

(by adding yellow/red) or cool it down (by adding blue/green), thus creating an overall look to the clip.

Depending on which application you're using, the controls will vary. Here are some of the most common controls.

Color balance controls: If you've ever experimented with color correcting video, you've probably used color balance controls. In most applications, they're represented as three color wheels that let you adjust hue and saturation; plus each wheel has a contrast slider. The reason for three wheels is that most applications break up the tonal range into three overlapping areas of influence—shadows (or blacks), midtones (or grays), and highlights (or whites). Using color balance controls, you can easily adjust the contrast and color of a clip.

Curves: Many applications also provide Curves to adjust both contrast and color along the tonal range. The

MAKE CONTRAST CORRECTIONS BEFORE COLOR CORRECTIONS
When you're making a primary correction, you should make contrast corrections before making any color corrections. As you adjust contrast, you change where in the tonal range a particular color cast might be occurring.

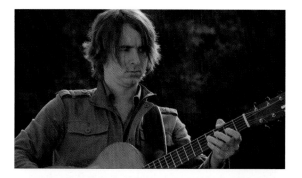

▲ Curves allow very fine control over correcting and grading a clip as the entire tonal rage is mapped across each curve.

curves allow for multiple control points because the entire tonal range is mapped along each curve. This control lets you make very specific adjustments to the red, green, or blue color channels as well as the luma component of the signal.

Saturation controls: You'll likely encounter saturation controls that allow you to adjust the overall saturation in a clip or selectively adjust saturation in the highlights only or in the shadows only. Saturation is a powerful way to enhance a clip, just be sure you don't overdo it. Oversaturated clips can lead to future problems (see the section "Broadcast Safe Video" later in this chapter for oversaturation problems).

Secondary Corrections

Unlike a primary correction that affects the entire clip, a secondary correction affects only part of the clip. You can selectively target a portion of the clip to be corrected. This lets you more easily fix problems (like a face that's a little too red) or add to a stylized look (like removing all the color except one in the clip). Most applications support secondary corrections using the following methods (or a variant).

HSL keys: Hue, saturation, and lightness keys allow you to select a particular hue, saturation, or lightness value (or a combination of HSL values) to target a specific portion of a clip. Once this selection has been made, you can affect the color or contrast of the selection or the portion not selected. HSL keys are great for fixing problems like color casts in skin tone or even changing the color of clothing.

Vignettes, shapes, and masks: In some clips, making a selection using an HSL key just won't work because the HSL values of what you're trying to select

PRIMARY CORRECTIONS WITH APPLE COLOR

Read this PDF and learn step by step how to correct an underexposed and overexposed clip as well as a clip that has a color cast using Apple's very popular software Color.

CORRECTIONS VS. GRADES, AGAIN

Earlier we described the difference between color correcting and color grading. But what can also be confusing is that many applications and colorists refer to corrections as an individual operation (darkening a clip for example) and refer to the sum of corrections (primary, secondary, and others) as a grade.

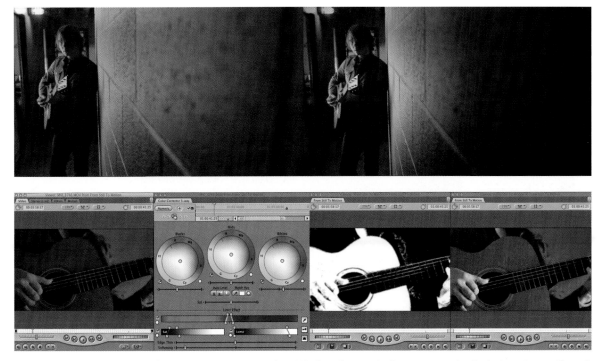

▲ Secondary corrections such as a vignette (top) and an HSL key (bottom) allow you to selectively target a portion of a clip for a correction.

happen in too many places in the clip (e.g., parts you don't want selected). Instead, you can use a vignette, shape, or mask to isolate a portion of the clip for a secondary correction.

Depending on the application you're using, you may need to duplicate the clip you're working on to get a vignette, shape, or mask to work properly. We use these tools for making secondary corrections on skies to add more color or to draw a viewer's attention to a part of the screen by lightening the inside of the vignette, shape, or mask and darkening the outside slightly.

Curves: You might be familiar with Curves from applications like Adobe Photoshop or even Lightroom and Aperture (with the use of additional plug-ins). Many color correction tools have the ability to make

secondary corrections using Curves. Typically, Curves affects the hue, saturation, or lightness of a particular point on the tonal range. Our favorite Curves feature is that it is very granular, allowing for very detailed secondary corrections. However, using Curves can be very time consuming. We often turn to the Curves tool when other types of secondary corrections don't work.

MORE ON COLOR CORRECTION AND COLOR GRADING?

Looking for more information on fixing color? You'll find additional training from Robbie Carman at Lynda.com. Richard Harrington offers lessons through Creative COW and Kelby Training as well.

▲ Curves can be used to make very stylized secondary corrections such as this remove/leave color effect.

Additional Corrections

With applications like Adobe After Effects, Adobe Premiere, Apple Color, Apple Final Cut Pro, and even Adobe Photoshop Extended, you have additional tools to help you grade your clips. In many cases, the combination of primary and secondary corrections can be enough to create the look you want. Other times, you'll need additional tools. Here some options to look for.

Effects: If you're using your edit application to grade your clips or even a motion graphics application like Adobe After Effects or Apple Motion, you have access to video effects. Everything from dirt and scratches to create an old film look, to blurs to selectively blur a portion of the clip is possible using effects. Many dedicated grading applications like Apple Color have additional effects capabilities using node-based (or individual effect) compositing.

Geometry: You can use geometry controls (scale, rotation, etc.) to help you grade a clip. If the overall look of the clip is set, but there is a distraction toward the edge of the frame, scaling up the clip a touch can eliminate the distraction and focus viewers' eyes to exactly where you want them to look, such as at your beautiful color grade! Just be careful not to scale a video clip too much. Most clips will hold up OK with a max of a 20–25 percent increase in scale before they become pixelated. Also, depending on the application you're using, there might be options for render quality when performing geometry corrections. For final output, always make sure these options are set to Best or High.

ADVANCED DIGITAL CINEMA WORKFLOW

The fine folks at Zacuto and Gary Adcock, who is one of our technical editors, have put a number of DSLRs through their paces, testing extensively how DSLR footage stands up to high-end digital cinema and color grading workflows. More information about their testing can be found by visiting www.zacuto.com.

VIDEO #28: CREATING A FILM LOOK IN FINAL CUT PRO

Many people using Final Cut Studio will automatically jump to Color to create a stylized look, but you can easily create looks directly in Final Cut Pro. In this video we create a bleach bypass film look in Final Cut Pro.

NATTRESS FILM EFFECTS

If you're using Final Cut Pro or Final Cut Express to grade your footage you should consider purchasing the Nattress Film effects (www.nattress.com), a suite of plug-ins and presets. You can use the film effects to quickly create very stylized looks that would take you hours to build making corrections and adding effects manually. The suite is available at a reasonable price of only $100.

Color Correction and Grading Software

Even just a few years ago, applications for color correcting and grading video were *very* pricey. Systems from companies like DaVinci, Autodesk, and Quantel cost as much as a very nice home. These systems are still available, but you'll probably want to use more accessible (both in cost and ease of use) software. The following list is by no means comprehensive; however, we've found these apps to be common, powerful, and relatively easy to use.

Adobe Photoshop Extended: Photoshop for video? Really? Yep, Adobe Photoshop CS3 Extended and later support video. So now you can use the tools that you're already familiar with. Photoshop is quite effective, but it's not the fastest. You also won't get some of the

Scene-to-Scene Color Correction and Grading

When working with stills, you're used to correcting and stylizing individual frames. Although you might consider contrast and color consistency across multiple images (such as a burst of photos or a studio shoot), most of the time you'll focus on a single image.

When correcting and grading video projects, working on individual clips is only half the battle. A major challenge with video is getting clips within a scene to look like they belong together. Plus, you'll want to make different scenes within a project feel like they match and are part of the same project.

As you develop more of an eye for video, you'll get better at applying a certain level of consistency to your clips. Here are a few tools and techniques that will help you make clips and scenes match.

Copy corrections and grades: In most applications you can copy individual corrections or whole grades (the combination of different corrections) from one clip to another. This is very useful when you have a clip like an interview that appears in the project multiple times. Besides lessening your workload and not having to do the same correction repeatedly, it allows for shots to match exactly. Some applications even let you group together clips so you can apply a correction or grade to a group of clips in one step.

Still store and comparative tools: Some applications, like Apple Color, have a dedicated still store where you can save a still of any clip and then load that still to compare it against other clips in the project. This direct comparison makes it easy to match different camera angles or clips that are supposed to have the same feel. Some applications also provide you with the ability to quickly navigate between two playhead locations or call up both frames simultaneously.

tools you'll want for grading (like scopes). Photoshop does have a vast number of plug-ins, including one for scopes. Check out Echo Fire (www.synthetic-ap.com) and Scopo Gigio (www.metadma.com).

Adobe Premiere Pro: Premiere Pro is Adobe's editorial application, and it has many tools. You'll find video scopes and color correction filters to correct and grade your project.

Adobe After Effects: In an Adobe workflow, you'll get the greatest control over color using After Effects. With built-in Dynamic Link, you can quickly copy and paste clips between Premiere Pro and After Effects to fix problems and create stylized treatments.

Apple iMovie: Although it's not the most professional tool from Apple, you can still use iMovie to do quite a bit to improve video footage. iMovie offers easy controls for fixing problems as well as stylization tools to enhance clips.

Apple Final Cut Express: The little sibling to Apple's Final Cut Pro also contains several tools for color correction and grading. You'll find color controls as well (but no three-way color corrector). If you're stepping up from iMovie (but aren't ready for Final Cut Pro), using Final Cut Express is a great move.

Apple Final Cut Pro: The center of Apple's Final Cut Studio, Final Cut Pro is a powerful editorial application. It has a range of tools for color correction including flexible video scopes, the Color Corrector 3-Way filter, and a broadcast safe filter. You can also use thousands of different effects plug-ins from a variety of manufacturers to create the exact look you want.

Apple Color: Part of Apple's Final Cut Studio, Color is a dedicated color correction and grading application with tools for primary, secondary, and geometry corrections as well as effects. In addition, Color has video scopes and the ability to work closely with Final Cut Pro. Color is a powerful tool for video and motion picture film-based projects.

Sony Vegas Pro: A popular Windows application, Vegas Pro, like other editorial applications for the Mac and Windows, has many color correction and grading tools.

Synthetic Aperture Color Finesse 2: Available as both a plug-in for popular applications like After Effects as well as a stand-alone application, Color Finesse is a strong contender for correcting and grading projects.

VIDEO #29: GRADING FOOTAGE IN ADOBE PHOTOSHOP EXTENDED

If you're using Photoshop, be sure to check out this video on how to use Photoshop to grade your clips. We also explore options for using scopes in Photoshop.

VIDEO #30: GRADING FOOTAGE IN APPLE FINAL CUT PRO

For many people, Final Cut Pro is their editorial application of choice. Check out this video to learn how to perform primary and secondary corrections in Final Cut Pro.

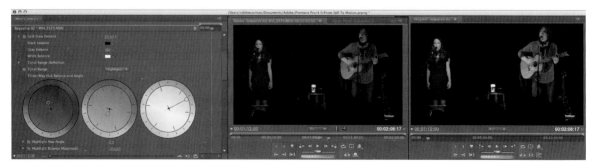

▲ Adobe Premiere Pro has many tools for making primary and secondary corrections.

Red Giant Magic Bullet Plug-ins: This app is not really a stand-alone application but rather a suite of tools available for popular applications like Final Cut Pro, Premiere Pro, and Adobe After Effects. Magic Bullet is available in several different configurations. We particularly like the new Magic Bullet Mojo, which makes color grading as easy as it gets: A few simple clicks and Mojo makes your footage look fantastic.

Broadcast Safe Video

Broadcast safe really means that your project adheres to technical standards of any given broadcaster. Even if your project will not be broadcast, it's important to understand what broadcast safe means and how it impacts you. Why?

Adhering to broadcast safe standards ensures consistency across clips and scene to scene since you're using a standard. Also, clips that are too bright or too saturated can have technical ramifications like colors that look like they bleed. Generally speaking, guaranteeing that your video is broadcast safe means making sure that the luma and chroma portions of the video signal are legal.

VIDEO #31: GRADING FOOTAGE IN ADOBE AFTER EFFECTS
Adobe After Effects is a motion graphics powerhouse but also has plenty of tools to grade footage. Check out this video to learn more.

THE BIBLE OF BROADCAST SAFE
Individual broadcasters will have different technical requirements, but the most followed set of standards are those published by PBS. Check out the Technical Operating Specifications (TOS) at www.pbs.org/producers.

Ensuring legal luma: Most broadcasters require that the luma level (lightness) when looking at a waveform scope be less than 100%. Short bursts above 100% are sometimes acceptable, but to be safe, your luma levels shouldn't go above 100%. On an RGB scale, this means keeping the image below a value of 235 for each color channel.

Ensuring legal chroma: Broadcasters also have requirements for legal chroma. When looking at a vectorscope, no part of the signal should exceed 100%.

Even the best colorists in the world have a hard time manually ensuring that every pixel in every project clip is broadcast legal. That's why most color correction and grading tools have broadcast safe controls that can help you effectively limit possible values of luma and chroma.

Quite a few variables make a project broadcast safe, so we recommend you dig a little deeper to obtain more information. We suggest checking out the following resources:

› Final Cut Help and Photoshop for Video podcasts

› *Color Correction Handbook: Professional Techniques for Video and Cinema* by Alexis Van Hurkman (Peachpit, forthcoming 2010)

› *Color Correction for Video, Second Edition: Using Desktop Tools to Perfect Your Image* by Steve Hullfish and Jamie Fowler (Focal Press, 2008)

› Video training from Creative COW, Kelby Training, Ripple Training, or Lynda.com

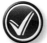

BROADCAST SAFE CONTROLS DON'T WORK MIRACLES
Broadcast safe filters and controls when faced with a really illegal clip can be pretty harsh when legalizing the clip potentially creating some undesired video artifacts. Even though it can be pretty difficult to manually get every pixel in a clip legal you should try to get the clip as legal as possible before depending on broadcast safe options.

Distribution Deal

Publishing Your Video

Many photographers feel that showing their work is one of the most important parts of the creative process. Whether it's publishing to the web, updating a portfolio, or setting up a gallery showing, the feedback loop is critical to personal (and professional) growth.

Today, we live in an interconnected media world. What's on TV in the morning will be on the web and social networking sites by lunch and on a portable media player by the afternoon. So, it's likely you'll publish your projects to multiple mediums and devices to cover all your distribution needs.

MANY PHOTOGRAPHERS FEEL THAT SHOWING THEIR WORK IS ONE OF THE MOST IMPORTANT PARTS OF THE CREATIVE PROCESS.

In your experience working with stills, you're already used to this multi-output process. For example, you might post proofs for a client to the web, make prints and albums, and then create a slide show on a DVD. Using multiple formats to share work has become standard practice.

When it comes to video, distribution might seem a bit more complicated. How do you share those big video files? It's not like you can print them out or attach them to an email. With a little effort you'll discover that you can share your video on a TV, put it on the web, make an optical disc like a DVD or Blu-ray, and even post the project to a social media site like YouTube, Facebook, or Vimeo.

In this chapter we explain how to publish your projects to a variety of mediums and devices so you can easily distribute your projects to other people.

Output Checklist

Before outputting any project, you'll want to make sure you've dotted all your i's and crossed all your t's. It can be pretty embarrassing when showing a project only to realize that the audio is a little out of sync or you misspelled text in a graphic. The postproduction process for video is lengthy and detailed; the chance for errors is pretty high. Let's look at the most important items to double-check before you output your project.

Graphics and Titles

Graphics and titles can really help tell a story, but if they're placed incorrectly or misspelled, they'll be an embarrassment. Additionally, video has technical limitations on type. Choose the wrong font and it will detract from, more than help, your project. Here are a few considerations to keep in mind when using graphics and titles.

Font size: As a photographer, you'll likely favor text that is unobtrusive and out of the way. Unfortunately, this may mean using text that is too small (just because it looks good on your computer doesn't mean it will work when published). In most video projects, a good litmus test is to stand 10 feet back from your computer (which is the typical viewing distance for TV watchers) and be able to read the text. Make sure that you don't have to squint to see the text. If your text passes this test, it should be a good size for the web as well.

Color and lightness: While watching TV, you might have noticed colored text that seems to bleed at the edges of letters or even looks like it shakes a bit. Both are symptoms of text that is illegal (by video standards). As we discussed in the previous chapter, broadcast safe standards ensure that footage is not too light or dark, or too saturated. Well, the same rules apply to text. You want to make sure that your text doesn't exceed 100% or 100IRE on a waveform scope, and that when looking at a vectorscope, your text is not too saturated or does not exceed the outside edges of the scope. We generally recommend avoiding bright red or yellow text and using a slight gray color instead of pure white.

Text and graphic placement: Where you place your text and graphics is very important. Besides respecting title and action safe areas, make sure you don't place text on top of people's faces or place a graphic in a location that makes something else onscreen hard to see.

Animation: We always take a close look at any animated graphics or text to make sure that the animation is smooth and readable. You should be able to read the text out loud twice before it disappears. It can be distracting to viewers if text and graphics fly all over the screen in a haphazard way (unless of course that is your intention).

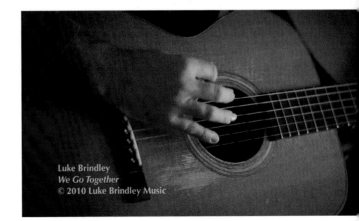

Luke Brindley
We Go Together
© 2010 Luke Brindley Music

▲ When placing text or graphics onscreen you should respect action and title safe boundaries.

BE SENSITIVE TO COLOR-BLIND VIEWERS

When choosing colors for graphics and titles, keep in mind that some viewers might be color blind, thus making it hard or impossible to read text or see graphics that use certain colors or combinations of colors (like red text on a blue background). We found a cool utility from Huetility for the iPhone that lets you simulate how color-blind viewers see stills, text, and graphics. It even works with items on the web. Check it out at www.huetility.com/tools/simulate.

Audio Mix

We discussed recording good audio and mixing earlier in the book (remember that audio is half the equation in telling a good story). Before you output or publish your project, it's a good idea to check your audio mix once more for several problems that often slip by.

Average level and peaks: No matter how you'll be outputting your project, audio level issues (like over-modulated audio or audio that is too quiet) should be avoided. For broadcast, make sure your average levels are around –20 dBFS on a digital scale, with peaks at –10 dBFS. For nonbroadcast projects, you can increase the volume by using average levels around –12 dBFS and peaks near –3 dBFS.

Drowning out dialogue: We hate listening to projects in which audio sources are competing with each other. Before you output, make sure that where music and the spoken word overlap the music is not too loud. Likewise, between dialogue or narration bites you can gently raise the level of music to "fill in" areas void of words.

Additional Visual Considerations

After editing and color grading your project, you'll still need to double-check a few details before you output your project.

Broadcast legality: As you make adjustments to color and exposure, it's very easy to create video that is not broadcast legal. This means you have luma levels between 0% and 100% on a waveform monitor, and saturation, when measured on a vectorscope, is less than 100%. Even if you're not broadcasting your project, it's always a good idea to follow broadcast safe rules. This rigidness allows for consistency across different output mediums.

Skin tone: If a person appears multiple times in different scenes in your project, do your best to make sure that person's skin tone matches from scene to scene. Although each scene will probably have its own look, viewers might find it distracting if skin tone varies greatly. In the real world, our brains blend skin tone, making it look natural under various lighting situations; in the video world, you have to put in an extra bit of work to make skin tone match.

Glitches through transitions: Check that all your effects and transitions are rendered properly. Make sure that you don't see any visible glitches or distracting movements that look like a flash onscreen as these can be distracting and interpreted as a mistake by viewers. Also, be on the lookout for any black holes that might have accidentally been created when editing and adding transitions.

▲ You should always check audio levels and overall mix of your audio elements in a project before publishing it.

Creating a Master File

No matter where it's going or in what format you need to publish, you'll need to make a digital master of your project. A master file is one movie (a self-contained file) of your entire project. The basic idea is that a master file is generally the best quality it can be, which allows you to make many different conversions and outputs from a single file. Also, having a single master file allows you to easily archive a project so you can make additional outputs in the future without having to reload the whole project.

Creating a high-quality master file requires a few essentials; here's a quick list of guidelines to stick to.

Compression: Make sure you use the mildest form of compression possible when creating your master file. This means choosing a compression scheme that matches the high-quality editing codec you've chosen to work with.

Using Apple ProRes on a Mac as the compression scheme for your master file is an excellent choice. Although the standard Apple ProRes is perfectly suited for mastering, ProRes HQ provides an even higher data rate. Apple ProRes 4444 (called 4 by 4) applies no chroma subsampling, giving you even better quality (but the trade-off is a larger file size).

We've continually been impressed by the CineForm codec (www.cineform.com). It performs equally well to other high-quality codecs like Apple ProRes and is a very cost-effective way to get a true mastering codec on Mac and Windows machines.

Frame size: Use the largest frame size you have. If you shot at 1920 x 1080, you'll want to create a master file that matches that size. You can always scale down

▲ The master file will have the best audio signal and video image due to the least amount of additional compression applied.

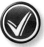

GOING TO BROADCAST?
There might be additional requirements from a broadcaster that you need to adhere to, so it's always a good idea to check those specific rules before outputting your project. If you're new to video, consider working with a postproduction facility to help you prepare the program or commercial for delivery.

START HIGH, FINISH LOW
Using a high-quality compression scheme for your master file ensures better-looking and cleaner outputs for the web. When compressing a file, if you start with a high-quality master file, you'll have less quality loss in the final file than if you started with a heavily compressed file.

video to lower resolutions like 720 x 480 for DVD (or even smaller for the web) and still be able to control whether to crop or letterbox the footage.

Frame rate: During editing, you likely locked in on a standardized frame rate. The frame rate of your master file should allow you to easily make frame rate conversions to other frame rates. The most common frame rates for this purpose are 24 fps (23.98) and 30 fps (29.97).

Interlacing: Remember, your DSLR camera shoots progressive video, which is great for the web but may need to be changed if the project is destined for broadcast, because most broadcast television is interlaced or uses a hybrid progressive system called PsF (progressive segmented frame). The good news is that interlacing (first discussed in Chapter 4), including PsF, can be introduced during output. It's much easier to add interlacing to a file than it is to remove it. Adding interlacing can be done using video hardware or software tools like exporting with your edit application, Apple Compressor or Adobe After Effects.

Creating DVD and Blu-ray Discs

Often, you'll need to put your video in someone's hands so they can view it. DVD is so ubiquitous these days that it's an easy way to publish your project and deliver it to clients, colleagues, friends, and family. The only downside with DVDs is that they're standard definition. That's why we love Blu-ray, it supports amazing HD video!

HD DISCS DONE CHEAPLY

Some DVD authoring applications can change your Blu-ray project to an AVCHD disc, which lets you use standard DVD media to play back HD video. So, you can use cheap DVDs and DVD burners to create discs that have HD content! Not all players are compatible.

When creating optical discs, two steps are usually involved. The first is compressing files into a compatible format for DVD and Blu-ray. The second involves authoring, essentially creating menus and designing interactivity on the disc.

If you'll be making lots of DVDs or Blu-ray Discs, we suggest that you research dedicated books on the subject or online courses. Here, we'll just tackle the basics to get you started.

File Formats for DVD and Blu-ray

To create a DVD or a Blu-ray Disc, you'll need to create audio and video files that will work on these formats. But deciding which type of files to create can be confusing, because each format supports multiple file types for audio and video. Well, you can take a simplified approach. Here are the standard file types used for each disc format.

For DVD:
MPEG-2: MPEG-2 is the standard compression scheme used for DVD. MPEG-2 is heavily compressed and is only standard definition for DVD. Software compression tools (discussed next) allow you to tweak quality settings to vary how much content will fit on a DVD.

AC-3: Also known as Dolby Digital, AC-3 is a compression scheme for digital audio. Using AC-3 files instead of uncompressed AIFF or WAV files on a DVD allows more room for your MPEG-2 video files and extras like menus and subtitles. Dolby Digital also supports surround sound, which is useful if you have audio that's been mixed in surround sound using tools like Apple Soundtrack Pro or Digidesign Pro Tools.

For Blu-ray:
H.264: That's right, the compression architecture that many DSLR cameras record video in is also used for Blu-ray. But it's not exactly the same (in fact it is a much higher quality version for your DSLR). The H.264 format can provide an excellent compression-to-quality ratio.

AC-3: Dolby Digital audio files are also used on Blu-ray Discs and AVCHD discs (see the tip "HD Discs Done Cheaply").

Software Compression Tools

Although hardware compression tools exist (and they're a good choice if you'll be doing a huge amount of encoding), the common choice for most people is a software compression tool. Most of the tools discussed in Chapter 15 that transcode footage shot with your DSLR also allow you to compress files for optical formats. Here are two of our favorites.

Compressor: The go-to choice on the Mac if you're a Final Cut Studio user, Compressor offers a range of tools and presets for compressing files for the web and of course DVD and Blu-ray. With Compressor you can create MPEG-2 and Dolby Digital files for DVD and H.264 files that work for Blu-ray and AVCHD discs. However, to create files for Blu-ray or AVCHD discs, you will have to use a newer version of Compressor (version 3.5 or later). One feature we really like when preparing files with Compressor is that we can use multiple computers on our network to help process all the files (known as a cluster). This enables compression to go much faster. As a bonus, you can use Compressor to author simple DVD and Blu-ray discs without having to leave the application.

▲ There are many software encoding tools available (for example, Apple Compressor and Adobe Media Encoder) to create files for DVDs and Blu-ray Discs.

VIDEO #32: USING APPLE COMPRESSOR
If you're a Final Cut Studio user, check out this video for more on using Compressor to create files for DVD and Blu-ray Disc.

How To Create a Master File

For many, getting footage into their edit application is the easy part. It's getting the footage out that becomes tricky. Although each editing application has its unique steps for exporting a project, the process is pretty standard. Use these steps to create a master file:

1. Identify the final sequence. This sequence should be "picture-locked," meaning that no additional changes will be made to the sequence.

2. Make sure the whole sequence is rendered. Click in the Timeline, choose Select All, and then render the clips.

3. Mark an In point at the start of the footage you want, and then mark an Out point at the end of the range. For many editing tools, you can use keyboard shortcuts: Press I for In and O for Out, but check your specific software for these commands.

4. Choose the File menu or Application menu to look for an option to export the file. Select the option.

5. Export the file using the same high-quality settings you were editing with: the same frame size, frame rate, and codec.

6. Save the file to the desired location. Keep in mind that the file you export will be large, so choose a location that has enough storage space.

After exporting the file, you'll have a master file that you can use to make compressions, pull stills, or archive.

Adobe Media Encoder: Adobe Media Encoder is a good choice if you're an Adobe Creative Suite user. Adobe Media Encoder works on a Mac and on Windows, and provides presets and tools to tweak compression settings for encoding files for DVD and Blu-ray.

Authoring Discs

So you've encoded files; now what? Well, that's when authoring comes in. This is when you design menus and create interactivity between those menus and the encoded audio and video files.

Besides basic interactivity (click this button to play this video), you can also author additional features like subtitles, web links, and slide shows.

Most modern authoring applications are intuitive and allow you to quickly author DVDs and Blu-ray Discs. Here are a few we like to use.

iDVD: A part of iLife on the Mac, iDVD is a simple authoring tool. Using iDVD you can choose from a number of menu templates and create simple interactivity. With iDVD you cannot encode video first. Instead, you just take your master file, drop it in iDVD, and the application compresses the file for you. iDVD only supports authoring of standard definition DVDs, not Blu-ray Discs.

HARDWARE TOOLS

Sometimes a little hardware help is just what you need for compressing files for optical formats like Blu-ray or even for the web. Why? Faster compression times. Hardware cards like the Matrox CompressHD card can increase H.264 encoding times for Blu-ray and the web by up to 10x. The El Gato Turbo.264 encoder is also a powerful tool and has the added benefit of being a USB device, so it doesn't take up room as a card in your computer.

VIDEO #33: USING ADOBE MEDIA ENCODER

Part of the Adobe Creative Suite, Adobe Media Encoder is an easy to use yet powerful tool for encoding audio and video to multiple formats. Check out this video as we explore using Adobe Media Encoder to create files for DVD and Blu-ray Disc.

DVD Studio Pro: Apple's professional authoring application allows for total creative and technical control when creating DVD discs.

Adobe Encore: Adobe Encore works on a Mac and Windows. From a single project, it allows you to author DVDs and Blu-ray Discs, and create SWF files that will play in Adobe Flash Player. You can use pre-encoded files or let Encore (which in turn uses Adobe Media Encoder) encode files for you.

Roxio Toast 10 Titanium: Although many think of Toast as a simple disc burning application, in recent versions it has become a very useful encoding and authoring application. Using Toast you can import a master file and then let Toast create a simple DVD or Blu-ray disc while also encoding your video and audio content.

Roxio DVDit Pro HD: A professional authoring solution on the Windows platform, DVDit Pro is a full-featured, encoding and authoring application for creating DVDs and Blu-ray discs.

Outputting for the Web

These days, just about every video is published to the web. Whether it's to get client approval or to share on a social networking site, video can be easily shared. The key to web video is to understand your format choices and make smart decisions when presented with options. You should master how to prepare files for the web, because it is a dominant distribution option.

About Web Formats

The web is an untamed wilderness due to the number of competing formats (called architectures) and compression schemes available. Which format or compression scheme you choose to publish your project to largely depends on what your audience will use to view or play back the files. With that said, here are some formats that are quickly becoming universal for presenting video on the web.

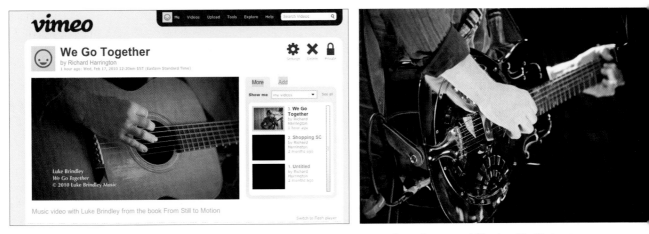

▲ When creating files for the web you'll need to balance architecture, compression scheme, and file size. You'll also want to find the balance to preserve subtle highlights and shadows (such as those in the guitar).

Flash Video: You'll encounter Flash-enabled video on the web everywhere. From Facebook to YouTube and Vimeo, most public video sharing sites use Flash Video. There are two types of Flash video encoding: FLV, which is an older standard used to encode Flash Video, and F4V, which is the newest format. It uses H.264 encoded media, which allows for higher image quality but does not support transparency in the video.

QuickTime: Truth be told, QuickTime is a very broad architecture that can encompass many media types. You'll find the QuickTime player on Macs and Windows (due to the large install base of Apple iPods and iPhones). Currently, QuickTime supports several file formats including MOV and MP4.

Windows Media: Windows Media (WMV) refers to both a media architecture (like QuickTime) and to a file type (.wmv). The big advantage of using a WMV file on the web is that the huge numbers of Windows machine owners in the world will be able to play back the file in their browser or play it locally after downloading it without needing additional software because Windows Media player is included on all Windows-based machines. You will find some compatibility issues with older machines if the media player software isn't up to date.

H.264: It seems like H.264 files are being used everywhere nowadays, from your camera to Blu-ray discs and also on the web. Well, that's the beauty of the H.264 format. It's so flexible. Several specialized versions (called parts) of the format allow it to work on different devices and tasks.

Creating an H.264 file for the web is a great choice because you'll be able to create true HD-sized files. These files offer amazing quality, and their file sizes are small enough to be easily downloaded (and in some cases stream). When quality matters on the web, we always create an H.264 file.

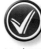

NON-SQUARE PIXELS
Some HD formats use non-square pixels, which can wreak havoc on web video. Be sure to always resize to a square pixels size like 1920 x 1080 or 1280 x 720 for the best results.

Encoding Files for the Web

Many edit systems, like Final Cut Pro or Premiere Pro, have export presets (or sharing functionality) that can simplify the export process. With a few clicks you can create a Flash, Windows Media, or H.264 file. Sounds great, right?

The problem is that an edit system lacks a lot of functionality. You won't be able to easily tweak settings to create a web video of the best quality and file size.

Fortunately, most of the video suites come with a compression program. You'll find the Adobe Media Encoder bundled in the Creative Suite packages and Apple Compressor included with Final Cut Studio. These programs offer several presets along with a broad range of tools for tweaking settings and creating files for the web.

Of course, many other compression suites are available for both the Mac and Windows. Compression is very much a personal choice. Different tools have very different user interfaces. Some are simplified for a streamlined workflow, whereas others offer robust options for customization. Here are some of our favorite tools:

For Macintosh:
> **DV Kitchen** (www.dvcreators.net/dv-kitchen)
> **Episode** (www.telestream.net/episode/overview.htm)
> **MPEG Streamclip** (www.squared5.com)
> **Squeeze** (www.sorensonmedia.com/video-encoding)
> **Stomp** (www.shinywhitebox.com/stomp/stomp.html)
> **Turbo.264** (www.elgato.com)

For Windows:
> **Episode** (www.telestream.net/episode/overview.htm)
> **MPEG Streamclip** (www.squared5.com)
> **Squeeze** (www.sorensonmedia.com/video-encoding)

Creating Files for YouTube

YouTube is synonymous with web video these days. YouTube uses Flash to play back videos—an F4V file with H.264 compression. YouTube can also play back video in HD sizes up to 1080p. If you want to post videos, you must sign up for a free account.

In theory, you can simply upload your master file to YouTube and let it do the compression. In practice, this won't work most of the time. YouTube has a 2 GB or 10 minute limit for uploaded files. If you try to upload a master file, it will be too big.

We've found that using compression software to pre-encode to a high-quality H.264 file works great. YouTube prefers that you upload an FLV, MPEG-2, or MPEG-4 file for the best results.

To share your video you can send the recipient a direct link or use YouTube's embed code and Share button (which are presented alongside each posted video). These allow you to embed the YouTube video on your own site or add it to your social media page.

OTHER GREAT SERVICES
We wish we had room to tell you about all the great video sharing services available (but we don't). Here are two more worth checking out for video as well as photo sharing: SmugMug (www.smugmug.com) and Exposure Room (www.exposureroom.com).

VIDEO #34: PUBLISHING FILES TO YOUTUBE
Watch this video to learn how to create files that work great on YouTube. You'll also learn how to speed up the upload and conversion process.

RESIZING FOR SMALLER FILES
One of the easiest ways to get smaller-sized files for the web is to reduce the frame size of the file. If you start out with a 1920 x 1080 file, reducing the frame size by 50 percent to 960 pixels x 540 pixels will reduce the file size by a little over 50 percent and still give you a respectable frame size for delivery.

Creating Files for Vimeo

We've become big fans of Vimeo over the past couple years and apparently so have a lot of people shooting DSLR video. The site has tons of content created with video-enabled DSLR cameras.

Vimeo is cool because of how it's organized. You can add content to a channel (such as the Canon 7D channel), which makes it easy to join a community or a discussion. You can also create your own projects that you can control access to.

Vimeo supports HD video up to true 1080p. Like You-Tube and Facebook (discussed next), your best bet for getting a great-looking file on Vimeo is to encode a high-quality H.264 file with your favorite compression application. We recommend the Apple TV preset available in many tools, which will allow Vimeo to process your video quickly.

Creating Files for Facebook

Facebook is the closest thing to an addictive drug on the Internet. In fact, because of its population, if it were a country, it would be the fourth-largest country in the world. Facebook is a great tool for connecting with friends and family, but it's also a great way to share video content.

UPLOADING FOR THE WEB PRACTICE
On the DVD we've included a file called We_Go_Together_Concert.m4v in the Chapter 18 folder to allow you to practice uploading to the web. Use this file for the training video exercises associated with this chapter.

VIDEO #35: PUBLISHING FILES TO VIMEO
Learn how to set up a private video on Vimeo and how to post to a community channel.

VIDEO #36: PUBLISHING FILES TO FACEBOOK
Check out this video to learn more about uploading a video to Facebook. We also explore the advanced privacy controls.

Sure, there are lots of ways to share video with your friends and family, but Facebook has some unique features: You can upload clips up to 20 minutes in length, and there's no limit on the number of clips you can post. You also have great privacy controls, so you can limit viewers to a group, your friends, or even a specific user. We recommend creating a page for your business to hold portfolio samples.

Facebook supports all major video formats like Quick-Time and Windows Media but converts them to Flash Video after you upload. As with other video sharing services, we often find we get the best quality by uploading a pre-encoded H.264 file.

Creating Prints from Video Frames

How do you take a great still photo with your video-enabled DSLR camera? That's easy—shoot in photo mode. You'll get the best quality and even the option of using a raw format. But what happens if you have the perfect shot while you're recording video? Well, the good news is that you can export stills directly from a video clip. However, there are just a few limitations.

Resolution Limitations of Video

You might be thinking, isn't video very low resolution? Yes, when compared to the native size of photos taken with your DSLR, video pales in comparison. But for many uses, such as the web or a newspaper, video has enough pixels for a decent resolution.

Currently, the highest resolution you'll get when exporting a still from a video clip that originated on a DSLR is 1920 x 1080 or approximately 2.1 megapixels. Although you won't be able to make any panoramic prints of those frames, you can still find several great uses for them. If you're printing at 300 ppi, you can extract a frame that is about 6.5 x 3.5 inches. In fact, many of the figures you see in this book are taken from video clips.

Creating a Still from a Video Frame

Creating a still from a video frame using your editing software is pretty straightforward. You'll need a video editing application and an image-editing application like Adobe Photoshop to clean up the file. Follow these steps to export a still image:

1. In your video editing application, move your playhead so it is on the video frame you want to use. Try to avoid very fast-moving footage, or it may become blurry.

2. Choose File > Export (or another similarly named feature). You'll need to choose an option for Still Images or Frame. Save the file as a TIFF or as a PSD file, which will give you great image quality compared to formats such as JPEG.

3. Choose a destination to write the file to and give the file a unique and descriptive name. Be sure that the file has the correct file type extension so you can easily open it in your image editor.

Once the file is written, you can use it as is. However, we usually find it necessary to open the image for further processing. Using an application like Photoshop, you can fix issues like contrast, resolution, and pixel aspect ratio:

1. Open the file using Adobe Photoshop. If you're using non-square pixels, you may get a warning. Click OK to dismiss it.

2. Choose Image > Image Size to check the pixel aspect ratio. Deselect the Constrain Proportions check box, but make sure the Resample Image box is selected. Set the canvas size to either 1920 x 1080 or 1280 x 720 and click OK. Then choose View > Pixel Aspect Ratio > Square (you'll find this command on the Image menu in older versions of Photoshop).

▲ Most video editing applications let you export a still frame to disk. We suggest you export a TIFF or PSD to get the best quality of still possible.

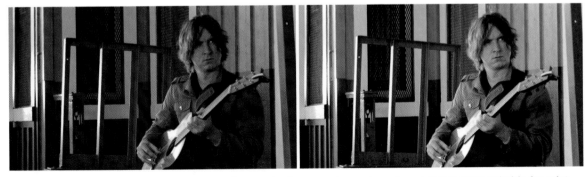

▲ You might have to resize the image to match your output size. Also, by applying a Levels adjustment in Photoshop you can restore contrast to a video clip.

DOUBLE THE FUN

You can generally double an image's size in Photoshop and get acceptable results. Choose Image > Image Size to modify the image. Set the Width and Height to 200% of their original size (you may need to click the Pixels menu to choose Percent). Make sure the Resample Image check box is selected, and choose the Nearest Neighbor method from the menu.

EVEN BIGGER IMAGES?

If you need larger images, you'll need to check out third-party scalers. One of the best we've found is Genuine Fractals from OnOne Software (www.ononesoftware.com).

3. Resize the image to your desired output size. If you're a purist, deselect the Resample Image check box and type in a resolution between 200 and 300 pixels/inch for print purposes. Otherwise, you can type in any size you want (but keep in mind that enlargements may get soft or pixelated).

4. Your video frame will likely look very washed out because video works in a different color space than photos. Choose Layer > New Adjustment Layer > Levels and click OK. Set the white point to 16 and the black point to 235 to "clamp" the input levels and give you better contrast in the image. You can then move the middle (gray) slider as desired to fix exposure. Click OK to apply the adjustment.

5. Try boosting the color using either a Hue/Saturation or Vibrance adjustment layer. Don't overdo it; just dragging a little to the right can really help.

6. Choose File > Save As and specify a destination and format. It's best to stick with either a PSD or layered TIFF file for compatibility and future editing.

▲ Adjusting Levels, followed by a Vibrance adjustment, allows you to create an image that is more suitable for print purposes.

Part V
Creative Explorations

The more you shoot, the more you'll discover new ways to channel your acquired experiences into fresh expressions. Time-lapse and stop-motion photography are techniques that cross back and forth between the mediums of photography and video. Each offers a unique way of portraying motion that is not readily seen by the naked eye. The manipulation of time is one of the irresistible attractions of motion picture making, and in the following chapters, we will demonstrate this through the animation techniques of stop motion and the time-shrinking features of time-lapse photography.

Stop and Go

Creating Stop Motion Animation

with **CHRIS GORMAN**

When shooting video, your camera usually captures the action as a series of rapidly recorded still images. But there's another way to create motion in the frame: stop motion animation. In its simplest form, an object in a scene is moved or manipulated in small increments, and then photographed. The process is repeated for several frames, which leads to the illusion of movement.

The process dates back to *The Humpty Dumpty Circus* releases in 1898. But the technique has been used throughout cinema and television. Some notable examples include *Gumby*, *South Park*, and *Robot Chicken* from television; *The Nightmare Before Christmas*, *Coraline*, *Wallace and Gromit*, and several effects like the AT-AT Walkers in the *Empire Strikes Back* show its use in cinema.

In its best form, stop motion animation conveys story and emotion in a way that can't be replicated using traditional filmmaking methods. A movie like *Coraline* is engaging because of its angular, nearly human characters. Add them to beautiful, complex surroundings, and a slightly off-kilter sense of reality is created.

EACH ANGLE [IN STOP MOTION ANIMATION] CONSISTS OF MULTIPLE STILL IMAGES, BUT WHEN THE SEQUENCES OF PHOTOS ARE STRUNG TOGETHER AND CLEVERLY EDITED, A STORY EMERGES.

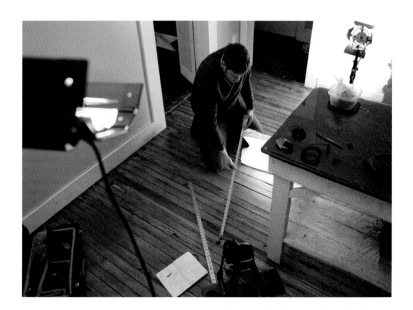

Stop motion is a long-drawn-out process, because you often have to build characters and sets. Those objects then need to be carefully manipulated to produce subtle changes between each frame. The very limitations of stop motion animation are in a way its greatest strength. Creating an altered reality is precise and time consuming. But diligent work and thinking about story a bit differently help achieve it. Stop motion animation is the marriage of still photography and live action. Each angle consists of multiple still images, but when the sequences of photos are strung together and cleverly edited, a story emerges. As a filmmaker you can create any synthetic world that you can imagine (you just need to be patient).

Gearing Up for Stop Motion

In this chapter we feature two stop motion filmmakers who share their equipment recommendations, work-flow, and art. Chris Gorman (who you met earlier in the book as a gaffer) works closely with Jeff Schmale. The duo has created award-winning short films as well as commercials for top brands. For them, stop motion is often about humor and intrigue. Their goal is to get a laugh out of the audience and bring viewers into the scene.

With the right tools, you too can create quality stop motion animation.

Choosing a Camera Body

Traditionally, stop motion animators have shot on film. But the recent trend has been to switch to DSLR cameras. The advantage is that a digital workflow increases your chances of producing a cohesive story. You can quickly check the files on set and even simulate the animation by quickly clicking through the frames right on set. This allows you to maintain the continuity and quality of lighting. You can also pay more attention to intelligent set design and shot selection.

The camera you choose for stop motion doesn't need to offer video capabilities, because you'll record single still frames. But you'll want to look for some key features when selecting a body.

Large storage capacity: You'll be shooting lots of frames, so you'll want the ability to use high-capacity memory cards to minimize touching the camera body.

Tethered shooting: Being able to directly attach the camera to a computer for tethered shooting can be a real plus. Files transfer easily to an application like Aperture or Lightroom, and you can check focus as well as sequencing.

Remote control: Again, it's all about vibration. Get your hands off the camera and use a remote to minimize movement.

Lens Selection

Quality lenses are a must for stop motion. You need precision and tight control over focus and depth of field. If you have a favorite piece of glass, but it has a bit of wiggle in the focus or play in the zoom, put it back in the case. Selecting the wrong lens leads to lots of additional "takes" and reshoots.

▼ Sharp focus is always important. Just don't forget to slide the focus lock switch or you'll tear out your hair later.

◄ A macro focusing rail is a great way to take precise control of a camera's position. The knobs allow for small adjustments in the camera's position.

Ancillary Gear

To achieve professional stop motion animation, you'll need to invest in a few related pieces of equipment. Although they aren't needed to begin, they'll quickly come in handy.

Micro dolly: The use of a small geared camera dolly allows you to slowly move the camera through a scene (for tracking or trucking the camera). This is a far better way to get movement than trying to pan or zoom. Consider a motion-controlled version or a geared unit to allow for precise changes. Repeatability and continuity of a shot is key. Gearing means dealing with fewer variables to get your shot.

Macro focusing rail: When using a macro lens, it can be difficult to achieve focus. A macro focusing rail attaches to your tripod and allows you to make minuscule adjustments with fingertip controls. You can make minute adjustments for very fine focus

Remote shutter release: A wireless version is best, but any shutter release will reduce camera vibration. Remember, don't touch the camera body! Plan on utilizing a remote shutter release all the time.

Light and color meters: The obligatory light meter is, well, it's still obligatory. Color meters are helpful too in that they ensure your eye isn't fooling you from angle to angle (at least when changing light is concerned). Because stop motion is a slow process, your eyes

If you can get them, always choose fast, prime lenses. The key benefit is that you get better performance without the risk of bumping the zoom. Some of the best glass for stop motion animation can be decades old. You'll be using film-style lights, so you can't expect an off-camera flash to make up for a slow lens. We recommend sticking with an array of primes, f/2.8 or faster.

Typically, when shooting stop motion, you'll be using scaled models or characters (as opposed to life-sized figures). Because of all the "small" work, stop motion animators often favor the use of macro lenses. Of course, if you use anything that is too long, you'll be shooting from across the studio toward your set. If you currently don't use a macro, don't skimp. Buy a quality lens, and it will pay for itself by putting a stop to potential cursing and throwing bits of clay and wire in anger.

 WHAT ABOUT ZOOM LENSES?
The use of zoom lenses for stop motion is not the norm. You want to get repeatable shots, so it's much more common to use a motorized dolly and prime lenses. But if you enjoy a little roughness around the edges, feel free to experiment.

will adjust to changes in the light. Using meters gives you accurate feedback. For instance, you might wonder, is this shot with the fluorescent just outside the frame different than the last one? Ah yes, the color meter says it's pushing green +3. Add some magenta to that light!

Professional monitor: The most important gear is your external monitor. A quality, professional CRT or LCD monitor is a must. It will give you the ability to check your shot all the time. We recommend using a CRT (or a Plexiglas-covered LCD) so you can use a grease pencil to track character movement or overlay a shot with tracing paper for matching purposes.

Camera Support

Remember the earlier statement that shooting with a DSLR improves your odds of making a solid film? Well, using pro gear is also part of the equation. A good set of sticks with a fluid head is essential. Weight is your friend; having a rock-solid base is important so your shot doesn't wander. A good tripod works well if you're shooting tabletop-style stop motion.

If you need low shots, rigs can be built or purchased that can help position the camera just off the floor (see Chapter 12). You'll want the flexibility to lower the camera as much as possible, especially because you'll be shooting scaled subjects. Positioning the camera at human "eye level" can feel like you're shooting from

a mountaintop when shooting stop motion. The good old Hi-Hat can be of some value (although it still positions you several inches off the ground).

Take to the Internet and you'll find several stop motion communities. Some of our favorite sites include:

> www.stopmotionmagic.com

> www.stopmotionanimation.com

> www.animateclay.com

You'll find instructions for building your own rigs as well as all sorts of gear made and sold for just about every idea you have. There are also plenty of message boards that provide great advice and experience from filmmakers all over the globe.

▼ Checking the distance from subject to lens allows for accurate tracking of your character. And if something goes wrong, you can precisely replicate the shot later.

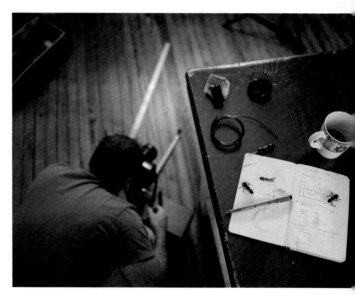

DIGITAL ZOOMS
Because you're shooting such high-resolution frames, you can perform zooms and pans during the editing stage. You can easily keyframe the shots using an application like Adobe After Effects to create additional movement.

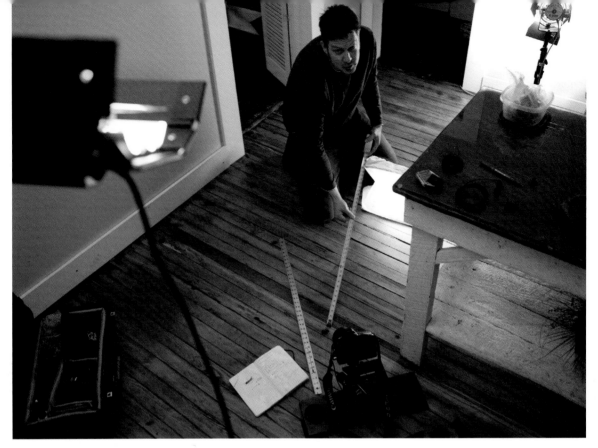

▲ Jeff looks like he's enjoying the act of measuring *everything*. This will ensure the visual matching of frames when the postproduction stage is reached.

Camera Lighting

Since you're shooting a series of stills, you'll be tempted to go back to shooting with a flash or a strobe. Don't! Hot lights are a must for producing stop motion. They never waver in their light output and allow you to work and shoot without worry. Keep in mind that repeatability is a necessity, and batteries are terminal. They will die; you just don't know when. Plug in everything.

Though we typically use a variety of HMIs, Tungsten lights, and Kino Flos, an Arri kit is sufficient for a typical stop-motion shoot. We choose open-face heads (which can be bounced) as well as Fresnel lights (which make great directional lights). Your chief concern (outside of light output) is the feel you are trying to convey in your film. Start thinking in terms of a miniature reality and favor smaller lights. Once they're set, be sure to lock those lights into place to avoid any changes on set.

Physics applies regardless of the scale of the set and characters. If you shoot a clay mouse, it's a pretty sure bet that a 650-watt Fresnel will create a fine sun source. For overall fill or soft keying, we use Kino Flo sources or Litepanels. Should you need a larger area of light and more punch, small HMIs can do the job without heating up your workspace very much.

 IT'S ALL ABOUT SCALE
Although a six-foot soft box in your still photo studio can replicate the output of the sun beautifully, it will feel like Armageddon in the miniature world. Remember to scale down the size of your light to match the characters.

Preparing for Stop Motion

Stop motion takes a lot of time and a lot of practice (but it is a very rewarding art form). The process of stop motion animation is labor intensive and often difficult to wrap your head around (think ten-hour days over and over again for days, weeks, or months). Every bit of story development and continuity improvement before the shoot begins is valuable. We recommend that you invest lots of time and thought before you undertake any project.

Initial Planning

If you ever visit an animator's studio or look at the behind-the-scenes clips on a Pixar film, you'll get a better understanding of the animation process. Walls and desks are usually papered with character studies that show different poses and emotions. Lighting diagrams and storyboards decorate most surfaces. The animators work out as much as they can on paper or on a computer before they even begin to create a single frame.

This level of attention is paid *before* animation begins. It also evolves throughout the entire production process and continues to nearly the end of production. This is not accidental. Fewer mistakes are made during production if you control the process before shooting begins.

We have on more than one occasion taken for granted that we could shoot the manipulation of our "character" without a proper test. We were sure we could do all the moves needed and get the lighting to work. But there's nothing like arriving on set and staring down the barrel of physical impossibility on a shoot day. Inevitably you ask, "Hmm, maybe we should have shot a test first?"

▶ Taking copious notes and having accurate plans is a must for the stop-motion filmmaker. You'll want to be able to refer to details as scenes will often cross days (or even weeks).

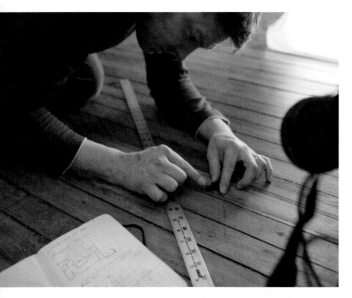

Rehearsals

If we're working on a challenging sequence, we'll do a "down and dirty" version first. By shooting just a few key shots and poses, we can then edit them together and figure out the proper timing of a scene; essentially, we are holding a rehearsal. You can in fact assemble your test shots into a functional storyboard so you know the plan for the "real" production.

You want to figure out the problems before you find yourself in the middle of a scene (think of it as painting yourself into a corner). A rehearsal can eliminate extraneous shots, saving you time and money. It also allows you to figure out the essential timings of the scene. Who cares if your hand is in the frame now and again; just shoot it fast and do a quick edit.

▲ Posing models requires delicate movements. Be sure to rehearse your poses before you start shooting.

Posing Materials

With stop motion animation, you'll need to make minor adjustments to your subjects for each shot. This often requires you to bend or pose items. Here are some useful supplies to pick up from your local craft and hardware stores:

> Baling wire of various diameters
> Stick pins of various lengths
> Tackle or toolbox with compartments for rigging and tools
> Needle nose and bent needle nose pliers
> Tweezers and scissors
> Clay sculpting tools
> Fishing line
> Carpet thread
> String
> Steel tape measure

Setting Expectations

From the perspective of the independent director or photographer, stop motion animation is liberating. The process allows you to examine lighting, design sets, and determine shot selection exactly how you envision it. Tests are easy and cheap to shoot, and ultimately ensure that less time is wasted on unnecessary shots during production.

Let's compare stop motion to a live action film. In live action the director places utter faith in the Director of Photography's ability as a lighting guru and shot maker. Each day the courier arrives with dailies of shot footage. Weeks (or even months) later work begins in a darkened room. The editor first sequences the shots, and then a colorist manipulates the footage. Essentially, you get what you get and you don't get upset. That can be a little frustrating.

On a stop motion set, most of the editing and manipulating steps happen right in camera. As a stop motion filmmaker, you can shape the development of emotional narrative and physical dimensions of the project. This means you must pay careful attention during the shoot because you won't often have the ability to get a bunch of takes from your "actors" due to the time requirements involved. You'll need to be prepared for some tedious work, but effective preproduction can speed up the process.

Fleshing out a story told through stop motion can be difficult. How do you decide whether the characters and set will be created using construction paper (*South Park*), clay (*Gumby*), humans (the White Stripes in "The Hardest Button to Button"), or action figures (*Robot Chicken*)? How many angles do you need to tell the story? Are you shooting on location or in a studio?

You need to assume that you will create a preproduction workflow just as you would for a live action project. Use the same techniques you learned in Part I of this book, but be sure to write down your plan. You will likely be your own producer, director, and Director of Photography at this stage, so notes ensure continuity.

Crew Requirements

When producing a stop motion piece, it's a very good idea to work with another professional. For the typical project shot with models in a controlled environment, two people are a must. Less assistant than partner, this person should know the scene and project well. For wide shots, another set of hands can be useful for moving set pieces or lights.

If your film's visuals are intricate, you might consider hiring a model maker/set builder. The number of changes can be immense, yet intricate, so you need qualified support.

Most important to the completion of a stop motion production is continuity. By developing an intelligent plan and having a crew prepared to implement it, you can succeed. Simply put, a pair of brains and two sets of hands make for a better film.

The Production Process

So you're ready to jump in and film your first stop motion project. Make sure you translate all your planning into action. Discuss and review the storyboards and shot list with your crew. Build the set and lock down those lights (even create a lighting diagram for reference).

Start Simple

You won't make a feature the first time out of the gate. Yet you will find thousands of kids making Lego stop motion animations on YouTube. The secret is to start simple and then expand as you gain confidence. Start with a reasonable project.

When 3D animation began hitting its stride in the mid-90s, studios started to teach 2D artists how to digitally animate. These folks didn't begin with complex scenes but rather simple 3D projects like animating a bouncing ball. These were very rudimentary pieces but allowed the animator to become familiar with the software and the process of developing a workflow.

In the same way, you should try a simple project first, a single subject doing a simple move. Animate an inanimate object like the computer mouse as it interacts with the mouse pad. Just have fun and shoot some starter projects that don't involve clients or deadlines.

Budgeting Time

How long does it take to make 30 seconds of animation? That's easy; it depends. Joking aside, making sense of a project's duration is very difficult because the process is very individualized. You might work slowly in production but fly through post, but someone else might be deliberate throughout the entire process. You'll also find that your work speed gets significantly faster with experience.

For our commercials, we are more interested in showing how our characters relate to the human world than creating an entirely synthetic environment. As such,

STORY DEVELOPMENT
If you're looking for some great examples of stop motion animation, be sure to check out Pes Films at www.eatpes.com. You'll also find several examples by searching on YouTube (although quality will vary).

we don't manipulate and pose our characters as much as the traditional filmmaker. This means we can usually put together a spot ready for editing in 20–40 hours of shooting.

Recently, we were hired to shoot a piece that would be woven into a live action commercial. Unfortunately, we had only one (long) night to complete it. Using little more than a camera, foam core, wire, and fishing line, and the client's packaging, the shot came off and integrated into the spot nicely. It's not the best way to work, but a digital workflow allows you to, with some creative thinking, almost immediately turn around a scene; just keep it simple.

In our case, we strive for a handmade quality. This style places the emphasis on dramatic interpretation and story as key virtues. For others, stop motion can demand absolutely painstaking animation flow, and continuity can take months to produce. Be sure to check out some of the behind-the-scenes features of Henry Selick's films to see the attention he and his crew put into the process. Just know that his films are glorious pieces of cinematic art and typically require a year or more to produce using a large crew.

With your production partner or crew, sit down and create a realistic schedule based on how you work. Of course, what good is a schedule if you don't stick to it? You need to set expectations for the speed you want to work or you'll "tweak yourself to death," and your film will never be completed.

However, if the train goes off the rails somewhere between preproduction and post, don't quit. Stop motion rarely goes smoothly; a few rough patches are totally normal (at least you have that going for you!).

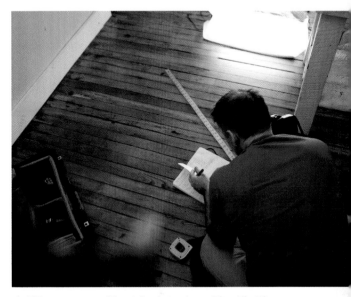

▲ This scene was ultimately shot using a Kino Flo Diva light and 2 HMI Joker 400s.

 SEE MORE OF CHRIS GORMAN AND JEFF SCHMALE'S WORK ON YOUTUBE.
› www.youtube.com/watch?v=yopOGlII8Qg
› www.youtube.com/watch?v=fThIcZ10mH0
› www.youtube.com/watch?v=e59PLiJBL0k

Our Stop Motion Rules

Here are a few rules we've developed over the years that we'd like to share. These guidelines are based on lessons learned (aka mistakes):

> Shoot in a space that is yours for days or weeks—whatever your project requires. Stop motion is time-consuming and moving locations is deadly to your continuity.

> Shoot photos of your equipment setups. You have a DSLR, so use it. Having reference shots will help you preserve continuity and develop your production approach.

> Lock down everything during setup. Tape the tripod, light stands, and every piece of gear to the working surface. Use shot bags (a smaller, yet heavier version of a sandbag).

> Mark cameras, lights, and grip gear positions with camera tape. You'll always know the location of your equipment in case you bump it when moving on set.

> Take notes on lighting. You may need to leave a scene and return on another day. Record the positions of light dimmers, as well as scrims or diffusion used.

> Measure and record camera height, distance to subject, focal length, and camera settings (ISO, f-stop, etc). Again, it's *all* about continuity.

> Diagram your lighting and camera setups. Put each diagram in a binder with the shot name at the top of each page (e.g., Scene 1B, CU on butterfly). This allows you to return to a setup in the future as well as build on your experience for new shots.

Always, always tape your lights and camera rig to the working surface. When possible also use shot bags for added stability.

The Postproduction Process

Are you ready for the good news? Postproduction is pretty standard when it comes to stop motion animation. Assuming that you properly calibrated your shots to match color, exposure, and contrast, the speed of your project (and life for that matter) can return to normal.

Color Correction

We recommend using Lightroom or Aperture for correcting color, exposure, and contrast. Both applications let you easily copy the correction from one image and apply it to several similar shots. If you have a bigger problem, like removing wire or a stray finger, turn to Photoshop. With robust cloning and healing tools, Photoshop gives you absolute control over the entire frame.

Resizing

Once you're happy with color, you'll want to size the images. Remember, still photos are often *much* larger than the video files you want. You can choose to shoot at a smaller size in camera or deal with the processing after the fact. You can use a photo editing application to resize your images by cropping or using menu commands. We find the Image Processor script in Adobe Bridge and Photoshop (or Aperture's Batch Export command) does the trick nicely. If you are outputting directly to a video file, you'll want to size the images to 1280 x 720 or 1920 x 1080 to match video output formats.

Assembly

You'll want to export all the shots for a clip into a clearly labeled folder (be sure to use meaningful titles). You can then preview them as movie clips using QuickTime Pro's Image Sequence option. Be sure to download and install QuickTime Pro (available for both Mac and Windows). If you're using Snow Leopard, you'll need to manually install QuickTime Pro from your install or upgrade DVD. Follow these steps to make an image sequence to view the frames:

1. Assemble the graphics in a single folder (as mentioned earlier).

2. Name each file by incrementing the number in its filename; for example, picture1, picture2, and so on. This can be done with the Batch Export or Batch Rename commands in Aperture, Bridge, or Lightroom. Your files are already likely numbered sequentially if you shot in order (gaps are OK).

3. In QuickTime player, choose File > Open Image Sequence (QuickTime Pro must be installed and activated).

4. Navigate to the folder and select the first file.

5. Choose a frame rate for the clip (such as 24, 25, or 29.97 fps) from the Frame Rate menu. Be sure to check your delivery format as discussed in Chapter 4. Click Open to create the movie file. QuickTime Pro will load all the sequential frames in the folder.

6. Choose File > Save to name and save the movie to your drive.

For the greatest control in creating movie clips, we recommend using Adobe After Effects. After Effects allows you to easily import an image sequence as a movie. Once imported, powerful features like keyframing, speed controls, and time remapping let you make important adjustments in composition and timing. When you're done, just render out QuickTime movies for your nonlinear editor (recall that we discussed the editing process in Part IV). You'll also find a movie in the Chapter 20 folder on the DVD about the time-lapse process that is very similar and can be used for guidance in assembling stop-motion movie clips.

Editing

During editing you'll determine the duration of each shot. You may also need to insert freeze or hold frames to further adjust timing. You can of course manipulate the story with editing, music, and dialogue as needed. At this point, postproduction returns to a normal state and differs little from the video editing process you already know (and hopefully enjoy).

Time Floats By

Creating Time-lapse Animation

This final exploration into creating video with a DSLR will feel like familiar ground. Time-lapse photography is the closest thing to how you already shoot as a still photographer. It's essentially clicking a shutter and making a

single image over and over again—potentially thousands of times sequentially.

If you've ever shot in burst mode, letting your camera shoot three or more exposures in rapid succession, you get the idea. By capturing images in a sequence, you can record a scene at a much slower frame rate than with video. You can also capture larger image sizes and even use raw images.

TIME-LAPSE PHOTOGRAPHY IS FREQUENTLY USED TO SEE OBJECTS THAT ARE OFTEN TOO SLOW TO SEE AT REAL SPEED. IN THIS CASE YOU CAN ABBREVIATE ACTION TO SHOW THE PASSAGE OF TIME.

Of course, the process is more time consuming than just clicking record to film a movie. You'll have to assemble the individual photos together and further process them to produce a final movie. But the end product is worth it because it condenses time, making the movie beautiful and elegant. Time-lapse photography is frequently used to see objects that are often too slow to see at real speed. In this case you can abbreviate action to show the passage of time. As a filmmaker, you may even use it as a way to tell a self-contained story within a single clip.

Essential Equipment

Shooting time-lapse photography may not require you to make any significant purchases because you are essentially back to shooting stills (albeit a heck of a lot of them). However, there are a few "nice to haves" that are worth considering. Let's review the essential gear so you can pack accordingly.

A solid tripod: In this case you can use your still equipment. With time-lapse photography, there is no panning or tilting when shooting. So, a high-quality fluid head is not needed. You need only a solid platform with great locks to keep the camera frozen in place as you shoot.

Your tripod should be beefy enough to not be influenced by wind, bumps, or other movement. You can take things a step further and weight the tripod down with sand bags, or use tie downs.

During some long time-lapse shoots, we even bolt the tripod to a solid surface (such as plywood or steel plating), depending on the conditions and the duration of the time-lapse shot. If your camera will be clicking away for days or even weeks, you can imagine all the intrusions or disruptions it might encounter in that time.

An intervalometer: Although you "could" sit next to your camera and constantly press the shutter button, this would get old really fast. The standard tool for regulating the amount of exposures you make during a time-lapse shot is an intervalometer. When you plug it into your DSLR, you can then remotely operate the camera to shoot stills. It allows you to easily set a timer for when you want the camera to begin recording, set the interval between exposures, and determine how many frames you want to take.

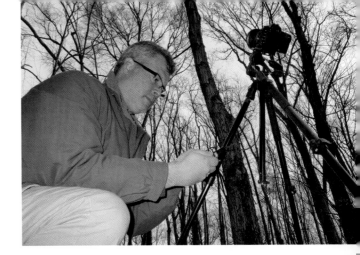

▶ An intervalometer lets you precisely control settings like shutter speed and number of exposures.

In many cases where you are not setting up the camera and leaving it behind for an extended period of time, you'll be mostly concerned with the interval setting. Then you can just let the camera rip. It's easy to edit out unwanted frames later on if you need to make a few adjustments across the first few shots as you tweak settings.

Once connected, do not leave the intervalometer dangling from the camera. When plugging it in and beginning your operation, make sure you have a good solid place to leave the intervalometer. If the cable is too short to reach the ground, don't just let it dangle in the wind. Tape it to one of your tripod legs with the face showing, or even better, run an extension cable to the camera. The remote switch function is very useful because it prevents you from coming in contact with the camera while it's running. If you need to turn off the operation during some break in the action, or change the interval, you want to avoid touching the camera or tripod. A subtle bump can appear as a jolting frame change in the final clip.

DO YOU OWN AN INTERVALOMETER?
Some cameras may have a built-in intervalometer. This allows you to shoot time-lapse shots without carrying extra gear. However, the external models make it easier to tweak adjustments as the camera is rolling.

Weather gear: The nature of time-lapse photography usually involves being out in the elements for prolonged periods. Some cameras and lenses are weather-sealed, but why test that fact or take a chance? You want to protect your gear from rain, wind, and other elements, not only to keep it functioning properly, but also to protect it from physical factors that will diminish the effect of the shot.

Rain covers and dust covers are the first line of defense, but for longer-term time-lapse shots, consider a housing that is constructed to protect against the elements. Housings can be quite sophisticated and can contain an internal intervalometer that can be programmed to go on and off at specified times when the action is most desirable. If you're outdoors and shooting during a period of extreme temperature and humidity changes, pack the inside of the housing with plenty of silica gel to absorb the moisture and condensation. You might also try some defog solution on the lens port to avoid external condensation in the early mornings.

Using a protective housing usually means that the camera will be in place for a long time, so it needs to be firmly mounted to something that cannot move. We've attached them to trees and steel girders, and have even welded them onto the observation deck of an old ship.

A spare body: Many pros swear by keeping a second (and even a third) camera body with them. If you have a spare camera body, use it! A spare body can be especially useful if you are shooting content that requires simultaneous coverage like an event or live process, such as at a construction site. You can get your master shot and some additional angles all at once. The shots will match better in postproduction and save a load of time.

Long-life battery sources: Depending on the duration of your record time, you may run out of power with the standard in-camera batteries. Easy, right; just swap 'em. But wait; taking the camera off the tripod would mess up the consistency of the shot. Even if the batteries are accessible, you still want to avoid touching the camera. A subtle change in framing from a bumped camera will quickly destroy the illusion.

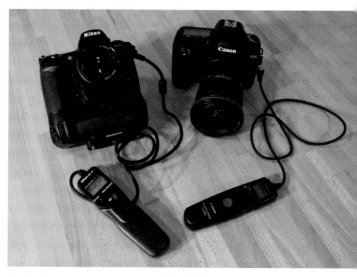

▲ Most camera manufacturers offer their own brand of intervalometer for attaching to your camera. Some camera models even include built-in controls.

You can extend the life of your camera's power capacity by using a battery grip. Another option is to switch to AC power. Just make sure you have a backup plan like using a generator or extension cords.

High-speed memory cards: If your camera is chugging away at 3 fps on the intervalometer, you don't want the camera to lock up. If you hear inconsistencies in the shutter or recording, there's a good chance your card is too slow. Variation in the record time means that the playback speed will be erratic once the time-lapse shots are assembled. So, make sure your memory cards are high capacity. Having to switch out a card can cause unwanted gaps or camera vibration as well.

DAY AND NIGHT

For shoots that will last over a period of days or weeks, it might be a good idea to invest in an intervalometer that includes a light-sensing switch or programmable timer. You can then avoid recording at night (if you don't want to). Check out the Time Machine from Mumford Micro Systems at www.bmumford.com/photo/camctlr.html.

Shooting Approach

By its very nature, time-lapse photography requires a sizable time investment. Executing a shot list for a stand-alone time-lapse video of just several minutes can take you weeks to shoot. The biggest variable of course is how much action you need to condense. The passing of clouds takes much less production time than the growth cycle of a flower.

But all shots take planning, and your goal should be to affect the variables you can control. You need to make smart decisions about camera placement, framing, and exposure to get an attractive shot. You also need to evaluate technical choices in shutter and interval in such a way as to increase the probability of success in manipulating the variables you can't control like weather and disruptions.

Staging a Scene

If you are incorporating time-lapse footage into a normal shooting schedule, keep in mind that it will tie up your gear for a while. Your camera may end up on a locked off tripod for hours (or even days). Plus you'll need to keep the frame clear of unwanted subjects or objects. How do you stay out of your camera's way? It becomes critical to plan your shoot with additional constraints in mind.

We recommend treating your time-lapse shots like a mini scene. Stand-alone shots are useful, but a short series of shots can expand the flexibility of how you edit time-lapse shots into a larger project—think master, close-ups, inserts, and closers. This is where multiple camera bodies can really save you time. You can plan how and where to transition into your standard full-motion video.

How Long to Shoot

Knowing how many frames to shoot can be tricky. We recommend that you consider the action in terms of how long it takes to happen in reality and in the finished clip. Some basic computations are needed to work with the following variables.

Real time: Start with the real time. How long is the event that needs to be recorded? An hour? 4 hours? Days? Break it down into minutes and then seconds for easier calculations later on.

▲ Using interesting foreground objects in your framing can give some depth to the average time-lapse cloud pass.

▲ You can take this a step further and place story-relevant objects in your frame. In this case, the topic is child safety.

Screen time: How long does the shot need to be for the finished video clip? 5 seconds? 10? 30 seconds?

Frame rate: At what frame rate do you need the finished file to play back? Are you editing in 24p? 25? 29.97? The number of frames you need to fill one second of video will affect the number of frames you need to capture.

Interval between frames: How quickly do you want time to pass? Do you want to show the passing of minutes or weeks?

All these considerations will determine the number of frames you will need, which will also indicate the time interval between each frame (or burst) from your camera.

For example, consider this scenario (and forgive us for sending you back to math class): You are trying to record the sun moving across the sky, edge to edge in your frame. From your sun path calculations you conclude it will take 4 hours to cross the frame you have set. You want the shot to last 12 seconds onscreen.

How many frames do you need? And at what interval do you record them?

Here are the calculations:

› 4 hours equals 240 minutes, or 14,400 seconds.

› The project will eventually be screened at 30 fps.

› Your shot goal is 12 seconds. Multiply 12 by 30 fps to get a length of 360 frames.

› Divide the total number of seconds (14,400) by the number of frames needed (360) to give you your frame record interval. In this case the answer is 40.

› Therefore, every 40 seconds you make 1 exposure for a 4-hour period, which will result in approximately 12 seconds of screen time.

A note of caution is warranted here if you're trying to be too precise. You may only need 12 seconds of screen time, but you want that time to be exactly 12 perfect seconds! You don't want any bumps or bogies walking through your frame; fogging of your lens; unwanted clouds, airplanes, animals; or just plain lack of activity for a portion of your shot. Good luck!

Consider a fudge factor and pad your record time if possible. Why? Things go wrong, so make sure you have the flexibility to lift out the best portion of the shot—just when the clouds were perfect or the traffic was at its most frenetic. If your glitches are only momentary, you have the benefit of eliminating the offending frames in post and smoothing over the jump with a proper edit.

Movement as Subject

No matter who or what you are shooting—people, landscapes, weather, machines—your subject is essentially the movement of one or more of these elements within the frame. So, you need to develop a talent for previsualizing how this movement will look in time-lapse mode.

This skill will guide you in determining that important interval setting. As you look up at the sky and watch the clouds barely moving or try to imagine a stadium filling with people before it actually happens, you will (with experience) make increasingly educated decisions about that span between exposures.

At times, postproduction will become your best friend. Sometimes it's best to just shoot lots of frames and then speed up the action in post. This will take some of the guesswork out of trying to constantly answer the "how long" question. But, don't get lazy; you still want to develop your time estimation skills!

Camera Placement

Where you place the camera is critical for time-lapse acquisition. You need to isolate your camera's position to minimize the chance of it getting bumped. You can use traffic cones or partitions to limit traffic. You can also choose a spot that's just out of the way (such as a camera mount or a remote spot). In addition, isolated camera placement helps to avoid elements blocking the frame and the action you intend to record.

Camera Framing

Keep two details in mind when framing your camera: sensor versus frame size and overall composition. The first point is easy. Throughout this book you've become used to shooting with only a portion of your camera sensor (typically shown with a darkened frame on your LCD). With time-lapse photography you are back to shooting an image with a 3:2 ratio (as opposed to 16:9). You may want to mark your LCD or LiveView panel with tape or just remember the difference when you compose the frame.

▲ Sometimes you need to get the camera up and out of the way of distracting activity or unintended contact. Here an all-weather housing is bolted to a 20' piece of water pipe to see the view below.

Speaking of composition; be sure to set your frame to minimize unwanted action. Some moving elements in your frame will distract from your time-lapse shots. For example, if you are recording an action that dictates flowing/natural movement (such as clouds), frame out the more hectic elements of the scene like tree branches moving frenetically in the wind. If you are shooting in the city, perhaps shooting general urban activity, be sure to hide the camera from view or place it at a height that will prevent unwanted attention from gawkers staring into your lens.

Scheduling

It's important to schedule your time-lapse shots for the right time of day. You want the images to really sing, so be sure to schedule the shot for the best light and motion. If you're unsure of the shot, scout the location beforehand. It's far better to make an extra trip than it is to waste a long day of shooting. You need to carefully contemplate camera placement, because getting a second crack at your scene is much more costly than usual!

When planning a time-lapse shooting schedule, keep in mind that it can be a bit of a waiting game for the right shot. You need to think about budgeting for that time. It's hard to wait around when you want to be getting shots in the can. If you can't tie up your principal camera, put a spare body into action. You can either place it in a secure location or task an assistant with babysitting the shots and monitoring them throughout the day.

 PRACTICE MAKES PERFECT
We recommend you experiment as much as possible before your "real" shoot. Try to get a feel for how long real movement will play on the screen with the different choices you make.

◀ Time-lapse is time-consuming, so go to the extra effort to get the camera in just the right place.

Technical Approach

Getting good shots is far more challenging with time-lapse photography than any other style of shooting. Due to the extended shooting times, you need to make accurate decisions about camera controls well before you see a change in your environment. You need to plan for exposure, choose the right shutter speed, and weigh the issues of file format selection.

How to Expose

Once you set the camera rolling, it's very difficult to adjust exposure. One problem is that touching the camera can create unwanted vibration. Another problem is that exposure controls are not very fine, so you'll often see "jumps" that jar the viewer. Fortunately, you have a few options. Exposure for time-lapse photography is a constant series of judgment calls. You'll have to find the right strategy for each situation.

Camera mode: Give careful thought to which mode you'll shoot in. Manual mode gives you the greatest control, but you may prefer one of the priority modes like Aperture or Shutter priority.

Manual exposure: Manual exposure control allows you to overcome the auto iris's desire to find normal exposure. But it also limits your ability to adjust for extreme changes. Once it's set, that's it—no touching. So you have to plan for sections of a shot to be unusable due to overexposure or underexposure, or shoot in the middle of the exposure range and compensate during post.

Shoot tethered: If your camera can be tethered to a laptop, it is often possible to control camera properties from the computer. This can allow for finite controls and smoother transitions without ever touching the camera. You will of course need to tie up a laptop and have an adequate AC power supply.

SHUTTER PRIORITY

If you'll be shooting in Shutter priority mode, it's important to remember that large changes in aperture will change the depth of field for the scene. This could have strange-looking results in the final sequence.

▲ Once you find the right camera position, that camera must not move! We go to great lengths to make sure of this, often using on-site resources that come our way. A professional welder helped us out at this shipyard.

▲ Portraying light as movement is a favorite in time-lapse work. Choosing interesting objects and landscapes for light to move across enhances the effect.

Use filtration: Be prepared to filter accordingly. You may be able to anticipate extreme differences in exposure in your frame and put a graduated neutral-density filter in to compensate. A good example is when the sun passes behind a mountain, putting a landscape in shade but leaving the distant sky too hot. If you have enough filters and a long enough shot interval, you can possibly swap filters on the fly. In this case,

WHEN TO BAIL

Sometimes you get a shot rolling and the action just doesn't seem to be panning out. It happens; you just can't control what happens in front of you all the time. You should balance the time already invested versus cutting your losses and starting again. Sometimes you need to know when to abort!

we recommend using an external matte box to avoid touching the camera body.

Fix it in post: Although it's a lot of work, you may need to adjust a few shots during the develop or edit stage. Fortunately, you'll have great latitude on exposure if you're shooting raw. You'll need to do additional work (and use larger memory cards) but it might be worth the effort. More about raw in a moment.

Shutter Controls

The shutter speed also affects your exposure when shooting time-lapse motion (and can serve as an additional exposure control). However, it's much more significant than that. The decision to use a short or long shutter can have considerable impact on the quality of motion in your image.

A short shutter (1/125 or faster) depicts motion that is sharp and staccato in its movement. A longer shutter (1/30 or less) progressively elongates and stretches movement. This is the effect you see when the brake lights of cars appear as long streaks on a highway or running water seems fluid and without detail.

Short and long shutter speeds are techniques you use in your still photography, and they can work in time-lapse photography to stunning effect.

Shooting Raw or JPEG

Choosing the right file format is an important decision. We'll avoid discussing the battle of raw versus JPEG. Let's just say there are benefits to each. You've probably already made a decision about which to use in your normal photography workflow, so here are a few additional points to consider.

JPEG: You'll likely be recording for very long durations. Because of the small file size of JPEGs, you can shoot longer on one card. JPEGs also offer more sizes to choose from in camera, so you can choose an image size that more closely matches the requirements that you need for video. Unfortunately, not all is perfect. JPEG files can show more compression artifacts. They also offer much less control when it comes to color correction.

Raw: Those photographers who have switched to raw have come to appreciate the great flexibility that raw files offer in post. Unfortunately, raw files are enormous (often 10X or more than a JPEG). This means less recording time to the card and longer delays as the raw files write to the card. Very fast, high-capacity cards are an absolute must if you're shooting raw files for time-lapse motion.

VIDEO #37: CREATING A TIME-LAPSE MOVIE WITH AFTER EFFECTS

Learn how to quickly assemble your time-lapse footage using Adobe After Effects in order to create ready-to-use footage.

NIKON ISO CONTROLS

Nikon has a great feature for using Auto-ISO to account for changing light levels. You can set the aperture to your desired setting and ensure that the camera shutter will not get too low. You can also set an ISO ceiling to keep noise at bay.

Assembling Time-lapse Clips

Once you've put all the effort into assembling time-lapse clips, you'll need to assemble them into a movie clip. You can use several methods to do this, but we recommend only two.

QuickTime Pro: You can create an image sequence to play back all the frames. In Chapter 19, you learned how to assemble a stop-motion clip—the workflow is identical.

After Effects: Adobe After Effects is a cross-platform tool included with some versions of Adobe Creative Suite and as a stand-alone product. The After Effects workflow is detailed but very easy to implement. With a little practice you can easily remap speed, adjust exposure, and animate camera movement (such as pans and tiles). Be sure to view the detailed tutorial on the accompanying DVD.

Index

WATCH
READ
CREATE

Meet Creative Edge.

A new resource of unlimited books, videos and tutorials for creatives from the world's leading experts.

Creative Edge is your one stop for inspiration, answers to technical questions and ways to stay at the top of your game so you can focus on what you do best—being creative.

All for only $24.99 per month for access—any day any time you need it.

peachpit.com/creativeedge